THE CLARKS
OF
COOPERSTOWN

THE CLARKS
OF
COOPERSTOWN

THEIR SINGER SEWING MACHINE FORTUNE,
THEIR GREAT AND INFLUENTIAL
ART COLLECTIONS,
THEIR FORTY-YEAR FEUD

Nicholas Fox Weber

ALFRED A. KNOPF NEW YORK 2007

This Is a Borzoi Book Published by Alfred A. Knopf

www.aaknopf.com

Knopf, Borzoi Books, and the colophon are registered trademarks of Random House, Inc.

Library of Congress Cataloging-in-Publication Data
Weber, Nicholas Fox, {date}
The Clarks of Cooperstown: their Singer sewing machine fortune, their great and influential art collections, their forty-year feud/Nicholas Fox Weber.
p. cm.
ISBN-13: 978-0-307-26347-6
1. Clark, Robert Sterling, 1877–1956. 2. Art—Collectors and collecting—United States—Biography. 3. Clark, Stephen Carlton, 1882–1960.
4. Art—Collectors and collecting—United States—Biography. I. Title.
N5220.C63W43 2007
709.2'273—dc22
{B} 2006037214

Manufactured in the United States of America

First Edition

TO LESLIE AND CLODAGH WADDINGTON

*Neither in environment nor in heredity can I find the exact
instrument that fashioned me, the anonymous roller that
pressed upon my life a certain intricate watermark whose
unique design becomes visible when the lamp of art is made
to shine through life's foolscap.*

—VLADIMIR NABOKOV, *Speak, Memory*

CONTENTS

ILLUSTRATIONS

COLOR INSERT I

COLOR INSERT 2

THE CLARKS
OF
COOPERSTOWN

INTRODUCTION

Sterling and Stephen Clark were obsessed with the art of painting. In many of their other indulgences and eccentricities, they were not unlike most other rich people; their vast wealth, the scale of their spending, the depths of their neuroses were extreme but not unique. What distinguished these two heirs to the same fortune was their consuming affinity for creative genius and visual mystery as these qualities were manifest in painted canvases. Their devotion to art as the celebrant of life's wonders, or as the beacon to hidden aspects of the human mind, was splendidly maniacal. Though they had been born into the same unusual family, the brothers were vastly different from one another in almost every other respect, and their tastes rarely overlapped; but the visceral charge they derived from objects, the zeal with which they amassed them, and the notion that their collections should one day go to the public were mutual.

These two of the four children, all sons, of Alfred Corning Clark and Elizabeth Scriven Clark were not just millionaires who collected; the treasures they selected in the luxurious showrooms of the world's greatest and most sophisticated galleries—in an era when Renaissance masterpieces and the consummate achievements of pioneering modernism could be had, if not for a song, at least within the same price range as racehorses—were their lifeblood. Sterling's and Stephen's existence

depended on, and revolved around, paintings. For that reason, in some very essential way, they were more closely aligned to the struggling inhabitants of grungy ateliers than to their fellow denizens of high society. In their inner selves, these two rich men were more the soul mates of the hardworking craftsmen mixing paints on their palettes and wondering how to pay for the next sausage and coarse wine than of their friends spooning caviar onto toast and washing it down with vintage Champagne.

One was hot-blooded and talked about his possessions all the time. The other was noticeably cool and taciturn and hardly acknowledged the world-famous masterpieces that were on the wall. But both had a remarkable awareness of the courage and creativity that marked the artists whose work their good fortune in life allowed them to own.

That binding alliance to painters from Perugino to van Gogh is the main thing that separated Sterling and Stephen from their confreres in the exceptional stratum of humanity into which they were born. They had an extraordinary amount of money at their disposal, but so did their two brothers—for whom pictures were just another accoutrement of the good life. They were sharply opinionated, and could be acid-tongued, but in their arrogance they were not unlike many others of their class who, as a consequence of having so much financial wealth, never felt the obligation to tact requisite to holding a job; they considered themselves free to voice arch and often outrageous views because they risked little damage to themselves even if they gave great offense. The brothers loved the pleasures of the table, they played sports, they traveled; but in these ways, too, they were not different at the core from lots of other people. It was only their passion for looking at, owning, and eventually giving away paintings, drawings, and watercolors that was as rare and fascinating as the objects of that passion. What grabs our interest is the intriguing drive that caused these two men to ferret out artistic gems and then to make an indelible mark on civilization by carefully donating them to public institutions so that they could be savored by the people they considered "the masses."

ROBERT STERLING CLARK was one of the only two Americans, the other being Henry Clay Frick, ever to own a painting by that most mysterious and elegant of Italian Renaissance masters, Piero della Francesca. Beyond that, he possessed two remarkable Ghirlandaios, a

Luca Signorelli, treasures by Goya and Géricault, and ravishing works by Courbet, and was so compulsive about Renoir and his evocation of pink-tinged female flesh that he bought thirty-nine canvases by the impressionist master. Along with the Renaissance masterpieces, he would give the lusty Renoirs, and even more salacious nudes (including a Bouguereau so erotic that its previous owner had purchased it just to sequester it), to a museum he founded near Williams College, then an all-male educational institution isolated in northwestern Massachusetts.

For Sterling, as for the painter he esteemed above all others—Renoir—what mattered about art was the force of life itself. This is why he disdained art historians and distrusted academics; they were too removed from the actual objects and, in his eyes, full of gratuitous, and often inaccurate, information. He preferred dealers, whom he considered more aware of standards of quality, as well as attuned to the issues of price and of the physical condition of objects, all of which mattered more to him than the views of so-called experts. He loved artworks in the most personal, and refreshingly self-assured, way, and listened only to the voice of his own taste. If some of the paintings he gave to a museum that served the population of an all-men's college had the same inspirational effect as *Playboy* centerfolds on the lonely students even while the professors presented them as objects of art-historical scholarship, this was fine; art was to be enjoyed.

Sterling made collecting—of rare books and fantastic eighteenth-century silver as well as paintings and drawings—his main occupation, an activity in which success was marked by the ratio of the connoisseurship evident in his choice to the amount he paid for it. He liked getting a good deal and buying right, as well as acquiring the best of the best. He bought some masterful paintings, and others of dubious merit; but whether he showed a sharp eye or evinced an utter lapse of taste, he did so out of the same gut response with which he devoured his preferred foods and drank down his Burgundies. As such he was the most interesting sort of collector, a breed that has become increasingly unusual as art has become a financial commodity or status object rather than something intimately and vitally connected to its maker and owner.

Because it was all so personal, the same individual who brought some of the most subtle Italian Renaissance paintings to America was led, by his love for paintings of the good life, to acquire work by such sickly sweet artists as the Belgian Alfred Stevens (whose pictures he bought periodically between 1920 and 1953) and the society portraitist Gio-

vanni Boldini. His taste for richness, for what was exotic and conjured foreign lands, sometimes caused unusual judgments, just as did the recipes he invented. (As a man of that generation, Sterling was as rare in his enjoyment of the kitchen as in his fondness for art. He made up a preparation for lobster with "mousse de Japon," heavy cream, apple, curry powder, sherry, and lobster liver in the sauce, and flavored his mayonnaise with vanilla.) But whatever he did, he did with confidence and gusto. That robust enthusiasm became his legacy in the great museum that bears his and his wife's names.

STEPHEN CARLTON CLARK was equally committed to the art he came to possess. In his case, it was courageous forays into the most imaginative modernism—outrageous in the eyes of many—that got him to pull out his checkbook. If on the surface Stephen was less eccentric and more an old-school gentleman than Sterling, in his collecting he demonstrated radical taste and immense personal bravery. For this reason, and because he then gave his treasures to the Museum of Modern Art, the Metropolitan Museum of Art, and the Yale University Art Gallery, he is responsible for millions of people a year having access to some of the most important modern paintings ever to find their way to America.

This work that is now secure in the pantheon of acceptability was, at the time when Stephen bought it, still considered a public affront for the startling way in which it broke with all known tradition and transformed the art of painting. He acquired one of Cézanne's rugged and powerful *Card Players,* and van Gogh's astonishing *Night Café.* Thanks to him, even though these paintings were in his house for most of his lifetime, the public often got to see them when these artists were first being discovered in America, from 1930 onward, both because Stephen lent them often and because he and his wife periodically opened up the doors of their house for viewings of their art collection to benefit charity. Today the Cézanne, which is at the Met, and the van Gogh, which is at Yale, continue to bring viewers face to face with the grit of human existence and the sheer force of the human mind. The Cézanne evokes the brain as a source of calculation, while the van Gogh presents it as the fount of emotional response—both having a temerity, and a proximity to the inner recesses of thought, unprecedented in art until the modern era.

Another gem purchased by Stephen and then given to the world is Bonnard's *Breakfast Room*—a fabulous sun-drenched canvas that has long

been one of the masterpieces of the Museum of Modern Art, to which he gave it anonymously shortly after the great French artist had painted it. This large painting, which evokes the splendor of daily living, has altered American sensibility—not just about art, but about how to start the day—with its revelation of the possibility of everyday sumptuousness.

In 1953, Alfred Barr, who had by then been guiding the Museum of Modern Art for most of a quarter of a century—and who had nearly single-handedly established the collection and exhibition program that determined how not only Americans, but people all over the world, regarded the art of the twentieth century—made a secret ranking of Stephen Carlton Clark's paintings. In a confidential memo he wrote to three of the most important trustees, he divided Stephen's major pictures into six categories ranging from "1+" to "5." Clearly the goal was to target the quarry that the Modern would like to be given by Stephen, who had turned seventy the previous year. There was one standout, the sole painting in "1+." This was Georges Seurat's *Circus Sideshow,* for which Barr had nurtured a consuming passion since he had included it in the first exhibition the Modern ever held, back in 1929, three years before Stephen, who had just accepted a position as one of the Modern's initial trustees, had acquired it. In this private evaluation, Barr declared *Circus Sideshow* "the most important single picture in the collection of any of our Trustees."[1] Given the Picassos and Mirós that belonged to James Thrall Soby, one of the chosen recipients of the secret missive, and the Matisses and other modern masterpieces that belonged to Nelson Rockefeller and William Paley and other trustees then at the helm of the institution—and also given that Stephen had been the person to hand Barr his walking papers ten years earlier and dethrone him as the Modern's director, causing what for Barr was a miserable interlude in his reign—this distinction cannot be underestimated.

In acquiring *Circus Sideshow,* Stephen Clark had achieved the coup of capturing one of the seven summation paintings by this most enigmatic and enthralling artist, who had died at only thirty-four. *Circus Sideshow* was in some ways the most audacious of that handful of large, complex compositions Seurat made evoking everyday entertainment. Stephen's decision to leave it to the Met, and the failure of the Modern to land it in spite of Barr's passion for it, is also part of our story.

Stephen had the connoisseurship, as well as the pocketbook, to enable him to acquire true masterpieces. When, in 1954, before he had left his

collection to the public, and crowds flocked to see his holdings in the dark interior of Manhattan's Knoedler Galleries on Fifty-seventh Street just east of Fifth Avenue, in a benefit whereby admission helped out the Fresh Air Association of St. John, they saw twenty-four paintings that could readily have been the core collection of a major museum. There were a dramatic El Greco, major portraits by Frans Hals, and one of Rembrandt's most intense religious paintings, as well as a dramatic and beguiling Manet of a woman in Spanish costume, a riveting Degas self-portrait and a stunning dancer, and four enticing Renoirs. The five Cézannes each revealed a major aspect of his art: besides the gripping *Card Players,* there was one of his quintessential close-ups of apples, a magisterial still life, a verdant landscape, and a portrait of Madame Cézanne. The great van Gogh hung next to a gem of a Seurat drawing, the charcoal worked on its side to extraordinary effect, with the monumental Seurat on the other side. American art was shown at its apogee: a sturdy John Singleton Copley portrait; Winslow Homer's crystalline *Morning Bell;* one of Thomas Eakins's images of the surgeon David Hayes Agnew; and a dramatic Albert Pinkham Ryder forest scene. The American public had rarely seen art of this caliber from a single source.

Stephen at one point devoted an entire floor of his house on East Seventieth Street to his Matisse collection—he decorated it accordingly—but then changed his mind about Matisse and divested himself of all of them. On the other hand, he never stopped seeking out, and buying, some of the most adventurous and fascinating paintings by Picasso. The switch of taste on the one hand and the complete fealty on the other beg our understanding. So does the collector's role as a museum trustee—a position that he assumed with propriety and a traditional sense of noblesse oblige, but which had an indelible effect, not necessarily for the better, on the course of American culture when he demoted Barr. That act, and the personality issues behind it, warrant careful examination.

HOW STERLING AND STEPHEN CLARK came to buy and give some of the best of the world's art ever to reach American soil, and how they related to the art they owned—and to one another, their wives, and the world beyond their magical possessions—are our story. So, too, are the extraordinary circumstances of their childhood.

There was an enormous secret that completely colored their upbringing. Their father, Alfred Corning Clark, was not just the man he seemed

to be in America—the reclusive philanthropist who loved music and books, who did what was expected of him as one of the richest men in the country endowed with a true social conscience. In Europe, in a life he led apart from his young family, he kept the company of handsome young men, including a burly sculptor who carved musclebound Michelangelesque nude wrestlers out of marble and called Alfred "the Governor" and who would eventually be Sterling and Stephen's main guide to the realm of art. When he was already a married man and father of sons, Alfred was so bold as to install a dashing Norwegian tenor—the person he cared most about in the world—in an apartment down the street from his own house in New York. The impact of that situation on Alfred's sons, and on their approach to art and the art world and on everything else in their lives, is impossible to gauge. But it is one of the many parts of the family saga that until now has never been considered, except perhaps in whispers by intimates, and that—furtive, confusing, potentially embarrassing to Alfred's wife and children—was a central spark to all that followed.

Until now, Alfred has been the least-discussed member of this illustrious family. He gets slotted simply as the link between his own powerhouse father, the man who made the money, and the generation of Clarks that spent it the most conspicuously. Yet Alfred was a man of exquisite sensibility and unimaginable generosity. He lived for art and for charity in its truest sense. Sterling and Stephen grew up with a father who in many ways was more remarkable than they were, although they became far better known. Alfred was a man of extreme erudition—a gifted linguist, a knowing amateur of music, a brilliant reader—as well as someone with a truly philosophical approach to life. When, at the same time he was fulfilling the role expected of him as a young father and the heir to his own father's staggering fortune and multiple businesses, Alfred Corning Clark translated from the Swedish a sensitive and revealing account of everyday life in ancient Rome, he addressed the essential questions of human existence. In his consideration of Antinous, the beautiful young Greek who was the kept lover of Emperor Hadrian, Alfred observes, "As man, before his apotheosis, he grieves over the annihilation that inevitably comes to every single thing, and asks with anxiety: whence and whither?"[2] Most people, until now, have considered Alfred simply as a mega-millionaire, generally characterized, falsely, as the man who built the great New York apartment building the Dakota (which in fact his father built). This most misunderstood member of the family is

also the pivotal one, in part because of the extent he felt his wealth to be a burden. Robert Sterling Clark's and Stephen Carlton Clark's sensitivity to artists and their plights, and their view of artistic creation and acts of philanthropy as central rather than peripheral to existence, developed because of, not in spite of, their remarkable, secretive father, who even by today's standards led a life that few people could have fathomed.

STERLING WAS QUIRKY, independent, and, when he wasn't grouchy, warmhearted. He would speak his mind with brute force, and then sweetly do his utmost to make up; he seemed to laugh at himself. He liked to box and to drink Burgundy, which he said warmed his heart. Even if he was Yale-educated, he lived, and wrote, like an autodidact, following his own whims, spelling in his own way (he invariably signed his letters to Stephen "effectionately") and speaking off the top of his head. He was not given to reflection, but he was immensely responsive to pleasure in every form—the track, amiable company, art, a good joke.

While Sterling led expeditions to China, lived in Paris, and initiated lawsuits as freely as he hopped on a horse, Stephen was more the man of order and logic, the methodical rationalist, the gray-suited man of business. He always seemed to rein things in, trying to be sensible and logical; his was the voice of temperance—the legacy of his Sunday-school teacher grandfather. Sterling, on the other hand, seems somehow to have appropriated some of the genes of his grandfather's business partner Isaac Singer, along with the shares of stock that bore Singer's name.

Both had responded very differently to a childhood about which, later in life, they said little.

The nature of all these personalities, the effects of character on taste, and the feud that ultimately wrenched the family apart—all these fed their legacy. Because of the incredible artwork that the Clark brothers put in the public domain, that heritage matters deeply to American life. So does the power of the nonprofit foundations their fortunes initially endowed, with their combined assets tipping toward half a billion dollars. Given their importance, the Clarks until now have been little known; this book tries to cast a closer look.

I
EDWARD

The person whose amassing of a fortune made all the collecting and high living possible was Edward Cabot Clark. Edward's grandsons—Sterling and Stephen and their brothers, Edward and Ambrose—would not have been who they were without the wealth they acquired thanks to Edward's phenomenal business success. They reaped the rewards of their grandfather's financial acumen, legal expertise, and common sense; and Sterling and Stephen, if not the other two, also felt the imprint of Edward's personality. While on the surface Edward, a Sunday-school teacher as well as a lawyer, was a man of traditional bearing who comported himself with conservative demeanor, he was intensely strong-willed, determined, and uncompromising, as well as crafty. Even if their own father, Edward's son Alfred, was a bird of a different feather, Edward's triumph in the world of commerce gave Sterling and Stephen their mettle and sense of entitlement.

The mild-mannered but tough man whose net worth in stock and real estate of approximately fifty million dollars, no mean sum when he died in 1882, allowed his heirs to do everything they did gave the impression of being an ordinary upright citizen, but he had a phenomenal grasp of power. He recognized the possession of patents as a key to triumph in commerce; and he had rare acuity about the needs and desires of ordinary citizens. With nerves of steel, and his finger on the pulse of the average American housewife, this well-situated business lawyer in New York City had at a young age burst beyond the confines of his milieu. On the surface he appeared to be a civic leader of correct bearing. When he died after thirty years of growing his money into the stratosphere, one of his business associates interviewed for his obituary simply called him "quiet and

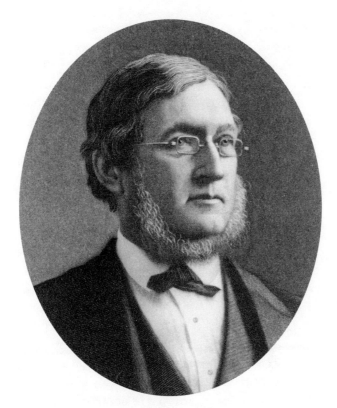

Edward Clark, c. 1850. He made the family fortune
as the lawyer and business partner of Isaac Singer,
the man who popularized the sewing machine.

undemonstrative."[1] A manager in one of his businesses credited him with a bit more aplomb as "a delightful companion, genial, entertaining and witty,"[2] but no one seemed to know what a fighter he was. The realities of Edward's professional life, however, were grounded in the rough-and-tumble: nasty litigation, and an affiliation with one of the most uncouth people who ever lived.

The reason for the family fortune is that Edward Clark had allied himself with the sewing machine developer, Isaac Merritt Singer. These two very different men achieved their meteoric rise in the world of commerce in perfect tandem, to such an extent that the outrageous Singer was a major part of the family legacy. Singer would become infinitely better known, in large part because his name was on every one of those machines

that entered households, at first all over America and then worldwide. But without Edward, Singer would not have succeeded, and the two men's lives were closely intertwined. The financial benefits that Edward reaped on such an enormous scale were inextricably connected with Isaac Singer's drive and inventiveness, but turning those qualities into a vast fortune was something both men owed to Edward's shrewdness.

The natures of these two exceptional men profoundly affected the fate as well as the personal values of their heirs. Sterling and Stephen Clark were to the manor born, but they grew up with a keen awareness of Edward's business partner, a true heathen who exemplified eccentric creativity and personal flamboyance. Sterling and Stephen would resemble Isaac Singer even more than their grandfather in the scale on which they lived and the extent of their personal extravagance, as well as their obsession with the culture of Paris, even if they modeled much about themselves on Edward—each in a different way—and bore many echoes of his strong character.

The most attractive aspect of their grandfather to penetrate Sterling and Stephen was his strong social consciousness and belief in using his position for the benefits of humankind. "The high moral beliefs of its controlling founder" caused the Singer Sewing Machine Company to treat its employees "without regard to race or creed" and, as it developed outposts and marketed its products all over the world, to have its manuals translated into fifty languages—an unusual step that was counter to the practices of many businesses in the era of colonialism. Even before the United States Civil War, the word "singer" was becoming synonymous with "sewing" and "sewing machine" in many tongues, indicating the reason the company was seen at the forefront of the idea of globalization.[3] For Edward Clark, that penetration into many different societies inspired a sense of responsibility to humanity at large that he would pass to subsequent generations—although sometimes the notion of knowing best would have outrageous ramifications.

BORN ON DECEMBER I 9, I 8 I I, in the small town of Athens in New York State's Greene County, Edward started life in relatively easy circumstances given the rigors of life in early-nineteenth-century rural America. His family belonged to the upper-middle-class establishment that had begun to take root in the recently formed United States. Six

years before his birth, his father, Nathan Clark, had established the
Athens Pottery Works. It was a successful business, known nationwide,
and Nathan and his wife, the former Julia Nichols, brought up their
sons—Edward was followed by Nathan Henry, who died before his
first birthday, and then by Nathan Jr.—in comfortable circumstances.
Nathan Sr. was a senior warden in the Episcopal Church and well
respected in the community. This highly rational man would be alive for
most of Edward's life—he lived to be ninety-two years old, predeceasing
his oldest son by only two years—and was always the foil to Edward's
more colorful life. He was described in his obituary as "one of the sturdy,
active but modest men who make their mark in American life without
creating excitement."[4] The "prudent, temperate" Nathan did, in a small
way, what his son Edward would do on an infinitely larger scale by virtu-
ally monopolizing the sale of pottery in northern New York State and
then establishing branches to increase the territory in which his wares
were sold. He helped build the local church and was known for his gen-
erous giving to charity. If his descendants would not completely follow
his model of being "free from ostentation" and certainly would not emu-
late the way he never left his small hometown, they nonetheless main-
tained his consciousness of the needs of his community.

Edward had a tutor at home before going to learn Latin at a local
academy run by E. King, Esq., one of the first men ever to be graduated
from Williams College. When he was twelve, Edward began four years
of education at the Academy in Lenox, Massachusetts, where he per-
fected his knowledge of Latin and added Greek to his studies; he also
became a voracious reader, devouring every single book—there were
about five hundred—in the school library. But he so disliked life at the
boarding school thirty miles from his parents' house that he declared to
the powers there early on that he was leaving, whereupon he walked the
entire distance home. His mother was happy to receive him, but his
father escorted him back—on horseback—the next day. This became a
routine—his leaving, his father patiently taking him back—until he
settled in.

Young Edward was transformed in the course of those years. A lonely
outsider at the start, he eventually made good friends. He got used to the
toughness of the teachers. And he emerged physically from being "of
slight, delicate frame, and almost sickly in constitution," to becoming "a
trained athlete" with muscles "like steel."[5] The mix of vulnerability and

fitness would pass to his art-collecting grandsons, each of whom was tall and lean.

In the fall of 1826, Edward Clark went on, at age fifteen, to Williams College, from which he was graduated in 1831. To enter the legal profession back then, one could train by preparing legal papers in an existing office rather than attending law school; and that same year Edward started work at the law firm of Ambrose L. Jordan in Hudson, New York. He was admitted to practice three years later, setting up a law office in Poughkeepsie.

Edward's early life flowed according to the rule book of America's most privileged population. His education and the launching of his career had gone easily and were right on target. With his straight, broad nose, perfectly formed mouth that seemed to have been drawn after a Roman statue, and large, ovoid face framed by a neat, well-trimmed beard that formed a precise curve along his jawbone and chin, the young lawyer had an appearance of rectitude. His waved, shiny wig bordered his high, wide forehead like a drapery; everything about his looks was aimed to suggest dignity, including the wire-rimmed spectacles that provided a certain tenor of seriousness. He was cut of the same cloth as most of the ancestors of characters in Henry James's novels: as a comfortable member of the new American establishment.

In 1835, this distinguished young man married his boss's good-looking eldest daughter, Caroline. Although he practiced law independently in Poughkeepsie from 1833 to 1837—as if following the notion that a bit of independence is requisite even for those born with a silver spoon—in 1837 he formed a partnership with his father-in-law. Although recent accounts say that Jordan had moved his practice to New York City in 1836, both Edward Clark's obituary, written by one of his friends in 1882, and a tribute to him written by his nephew seem more reliable sources—as they do for information on the precise chronology of Edward's connection with Isaac Singer, where there are also discrepancies—and according to those texts the partnership first moved to New York in May of 1838. In any case, Jordan & Clark soon was considered "New York City's most prestigious law firm,"[6] and it benefited immensely from Ambrose Jordan's position as state's attorney general.

In 1836, Edward and Caroline Clark had had their first child, a son they named Ambrose Jordan Clark. In 1838, their second son, Edward Lorraine Clark, was born; in 1841, he was followed by a sister, Julia, but

she lived for little more than two months. In 1844, their fourth and last child, Alfred Corning Clark—the only one who would outlive his father—appeared. It was in this period of raising his young family while living in New York City that Edward Clark's life, and fortune, gained a momentum that thrust him into a very different world.

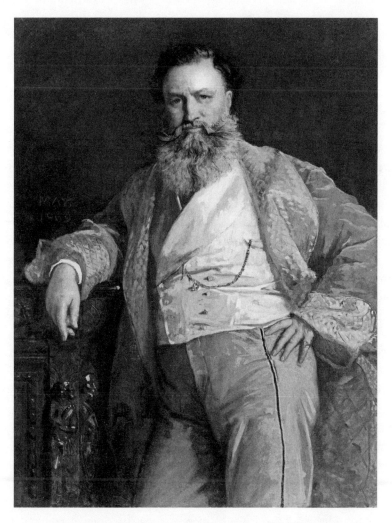

Isaac Merritt Singer, 1869: portrait by Edward Harrison May.
The father of twenty-four children by five women, some of them his wives
concurrently, he was almost as scandalous in his business practices as in
his private life. Singer needed Edward Clark to defend him in court
and whitewash his reputation as best as possible.

· · ·

EDWARD CLARK'S background and temperament could hardly have
been less like that of the man whose situation he would change immea-
surably and whose temerity would in turn have such an effect on his own
fortune. Isaac Merritt Singer, also born in 1811—in Pittstown, a small
town not far from Rochester in upstate New York—was the son of a Ger-
man immigrant and an American mother who died young. Singer grew
up in dire poverty and left home at age twelve. For the following seven
years, he worked in Rochester at any job he could find where unskilled
labor was required. Then, at nineteen, he became an apprentice machin-
ist, working for four months in a machine shop.

This was when the penniless lad married the fifteen-year-old
Catharine Haley. They quickly had a son, and Singer was perpetually
desperate for enough money simply to eat and to have a roof over their
heads. They sought refuge with Catharine's parents in New York City,
where Singer began to make "a good living because of his mechanical
cleverness" and had a series of jobs that broadened his experience of
machinery.[7] But after little time the young couple and their baby took
off for nine years of a completely itinerant life, in which they traveled
around from state to state with everything they owned in a wagon.

Singer was six feet four inches tall, and of massive build. He stood like
an operatic lothario, and had a broad chest and bulging stomach to
match the role. If Edward's beard was neatly confined to the bottom of
his face, Singer had a handlebar mustache that twirled beyond the
boundaries of his massive head, and his full beard looked as if it had been
cultivated for maximum bushiness, hanging below his sternum. Singer
spoke in a stentorian voice, and when he wasn't working in tool shops he
was performing as an actor, generally in plays by Shakespeare.

But neither Singer's size nor his imposing appearance prevented him
from being the butt of some vicious teasing in the workplace. In the
town of Newark, New York, not far from Rochester, and not to be con-
fused with the city of the same name in New Jersey, Singer worked in
a large foundry and machine shop where carding machines and other
devices to manufacture cloth were built. The journeyman apprentice
had a hard time; the owner would "tell of the ridicule Singer had to
endure from his fellow-workers for his cranky notions."[8] It was when
he was in that shop that he began to develop the idea that evolved into
his sewing machine, but for which he was "subjected to the jibes and

jokes of his fellow workmen who doubted the practicality of the machine."[9]

That ability to withstand taunts, and to survive the consequences of an inventive mind that was out of sync with the less creative approach of the surrounding population, became part of the Clarks' family lore. Different as Edward Clark was from Isaac Singer, and however staid his own background and that in which his heirs were raised, they grew up knowing the real pros and cons of original thinking.

In 1836, Singer joined a traveling theater company. In Baltimore, he met a young actress, Mary Ann Sponseler, and the next year he fathered two more children, a daughter with his wife and a son with Sponseler. Then, in 1839, Isaac Singer got his first patent. At the time he was working with one of his brothers, who was digging a waterway in Illinois; the patent was for a machine for drilling rock. The two thousand dollars the device garnered enabled him to found an acting troupe of his own. It was called the Merritt Players, and he was now Isaac Merritt, while Sponseler became "Mrs. Merritt." The troupe ran out of money in Fredericksburg, Ohio, where Singer patented his next machine, a device for carving wood-block type. Singer moved on to New York, where this second tool became sufficiently important to warrant his seeking help from Jordan & Clark in 1848.

Ambrose Jordan, however, found Singer "too personally distasteful to represent." But he must have seen something in the cretin, for he "referred him to his son-in-law."[10] Between 1836 and 1844, Edward and Caroline Clark had had four children, and the young lawyer was leading a life that was not out of the norm for a hardworking family man who simply accepted his obligations and took on any tasks that came his way. The dour Edward Clark's first task with his colorful client was to straighten out problems concerning his title to the invention for carving type. Edward helped Singer with his patent, which was awarded in 1849, and the following year Singer assigned Edward three-eighths of it, apparently in lieu of paying legal fees that the penniless inventor could not afford.[11]

In many respects, Singer and Clark were like oil and water. Besides being a Williams graduate, an attorney, and a well-connected man with a traditional marriage, Edward was a deeply religious man who, at the start of his legal career, had also taught Sunday school. The "straight-laced lawyer"[12] served as the perfect foil to the "indolent, self-regarding would-be actor and self-promoter" whose showmanship and gift for

advertising as well as "forceful personality" would soon help him launch the product that would transform domestic existence all over the world.[13]

Edward had a profound knowledge of business law, and was as personally refined as Singer was uncouth. Those sharp contrasts seemed only to abet the relationship. Edward resolved the issue of who owned title to the carving type, and extricated Singer from the problems caused by the "injudicious contracts"[14] that kept him from the rights to his own invention, but when a steam boiler burst at A. B. Taylor & Co. on Hague Street in New York, where Singer had the sole prototype of his cutting machine, the device was completely destroyed.

This background—with its elements of pure chance, and the vital role of both sheer inventiveness and resilience—would give Edward Clark's grandsons an understanding of the lives of artists, of the creativity as well as the resolution requisite for success in the field of painting, that would be vital to their roles as patrons. Sterling and Stephen would inherit some of the toughness and willingness to engage with risk takers, even unseemly ones, which was seminal to their grandfather's amassing of his fortune.

Isaac Singer was not the sort of person whose energy slackened. Soon after that explosion destroyed the device with which, thanks to Edward's good work, he thought his success was ensured, the immigrant's son began fooling around with sewing machines. Orson C. Phelps, owner of a machine shop in Boston, had heard about the cutting machine and invited Singer to build a second one in his shop. Singer never got around to making it, but in his Boston shop Phelps had sewing machines, made by the firm of Lerow & Blodgett. The few that Phelps managed to sell often came back for repairs.

Sewing machines had existed at least since 1790, when Thomas Saint had received a patent for one in England. A French tailor, Barthélemy Thimonnier, had invented an improved machine in 1829. In 1833, an American named Walter Hunt had made a fairly decent sewing machine, but then had abandoned its development out of fear of its effect on tailors and dressmakers who sewed by hand and would be put out of work by it. In 1846, Elias Howe Jr. had received a patent for his sewing machine. Yet in spite of all these devices, there was still a crying need for something better. Orson Phelps recognized the impact such a machine would have, denigrating his own product by telling Singer, "If you can make a

really practical sewing machine, you will make more money in a year than you can in fifty with that carving affair."[15]

Isaac Singer longed to be famous and rich; he often imagined life on the grand scale. He also had enormous responsibilities. He and Mary Ann Sponseler had had another nine children, and besides having to take care of that family and his legal wife and their two children, he had had a daughter, Alice, born in 1850, from a third woman, Mary Eastwood Walters. He needed a quick solution.

He found one. It took Isaac Singer eleven days to invent the new sewing machine that would enable him to provide for his growing brood on a scale no one could have imagined. He had managed to borrow forty dollars to create a prototype of a new and improved sewing machine that could make strong stitches in an impressively straight line. It resembled the one made by Lerow & Blodgett, but was more practical. On August 12, 1851, he received a patent for it, and, with financing from George B. Zieber, Singer went into partnership with Zieber and Orson Phelps to found the Jenny Lind Sewing Machine Company. It was named for the Swedish soprano, then touring the United States, because its speed and sonority and smoothness conjured the voice of this singer known as the "Swedish Nightingale."

Although the by-product of Singer's around-the-clock work had distinct characteristics, it was sufficiently close to Elias Howe's machine that Howe initiated litigation against Singer for patent infringement. It made perfect sense for Singer to turn again to his trustworthy New York lawyer. Caroline Clark implored her husband more than once to "leave the nasty brute,"[16] but Edward was not going to break away from what he recognized as some very rich possibilities. In some secretive way, he may even have liked the flamboyance and toughness of his hard-living business associate, such a contrast to the world of Sunday-school teachers and traditionally educated upper-class lawyers.

This time round, the ruffian and the venerable sage were working even more in tandem. As often occurs when a flamboyant impresario and a solid professional elect to join forces, the relationship served both. Edward's role in Singer's life became even more significant. For a while, each remained skeptical about being in business with the other; but they recognized its potential benefits, and each was attracted in some way to the very different qualities of the other. Singer fully understood the value of Edward's legal knowledge and consummate professionalism, from

which he already had benefited. Edward liked Singer's out-of-the-box inventiveness. Each had tenacity and complete devotion to work, however different their pursuits.

Moreover, Edward must have recognized the advantages of the part ownership in the sewing machine patent he could receive as remuneration for his work and reimbursement for certain out-of-pocket expenses for which the still indigent Isaac Singer lacked the funds to pay. He offered the outrageous Singer all of his legal services in exchange for a third-interest in his company, with no cash changing hands. For all of his conservative bearing and proper demeanor, Edward was a risk taker of the first order. The forty-year-old lawyer was willing to back someone who was totally broke, and Isaac Singer had no choice but to accept the offer, for if he lost to Elias Howe, as he would have without Edward's maneuvering, he would have had nothing.

Edward sensed a good thing. The moment he began to defend Singer's interests, he became dissatisfied that while he and Singer would each have a third of the patent and business, smaller investors owned the remaining third. He was determined to buy them out, with their shares to be divided between Singer and himself. To do this, he demonstrated his brass knuckles. He was able to acquire the remaining stock only "by borrowing from friends and relatives and by borrowing against his own credit to its limit" to come up with the necessary four thousand dollars.[17] It was worth the effort. In 1851, when what soon became I. M. Singer & Company was formed, Edward Clark was thus a half owner. He also obtained ownership of half of all of Singer's future patents, and the right to take control of the management of the company.

What is significant about the patent litigation in which Isaac Singer was represented by Edward, and which can be seen as the basis of the entire Clark family fortune, is that Singer truly had violated the law and had infringed on one of Elias Howe's patents. When Howe pressed for a settlement of twenty-five thousand dollars in 1851, he did so because of Singer's use of the eye-pointed needle in his new machine. Howe had not invented that device, but he did own the patent to it. Everything else about Singer's machine was an advance over Howe's—it was better designed and sewed far more effectively—but the use of that needle without authorization and payment was illegal. The settlement that was reached in 1854 awarded Howe a royalty from all Singer machines. Edward's genius was in keeping that settlement from being more onerous, and in mitigating the effects of his business partner's criminality.

If his heirs—at least Sterling and Stephen—did not ultimately emulate their grandfather's cleverness, they would deeply admire it. They also learned to follow his example of fighting for what they wanted. Edward's courage and tenacity—and the affinity for truly original thinking—would be as vital to his grandsons' legacy as was the fortune that came as their result. The most important thing was the willingness to take a risk and to back a dark horse. This is what made Sterling and Stephen so truly at home in the world of art, a comfort that eluded most of their social set. However much more assured their own finances, and luxurious their circumstances, than their grandfather's, they admired his quality of daring.

FOR THE NEXT DECADE, Edward Clark made one shrewd business decision after another. At the same time that he waged battle against all the forces that would have put Singer out of business, the lawyer-turned-entrepreneur guided the company toward its meteoric success and was the brains behind its growth. The stunning rise of I. M. Singer & Company "was due in large measure to Edward's brilliant management skills."[18] In 1853, Edward persuaded Singer to move the firm to a factory building on Mott Street in New York, "where he assiduously advanced the company's interests while Singer basked in the role of resident genius. Clark oversaw every aspect of the business, stealing ideas from their competitors and pitting one against the other, while expanding the Singer empire."[19] The Singer No. 1, an improved version of the original machine, was so popular that Edward had the company open branch offices in Philadelphia and Boston the same year—and the newly renamed Singer Manufacturing Company reported assets of over half a million dollars. Edward hired sales agents, personally selecting people who were articulate and technically competent, and advertised that people who bought sewing machines would both gain free time and be able to augment their incomes by owning them. Edward was concerned with aesthetics, and got Singer to decorate the black machines with decorative gold ornament. He wrote advertising copy himself, and had the idea of selling machines to ministers' wives for half price so that they would introduce them to their sewing circles. He had his agents accept old machines as trade-ins for the latest models.

His grandsons would be born into a different world, and with sumptuous bank accounts from before they could remember, but their energy and will to live on a big scale would be modeled on Edward Clark's.

Within the first decade of that company of which Edward owned a half, Singer sewing machines were being sold in volume to households not only all over America, but also in Europe, Asia, and South America. During the recession that swept over America in 1856, Edward had the genius to introduce the idea of buying sewing machines on an installment plan. When the recession worsened the following year, he took this idea even further with a program whereby people could put a mere five dollars down and then pay three dollars a month, which allowed them to lease their machines until they assumed full ownership. These installment plans were an innovation in which the Singer Company was a pioneer. The unprecedented ability to make small monthly payments enabled people of modest means to acquire the sewing machines that in turn changed their everyday lives.

By the time the Civil War began in 1860, Singer's seventy-four factories in the United States were making over a hundred and eleven thousand machines a year, and when the tumult that swept over America curtailed sales there, the European market proved so favorable that the company continued to expand. Edward developed overseas sales to a degree unprecedented in American manufacturing. In bridging the Atlantic, he set yet another vital example for the progeny he made so wealthy.

EDWARD CLARK was also involved in the management of Isaac Singer's extraordinary personal life. Between 1852 and 1857, an additional mistress, Mary McGonigal, gave Singer five more children, who were brought up with yet another of his invented last names, Matthews. More amorous adventures would follow—Singer would sire a total of twenty-four children—with Edward, his trusted adviser ever since that first meeting in 1848, having a certain amount of work cut out for him because of associated legal issues. But Edward's main obligation was to fight "costly and vexacious lawsuits,"[20] one after another. He and Singer "were menaced by hostile injunctions for infringements of patents which threatened to destroy the business entirely." It took immense fortitude as well as cleverness to survive.

In 1856, Edward created the "Sewing Machine Combination," which was the first American patent pool. The Sewing Machine Combination is considered "the world's first strategic alliance of large manufacturing concerns."[21] By controlling the patents for sewing machines, the combi-

nation overpowered its smaller competitors, forcing them to pay a fee to make machines and limiting the number they could produce. Edward's creation was a welcome peace treaty in what is known in the annals of business history as the Sewing Machine War, during which there had been moments when Singer's company was in litigation against over twenty other manufacturers simultaneously; it brought the rash of lawsuits to an end. The combination, which licensed twenty-four companies, would last until 1877, when the last patent expired.

"Vexacious lawsuits," however, would become a family legacy. For most people in the Clarks' world, public attention and hard-fought legal contests were out of the question, but seventy years later, Robert Sterling Clark would get the family name into newspaper headlines by heading to court to fight taxes and then to challenge some essential aspects of his parents' estate. To a descendant of Edward Clark, court battles were an intrinsic aspect of everyday life.

Once the sewing machine business took off, Isaac Singer instantly became legend. He and Mary Ann Sponseler, whom most people took to be his wife, and their children lived in a palatial and conspicuously grand house on lower Fifth Avenue. One of his six horse-drawn carriages weighed nearly two tons and seated thirty-one adults up front, with ample space for children and servants in the rear. Pulled around New York by nine horses, the baroque-styled contrivance, "brilliant yellow with glossy-black trim,"[22] also "held a nursery and smoking room."[23]

Such definitions of luxury would have a major impact on Sterling and Stephen Clark when, half a century later, they inherited much of the fortune made by Edward's management of Singer's invention. Sterling and Stephen's grandfather and grandmother, however, went out of their way to separate themselves from the ostentation. The Singers—if so they can be called—"did not socialize with their business partner, Edward Clark, whose religion-ingrained society disapproved of Isaac's infidelities and open marriage."[24] Caroline Clark did not let her husband's partner enter her house.[25] And the Clarks' social set—Wall Street bankers, business lawyers, people of what was considered "good taste" and correct social demeanor—rejected the Singers wholeheartedly.

While his meteoric financial success in association with Isaac Singer's growing empire was invigorating to Edward, the battles over patent issues and the problems resulting from Singer's personal life took their toll on the straitlaced attorney and former Sunday-school teacher. One of the tasks that befell Edward was negotiating Singer's divorce, in 1860,

from the woman who was still his wife even when the public perceived him as being married to someone else. Because appearances mattered to Edward, this was both an urgent matter and a great ordeal. The sewing-machine-buying public disdained Isaac Singer for his scandalous ways, and it was in the interest of the company's future to try to clean up his reputation. At the same time, Edward and Caroline's friends and family were beginning to point fingers at Edward himself for his alliance with such a heathen. It became essential to get his business partner seen in a better light.

The hard-nosed attorney achieved both his own and Singer's goals of a relatively inexpensive divorce by maneuvering Catharine Maria Haley Singer to accept ten thousand dollars in the settlement and to admit publicly in court that she had committed adultery, which at that time was the only basis for legally terminating a marriage in New York State.

Edward had assumed that Singer would then simplify life by having the grace to marry Mary Ann Sponseler—the woman to whom most people thought he was wed. But Singer was unwilling to be pinned down and remained too loyal to another of his mistresses, Mary McGonigal, to make wedding vows again. After all, McGonigal had borne him five children since 1852, while during those same years Sponseler had given him only three. Singer and McGonigal had a life as "Mr. and Mrs. Matthews" in a separate house in New York.

It was not as grand as the house at 14 Fifth Avenue where he lived with Sponseler as if she were in fact Mrs. Singer, but he enjoyed his role as Mr. Matthews. In early August of 1860, he took that pleasure too far for Sponseler to continue to put up with it. Mr. and Mrs. Matthews were out on a leisurely carriage drive down Fifth Avenue when they passed Sponseler on her way uptown. Sponseler unleashed a tirade that instantly became the talk of New York. Singer was a very public figure, and when onlookers heard her shouting, it confirmed every rumor about the great industrialist.

Singer became livid. The public display of rage and the gossip it instantly launched were more than he could bear. Within an hour of the carriages passing, he stormed into his and Mary Ann's house, and minutes later he "resorted to choking his wife-of-convenience into unconsciousness."[26] He then did the same thing to an older daughter of Sponseler's who had tried to intervene.

It cannot have been a pleasure for Singer's attorney when Sponseler subsequently "told authorities that Isaac Singer beat her physically."[27]

Before legal action was initiated, Singer fled to England: by late September he was on an ocean liner, leaving behind all his sixteen children (two of the eighteen he had sired had died). He was also leaving their four mothers—Catharine Maria Haley Singer, Mary Ann Sponseler, Mary Eastwood Walters, and Mary McGonigal—each of whom he conveniently addressed as "Mary." Heading to Europe, he was now accompanied by Mary McGonigal's nineteen-year-old sister, Kate.

It was a far cry from Isaac Singer's scandalous ways when Robert Sterling Clark, over half a century later, married a French actress of illegitimate birth, with an illegitimate child from a previous liaison, but to his brothers and their wives, then very much part of a correct New York social set, it was almost as dastardly.

Singer's departure for another country, and all its attendant sordidness, left both him and Edward Clark wishing to have less to do with one another. Edward was also deeply concerned that Singer's personal scandals would have an adverse effect on the company's success; the sort of American household that bought Singer sewing machines would not want them tainted by adultery, wife beating, and illegitimate children. Edward's conclusion, in 1863, was to persuade Singer to relinquish active involvement in the existing company's management and to incorporate the Singer Manufacturing Company. Edward and Singer would jointly own four-fifths of the stock, with the rest sold to key employees, but both men would be less actively involved. Singer returned to America to conclude the deal and sign the necessary paperwork. Edward Clark was one of the directors of the new company—which, thanks to his guidance, held twenty-two patents—but now there was professional management, and he could assume a less active role.

In that technically reduced capacity, he still had a major impact. It was his idea to donate a thousand machines to the Union Army. Edward also oversaw the creation of manufacturing plants abroad—in Glasgow in 1867, and then in Russia, Canada, and Germany—as the foreign market burgeoned.

As a businessman, Edward Clark established an example of steely control that had significant influence, two generations later, on his grandsons' notions of being in charge and of their power to hire and fire the people they liked. He also demonstrated the degree to which individuals could create and run institutions.

Edward had persuaded Singer to give up the leadership of the new company, but as a consequence, and because of their many other personal

differences, Singer stipulated that Edward was not to become its president as long as he, Singer, was still alive. What they could agree on, however, was that Inslee Hopper, a former office boy who earned twenty dollars a week and ran the company in the partners' absence, could take over if he gained respectability by marrying his girlfriend. Hopper did so and, with a salary increase of ten dollars a week, became president of the firm. (His pay was quickly quadrupled to six thousand dollars a year and eventually rose to twenty-five thousand.) But Edward, who understood and liked power, was made chairman of the board. His steely rule would be his grandsons' model.

IN 1874, Caroline Clark died. Had she lived another year, she would have witnessed the death of the man she loathed but on whose wits her family's fortune depended. Isaac Singer's death enabled Edward Clark to take over the presidency of the company they had started together. He retained that position until his own death on October 14, 1882.

Singer's funeral befitted the manner in which he had lived. The procession of seventy carriages, carrying two thousand people, stretched a mile. In the English countryside, it seemed, people were more tolerant of a rich ne'er-do-well than they were in the inner sanctum of crusty New

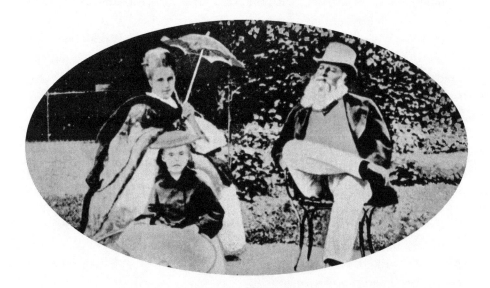

*Isaac Merritt Singer; his wife Isabella; and their daughter Winnaretta,
who would become the princesse de Polignac, c. 1870.*

York. And Singer had been the quintessential good sport, leaving his estate, valued at over thirteen million dollars, to be divided evenly among his twenty remaining children and all of his legal or common-law wives except for poor Mary Ann Sponseler, who had committed the unforgivable sin of having publicly humiliated him.

As with all estates, however, there was squeezing room. At the same time that he assumed his position as president of Singer, Edward Clark, in his capacity as lawyer, took on the representation of Isaac Singer's widow. In June of 1863, when Singer had returned to New York to make his new business arrangements with Edward, he had married again. This time his bride was nearly nine months pregnant. Twelve days after walking down the aisle of an Episcopal church in her maternity-style bridal gown, the Parisian Isabella Eugenie Summerville, a divorcée whose first husband had also been American, gave birth to yet another Singer child. The nature of their marriage did not suit New York society much more than had Singer's previous shenanigans, and Isaac and Isabella Singer quickly returned to Europe, where they lived in grand style as she gave him another five children to complement the baby born just after their wedding day.

Following Singer's death, Edward Clark saw to the well-being of Isabella and her progeny, one of whom, Winnaretta, would, as the renowned princesse de Polignac, become a great patron of music and architecture. Edward by now also had his own reasons to consider the notion of maximizing and altering the proceeds of a large estate. His eldest son, Ambrose, had failed to marry or produce children, and his second son, Edward Lorraine, had died at age thirty-one in 1869. But after leading a secretive life abroad, Edward and Caroline's youngest son, Alfred, had married and begun to produce a family. Edward Clark had his eye on the future.

IN HIS NEW POSITION, Edward was unfailingly bold. In 1877, the year after he became the Singer Manufacturing Company's second president—and the year that his second grandson, Robert Sterling Clark, was born—he made the drastic move of halving the retail price of the Singer "New Family" machine. At a retail price of thirty dollars cash, or forty on the installment plan, it was an irresistible bargain. Even if this meant selling machines at a loss, it was a wise and crafty step; patents were about to expire, and he needed to monopolize the market before the

competition would be able to produce rival products. He also introduced the Quality High Arm machine, which became another winner.

Beyond those clever marketing moves, he initiated some wise procedures for the management of Singer funds. "It was Clark who established the company's financial policy of investing roller-coaster profits into low-yielding but safe securities. Clark then called on this cash cushion during economic downturns. The resulting solvency enabled the company to ride out Black Friday in 1873, the Panic of 1907, the Great Depression and two world wars." And Edward had taken the brilliant move of having the company acquire property rather than rent it. Thanks to his guidance, "the Singer Company owned all of its branch offices and factories outright—including the real estate they occupied. It was Clark who successfully countered shareholders' overtures to skim off great cash reserves as profit . . . Edward S. [sic] Clark had created a stable conglomerate of plenty: a great business empire comfortably lodged behind secure gates of solvency."[28] A precise micromanager, he carefully restructured the Singer retail operation with a complex network of central and branch offices and rules as to how the selling territories out in the field would be divided.

Edward also forged ahead on other fronts, in a way that added to his family's already bulging coffers. Having recognized and enlarged the audiences for sewing machines, he did the same for luxury apartments in Manhattan. In an unprecedented way, the astute lawyer provided for the lives of the very rich as readily as he had for the middle class. And this time he financed and owned his enterprises a hundred percent.

In 1877, he purchased two major pieces of New York real estate. One was in Midtown, on the west side of Seventh Avenue between Fifty-fifth and Fifty-sixth streets; the other faced Central Park at the corner of West Seventy-second Street, in what was considered a distant outreach of the city. On the Midtown property Edward built the Van Corlear, a luxury apartment building that deliberately beckoned toward France in its style. (It has since fallen to the wrecker's ball.) There was a large central courtyard with a fountain; each apartment had two thousand square feet and felt like a private house. He followed that with other apartment houses and rows of town houses. And in 1880, on the Seventy-second Street site, he started construction of the Dakota, the spectacular apartment building that would be completed in 1884, two years after his death.

Whether or not the Midas touch actually exists, there was no doubt as

to Edward's natural bravura. The multigabled, châteaulike, nine-story-high Dakota is today a legend. This is both because of the people who have lived there—John Lennon and Lauren Bacall among them—and because of the awareness of what a bold step it had been on Edward's part: the slightly elevated bit of land on which its savvy developer built it was still the countryside. But just as he had gone to Europe to sell sewing machines, and found audiences for the Singer No. 1s who could hardly have imagined that they would or could buy such a thing, he had a foresight ordinary people lacked.

Edward had witnessed the population of New York double in a decade, and he recognized that the city would have to grow accordingly. If others thought his judgment about the direction in which it would do so was outrageous, he made the most of their mockery. When a friend scurrilously inquired, "Why don't you go a few more blocks and build it out in Dakota?"—a territory in the American West that would be admitted into the Union, as two separate states, eight years later—he named the building accordingly, even if others called it "Clark's Folly."

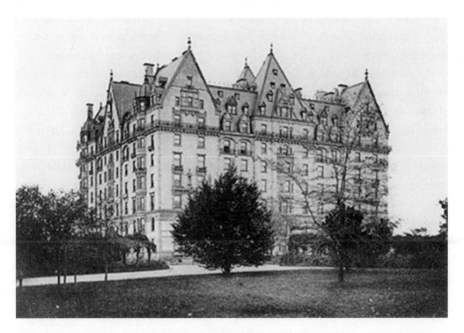

The Dakota. Edward Clark understood how the rich wanted to live, just as he knew how to sell sewing machines. He built this great apartment building in what seemed like the wilderness of Manhattan and changed the city forever.

Having transformed lower-middle-class living by chopping in half the price of a sewing machine and making it available on the installment plan, he now changed the way the rich lived by offering an alternative to the private house. The sort of people who could afford an apartment in the Dakota would not normally have wanted an apartment; these were single-habitation dwellers. Edward Clark had rare insight into the human mind. He knew that it was a fantasy to occupy a palace, and here, in scale and style, was a palace for people whose reality was that they could only live in part of one.

The architect Henry J. Hardenbergh's design was also a fantasy. The style has been termed "Brewery Brick Victorian neo-Gothic Eclectic";[29] it was as if the man who got Isaac Singer to add a scrolled gold line to his black sewing machine had now gone berserk. There was a public dining room with an elaborate marble floor and a carved-oak ceiling, a ladies' reception room with "a frieze of clematis,"[30] and vast apartments, some with as many as twenty rooms, along with smaller flats. Every apartment had at least four bathrooms. It was taken for granted that space was needed for five servants per apartment, for which reasons staff accommodations as well as rooms used exclusively to dry laundry were on the top two floors. The building had its own stables, telegraph office, and florist, and was connected to the local fire station by its own private wires. It enabled people to live opulently and comfortably without having the worries and obligations brought on by a private house. Edward knew how to accommodate human needs and desires, whether with sewing machines or real estate, and he thought for himself.

Edward did not live to see the Dakota completed, but he built it for people of similar mold to his own. There may not have been anyone quite as outlandish as Isaac Singer living in its palatial apartments, but neither was this a haven for the Social Register set. Edward Clark and his family were very rich—all the more so because of the Dakota—but they were a different sort of rich people. They acknowledged rather than concealed that they had money. They were willing to spend it, conspicuously, but as an act of pleasure rather than a form of ostentation or pretension. They lived well, but they did not think of themselves as aristocracy or landed gentry. This was the world in which Edward and Caroline lived and flourished, and the values with which they raised their children—and it was the heritage that would be passed on to Alfred Corning Clark's sons.

. . .

EDWARD'S ASSOCIATION with one of America's most successful businesses had allowed him to begin living with considerable style and grandeur very quickly after that first meeting with Isaac Singer. His father-in-law had started his legal career in Cooperstown, a town in the middle of a farming region farther upstate, where Edward's wife Caroline had been born and spent her childhood. Ambrose Jordan had sent Edward there to work on a purchase of property, and Edward became enchanted with both the picturesque village center and the surrounding region with its dairy farms, river, woods, streams, and impressive lake. It carried with it a wonderful history, for this was the region that James Fenimore Cooper came from and where *The Deerslayer* and many of his other novels were set. In 1854, the financial rewards of the new sewing machine company were already sufficient to enable Edward to buy a beautiful property, Apple Hill, which straddled both sides of the Susquehanna River not far from where the river begins at Otsego Lake.

He also began to travel. Just as the sewing machines became a major presence in Europe, so did Edward Clark. With his wife and children, he rented a house in Paris on three occasions and spent a winter in Rome. He bought art during those travels, establishing a vital precedent for the next generations of his family. When, in 1869, Edward and Caroline built a vast and sumptuous stone mansion, which they named "Fernleigh," on the site that had been Apple Hill, it might have fit into the rolling fields of Normandy, and it had ample space to showcase the trophies of their travels.

Edward was establishing a precedent to be followed by his son Alfred and grandsons: the Clarks were to live in style. Like philanthropy and seeing to the public good, spending money with considerable panache and no self-consciousness would become a family tradition. And in lavishing luxuries on themselves and their families, the Clarks were to bring the style of continental Europe to the American continent on a grandiose scale.

Fernleigh would be the family seat, the place where his grandsons eventually had what were, on the surface, idyllic childhood summers, jumping into the narrow river, sailing or rowing on the lake, where they had a boathouse. There Sterling and Stephen Clark would absorb

Cooper's tales of American pioneers and American Indians. They and their brothers would discover the joys of riding on horseback in a setting where the American wilderness merged with the most sophisticated achievements of French, Italian, and English art and architecture: a cultural crosscurrent that would live within them always.

This summer residence became all the more splendid when, five years after constructing the enormous house, Edward bought five hundred additional acres, including land at Point Judith, at the tip of a cape jutting out from the lakeshore. There he erected a picnicking house that resembled a rustic Swiss chalet and conjured up sounds of cowbells and Alpine yodeling. In 1876, two years after Caroline died, Edward completed on the same spit of land Kingfisher Tower, a sixty-foot-high miniature castle that rose out of the water and brought the look of eleventh- and twelfth-century French châteaux to the side of a lake in upstate New York. The construction of this instantly antiquated monument had a social purpose by providing work in a time of widespread unemployment. Furthermore, as with Robert Sterling Clark with his gift of Courbets and Renoirs to Williamstown and Stephen Carlton Clark with his donations of Cézannes and a Seurat to museums in Manhattan and New Haven, Edward saw this act of architectural patronage

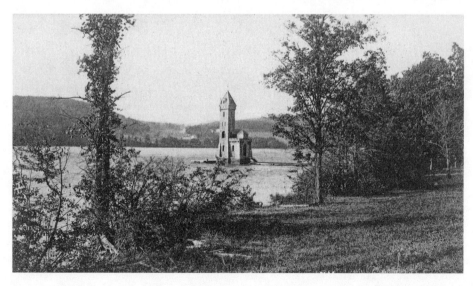

Kingfisher Tower. Edward amassed vast properties on the lake in Cooperstown, New York, and built houses and follies that brought a range of European styles to the countryside around Cooperstown.

as a service to the larger public, opening American eyes to the finest of European style.

An account written just a few years after the castle was constructed points out its aesthetic and social values, the enhancement of everyday life through art that would motivate Sterling and Stephen as it did their grandfather. "Mr. Clark was led to erect it simply by a desire to beautify the Lake and add an attraction which must be seen by all who traverse the Lake or drive along its shores . . . It adds solemnity to the landscape, seeming to stand guard over the vicinity, while it gives a character of antiquity to the lake, a charm by which one cannot help being impressed in such scenes. The effect of the structure is that of a picture from medieval times, and its value to the lake will be more and more appreciated as time rolls on . . . Those whose minds can rise above simple notions of utility to an appreciation of art joined by nature will always appreciate it."[31]

THE GESTURE OF BUILDING a European castle on a lake in rural America shows a fundament of the Clarks' family values. Edward's heirs would greatly differ from one another, but they inherited his willingness to live on a large scale, with a temerity that many people of equivalent means often lack. None of these Clarks thought twice about importing whatever they liked from Europe to their home turf.

And they wanted the greater American population, which otherwise would not have had an inkling of such things, to know, as close to first-hand as possible, what French civilization had to offer. This was the means by which one culture was transmitted to another. Thanks to the money made from sewing machines, which had become as much a part of middle-class American households as the bread and butter on their kitchen tables, the Clarks could give those same households an education in European civilization—predominantly French, ranging from the grandeur of Romanesque and Gothic architecture to the adventurousness of postimpressionism and cubism. Edward laid the groundwork for the way of thinking that his grandsons promulgated. The ultimate impact of this approach on everyday American life is immeasurable; without the Clark family, and a handful of others who acted similarly, the average American today might have no inkling of the great achievements of Chartres and Blois and turn-of-the-century Paris; words like *château* and

chalet might never have crossed the ocean; no one would have the chance to complain about Renoir's sweetness or to be puzzled by Picasso's distortions of forms. But by taking the path from giving legal advice to an itinerant autodidact to amassing a wealth that permitted extensive travel to Europe and energetic construction projects in upstate New York, and then by passing that vast fortune and that legacy of Europeanization to the next generations, Edward Clark had an impact on the subtle transformation of America from an isolated country to one strongly connected with the greatest achievements of French and Italian culture.

At the same time, the doyen of the family evinced none of the flamboyance of the subsequent generations. He was above all a highly attentive, detail-obsessed businessman, known to require careful and minute reports from the people who worked for him in any capacity, whether at Singer or in the management of the working farms he acquired in Cooperstown. He treated his colossal fortune as a springboard for responsibility and care, not for frivolity. He also showed a devotion to education, becoming a trustee of Williams College and funding a building for the natural history department there. (Its main distinction was that it was fireproof, unusual for the time.) In return, the college awarded him a degree as Doctor of Laws.

When he died on October 14, 1882, his obituary described him as "never disposed to make an ostentatious or vulgar display of wealth, though living in its full enjoyment and surrounding himself with the comforts and attractive objects which it may command . . . He entertained a sincere respect for the man who with cheerful courage fought out life's battle on the line where Providence seemed to place him. He did a great many charitable deeds in a quiet way; and in business matters was ready to help those who showed a will and capacity for helping themselves. His temperament was somewhat peculiar, he was naturally reticent, courteous, but never familiar, and he was at times likely to be misjudged by those who knew him but slightly."[32] Reading between the lines of this unusually frank assessment, so counter to the laudatory nature of most obituaries, one gets a clear picture of the diffident, reserved, old-school Puritan, the good churchgoer who "ministered to the wants of the poor" but wasn't a barrel of laughs.

Edward's son Alfred and grandsons would allow themselves a lot more frippery than did the founder of the family fortune. Stephen would have Edward's taciturnity and comport himself with the same clenched jaw

and tight mannerisms, but would enjoy certain extravagances and marry someone with a keen sense of fun. Sterling would indulge in racehorses and fine wines, and settle down with a pleasure-loving French actress. Both, however, would follow their grandfather's example of devotion to public causes and intense social consciousness, a sense of responsibility accompanied by the belief that he knew best.

EDWARD CLARK'S funeral was as much a reflection of his life as Isaac Singer's had been of his. Having become ill on a night boat going up the Hudson River from New York to Cooperstown, he died at the age of seventy-one—failing to maintain the longevity of his parents (his father lived to ninety-two, his mother to ninety) but ensuring himself a lot of mourners. When his body was in state in his sumptuous mansion at Apple Hill, hundreds of indigent people, and students from the Cooperstown Union School and Academy, to which he had given generous sums of money, filed by to pay their last respects to the man who had made their lives easier. Then his rosewood casket was shouldered to the gates of the yard in front of the local Episcopal church, where it was met by seven white-robed ministers. The church facade was draped in black; its interior, white flowers in abundance everywhere, was packed to capacity, with the overflow standing outside. It was a lengthy service of organ music, Bible readings, and prayers, and Edward's favorite hymn, "The Voice of Free Grace," sung jubilantly. Afterward, at the local cemetery, the millionaire's body was lowered into the ground to the sounds of the choir singing "I Heard a Voice from Heaven," and the benediction was followed by "Nearer, My God, to Thee."

The mourners included a delegation of twenty employees from the Singer Manufacturing Company's New York office. But Singer was not the only business affected by Edward Clark's funeral that day; all offices and shops in Cooperstown had shut down from one to three p.m. in honor of the deceased.

Shortly after his death, the Cooperstown Union School and Academy established the Clark Punctuality Prize in memory of the man who had "raised the character and discipline of the school to a point it could not otherwise have attained."[33] These were the values with which a scoundrel's business partner had managed to associate himself.

Beyond the recipients of the Punctuality Prize—and everyone who

either directly, through his financial generosity, or indirectly, through the French and Italian architecture with which he had altered the American landscape, had benefited from the fantastic financial successes of this former Sunday-school teacher—there was one person who was affected more than anyone else by the death of this iron-willed man. Alfred Corning Clark, the youngest of Edward's three sons, was his sole survivor. The obituary makes him sound like a Henry James character returned to the fold: "a studious gentleman, much of whose life had been spent abroad, who had thus suddenly thrown upon him great care and a heavy responsibility."[34] The young gentleman had indeed spent much of his life in Europe, but what the writer of that obituary failed to note was that he also had a wife and sons. Responsibility was not totally unknown to him; nor were the privileges, or the weighty obligations, of a fantasylike fortune. But his new role was not an easy one.

Edward, having not been totally at ease about Alfred, had assiduously left his real estate to his grandsons. The entire block that included the Dakota, and the house in Cooperstown, went to the oldest of them, another Edward Clark. And each of the four grandsons, including six-week-old Stephen, inherited about a city block or its equivalent on the West Side of Manhattan. Alfred was an exceptional human being, and he became a very rich man when his father died; but it would take the next generation to carry their grandfather's torch.

The results of Edward Clark's and Isaac Singer's association would have a lasting impact on his descendants, and, through them, on the American cultural landscape. Edward left an estate of some fifty million dollars.[35] His heirs owned a controlling interest of Singer, which they would maintain until 1959. They would run it like a family business, and even if they absented themselves from its active management, they would choose its next four presidents. The Clark family had major amounts of money and power, as well as a personal legacy that combined courage, willpower, an eye for European civilization, and no little sense of their own importance.

Edward's heirs expected to run things and to have the last word. But they never lost sight of the people who kept Singer afloat—the ordinary households who without Edward's idea of buying on time could not have afforded the appliance that so eased their lives, allowing them to make the clothing, draperies, and household materials essential to more pleasant and comfortable living. And they grew up thinking that the world on the other side of the Atlantic Ocean was closely linked to their own—

a vision that reflected considerable independence and broadmindedness in isolationist America.

Another way in which Edward Clark impacted Sterling and Stephen was the extent to which he straddled two worlds. He belonged, as they would, to the entrenched upper echelons of American society, with its codes of behavior derivative of Puritanism, its correctness, and its prevailing Protestant ethos. Until the time of her death in June 1874, Caroline Clark—who, as the daughter of the distinguished Ambrose Jordan, the man who foisted Isaac Singer on her husband, was even more entrenched in that milieu than he was—was appalled at anything that had to do with Singer, whom she despised. She begged her husband to separate himself completely from the inventor. But Edward had something that kept him apart from Caroline's more exclusive milieu. He was willing, in effect, to thumb his nose at his social set by working with one of the most notorious heathens of the nineteenth century. His motive was financial gain more than anything else, of course, but he still was an exceptional risk taker, and he had very thick skin. No wonder his grandson Stephen would, at a time when the act required similar bravery, be one of the prime movers behind the newly formed Museum of Modern Art. No wonder Sterling would collect very sexy paintings at an unprecedented scale. Their grandfather had set the example of disparaging timidity, of putting up with opprobrium in the interest of what was exceptional.

When Edward Clark left his family their fortune, he also left them with the notion of control. More colorfully, he showed them the power of real originality, imbuing Stephen and Sterling especially with the respect they would hold for artists. He kept his Puritan face, but he bowed to no one in the rules by which he lived. And he was constantly open to change, perpetually aware of the shifts of the world and eager to ride with them; this would affect how his family approached art and arts institutions.

Edward also had famously high standards for other people. All of his employees were encouraged to engage actively in suggesting technical advances or approaches to selling. They were also expected to abide by the code of not revealing information to people outside of the company. His heirs grew up not only knowing that they descended from a man who redefined the possibilities of capitalism, but from someone who thought as few people before him ever had.

No wonder that Sterling would eventually be willing to sue his family

while Stephen would try to run it, and each would have boundless energy to do as he wanted, extraordinary openness to the extremes of life, and a confidence bordering on mania.

STERLING AND STEPHEN would become the two best-known members of their family, acquiring a Medici sort of immortality because the art they owned still bears their names. Whenever one of Stephen's Cézannes or Sterling's Renoirs goes on view or is reproduced, its former owner gets cited almost as prominently as the person who painted it. Their grandfather, on the other hand, remained behind the scenes. But not only did he give his family its wherewithal; he also established an incredible precedent of extravagant thinking (even more than extravagant living), a willingness to enter totally new territory that others would have considered treacherous, and a complete absence of fear of the unusual. It was as if this modest, "bookkeeperish" man could not help taking giant steps. What others would have considered eccentric, he found not just fascinating, but irresistible.

Edward also had the habit of speaking out. If what he said in public seemed arrogant and eccentric, he was not fazed; there is no suggestion that he feared the repercussions. This is one of the traits that would fall most directly to his grandsons Sterling and Stephen. He would willingly voice, as if through a megaphone, a strong opinion, however quirky and off the charts. When a new steamboat was christened on Otsego Lake, near Cooperstown, and Edward Clark was the first speaker once the band music subsided, he told the assembled: "This is the only country in the world where lake and river steamers are so constructed to accommodate passengers comfortably. A passenger steamboat on the Thames in London is a long, narrow, sooty, and dirty contrivance, without any protection from sun or rain; and the steamboats all over Europe are generally of the same detestable pattern. I am not inclined usually to boast of the superiority of my country as compared with foreign lands, but I may safely affirm that in the matter of river and lake steamboats, we are far in advance of the rest of the world."[36] Arrogance and chauvinism were family traits; because of the magnitude of the bank accounts that accompanied them, they would, some fifty years after Edward's death, risk having an effect that might possibly have altered the course of civilization.

II
ALFRED

E dward Clark was the family piston. He presented himself as a stolid, feet-on-the-ground, pinstriped lawyer and maintained a personal lifestyle in accord with nineteenth-century decorum based on the true Puritan tradition, but he laid the foundation of the family fortune because of a well-concealed sense of daring and a prize-fighter's toughness. His son Alfred Corning Clark did, on one side of his life, what was expected of him; but he lacked the same drive in the business arena, and the wealth he inherited was as much an obligation as a pleasure. He would substantially grow his inheritance in the fourteen years that remained him after his father's death, but this was thanks mostly to the good management of the people he hired in advantageous times. He had no career or vocation of the usual sort, although he was a man of consuming passions and refined sensibility.

Alfred enjoyed both the privileges and the burdens inherent to the second generation of wealth: the freedom to live without needing to make money, and the weight of his taste for a lot that was contrary to the ways of his strong-willed parents.

Whatever his conflicts, however, Alfred was famously generous, and in Elizabeth Scriven Clark he had a warmhearted and truly charitable wife. That their sons Sterling and Stephen should become exceptional people and devoted arts patrons with a sense of public service is no surprise. But it is also equally understandable that neither of those men was at ease in his life, and that Alfred's and Elizabeth's other two sons conducted their adult lives in unusual ways.

Alfred was even more expansive, and Elizabeth even more generous, than most people realized. If one reads between the lines, while Alfred was the quintessentially proper businessman, philanthropist, husband,

Alfred Corning Clark, c. 1870. The second generation
of the family's wealth, he fled to Europe as a young man,
and even after returning to the fold led a life far from
the one expected of a man of his fortune and position.

and father of four sons to all who knew him or knew about him in America—and because of his immense wealth, he was a public person in spite of his famously retiring ways—one can detect a completely other life. This second existence, clandestine to most people but open to his cohorts in Paris, was dominated not just by his love for music and art but, in close conjunction with that, by his attraction to other men.

It is only surmise rather than proven fact that Alfred led a passionately homosexual existence on the other side of the Atlantic. But there is every reason to believe it, and to believe that this other life inevitably had a profound effect on the two main subjects of this narrative, his sons Sterling and Stephen, and inspired some of the demons behind their art collecting. Alfred's nineteen-year-long relationship with a Norwegian tenor whom one writer has called "Clark's lifelong male companion"[1] was one

of the most significant elements of his life. Moreover, the singer's tragic early death in turn led the grieving heir to another connection of vital importance to him when he asked a talented and dashingly handsome young American sculptor then living in Paris to make a memorial to commemorate both the man who had died and their relationship. George Grey Barnard was a carver of marble figures of muscular Michelangelesque nude men who was totally destitute until Alfred turned his life around by making him what others would call his "kept boy."[2] Thanks largely to Alfred's beneficence, not only would Barnard have a successful career and help create New York's wonderful Cloisters museum, but he would also guide both Sterling and Stephen Clark, in the brief period of their adult lives when they were still friendly with one another, to discover the wonders of European art and begin collecting it.

Alfred's life, until now the least examined aspect of the Clark family saga—in fact, the one that never gets discussed—was a more major determinant of all that followed than has been previously realized.

ALFRED CORNING CLARK was the last of the four children of Edward and Caroline Clark, but would be his father's only survivor. Edward Lorraine Clark had died in 1869 at age thirty-one; Julia had died in infancy; and the firstborn, Ambrose, had died in 1880, at age forty-four. Born in 1844, Alfred was thirty-eight years old when his father died and left him the bulk of a fortune generally estimated at fifty million dollars, with his young sons acquiring real estate of comparable value. The sales of Singer sewing machines all over the world, from urban hubs to the remote reaches of Africa, and, more recently, the construction that had begun on the mighty Dakota, which would belong to his young son, put the heir in a position of immense power, with the means to do almost whatever he could possibly want or imagine.

When Alfred was born, his parents, who were living on Walker Street in lower Manhattan, were already well off—Edward a successful lawyer in his father-in-law's firm—but there was nothing exceptional about them. The phantasmagoric changes in their situation would occur only during his childhood. It was in the years when he was a young schoolboy that his father began to work with Isaac Merritt Singer, and, as sewing machines were sold to the multitudes, a way of life that was similar to that of the families of most of his chums gave way to unimaginable affluence and sumptuous luxury.

As he would later tell the sculptor George Grey Barnard, he also felt the weight of his princely obligations. Alfred's dream from earliest consciousness was "to be a great pianist, to write poetry. But a stupendous shadow . . . overhung his ideal . . . While Alfred was yet a child his father let him realize that the day would come when he must assume control and responsibility for a great business whose gigantic world-wide sales were growing by millions of dollars each year . . . the hugest corporation on earth."[3] That burden he felt growing up, and the priority he ultimately gave to philanthropy and music and the plastic arts while delegating a lot of those obligations to others, would be seminal to the way he later encouraged his own sons to believe they might give their lives to their own interests and the public good rather than to the Singer Company. The anguish caused by his father's demands would be an essential determinant in the license Alfred would give his own progeny to live more freely.

For a while, however, Alfred stayed clear of anything directly connected with the Singer Manufacturing Company. He escaped family life in New York and Cooperstown when he was in his early twenties and moved to Milan to study both piano and art at a safe remove from the Clark family's home turf. He had not been in Italy for long when he inherited five hundred thousand dollars from his grandmother, which gave him independence from his tough and demanding father. "His life became an idyll. He knew supreme happiness, worshipping in the temple of Etruscan art and at the shrine of friendship," Barnard recalled Alfred's account.[4]

Some twenty years after that first burst of freedom, the lace-collared heir, by then a married man with four children, would feel sufficient ease and comfort with the ruffian-like sculptor to reminisce about those halcyon days in great detail while sitting in the Paris studio for which he was paying the sculptor's rent. The main element in that idyllic existence he enjoyed as a young man abroad, Alfred would confess to Barnard, was his relationship with the successful Norwegian singer Lorentz Severin Skougaard (who used the stage name Skougaard-Severini), whom he met in 1866 and to whom he was devoted for the next nineteen years, and from whom he was "inseparable in those haunts of mellow, gala Milan."[5]

Skougaard was the son of a customs collector in Langesund, about a hundred miles south of Oslo. A scholarly analysis of the period puts their relationship in a gingerly way: "While one can only speculate what the exact relationship between Alfred and his Norwegian companion was, it

Lorentz Severin Skougaard, c. 1870. The Norwegian tenor became Alfred's obsession; when they weren't traveling together in Europe, the singer was in an apartment just down the street from Alfred and his wife and four sons.

may be surmised that Alfred preferred the 'company of men.' "[6] From the time Alfred befriended the tenor during an American tour, the two young men spent as much time together as possible: in Paris and Milan, and in Norway, where Alfred was treated as a member of the Skougaard family, and where he built a house on the island of Langoen near the tenor's village.

Even after Skougaard's death closed one chapter of Alfred's life, his connection to the tenor continued to loom large. Alfred had become so attached to Skougaard's family and his alternative Norwegian existence that he would continue the annual visits to the house south of Oslo until

his own death in 1896. Alfred would maintain his role in an entire other, collateral family that was his refuge at a remarkable distance from his life in America. Moreover, he seems to have been assimilated into the Skougaard family, where "the matriarchal Sara Helene Skougaard (1813–1910) became the revered 'mother' of his late years, and her children—thirteen in all—were to him as brothers and sisters."[7]

Alfred led a carefully divided life. At the same time that he carried on happily in Italy and Norway, in America he had no choice but to do what was expected of him, at least on the surface. Three years after he met Skougaard, he married Elizabeth Scriven, the Brooklyn-born daughter of English parents. Their wedding took place in Devonshire in October 1869. The saving grace was that Alfred did not have to give up his other passions; that summer, he had, as usual, visited Skougaard's home in Norway for the annual encounters he never missed.

Alfred even managed to maintain his dual existence back in New York, where he became music critic of *The New York Times* and installed Skougaard in an apartment just down the block from the brownstone his father bought on West Twenty-second Street and where he and Elizabeth lived. What Alfred's wife and parents knew or suspected or acknowledged to themselves is uncertain, but to some observers it was a gallant, face-saving gesture when Alfred's parents and his brother Ambrose dutifully began to treat the tenor as if he were a member of the family. There were those who assumed that Edward Clark had legally adopted the young Norwegian—to make the relationship appear publicly as the connection of two siblings.

Skougaard's importance was further acknowledged in 1870 when Alfred and Elizabeth named their first son—who was born in the Paris suburb of Neuilly nine months to the day after their wedding—Edward Severin Clark.

Edward Clark was not so happy about his youngest son's way of life, however. When Edward Lorraine Clark died in Rome in 1869, the father stepped up pressure on his youngest child to spend more time in New York and give the sewing machine business precedence over art and music. Nonetheless, for the next decade Alfred juggled his two lives. He never missed his summertime jaunts to Norway or stays in Paris and other European centers of culture, even as he conducted his life in New York and Cooperstown with Elizabeth and their growing family.

The unusual Alfred Corning Clark developed a mastery of Scandinavian languages, not only Norwegian—among the most difficult of

tongues for a foreigner to learn, requiring great aptitude and determination—but also Swedish, in which he became equally fluent. When he was in his early thirties, he set about translating, from the Swedish, Viktor Rydberg's 330-page *Roman Days*. "The purity and grace of his English"[8] would garner high praise when the book came out in 1879. But this was far from the profession for which his father had intended him.

In 1877, Elizabeth Clark gave birth to a second son, Robert Sterling Clark, known in the family as Robin; he was followed in 1880 by Frederick Ambrose Clark. Nonetheless, that same year, according to the personal history Alfred would later adumbrate to George Grey Barnard, Alfred wrote his father from Milan "begging . . . to let his brother take his fortune, all of it, and leave him free to be an artist."[9] The family agreed; "To his heavenly relief, this was granted. The shadow again lifted."[10]

Probably motivated more by a wish to keep his youngest son's scandalous way of life safely distant than to assure his happiness, Edward dispatched Ambrose, his eldest son, and Alfred's only remaining sibling, to Italy to have the renegade sign the necessary papers. But shortly after arriving in Milan, the forty-four-year-old Ambrose Jordan Clark became ill—in true Victorian manner, the malady was simply termed a "contagion"—and within a week he was dead. The facts are difficult to corroborate, and Barnard apparently mixed up some of the details when he later recounted Alfred's saga to his own biographer, because while Alfred's brother Edward had died in Rome, his brother Ambrose actually died in New York. But what is certain is that, now that he was an only child, "a double shadow now replaced the single shadow" in Alfred Corning Clark's life.[11]

His father then summoned him back to New York on as permanent a basis as Alfred's life would permit. When the senior Edward Clark died two years later, in 1882, Alfred had no choice but to assume many of his father's roles. That same year, about six weeks before Edward's death, Alfred and Elizabeth had had a fourth son, Stephen Carlton Clark. With a wife and four boys, and a fortune to manage, the thirty-eight-year-old father with his "gentle eyes and silky beard"[12] now had his life cut out for him. But for three more years he also had Skougaard on the scene, until the singer died unexpectedly from typhoid fever on February 14, 1885, in the New York apartment he shared with Alfred when Alfred was not down the block being a socially correct husband, father, host, and businessman.

As he assumed more of his expected roles in New York City and Coo-

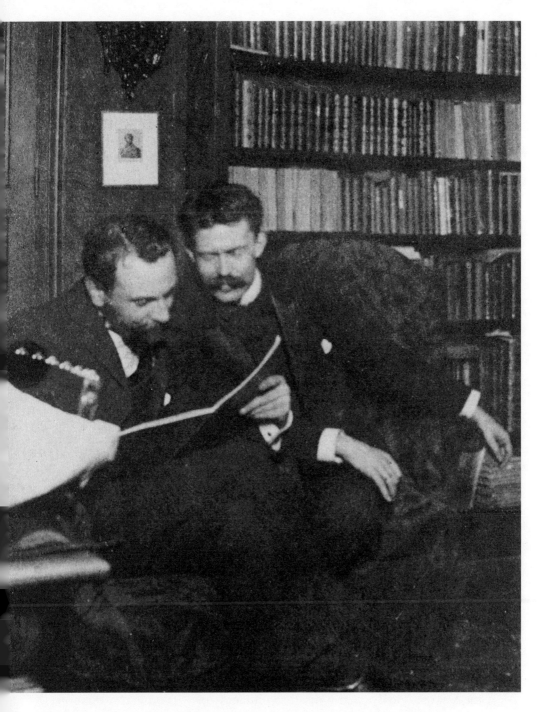

Alfred and Lorentz, late 1860s. The two were as inseparable as circumstances would permit; when "Severini" died, Alfred wrote his biography and commissioned art in his memory.

perstown, monitoring his inheritance of fabulous dwellings as well as his sky-high bank account and his responsibilities with Singer and the Dakota and other real estate his father had left to his minor sons, Alfred was determined to do the right thing. But most observers recognized an air of hesitation. Alfred had inherited his father's upright demeanor but not the old man's toughness and panache. By a contemporary account, "Alfred Corning Clark possessed in a magnified degree certain qualities which had distinguished his father. He was more retiring, more reticent, more inclined to find the full joy of life only among intimates."[13] The main perception of him was that he was a bookworm. The only times the public of Cooperstown glimpsed the eccentric millionaire who mostly stayed at home, poring over the classics and reading multiple foreign languages when he wasn't out walking his grounds, was when he went to the local bookstore to buy something current.

Those who commented publicly about Alfred Corning Clark would refer to his personal reticence and his religiosity. Like his father, he lived on a scale that could not help attracting attention, but he comported himself as a good churchgoer, a reader, and a shy, self-effacing man who loathed the idea of drawing attention to himself. E. T. Moran, a friend who had known Alfred since he was twenty years old, wrote a portrait of him called *A Man Who Lived for Men*. It presents a clear portrait of "a humble, devout Christian" with an "aversion to publicity."[14] Alfred's obsession "was doing good to others."[15] For the most part, the sewing machine heir did so behind the scenes, "although when one . . . built a concert hall, it wasn't possible to keep entirely cosseted." In Moran's eyes, Alfred "hid his good deeds more carefully, and more skillfully, than men hide their sins."[16]

It becomes clear that Ned Moran knew exactly what Alfred was concealing, that in France and Norway his subject was in every sense of the phrase "a man who lived for men." But when he made that the title of his biography, few readers would have assumed that it referred to anything other than Alfred's abiding concern for humanity. Most people had no idea that the rich New Yorker, whose father had made a fortune and whose sons would lavish art on the public, had a completely separate existence. In America he was a pillar of society, a husband and father of four sons, with a splendid house in New York as well as an apartment at the Dakota. He devoted himself to philanthropy—serving, for example, as a trustee of Williams College from 1882 to 1886—and was the face of propriety. In Cooperstown, few people realized that the family's other

splendid residences—Fenimore Farm, Fernleigh Farm, and Pine Grove Farm—belonged, respectively, to his young sons Edward, Sterling, and Ambrose, and that there may have been a particular reason Edward Clark had assigned them to his grandsons and not his son; all that was known was that during the summers Alfred was off on his own travels.

Luckily, Alfred had found just the right person to manage the enormous corporation that had become his main responsibility. There are two versions of how he first encountered young Frederick Bourne. One is that he spotted Bourne singing in the Mendelssohn Glee Club, an all-male singing society which Alfred had joined in his youth and to which he remained devoted. (According to someone who heard him frequently, he used his tenor voice "with rare taste.")[17] The other is that he had noted and admired Bourne's industriousness and upbeat attitude when the younger man was working as a clerk in the Mercantile Library, a place where Alfred loved to while away the hours when he was in New York. In either instance, what is significant is that music or literature was the bridge to a pivotal business relationship. Alfred recommended Bourne to his father, who made him construction manager of the Dakota when Edward had only recently started work on the building. Bourne proved himself there, and after Edward's death he helped Alfred, who had no wish to run the sewing machine company himself, manage his business affairs. In 1889, Alfred appointed Bourne president of Singer. This relationship of Alfred Corning Clark's would eventually lead to a significant leap in America's cultural history, for in time Bourne would be the catalyst through which the Clark family changed the architectural landscape of America by commissioning the largest skyscraper ever for the Singer Company.

AFTER SKOUGAARD'S DEATH in 1885, Alfred wrote his friend's biography and then funded its publication. The book whitewashes the precise relationship of author and subject, but the emotional truth of Alfred's obsession with the Norwegian tenor comes through.

The "Note" with which Alfred begins the book—dated November 23, 1885, with the address 64 West Twenty-second Street—is eloquent and self-effacing. "The fury for writing is understood to be commoner than the power to write well. With this recommendation to mercy, the book is given to those it was intended for."[18] Alfred Corning Clark was as lacking in presumption as his sons would be high-handed.

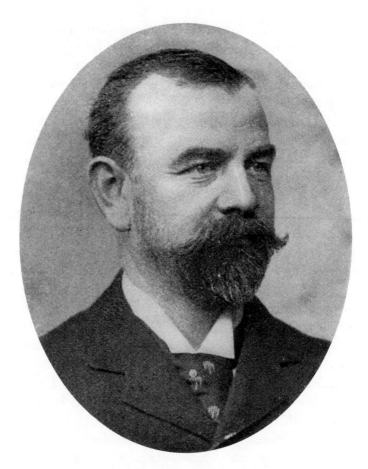

Frederick Gilbert Bourne. Another young man whom Alfred
met through the all-male Mendelssohn Glee Club, he would
run the Singer Company for the reluctant heir.

Alfred opens the biography by describing himself on a Sunday after-
noon in July 1885 at Skougaard's graveside in Norway. The unknowing
reader would have no clue that four thousand miles away, Alfred had a
wife and four sons, the oldest fifteen years old, the youngest three, who
were enjoying the pleasures of their own summer in upstate New York.
While the restless father was off in a small village on the windswept
Norwegian coast, the boys had endless staff to care for them at their vast
house and in their pursuit of sports and other summer pleasures. But on
Alfred's mind at the moment were only the words of the mother of his
beloved singer as she mourned the oldest of her thirteen children. Sitting

next to her son's grave, she said to Alfred, "It was his prayer to God, from his earliest childhood, that he might be helpful to his parents and brothers and sisters."[19] Alfred then focuses on himself as he amplifies on the bereaved mother's words: "To these, one who had the advantage of a friendship loyal on both sides through nearly nineteen years of good and ill, may be allowed to add those that follow.

"Skougaard-Severini (whose faults none knew so well or lamented so truly as he himself) had a trusting nature joined with a mind in judgment direct searching and sound, a heart of which the Heaven-granted power to feel for others ripened so that its love became at last universal, and a hand stretched always out to uphold those who faltered or to raise those who had fallen and whom the world had passed by."[20]

Here was the essence of Alfred Corning Clark's values: the message that on some level would be the family legacy. The main subjects of the present book—Sterling and Stephen Clark—had a father of such fine-tuned sensibility, and with such overriding notions of right and wrong, and of the need to succor and help others not as privileged—a man so far outside the norm of America's robber-baron millionaires—that their lives and their brothers' were sure to be sculpted very differently from those of anyone else they knew.

Skougaard was forty-eight when he died; Alfred was forty-one at the time. The singer had left home at a young age to perform all over Europe; from the start, the audiences had been enthusiastic. Alfred's book about him consists mainly of Skougaard's letters recounting his travels, the performances, and the occasional travails of his repeated stays in Paris, Milan, London, and other capitals of culture. It was in 1866, nineteen years before his death and his biography, that Alfred himself entered the picture. Edward Clark had heard Skougaard sing in Paris and immediately offered to fund a journey to New York, where the twenty-nine-year-old singer met twenty-two-year-old Alfred. In Cooperstown, throughout August, they sailed and rowed and rode and hiked together.

Edward and Caroline Clark took the Norwegian in completely. There was a cholera epidemic in New York City that year, but they felt safe upstate. Once the danger level was down in late October, Skougaard traveled back to Manhattan in grand style in the Clarks' horse-drawn carriage, to give an important concert. The tenor had a mixed response to his performance of arias by Rossini, Donizetti, Bellini, Verdi, and Beethoven and lieder by Schubert. "The lovers of the Italian school in the audience" were pleased even if they disapproved of his use of a falsetto

voice, but "the Germans were hostile" because of "the idea that prevailed among them that Severin . . . who . . . sang their language like a native, was a German masquerading under an Italian name."[21]

From then on, Skougaard returned to New York about once a year on his concert tour. There he was always under the wings of the Clarks—Alfred makes it clear in his biography that the tenor was close to his brother Ambrose and to his parents as well as to him—and often went to Cooperstown. Then, on October 10, 1875, the Norwegian took his own place at 60 West Twenty-second Street, where he taught fifteen pupils. Alfred neglects to mention that he and his family were at number 7 on the same street, and that he paid Skougaard's rent.

The father of the growing family at number 7 and the bachelor tenor at number 60 saw a lot of one another; Skougaard began to attend concerts of the Mendelssohn Glee Club. He wrote his parents that his life was mostly monotonous except for his evenings out with Alfred, sometimes with Alfred's older brother Ambrose there for good measure. The singer reported to his mother that on Christmas Eve of 1878, they lit the Christmas tree and had dinner in his apartment, which was basically a single room. The tree was "on little R's account, particularly"[22]—the "R" standing for "Rino," eight-year-old Edward Severin Clark's nickname, coming from "Severini," Skougaard's professional name. Alfred was there, of course, and so was Ambrose. This was deliberately an all-male event: "It is Christmas Day that is generally celebrated, so we were able to have our bachelor party on Christmas Eve."[23] Elizabeth, presumably, was home with Sterling, who was then eighteen months old.

In 1882, after Edward Clark died and Alfred came into his own money, he moved Skougaard into larger digs at 64 West Twenty-second Street. There Alfred was able to spend even more of his time in the winter months, while in the summers he and Skougaard continued to travel to Europe as usual and make their annual pilgrimages to the tenor's hometown in Norway.

This is not clear in Skougaard's biography, however. Alfred Corning Clark substantially leaves himself out of the narrative. One would never know from the book, for example, that he was present on those summer trips to Norway, although they appear in the biography, let alone that he had built his own house there. But even if he fails to mention his presence on many of Skougaard's voyages he describes, Alfred was often at the singer's side. It's almost certain, for example, that he was there for a late-spring idyll in Sorrento, on the Amalfi coast, when the sunshine

was bright and the sky a perfect blue as Skougaard took a rowboat to Capri.

Alfred is less secretive, however, about Skougaard's visits to Coopers-town—legitimized because the rest of the Clark family was around. And he makes clear how much time he and the tenor were spending together in the period preceding Skougaard's death. Although they had no reason to anticipate the sudden illness that would come later that year, in the summer of 1884, during Skougaard's visit to Cooperstown—Alfred always stayed at Fenimore Farm, although his son Edward, having inherited the place at age twelve, technically owned it— they drove in a carriage "over old familiar roads, recalling many memories happy and sad."[24] Alfred also does not dissemble about their

Sara Helene Skougaard. Severini's mother treated Alfred Clark as a member of her family in the little village on the Norwegian coast where he escaped his New York life.

being together on Christmas morning in New York later that year. That day, Skougaard took communion "in company with the writer and another loyal and dear friend."[25] This was, according to Alfred, the moment when Skougaard contracted a cold that had him bedridden by New Year's Day and that led to the illness that took his life in mid-February. Alfred and Frederick Bourne were among the small group of friends at the tenor's bedside when he died.

In April of 1885, Alfred and Skougaard's brother Jens took Lorentz's remains to Norway. From Hamburg they went to Copenhagen, then on to Malmö in Sweden, and then, with one change of train after another, and the casket as part of their luggage, they proceeded to Langesund, the village where Lorentz Severin Skougaard and Alfred Corning Clark had had their wonderful holidays together. Once they were at the family cot-tage, Skougaard's mother led them in singing a psalm. Flags in the village were at half-mast; palms and floral offerings kept arriving, bearing cards from locations as far away as New York.

Alfred, however, had one offering that he preferred to all the rest. "The

most touching tribute of love came from Aunt Severine in Egvaag. It was a little cross made up of mosses, one or two wild flowers, and a few buds of immortelle . . . To one who knows how tenderly the little last offering was put together, from the poor scant material which could be found in the barren neighborhood, the cross was unspeakably pathetic; and I asked for a bit of the moss to keep."[26]

George Grey Barnard, 1888, the sculptor whom Alfred commissioned to memorialize Skougaard with the marble Brotherly Love. *In Paris he was considered Alfred's "kept boy." Decades later, he would guide Sterling and Stephen Clark as they formed their collections.*

The next morning, the mourners assembled at the Skougaards' modest cottage and then walked to the village church. As at Alfred's father's funeral three years earlier, the church was draped in black—although this time the folds of dark material were inside rather than out. Alfred found it hard to maintain his composure both here and at the grave, where Skougaard's mother leaned on the sewing machine heir's arm. Now, unlike at his father's service, he could let the tears flow.

Who might have guessed that the forty-one-year-old visitor from New York weeping in the small church, with the customs collector's widow leaning on him as her son was buried, was one of the richest men in the world? Did anyone there even know that as he stood in this fishing village a hundred miles from Oslo, his wife and four sons were being waited on by servants in livery in one of the grandest country houses in America? Or that the doe-eyed young man with silken beard who had brought the tenor's remains across the ocean with him had been raised to run one of the largest conglomerates on earth, of which his tough and crafty father had been the mastermind? All that was clear was that the young man who so loved that simple cross made of moss was as at home here as anywhere else in the world.

IN THE SPRING OF 1886, Alfred Corning Clark returned to Paris seeking solace for Skougaard's death and searching for the best way to memorialize him. "Clark believed France to be the Mecca of brotherly feeling,"[27] and he wanted to be there even without his usual companion. The grieving millionaire was, as usual, ensconced at the Hôtel Edward VII, facing the Opéra. While he mooned about in the same luxurious quarters where he and Skougaard had always stayed—his friend's absence weighing on him in the sprawling suite, complete with a private dining room that now seemed unnecessary for him alone—the struggling American sculptor George Grey Barnard was bottoming out at the other side of the city. Fortunately for both, a mutual friend took Alfred to Barnard's studio.

The friend was the Indianapolis-born baritone Charles Holman-Black, who had studied with "Signor Severini"—Skougaard's name as a voice coach—and traveled with him to Germany, Denmark, and Norway. Holman-Black now sang in some of the finest salons of Paris. He and his half-brother, the Boston-born painter Frank Holman, lived in an open homosexual relationship in an apartment on the avenue de Breteuil, a

wide street near Les Invalides. They were part of Clark's and Skougaard's longtime Paris circle. Holman-Black had initially introduced Clark and Barnard in the fall of 1885.

Charles Holman-Black would, a decade later, write a letter to the woman about to marry George Grey Barnard that when the sculptor joined their circle, he "became a part of us."[28] Barnard often went to Holman and Holman-Black's home and had attended a housewarming there that was the equivalent of a modern gay commitment ceremony; he made figurative carvings and a fountain for the luxurious residence. The sculptor, however, kept himself off limits to both sexes. "His boyish appearance, together with his poverty, made Barnard sexually irresistible to both men and women, but he vowed to remain celibate, and hence retain his creative powers."[29] The tension of his relationship to the abstemious sculptor would now dominate Alfred Corning Clark's existence.

THIS SECOND ENCOUNTER between Alfred and Barnard proved to be the salvation of both of these men at low points in their lives. From the moment they met, the attraction revivified Alfred. Barnard, eighteen years his junior, was his opposite and hence his ideal. Born without a silver spoon in his mouth, he had had to make his own way with temerity and boldness. His life was devoted entirely to his consuming passion for art. Barnard was a gifted sculptor, competent at molding plaster and chiseling marble, and sufficiently robust, both physically and emotionally, to surmount the many challenges for which he had opted in his life and work. To the velvet-clad and lace-collared prince, the younger man was the perfect pauper—tough, manly, gutsy.

Barnard, a preacher's son, was born in 1863 in Bellefont, Pennsylvania, and grew up in a series of small midwestern towns. He had been a classic Huck Finn–style bad boy, playing hooky and shooting pigeons with a slingshot from the church belfry. As a young teenager he ran away from home in the Illinois town of Kankakee to Chicago, where he became a cabin boy on a ship on Lake Michigan until the police found him and returned him to his parents. At age thirteen, he earned enough money carrying buckets of coal to get himself to the Centennial Exhibition in Philadelphia, where the bronze and marble sculpture so impressed him that he returned home to make an image of his sister out of local Kankakee clay. By eighteen, determined to become a sculptor, he made his way back to Chicago, where he discovered casts of work by

Michelangelo at the Art Institute. When at twenty-one he earned three hundred and fifty dollars from the sale of a bust, he used it to go to Paris to study at the École des Beaux-Arts. There he was influenced by Rodin to produce work that was a realistic depiction of human beings in a state of intense physical and emotional engagement.

At the time that Alfred Corning Clark entered the scene, George Grey Barnard was barely surviving. But he was determined to let nothing stand in the way of his making sculptures of godlike creatures in a state of operatic drama. As one of the few scholarly publications to discuss this little-known but seminal and fascinating figure in the history of American sculpture pointed out a century later, "While laboring with the determination of a zealot, he had been forced by lack of money to subsist at a level of indigence."[30] He lived in an unheated lean-to that was a three-mile walk from the renowned art school where he hoped to gain the traditional training and knowledge of his craft that would enable him to work in the manner of the greatest sculptors of all time. He often shivered at night because he had to use his only bedcovers to keep his modeling clay from drying. Sometimes he had to burn his own drawings to keep warm. For his meager meals, he had figured out a way of cooking rice without a stove by soaking it overnight and then heating it over his oil lamp.

Alfred Corning Clark was not the sort of person to complain as he made his way to Barnard's squalid digs in one of the poorest neighborhoods of the French capital. Barnard was not in at the time, but Alfred instantly understood why Charles Holman-Black led him there that balmy afternoon. Ever since the millionaire and the sculptor had met half a year earlier, Barnard had been working on a large statue that he had hoped to have ready for Alfred's visit, knowing when it would be. When Alfred saw *The Boy* in the sculptor's studio, he was moved to such an extent that he immediately left a dinner invitation for the man who had made it.

The statue was of a "nude boy seated, his left leg pulled up, head dropped as though napping. Barnard said that there were memories here of his own dreaming boyhood."[31] The model, he had told Holman-Black, was a lad who had been lent to him by a friend to pose "without compensation to keep him out of mischief."[32] Hearing all of this, seeing the statue of the naked youth, Alfred knew that Barnard was someone he would like to rescue.

The indigent young sculptor appeared that evening at Alfred's hotel.

Walking into the palatial Belle Époque hostelry facing the recently con-structed Opéra, he was in a world he had previously only glimpsed from afar. An attendant in white tie and tailcoat directed him past the ornate lobby, where Barnard could see his own reflection in the polished wood, and through the hotel's great courtyard to the elevators, where he was ferried up to the millionaire's suite. Barnard would report to his parents, "He has an immense floor to himself. We had a most extravagant dinner in his private dining room."[33]

The encounter between the handsome young artist—clean shaven, with a strong jaw, fine nose, intense dark eyes, and shock of black hair, he looked like a young Montgomery Clift cast as Heathcliff—and the reti-cent, bookish millionaire with his fine beard would get written up over fifty years later in *Reader's Digest*: "He had been living for weeks on rice soaked at night in his washbasin and boiled in the morning, but this evening he ate his fill. After dinner, the millionaire said, 'What do you want for your *Boy?*'" Barnard answered that he did not know if the sculpture, which was a plaster, was worth a thing until it was carved in marble. Clark asked if three hundred dollars would suffice. "An atten-dant brought in a tray loaded with shining gold pieces, and the manufac-turer smilingly said: 'Give me your purse.'

" 'I haven't any,' the ragged artist told him."

When Alfred then proposed that the young man put the coins in his pockets, Barnard turned them inside out to demonstrate that they were torn and had no bottoms. Alfred next asked him to open his handker-chief, but Barnard did not have one. "In humorous despair, Clark tied the gold in his own handkerchief and thrust it in the young sculptor's hands."[34]

The next day Barnard used his advance to pay his landlady his overdue rent. His life had changed completely. A few days later, a further six hun-dred dollars followed from his new admirer; it was only the beginning. After Barnard finished modeling *The Boy* and sent it to Alfred, Alfred put his protégé on a stipend of about a hundred dollars a month, where-upon Barnard wrote home that he was receiving "1200 per year almost as much as you get father."[35]

By the time Barnard completed cutting the marble version four years later, the lives of the sculptor and his sole patron would be completely intertwined. It was a side of Alfred's life that he had to keep under wraps, of course. In 1894, when Barnard was in New York, he discovered that Alfred kept *The Boy* out of public view—in a storage room at the top of

the Dakota. But there, at least, the conflicted father and husband could have his time alone with the work.

In addition to the stipend, Alfred offered to send the sculptor to Italy to pursue his studies where Michelangelo had actually worked. Barnard didn't accept the idea of going there to study, but when Alfred then funded Barnard's father coming to Europe for the first time, father and son permitted the patron to organize a trip to Italy for the two of them. Once the Reverend Barnard returned to America, Alfred took it upon himself to write him with updates on his son's progress in Paris. In one of these missives, he assured the minister that George had not given in to "the great temptations to which young people are always exposed in Paris."[36]

It was during this period that Alfred commissioned Barnard to make a monument for the grave of his beloved Skougaard. The patron recognized that the plastic arts offered the only possible vehicle for expressing the magnitude of his affection for his dead friend and the beauty of their connection.

The extent to which a material object could reflect and evoke private emotion was part of the legacy Alfred would pass on to two of his four sons. Even if Sterling's and Stephen's tastes, and their personal issues, were not the same as their father's, they intrinsically believed in the complete integration of paintings and sculptures with the feelings lurking in the depths of their souls.

ALFRED CORNING CLARK was also demonstrating the benefits to others when one spent money on art. He played a momentous role because of the support he offered George Grey Barnard. Barnard's name is not known the way the artists collected by Sterling and Stephen are, but the sculptor's effect on American culture was profound, and he probably would not have had it were it not for Clark's support.

And George Grey Barnard, in turn, would have a direct effect on the activities of Sterling and Stephen. The sculptor is the little-known key to our narrative about the sons as well as about their father. The relationship between Alfred and Barnard—the attraction to someone in another world, the affinity of a man of inherited money to a tough and wiry, hardworking and penniless sculptor who gave every iota of energy to sculpture, both to making it and collecting it—set an example. The choice to go from one's safe world into a rough-and-tumble one was daring. At the

same time, for sons to see their father latch on to a younger man who was part surrogate son and also the object of an obsession was not easy.

IN THE CAPACIOUS STUDIO that Barnard now had, thanks to Alfred's support, on the rue Boissonade, a street of ideal ateliers in the fourteenth arrondissement, he got to work. The monument, *Brotherly Love,* had the purpose "of commemorating beyond life the bond between Clark and his 'brother' Severin."[37] In the resultant sculpture, two muscular, athletic, naked men—in the vein of Michelangelo's greatest slave figures, with broad shoulders, triangular torsos, perfect buttocks, and powerful legs—lean into the grave stele, their hands groping toward one another. There is a palpable feeling of longing.

The composition Barnard used for *Brotherly Love* had been suggested by Alfred. It was based on a Roman statue depicting Antinous, the young male lover of Emperor Hadrian, alongside a slightly older man. Alfred had written extensively about imagery of Antinous when he translated Rydberg's *Roman Days.*

When Alfred met Barnard, he must have sensed from the start that this was someone in his own lifetime who embraced the same ideals that were the subject of Rydberg's book. Discussing Roman statuary, Rydberg refers constantly to Michelangelo and perfectly formed specimens of masculinity preserved forever in marble. And in Rydberg's chapter devoted to Antinous, as we know it from Alfred's version, he might as well have been describing the beloved Skougaard.

The emperor Hadrian had been traveling in Greece at the age of fifty when he first saw and fell for the eighteen-year-old youth, making him part of the court. His feelings were not unlike what Alfred had experienced when he first encountered his Norwegian. "The mysterious face has always the same power of attraction. He muses upon a riddle, and himself is one, that tempts to solution and baffles the solver."[38]

Alfred Corning Clark's translation is marvelous for the underlying vehemence of passion so admirably restrained by his measured linguistic tempo and sureness of vocabulary. Having been brought up by a straight-shooting lawyer and in the shadow of Isaac Merritt Singer, Alfred was their opposite in the delicacy with which he described the ideal of innocence and purity in this character of Antinous, who was such a perfect stand-in for Skougaard. "The brief road of his life lay through a morally debased world; but he looks as serene and pure as if no shadow could ever

have been cast upon his memory, and it is with the halo of innocence that he takes the heart captive."[39] Antinous also has that slightly naughty aspect that was one of Alfred's imperatives—and made him the ideal model for Barnard's memorial to Skougaard: "He looks as if he were good, but reticent; absorbed in himself, and nevertheless roguish; resolute, yet floating in spaces where foreboding and dreams are all, and the will is nothing."[40]

Antinous had died tragically young. When Alfred wrote about him, he had no reason to believe that his beloved Skougaard would be struck down only six years later, but it is easy to see why, once he wanted to memorialize the Norwegian, he now turned back to Hadrian's beloved: "Beneath his exterior, we might imagine the spirit of the universe, effulgence of the first-created light . . . And notwithstanding all this, he is a human being of flesh and blood, that art has made its subject—a boy, and nothing else, who was cut off in his bloom, by death. He is in a word, from head to foot, a web of contradictions, resolving itself into a whole of touching beauty."[41]

Hadrian was a perfect emblem for Alfred himself. The Roman had the obligation of an empire to run, but clung to the memories of his own carefree youth when he had traveled far from the seat of his power. The identification of translator and subject could hardly have been more total: "Hadrian spent a long time in that land, the memories, art and literature of which had been from youth his delight, as its regeneration was the dream of his riper years. These years were his happiest."[42]

In Alfred Corning Clark's eloquence about Hadrian and Antinous, the source for the vision he urged on Barnard to honor Skougaard, he betrays his extraordinary sensibility. He was a man apart from his world. When he could more easily have opted to lounge around country clubs and boardrooms as was expected of him, he had chosen to master Scandinavian languages and translate obscure tomes. But Alfred's values were carved deep in his soul—to such an extent that, strained as the relationships inevitably were, he had a pivotal, and until now underacknowledged, effect on the intense cultural engagement of his sensitive sons Sterling and Stephen.

When Alfred wrote of the emperor's view of Antinous, it could have been his own vision of Lorentz Severin Skougaard: "Hadrian loved in him his own best dreams and those of his time. That the emperor, artist as he was, was struck at first with his physical beauty, seems unquestionable; but with Socrates and Plato before our eyes, we may and ought to believe

that this feeling, so common in the antique world, was not seldom coupled with the aim of forming in the physically beautiful, the morally good."[43] Herein lay the key to Alfred Corning Clark's credo: physical beauty was the equivalent of true goodness. Both obsessed him. He adored what was irresistible to him—in sculpture, music, or men. He also believed, utterly, in the need to give away one's riches and make the lives of other people better; the two sentiments—adoration and charity—were completely intertwined. Guilty about the wealth that came his way through no effort on his part, born to a mother who loathed the scandalous figure who was the source of his father's millions, Alfred sought goodness in every sphere. He valued kind behavior, alms for those of lesser fortune, impeccable physical form. It was all connected. Translating the Swedish text on Roman life, he was articulating what he prized most in all human existence: "Where youth and beauty appeared, joined with fine intellectual gifts, the striving after wisdom, and religious aspiration, they acted as the revelation of a higher spirit."[44]

Would art have a similarly moral component for his sons? Was it as inextricably connected with the highest human values as it was for their father? They certainly lacked his refinement of expression, but they may have had more of his emotional delicacy and sensitivity than either of them let on. Robert Sterling Clark would insist on speaking with a perpetual "kick in the pants" harshness, and Stephen Carlton Clark would adopt the driest and most legalistic of voices, but their eschewal of their father's eloquence, which may have been their way of not being seen as his carbon copies, did not prevent both Sterling and Stephen from having absorbed Alfred's rarified and deeply reflective response to life.

The nature of an eccentric, warmhearted, conflicted father was inevitably a major determinant in the lives of Sterling and Stephen Clark and their brothers. Their public veneers, their sympathies, and their intense rages had their origins in the truly unusual nature of their childhoods, which seemed so orderly on the surface and were so full of surprises underneath.

THE MODEL OF ANTINOUS that the grief-stricken Alfred Corning Clark counseled George Grey Barnard to use for his beloved Skougaard was very specific in certain details. The father of the four boys who were back in America had studied the male face at every stage, and had written eloquently on the subject when he translated Rydberg. "A

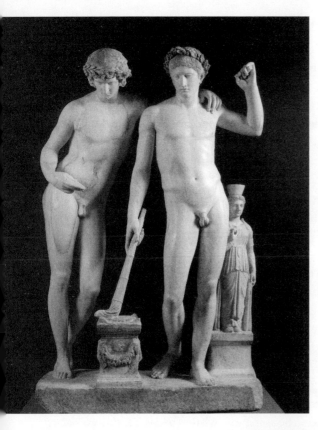

LEFT: *San Ildefonso Group. A Roman sculpture at the Prado, Madrid, this expression of male camaraderie and beauty was the model Alfred selected for Barnard's* Brotherly Love. BELOW: *George Grey Barnard,* Brotherly Love, *1886. Alfred commissioned this sculpture to memorialize Skougaard and celebrate their relationship; it ended up on the tenor's grave in Norway.*

few words now, concerning the Antinous type. The somewhat broad head, with its waves of luxuriant curls, has an arch that has often been thought the peculiar property of men with great sensitivity, imagination and attraction toward the ideal. The forehead, in great part hidden by the falling curls, had a mighty breadth . . . The distance between the nose and mouth is unusually small. The lips are full and lightly closed. The chin keeps something of the child. So, too, the cheeks. The last named features are especially those that by their formation, at once refined and full, give the face in its entirety the expression of childishness and innocence."[45]

There was one depiction of Antinous above all that Alfred had proposed to Barnard, and that the sculptor ended up using. This was the San Ildefonso Group at the Prado in Madrid, of which there were marble copies in Paris and Naples and plaster casts in Dresden and Berlin. "Two youths, entirely nude, crowned with wreaths, stand side by side, both looking toward the same point, with the gaze inclined downwards, as if towards an abyss that yawns a short distance from them, in front . . . The features express solemn repose. The younger had his left arm around the other's neck and leans toward him with sorrowing trustfulness. The weight of the body rests upon the left foot, while the right, drawn back, touches the ground only with the tips of the toes. The youth, who has something of longing in his looks, bends forward with drooping head and attentive gaze."[46]

This was Rydberg's description, as Alfred translated it, of the remarkable sculptural pair at the Prado. The first-century Roman sculpture—said also to depict Orestes and Pylades, or Castor and Pollux, although there are those who hold out for Antinous and Hadrian—was a fantastic selection on the part of Alfred Corning Clark as the basis of the work he commissioned. Slightly smaller than life size, the two totally naked young men—there is no hint of the fig leaf or drapery usual in Roman statuary—are both deep in thought. The taller of the slim, smooth-skinned youths leans on the shorter, with his left arm draped over his companion's shoulder. Rarely had the connectedness of two nude males been so tenderly evoked.

What splendid proof this was of the way that marble, carved and finished exquisitely, could serve to evoke smooth skin, taut over the young men's ribs, their muscular arms, and every other detail of their perfect bodies. And however much each of these curly-haired gods is striking on

his own, the union of the two makes Alfred's chosen prototype all the more exceptional.

Barnard would capture all these qualities in the memorial Alfred Corning Clark commissioned—not just the physical charms, impressive though they are in Barnard's sculpture, but the longing, the trust, and the tenderness. What was probably lacking in Alfred's childhood, and patently mattered to him most in his own life, would be achieved in marble.

This was the role of art for the secretive, fantastically intelligent, conflicted father of Sterling and Stephen Clark: to capture the ideals of human existence, to evoke emotion, to embody the dream. Art was not something apart; it was inherent to what mattered most: the issues of love and connection.

POETRY, HAPPINESS, FEAR, and the power of male innocence and beauty were all as one in Alfred's eyes.

He did not write Rydberg's text, he only translated it; but his version of that book has, at the end, a passage that seems a perfect reflection of what must have coursed through Alfred's mind as he thought about the man who had, it seems, meant more to him than had anyone else. "If we have long stood face to face with Antinous, all impressions at last combine in one feeling, the nearest utterance of which is given in the poet Lenau's admonition:

> *Didst thou e'er see a joy go by,*
> *Thou never mayst recover,*
> *Cast on the hurrying stream thine eye,*
> *A bubble, and all is over.*"[47]

THE PEOPLE WHO KNEW Alfred Corning Clark and his family back in New York probably had no idea of what he had paid for in Paris. Nor did any of them see the sculpture he sent his young protégé to install that October on a remote reach of the Norwegian coast. For *Brotherly Love*—although one could choose to regard it only as an allegory—encapsulated homosexual attraction.

A related tension now seemed to exist, on a very different level, with

George Grey Barnard. When Barnard returned from Norway, he and Alfred got together in Paris. Alfred poured out "the story of his own life, its great disappointment, its great compensating opportunities"[48] to the rough-and-tumble sculptor whose effect on Alfred was increasingly like a magic potion.

By the time Alfred Corning Clark was telling his saga to the sympathetic young sculptor in Paris five years following his father's death, he was earning annual dividends of hundreds of thousands of dollars from his Singer holdings. In 1887, that money went far. One of the extraordinary traits of this relatively unknown member of a famous family, the sole survivor of his generation, was the extent of his compulsion to use that inheritance for the benefit of others. This went well beyond mere kindness or generosity. He told Barnard that "he always searched the newspapers . . . for news of any destitute or meritorious persons."[49]

Inevitably, the ones he saved were male, generally urchins. He showed Barnard a clipping from a recent paper that described a boy in Lyon risking his life by jumping into a rushing river to save another boy who was drowning. Alfred had immediately gotten in touch with Singer's representative in Lyon and had him meet the youth and his family. Once he learned that the heroic lad "was the son of a poor lace mill worker of finest character, he instantly took the train for Lyon."[50] The family met Alfred's approval. He put a hundred thousand francs into the building of a lace mill to be operated by the boy's father, while arranging for the lad himself to come to Paris for "technical training"—and putting George Grey Barnard directly in charge of him.

The salvation of young men in duress was his specialty.

THE SAME YEAR, Alfred personally changed the life of another boy—only this time it was in New York. The piano prodigy Josef Hofmann had been born in Poland in 1876; at age eleven, he made his debut in New York at the Metropolitan Opera House. The effect of the performance was not unlike that of early concerts given by Wolfgang Amadeus Mozart. The critics wrote that his playing was unequaled by pianists of any age: "This is no child, they wrote."[51] The lad was quickly put on tour, giving fifty-two concerts within two months. Not much taller than the grand piano at which he performed, he played from his substantial repertoire of piano solos and of works by Beethoven, Mendelssohn, Liszt, and Weber in which he was accompanied by orchestra. Thomas Edison, who

had invented sound recording the year the boy was born, invited him to his studio and made several cylinders, as a result of which Hofmann was the first successful pianist ever to have his work recorded.

But not everyone was happy to have the youth function like a circus act. Josef Hofmann was a delicate child, noticeably frail in the eyes of the most observant members of his audience. Halfway through the tour, Alfred approached the boy's father and teacher, Casimir, who was traveling with him. Alfred offered fifty thousand dollars—a mind-boggling sum in an era when an annual salary of five hundred dollars was deemed substantial for a man supporting a wife and children—if the father would remove his son from the stage with a guarantee that he not return until he was eighteen. Shortly after this offer was made, the Society for the Prevention of Cruelty to Children put a stop to the concerts, which made it especially propitious for the boy and his father that Alfred had provided such ample financial compensation.

Following the negotiations between the philanthropist and the voyager from Poland, Casimir and Josef Hofmann took off posthaste for Berlin. And the father kept his word. Josef studied piano with the great Russian pianist and composer Anton Rubinstein, and remained in touch with Thomas Edison, sometimes making suggestions about the drive mechanism of Edison's recording device. But he did not return to the stage until he was eighteen, when, having been Rubinstein's only private pupil, he performed Rubinstein's Concerto in D Minor, with the composer conducting. Rubinstein died later that same year.

Hofmann went on to have a spectacular career. He was gifted with a legendarily acute ear: during an afternoon with Josef Lhevinne, another great pianist, Lhevinne played Liszt's "Lorelei," a piece Hofmann did not know. He asked Lhevinne to play it again—and later, with a wink at Josef and Rosina Lhevinne in the audience, played the piece perfectly as his first encore in the concert he gave that evening. He made acoustic recordings for the Gramophone Company in Berlin and for Columbia and Brunswick in America, and performed with the New York Philharmonic and at the Metropolitan Opera. His friend Rachmaninoff considered him one of the greatest of all pianists. According to music critic and historian Harold Schonberg, Hofmann was "the coolest of the great Romantic pianists," remarkable for his "aristocratic, elegant performance"[52] of Chopin's Sonata in B Minor and for playing Chopin's Grande Polonaise in a way that Schonberg declared "coruscatingly brilliant. Every note is clear in this difficult virtuoso piece, textures never blur, and

there is a grand sweep." A 1935 test recording of the scherzo of Beethoven's Sonata no. 18 in E-flat, Op. 31, demonstrated "Hofmann's classic precision, unflagging rhythm, and sheer joy of playing."[53] That Josef Hofmann, who went on to head the Curtis Institute, acquired the maturity and personal grace to perform in this way, that he escaped what might otherwise have been a horrific childhood, is thanks to the guts, generosity, and large pocketbook of Alfred Corning Clark.

It would have been one thing to write out a check to the New York Philharmonic; it was quite something else to hand money over to an individual, both to help and to save a brilliant child. Alfred's sons grew up with a father who had a proclivity for turning around the lives of boys at the onset of adolescence. They could not help being affected by their father's bent, either in reaction to or in imitation of it, or in a blend of the two.

WHEN GEORGE BARNARD and "the Governor" had their most personal conversation to date following Barnard's return from Norway, the sculptor talked to the older man of "the temptations of women." Barnard said he had always resisted, that he had a theory of "translating from his body into art." He believed that sexual sublimation had a direct benefit on his work. Barnard's credo called for "turning the surging power of procreation not into license and dissipation but into creativeness in art."[54] In that same vein, the sculptor wrote to his parents, "I am not to be married *now or ever.*"[55] The one time Barnard was seduced by a female model—she had been urged on by classmates eager to see if this could happen—he subsequently tried to commit suicide.[56]

People who knew Barnard, however, believed that when he spoke about sublimation, the desire he was really repressing was for other men. One of Barnard's intimates wrote that Walt Whitman, whose homosexuality was acknowledged, and George Grey Barnard "were one intellectually and in feeling . . . But in Whitman was liberation to sing of things Barnard could feel but not utter. In [Barnard] was a terrible frustration, a locking up, an imprisonment of the lusty throb of the body which Rodin knew, that throb of body singing itself in such robust vaunting candor in Whitman's powerful cadences."[57] This purple prose was written by Daniel Williams, a biographer who knew the sculptor well and was thus privy to Barnard's constant wish to minimize the homosexual theme.

Williams believed that Barnard's adamancy about repressing all sexual

desire was his discomfort that it was focused on men rather than women. "In a remembered conversation with Clark, Barnard spoke of the difference that existed between their sexual outlooks."[58] What was meant by this was not the issue of heterosexuality or homosexuality, but the willingness to give in to one's desires. "Like the Holman-Blacks, Clark had no intention of curtailing his sexual activity. Barnard, on the contrary, vowed abstinence. Barnard was a follower of Henri Bergson and John Addington Symonds, Michelangelo's biographer, in his belief that the sexual urge, unless used for procreation, should be preserved and 'drawn upon to forge a work of genius.' "[59]

Daniel Williams revealed the workings of Barnard's mind: "He, a Christ, a Buddha, a St. John, must, by abstemious living, by purity of thought, yet show humanity how to live to be two hundred years old, by preserving the great life force. Many youths destroyed themselves by dispersing these life-forces—these forces of creation and truth—the great evidence of God in man. The procreative power was all of life, all God, all divine and so great that it were a horror to treat it as a drug or a diversion, to put it on a par with alcohol or narcotics. . . . Indulgence of sex should occur only in the sacred functioning of begetting new life on earth."[60]

To cope with his desires, Barnard wore a contraption that was a sort of male chastity belt, or erection restraint. "Barnard thought of all indulgences, especially sex, as 'dope'—recourse in extreme joy, or in dejection—it was all the same . . . Man must grow a will against this. Barnard fastened a straight-jacket upon his own fierce animalism by a strap lined with rabbit fur. And his fanaticism was showing in the flash of his eye, bringing its own scourge, perhaps the cruel immolation of the flesh and will. He called his abstinence: 'translating from the body into art.' "[61]

Alfred made clear to Barnard that he did not buy the theory. "He said that while he did not condone weakness toward sin he believed in finding the reasons why people erred and so he made great allowances. He professed 'the Sermon on the Mount' as his religion and as his moral code the words of Christ to those about to stone Mary Magdalene: 'Let him who is without sin among you cast the first stone.' "[62]

When the minister's son professed his moral judgmentalism in that same conversation about desire and repression, Alfred became unusually huffy. "You don't know anything about it. I would never want to pass judgment on any man,"[63] he insisted.

Then Alfred Corning Clark did something unusually impulsive. He

"asked George to let him have the little engraving tool which he held in his hand and had fancied as a symbol of what he himself had lost in life."[64] The sculptor handed over the instrument.

Alfred said he would always treasure the tool along with "the three pennies that fell out of your pocket the night you came to me in rags at the Hôtel Edward VII."[65] He joked that the pennies had earned interest since then, that Barnard should come to him whenever he needed anything. But he was not in jest about treasuring those mementoes of that encounter between the prince and the pauper.

THAT THESE DETAILS are known today is not because of any notes or recollections on the part of the intensely private Alfred Corning Clark or his family, but because of letters Barnard wrote to his parents and, later in his life, his conversations with Daniel Williams. In this account of his Paris life, Sterling and Stephen's father comes into focus as through no other source. "The Governor," after all, was the person who had turned Barnard's life around. Alfred's warmth and generosity were palpable, even if tinged by an edge of despair, and Barnard was not about to slight their effect in his reports of this vital period in his life.

But that aspect of unfulfilled longing, of personal neediness, especially in the years following Skougaard's death, was clearly troublesome to Barnard, and may be one of the reasons the sculptor had to describe the interactions with Clark in such detail, even if he did not analyze their meaning out loud. He recounted an incident of his benefactor urgently needing to have lunch with him, and then, "with the eyes of a faun," instructing Barnard to accompany him on his annual May 1 pilgrimage to Milan, departing that same evening. It was his palpable sense of urgency rather than any imperiousness that made clear to Barnard that Alfred absolutely expected him to comply. When Barnard said he could not, that it was impossible because of his work, Alfred insisted. The millionaire explained, "I have money to carry. I must have a guard. You are strong."[66]

Alfred then told Barnard that the yearly ritual, in which he knelt in the great Duomo "on the same day at the same hour each year,"[67] was his way of reliving his happy times with Skougaard there. He needed to kneel exactly where he had knelt when the Norwegian was there beside him.

When Barnard returned to Alfred's hotel suite that evening, he was given an ordinary black suitcase to carry. It was so heavy with gold pieces, totaling five hundred thousand francs, that he could hardly lift it.

Yet throughout the journey, the burly sculptor carried it as if it were light, so as not to make its contents apparent to possible marauders.

As they traveled to Milan, Alfred Corning Clark's eccentricities became particularly apparent. He had a tantrum at the train station when a news vendor tried to overcharge him for a paper. "In an uncontrollable rage, he scooped up all the papers he could hold, strewed them all the way into the station, aquiver with fury, his usually red cheeks white, his sensitive mouth tremulous." Once they were in their adjacent suites in the sleeping car, Alfred hung his overcoat over the window to his compartment so as not to be seen, then emptied all of the gold onto the floor, divided it into piles, and "tied each heap in a separate handkerchief"[68] before putting it back in the suitcase and instructing Barnard to sleep with it under his pillow. Barnard could not sleep, but Alfred was comfortable.

What happened from then on has the ring of fiction; with its combined elements of fabulous wealth and fantasy behavior, one could imagine it in the voice of Gogol or Turgenev. The refined millionaire/landowner and the sculptor who resembled a burly serf stopped for a night in Turin. In the newspaper there, Alfred read that a troupe of actors from Rome had been "stranded . . . their effects seized."[69] He had the local Singer representative come to his hotel; yet again it was the obligation of one of these middle-management people to investigate someone beset by misfortune. Then the travelers continued to Milan, where they stayed in the splendid hotel suite that was set aside for Alfred on that same date every year. In the morning, they went to the Duomo so as to be there precisely at ten. When Alfred headed to a pew not far from the altar, Barnard sat in the back to let his patron experience his memories in solitude.

Once Barnard saw Alfred emerge at slow gait down the aisle, he joined him, and together they exited onto the great piazza in brilliant sunshine and returned to their palatial hotel. There were messages awaiting Alfred. He let Barnard know that the agent's report had been favorable and that the actors were safely en route back to Rome. The sculptor quickly realized how effective the wheels of power could be.

Alfred Corning Clark seemed satisfied. He now urged his protégé to join him for the next leg of his journey, on into Germany and Austria. Barnard begged off, but "saw Clark off on the train, the satchel containing the wealth in gold with him." As the train pulled out, the American midwesterner stood there in the great Milan station utterly stunned. He

"thought that never had there lived a man with such a heart as this. He knew now where the gold would go, each separate share of it. He realized that this great fortune was to his friend as a chain of golden links binding him all about. So he would go through Europe casting off golden links of this chain, this man with the wings and the heart of a hummingbird who suffered so much the misfortunes of others." The millionaire would distribute his fortune wherever he found anyone in need or encountered human suffering, "feeling freer and lighter at every step."[70]

WHILE ALFRED CORNING CLARK headed on that train through the Alps from Milan toward Frankfurt, Elizabeth and the four boys were continuing life as usual in New York. Edward—or Rino—was now seventeen. Sterling, whom the family called Robin, was ten. Ambrose—Brose—was seven; and Stephen, the only one without a nickname, was five. Well supported by domestic staff as always, Elizabeth took them to Cooperstown during the school holidays, with Alfred extending his May trip into his annual stay on his island retreat south of Oslo and staying away all summer long.

That September, Alfred returned to Paris. The day before he was scheduled to sail back to America, he sent a note summoning George Grey Barnard back to his splendid suite at the Hôtel Edward VII. At dinner in the private dining room, a cheerful Alfred told his visitor he would finish spending his gold by buying small houses for two elderly people who were in need. "With that, the gold will be all gone and I can go home."[71]

After he and Barnard shook hands, and Clark was closing the door of his hotel and about to return to solitude in the vast suite overlooking the Opéra, he stopped himself and called after the handsome sculptor. "George. It almost slipped my mind. Make me a copy of *Brotherly Love* for America! If you duplicate the statue, I can duplicate the fee."[72]

That image of two young men resembling Michelangelo's slaves with their rippling muscles, perfect torsos, and handsome faces—reaching toward one another but separated by an unbridgeable void—would evoke Skougaard not just in a remote village in Norway. Barnard got the marble from Carrara and carved away throughout the cold winter months. When Alfred returned the following spring, he was as delighted with the second version as he had been with the first. What the rest of the family thought when the sculpture eventually arrived in New York is

Left to right: *Ambrose, Sterling, and Stephen Clark, Cooperstown, c. 1887.*
With their brother Edward, they would become among the richest men in America.

uncertain. But Alfred Corning Clark could now feast his eyes on this
memorial to the great Severini, and to their relationship, in winter as
well as in summer.

WHEN ALFRED WASN'T CAVORTING with his male friends in
Europe, he and Elizabeth were good upright citizens of New York. It's
unlikely that anyone had an inkling of the specifics of his other existence,
even if intimates of the family might have whispered about the length of
his absences. When former president Chester Alan Arthur died at his
home on lower Lexington Avenue in November of 1886, "Mr. and Mrs.
Alfred Corning Clark" were among the scions of New York society whose
condolence call the following day was mentioned in *The New York Times*.
They also had begun to demonstrate the family bent toward public liti-
giousness. In 1890, a case was heard by the U.S. Supreme Court, with
Alfred Corning Clark as plaintiff, asserting ownership of real estate in
Illinois where a man who had put up structures on the land was purport-
ing to be the owner and claiming homesteading rights. Alfred's victory

in the case received extensive publicity; there was no escaping the lime-light when you were one of the richest men in America. It took the distance of an ocean to escape the public gaze.

IN 1887, George Barnard twice visited Alfred and his family in New York. The welcome with which he was received by Elizabeth and the children, and the warmth he felt during his stay, are further evidence of the really extraordinary circumstances of the childhood of Sterling and Stephen Clark and their brothers—of the openness of the household and the degree to which a struggling artist was made a member of the family.

Barnard was stunned by the family's three residences—the main house at 7 West Twenty-second Street, the adjunct flat down the street at 64, and the sprawling apartment at the Dakota that was used mainly for entertaining. He stayed at number 64.

This, of course, had been Skougaard's place. The stationery on which Barnard wrote his father, mother, and sisters from there bore Skougaard's monogram and, above the address, the Italian inscription: "Abbiamo diversa l'indole ma uguale il cuore in petto (We are different in our natures, but the hearts [beating] in our breasts are equals). Although the letters are undated, we know that one of the visits occurred in the spring, because Barnard described the house as being filled with flowers for Skougaard's birthday, which was May 11. Barnard sailed back to France the following day, but returned to New York in December and again stayed in Skougaard's apartment. He wrote to his parents "I stay in this lovely little home 64W, and take my meals with the Governor's family . . . The more I see of Mrs. Clark the more I admire her, and [their] wonderfully brought up children."[73] The next account was ever more rapturous. Barnard was both ecstatic over the relationship he had with all of the Clarks and grateful to his parents for bringing him up in a way that made him susceptible to it. Again using Skougaard's old stationery, he wrote: "Here I am in as lovely a place as can be found *away from home,* and with as much love around me as can be given—away from Home.

"Why should I find such good friends—if it were not for having such a Father and Mother . . . I am here in sweet 64, the home of Severini. I have the old room full of hallowed memories—the Governor comes here every morning to talk. Eat at his home with Mrs. C and boys at noon and spend the evening there—so the days are passing—He will not let me go till next week Saturday—New Year's Eve and New Year's day we passed

at his house with the family. It *is my home* so he says and I am his boy—
And I consider it a home your own goodness has made for me when out
in the world.

"I like Mrs. Clark very much and the boys are indeed exceptional." One
of the boys, Barnard reported, was sick, but now "free from danger"—
unable to be visited by the others and quarantined in a different part of
the house (we assume this to be Rino)—while Barnard and the other
three boys and the woman he referred to as "Mrs. C" passed an evening
shooting marbles, playing a game called "Authors," and eating candy. "So
I am beginning to feel I know them and like them all," he concluded.[74]

This image from a letter written by a struggling sculptor to his par-
ents in the Midwest—an intimate glimpse of their son shooting marbles
on the floor with Sterling, Ambrose, Stephen, and "Mrs. C"—tells us a
lot about what it was that ultimately made at least two of them so recep-
tive to passionate creation and the world of serious art and the museums
that house it. On the surface, the Clark children led the same blue-
blazered childhood as many of their confreres. But the little-known sides
of life at home were something else.

FROM PARIS, the following April 10, Barnard sent his parents
another, even more remarkable, letter about Alfred Corning Clark.
"What a time we have had," he wrote about his days with Alfred. They
had met up in Fontainebleau, the town at the edge of the Barbizon For-
est south of Paris; it seems that Holman-Black and Holman and others of
that coterie were there as well. Barnard informed his family, "The Dear
Governor came to the depot with me as well as for me, and a long dark
walk. He is too kind, the happiness of these meetings impresses me too
deeply to ever suppress that sigh coming from, truly happy hours, but I
dare not denigh [sic] the same eternal battle keeps up within my soul, as
to . . ."[75]

The words "as to" are at the bottom of the page; the rest of the letter is
lost. "The eternal battle," we assume, had to do with the sculptor's long-
ing for men, possibly Alfred specifically—which may well be why the
remainder of the document is gone.

BACK IN PARIS, following the completion of *Brotherly Love,* Alfred
continued to function as a Medici to his young Chicago-born Michelan-

gelo. George Grey Barnard went on to make portrait busts of Alfred himself and of Skougaard and his mother, Sara Helene Skougaard. These vividly realistic marble sculptures of the Skougaards, each showing its subject in intense concentration, would be shown in New York and Philadelphia a decade later, and would be given in 1896 to Langesund by another member of the Skougaard family in memory of Alfred Corning Clark.

Though the legacy of Alfred's sons Sterling and Stephen is readily accessible today to much of the American public, it requires a pilgrimage to a small seaside village several hours south of Oslo to understand in full the patronage of their even richer, and more artistic, father.

One great work of art inspired and commissioned by Alfred, however, would be for a while in plain view in the Great Hall of the Metropolitan Museum of Art. This, too, was a sculpture by Barnard. Two years after Alfred died in 1896, his estate would give a highly animated, arresting sculpture of two naked men to the museum. When the Met's great new entrance hall opened six years later, this was one of the main works of art on view in that central location. The monumental marble piece prompted references to Michelangelo and Rodin (an allusion Barnard rejected); it garnered critical praise; and, at the same time, it begged a lot of questions.

Although it is now relegated to the Met's storage, the larger-than-life-size sculpture remained in that prime position near the museum's entrance and the main staircase for many years. To anyone willing to understand its meaning, this large marble statue was even more revealing than *Brotherly Love*. It was this great project that was brewing as Barnard worked on the smaller portraits of Alfred and Skougaard—and that would be such a remarkable part of the Clarks' legacy.

BECAUSE HE SPOKE NORWEGIAN, "the Governor" had introduced Barnard to the Norwegian sagas. He also saw to it that the sculptor read *Heroes and Hero Worship*, in which Thomas Carlyle champions the sagas. This behind-the-scenes effect that the sewing machine millionaire had on the young sculptor transformed Barnard's work; the themes of those Norwegian legends quickly became apparent in sculpture in which beautiful Viking men, the epitome of earthly power, and lithe Scandinavian women, all softness and curves, emerge. It also led to this piece Alfred's heir gave to the Met, in which both figures are male.

Between 1886 and 1894, George Grey Barnard worked on the sculpture *Je sens deux hommes en moi,* which in English is generally known as *The Struggle of the Two Natures of Man.* Alfred Corning Clark paid twenty-five thousand dollars for it in February of the year it was completed—an enormous amount of money for the time, enough to change the sculptor's life even more dramatically than the rich young collector had already done. The piece was shown at the Salon du Champs de Mars that May, where Barnard had more work on view than any other sculptor, the jury having accepted all six of the pieces he submitted.

They were exhibited in a prime spot, with *Two Natures* impossible to miss. Alfred's protégé instantly became the sensation of Paris. Mutual friends sent Alfred a telegram: "George great success most discussed man in Paris."[76]

The ruling figure of French aristocratic society at the time was the elderly Princess Letitia Bonaparte. Rodin, who admired Barnard's work, escorted her to the exhibition at the Salon.

As she walked through, surrounded by her entourage of noble ladies, she stopped short on seeing the great sculpture funded by Alfred Corning Clark. Its scale and force made her back off instantly, while she continued looking at it through her lorgnette.

Princess Letitia turned to Rodin. "What is this?" she demanded as in amazement. "Who did it?"[77]

Rodin presented Barnard, who was standing nearby. "This young man, right from the prairies of America,"[78] he told her.

Princess Letitia, incredulous, then spoke English. "Do you mean you did this, or did someone else do it?" she asked Barnard. "It's my own struggle," he purportedly replied.[79]

Princess Letitia instantly declared that she would introduce him to her friends, that he must come to her palace the next Tuesday evening. He would meet the novelist Alexandre Dumas, and the president of France.

Barnard declined. The thought of society terrified him. The princess, rather than being offended, then proposed Wednesday (again he said no) and then Thursday, to which he finally acquiesced. Dinner would be at 8:30; he would sit on her right.

On Thursday evening, Princess Letitia sent her carriage to the studio to which Barnard had recently moved on the avenue de Breteuil. Where Barnard got his evening clothes is unknown—he may well have borrowed them from Holman or Holman-Black, since Alfred was not in town, and was too slight for them to have fit in any case—but he wore

the correct "smoking" attire. Going through the streets in a vehicle bearing a royal coat of arms, he felt his life had changed, just as when he had first dined in the private dining room of Alfred's hotel.

At the princess's palace, just off the boulevard des Capucines near the Madeleine, the young truant from Illinois could not help but be proud as he presented his card to a doorman in blue uniform, silk stockings, and slippers. The low marble entrance hall and grand staircase were lined by servants in identical livery. When the sculptor entered the enormous salon, the music stopped and voices quieted when "a functionary wearing a seal . . . called out: . . . 'the American sculptor, M. George Barnard!' "[80] Princess Letitia rushed forward and offered him her arm. And even though Barnard stepped on the train of her evening gown, the eighty-year-old delighted in presenting him to her court of counts, countesses, dukes, duchesses, statesmen, military leaders, and many of the best-known artists and authors of the day.

A hundred people were seated at the head table, while hundreds more were in groups of eight at smaller tables. As promised, Barnard sat on his hostess's right; the writer Edmond Rostand—author of *Cyrano de Bergerac*—was on her left. Before dinner began, the princess toasted Barnard as "the Rising Star of the Champs de Mars," and referred to the viewing of *The Two Natures* the previous Monday.

Barnard could not eat the caviar, and hated the idea of dancing when the princess asked him to head to the floor with her. According to his biographer, although he acquitted himself respectably—"he was extremely handsome, had excellent manners by nature, a remarkable voice, and he spoke as impeccably as any aristocrat"[81]—he was thrilled the moment he could leave. Barnard "went away into the night, giddy yet depressed by this near farcical imitation of the monarchic in a great democracy and in a city most of whose people lived always close to penury."[82] He had none of the feeling of ease he experienced in the world of the Clarks, where the division between wealth and poverty was somehow so different.

Leaving Princess Letitia Bonaparte's palace, Barnard stood under a streetlight and looked at the bits of clay that had remained under his fingernails in spite of all the scrubbing he had done to prepare for the evening. "These hands were his 'tools'—the only thing he could do or wanted to do was work with them."[83]

The splendors of Paris had not suited him. But none of this would

have happened without the patron whose very different attitude toward wealth, and whose own sense of reality, were somehow so right.

IT'S NO SURPRISE that *The Struggle of the Two Natures of Man* caused such a sensation. Based on a poem of Victor Hugo's, it reveals immense sculptural skill. An emotional and physical intensity charges the air around the piece.

The statue presents two figures who epitomize male beauty. Each has the perfectly proportioned features of Michelangelo's renowned *David:* a chiseled, straight nose; sharp cheekbones; and large, wide-set eyes. Each has the sort of full head of wavy hair that to this day is invoked by male hairdressers and the makers of men's hair products as the masculine ideal. One of these broad-shouldered, ripped young men is standing; the other lies on his side. The standing one has his right leg planted between the legs of the one lying down. His foot is positioned rather tightly in the other man's crotch—if the viewer allows oneself to acknowledge it.

With his massive left hand, the standing one points at the supine one. The two men do not, however, in any way catch one another's eyes. Rather, each looks off into space—in the same direction, as if at the same distant star—in a sort of reverie. The one lying down, whose muscular back and buttocks and long sturdy legs are revealed with rare sculptural dynamism, appears almost to pout. The one standing, whose genitals are discreetly covered by his right wrist, is closer to ecstasy.

Barnard had intensified the vitality of these figures and their interaction by using marble. As the sculptor said in an interview, "Clay means life; plaster death, and marble the resurrection."[84] It was Alfred Corning Clark—the person to whom Barnard referred as "the dear Governor" and of whom he wrote to his parents "he is too kind"—who had provided the financial resurrection that made the use of that material possible, and that enabled the sculptor to enliven his masterpiece as he dreamed.

AFTER STARTING *The Struggle of the Two Natures of Man* in spring of 1888, George Grey Barnard had said, "The same eternal battle keeps up within my soul."[85]

A natural interpretation is that "the two natures" are the feminine and

George Grey Barnard, The Struggle of the Two Natures of Man, *marble, unfinished, 1892–93. The sculptor worked for six years to make this piece that revealed the two sides of his tortured existence, and that made him the talk of Paris.*

masculine sides of the male personality, and Barnard's struggle between the attraction to women and the attraction to those of his own gender.

The way Barnard has rendered the two characters supports that idea. The standing figure is a bit more boyish and feminine than the Herculean guy lying on his side, but what is most striking is not the difference between them but their intense connection to one another, and their sheer physicality and beauty.

The Two Natures of Man can also be read as a parable of victory and defeat. In either instance, the theme was close to Alfred Corning Clark's heart. George Barnard wrote, "I shall try and bring all the anguish that what we *call* a *victor* is susceptible to—that is the higher one gets, the more delicate he is strung."[86] The fallen figure and the victorious suggest vulnerability and triumph. Like most people, Alfred would have identified with both states of being. His wealth and position made the appearance of triumph more pronounced; his delicate nature, his true empathy with others, his own inner struggles, all contributed to the palpable feeling of woe.

. . .

ON THOSE OCCASIONS when he was back in his house on Twenty-second Street with Elizabeth and the boys, Alfred regularly saw, in the dining room, two vividly painted canvases by the French nineteenth-century academic painter Jean-Léon Gérôme. Both were painted in colors like those of Cecil B. DeMille's epic films of the 1950s—a sort of lurid Technicolor in its earliest stages. *The Snake Charmer* focused on a naked boy posed with a python in front of onlookers in a densely decorated Oriental courtyard (see color section 1, page 1). That the Clarks hung this tender rendering of a boy at the brink of puberty, displaying himself to a male audience for all to see, in their New York life, is nothing short of astonishing. The other, larger Gérôme—nearly five feet high and over three feet wide—is now called *Thumbs Down (Pollice Verso)*, but was then referred to, at least in the Clark household, as *The Gladiator* (see first color insert). The main imagery is remarkably similar to that of *The Two Natures.*

A triumphant gladiator stands in splendid regalia. He sports a fantastic helmet, armlets, and massive boots that extend just over his knees; other than that, his chest and thighs are naked, while a wide sash and elaborate loincloth cover his middle. He holds a shield in one hand, a dagger in the other.

The gladiator's booted legs are planted next to the body of a man he has just vanquished. The victim lies there in a pose very similar to that of the supine figure in *Two Natures,* and the triumphant fighter poses in a way that could well have been the model for Barnard's standing figure.

There is a second victim, lying facedown, and yet another one at a distance in the stadium. These have nothing to do with the Barnard composition; nor does the elaborate architectural setting, with a sort of royal enclosure, spectator boxes, and other spaces for onlookers. But Gérôme's pairing of the first two is remarkably like the Barnard.

Gérôme's canvas had been painted in 1872. There are any number of possibilities as to its connection to the Barnard sculptural pair. It's possible that Alfred bought the painting in Paris and that Barnard saw it there; it could also be that, as with *Brotherly Love,* Alfred had proposed the composition. This may never be known, but what is certain is that when Alfred Corning Clark supported George Grey Barnard, he was far more than a rich man buying an artwork; he was an active participant in the process.

He had provided the two hundred dollars to pay for the two tons of

clay with which Barnard had started out in 1886, and his backing had paid for the iron Barnard used for the armature of the clay sculpture that recalled his work as a taxidermist in his youth—"exactly the same" as what one constructed to support a dead deer.[87]

The labor made Barnard believe he could feel himself growing "all in the shoulders and arms"[88] when he made *Two Natures.* For all of his disavowal of sex with others, Barnard was certainly aware of his physical self; he narcissistically wrote his brother Evan, "Everyone says I don't change any more than the sun—Have never let a sign of hair grow on my face. Have developed because of my work in the shoulders and breast."[89] At a hundred and sixty pounds, he was pleased that so much of his weight was from muscle. And, he let them all know back in Madison, Indiana—where his mother and father had moved—they "would blush" if they could hear his confreres in Paris calling him the "Young Giant Michelangelo, etc."[90]

IN 1890 the Polish artist Anna Bilinska painted a large canvas of George Grey Barnard at work on *The Two Natures* (see color section 1, page 2). Alfred bought the painting as a gift to Barnard's parents. It presents their burly son looking like a stevedore, stocky but without an iota of fat. The broad-shouldered, athletic sculptor bears no resemblance whatsoever to most artists in late-nineteenth-century Paris, where the norm was a beard and a black suit. Rather, he could be the young hunk in a stag film, with his handsome, clean-shaven face and thick but well-trimmed black hair, his blousy leather top open halfway down his bare chest, and his sleeves rolled up above the elbows of his powerful arms, his thigh muscles bulging in his knee breeches as he sits with his legs apart on the corner of his bed, one foot turned at ninety degrees and elevated on a platform. He is wearing unusual footgear, perhaps from the trip to Norway, essentially sandals with cross-lacing that extends the height of his shins over tight kneesocks.

By the time this portrait was made, Barnard had progressed from the first stage of *The Two Natures* to its transformation into life-affirming marble he had selected in Carrara to work with his chisel in Paris. "I find marble cutting easy as all things when force is employed"; he could "now cut out a figure as Father would write a sermon."[91] It took eight horses to pull the block of marble through the streets to the larger studio on the avenue de Breteuil, not far from Holman and Holman-Black.

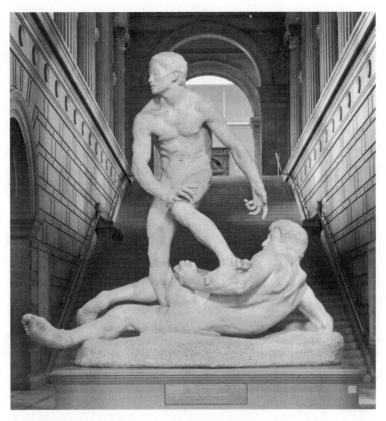

George Grey Barnard, The Struggle of the Two Natures of Man,
*marble, final version, 1891–94. On the death of Alfred Corning Clark,
his heirs quickly gave it to the Metropolitan Museum,
where for years it stood in the Great Hall.*

"The Governor" had not only funded the marble but had also given
Barnard's parents three thousand dollars toward the purchase of a home
in Madison. "Mr. Clark sends it to you as with God's goodness to him he
is able to,"[92] George had written them.

This was the sort of generous act Alfred did privately; to a limited
degree, he also was becoming known publicly for his philanthropy. His
main cause was the all-male singing group with which he had per-
formed, the Mendelssohn Glee Club. Alfred had inherited a site on For-
tieth Street, just east of Broadway. In 1891, he began construction of
Mendelssohn Hall on it. A mix of gray rock and oatmeal-colored brick,
for many years it would be one of New York's most important perform-

ing spaces. This building that Alfred funded in its entirety consisted of an eleven hundred–seat auditorium, as well as club rooms, a rehearsal hall, a smoking room, a library, and three floors of bachelor apartments (with Winslow Homer among the first occupants). The place quickly became an unusual New York institution, with particular rules for the performances of the men's choir; if you showed up at a concert not dressed formally, you were turned away.

Mendelssohn Hall would have an unfortunate end. Alfred Corning Clark would live only a few more years, and he failed to make provisions for the future of the building or to mention it in his will. Neither Elizabeth nor their sons thought it was worth maintaining; the bastion of male entertainment was eventually torn down, with the murals going to the Brooklyn Museum. The glee club is still in existence, but its magnificent headquarters are now part of its distant history.

As with Frederick Bourne, Alfred Corning Clark also met Douglas Alexander, Singer's next president after Bourne, at the Mendelssohn Glee Club. One of their first conversations became further part of the family legacy. Alexander, a lawyer, wanted only to be an opera singer. With the rejoinder, "Think of your legs in tights," Alfred got him to go into the family business instead.

GEORGE GREY BARNARD'S life took a very different turn at the start of 1893. On January 8, he wrote his brother Evan, "I have made the acquaintance of the sweetest woman in the world." After periodically telling his family he felt he had passed the age of falling in love, he had met the New England–born Edna Monroe, and in little time they became engaged to marry.

It was then that the sculptor made the decision to return to America. His new audience of admirers in Paris was shocked. But the person who was most disappointed was Alfred Corning Clark. "Barnard's return to his homeland was strongly opposed . . . almost bitterly so by 'the Governor,' who agreed with Rodin in admonishing him to 'give up America as a home, or give up art.' "[93] Why Alfred was so upset has never been precisely established. He may, as he claimed, simply have felt that Europe was the only true place for artistic inspiration. But he also was desperate at the idea of giving up the feeling he derived from keeping Barnard in Paris, where the life he and the sculptor and Holman and Holman-Black led, three thousand miles away from New York, meant so much to him.

And it wasn't just the move, but the alliance with Edna, that troubled him. To everyone in their circle, there was a distinct feeling "that Clark had scant enthusiasm for his protégé's marrying at this time."[94]

Alfred did everything he could to persuade the buff and passionate young sculptor, the impassioned former truant, not to leave Paris. The patron cautioned Barnard that the return to the U.S. "would mean his artistic death."[95] Then, in the middle of the period when Barnard was contemplating the move, Alfred Corning Clark showed up one day at Barnard's studio and said that they should take a walk together. Clearly he had an important reason.

Near the Invalides, in the heart of the Faubourg St.-Germain, one of the most elegant Parisian neighborhoods, the two men arrived at "a walled enclosure. . . . Clark pulled the bell cord. A concierge opened the gate."

A bearded gentleman, who clearly was expecting them, showed them around a beautiful garden, full of blooming fruit trees, with a house in the center that seemed like a country house in the middle of the city. "The scent of the blossoms and the earth under the fresh spring air was to Barnard an enchantment."[96]

Alfred Corning Clark, who was sporting a wide-brimmed velvet hat, then pointed to the large villa and said to Barnard, "George, this belongs to you."[97] He was perfectly matter-of-fact. Alfred explained that he had had his agents search throughout the entire city to find the right place. Here Barnard could build a studio. To a speechless Barnard, the sewing machine heir explained, "You have got everything you love, tree, blossoms, birds, everything but the Mississippi River. This is yours, with $50,000 a year for the rest of your life."[98]

It's no surprise that Alfred Corning Clark's sons would grow up to believe that their fortune empowered them to determine how other people would live. But George Grey Barnard turned his patron down. The woman he intended to marry was insisting that they move back to their native country; he concurred that he had an obligation to contribute something to his homeland.

Alfred did everything he could to prevail. "The American people know only the dollar. They're commercially minded. No, it would be the death of your sculptural genius. Stay here. No one can survive as an artist in America and be himself. This is the great world center of art, Paris. Here is opportunity, inspiration, criticism, materials to work with, models, marble. I won't have you go back there."[99]

To Alfred's consternation, Barnard became possessed with patriotic fervor. He said that "he must return there, he must be to art in a new phase of American life what Daniel Boone was to pioneering. . . . America, with its vastness of reach, its great rugged and virile spirit, would yield an art more hardy and adventurous than any before known in the world. All Americans are needed in America. I am needed. We must build a great national art."[100]

Alfred's answer was especially interesting in light of the attitudes that would subsequently be taken by his sons. "New York is a mercenary place. Go back there and you would not be able to do anything." The critic Thiebault-Session, a voice Barnard respected, agreed that by leaving Paris Barnard would be forsaking art, that the American climate would not encourage creativity in the same way.

What an extraordinary man Alfred Corning Clark was when his beloved sculptor refused to heed his advice. Leaving the magnificent villa and garden where he had intended to build George Grey Barnard his studio, Barnard observed to what an extent "the refusal of his well-reasoned advice and of his great bounty so eagerly planned was a severe blow for Mr. Clark. . . . But as he beckoned to a cabman and got into a carriage, he said: 'You will have dinner with me before I sail, George, and when you and your bride get to New York, I will give you a good reception.' "[101]

BARNARD RETURNED TO AMERICA in the summer of 1894 to marry Edna in Dublin, New Hampshire, where her family had a summer house. For the occasion, Alfred commissioned a lace bridal veil that was twenty feet long. He had it made at the mill he had financed in Lyon for the boy who had saved his drowning friend. "At Barnard's stipulation, no man was permitted to touch a hand to it who had not led a blameless and virginal life."[102] There's no saying how many wedding guests would have been allowed to touch the sacred object, but they were never put to the test, for the veil burned in a fire that occurred on the pier at Boston harbor after it arrived from France. Barnard was grief-struck—"it was to have been the representative at his marriage of his spiritual father, Alfred Corning Clark"—and Edna, who had looked forward to the effect all that lace would have as she walked down the aisle, was bitterly disappointed as well.

Shortly after returning to America, Edna and George Grey Barnard headed to New York. Alfred kept his word, and in November gave a

reception for the newlyweds at the Dakota. If Letitia Bonaparte's crowd had not been to Barnard's taste, the Clarks' was; he and his bride were more than happy to meet the leading figures in the world of art and society to whom Alfred and Elizabeth had easy access. But Alfred was not about to let Barnard go. When the last of the guests had left, he asked Barnard to reappear the next morning at ten o'clock. Barnard arrived as summoned, and Alfred took him outside. Next to the Dakota he owned a plot of land, some three hundred feet square. Again Alfred offered Barnard a studio, saying he would build it on the spot.

And again Barnard turned him down. The sculptor insisted he needed to be in more open space; unlike Skougaard, he would not permit Alfred to install him next door. In little time, he and Edna found an old brick house with twenty acres where they could live at the northernmost tip of Manhattan, in Washington Heights. Alfred tried desperately to dissuade him, saying he was putting himself too far from clients. It was the beginning of the end of their close connection and of Alfred's willingness to keep footing the bill.

Alfred had style, however. Three days before the Barnards' first Christmas as a married couple, a small package arrived. "May, 1886" was written on it. Edna unwrapped the vellum, and found a small worn tool and three French copper coins. There was a letter from Alfred Corning Clark saying that her husband would explain these "two previous trophies . . . which I have been keeping to offer his wife, when he should marry, and which will seem to you a plaintive cry. . . . God bless you, now that you are together, is the prayer of, Your sincere friend, The Governor."[103]

These were the copper coins that had fallen from Barnard's pocket when he turned them inside out on the first visit to Alfred's hotel suite. Back then, before Alfred had commissioned *Brotherly Love* and everything began to change, they had been all the money he had in his tattered clothes. The tool was the engraving implement Barnard had used when working as if he were an indentured servant to "the man tormented with the responsibility for tens of millions of dollars."[104]

IT IS NOW PART of the record that it took a long time for Barnard to consummate his marriage. After they were married on August 21, 1894, "gripped by a worship of Edna for her herself, George Grey Barnard

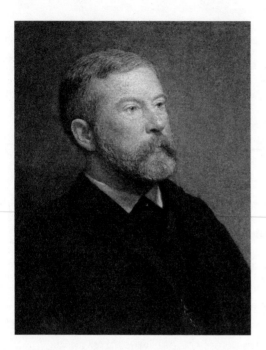

William Jacob Baer, Alfred Corning Clark,
*1893 (repainted in 1911). By then Alfred was
one of the most generous people in New York,
savior to many in need.*

*Elizabeth Scriven Clark, c. 1890.
Alfred's wife was known for her correct
demeanor and strong opinions, but few people
were aware of her secret struggles.*

could only kiss her upon the cheek each night, for two months."[105]
When Edna subsequently became ill four months after their wedding, a
physician observed that the bride was still a virgin. "Aren't you a man?"
the doctor asked Edna's sculptor husband. Barnard replied: "I wanted to
show her I was interested in her for herself alone."[106]

Given the importance of George Grey Barnard to the history of American sculpture and collecting, and the significance of Alfred Corning
Clark in the history of New York as one of its richest men at the end of
the nineteenth century, this subject matter has been until now left
remarkably untouched. But in the lives of Alfred Corning Clark's sons, it
played a significant, if previously unacknowledged, part.

WHILE DEALING WITH his private self in Paris, in the country
whose culture he alleged to disdain, Alfred Corning Clark was deter-

mined that the larger public taste more of life's pleasures. Until 1891, Cooperstown had had limited public recreational facilities, even if the rich could head to the golf links or polo fields at will. There was a base-ball diamond and two tennis courts with a changing room and cold-water showers, but nothing more. Then, for nearly three thousand dollars, Alfred purchased a property on Main Street. He razed the marble yard and engine shop that were there in order to construct a gymnasium that opened in February 1891. Men paid three dollars, ladies and chil-dren one and a half dollars, for six months' membership. It was one of many strides he helped the local townspeople make.

As would be true of the next generation, Alfred divided his philan-thropy between sports and arts. He took it as his obligation to enrich the lives of the American public on both fronts. Besides his support of George Grey Barnard and several other contemporary artists, he will-ingly lent the art he collected so that a larger population could enjoy it.

In 1893, the World's Columbian Exposition in Chicago, which was like a world's fair, had a major loan exhibition called "Foreign Master-pieces Owned in the United States." The collectors who provided works represented some of America's greatest fortunes; they included John G. Johnson of Philadelphia, Potter Palmer and R. Hall McCormick of Chicago, and Henry O. Havemeyer of New York, as well as the estate of Jay Gould. In general, only the men's names were given as the lenders.

Alfred Corning Clark, who kept art in both the vast apartment at the Dakota and the house on Twenty-second Street, lent just the sort of nine-teenth-century paintings a very wealthy and properly cultivated cos-mopolite of the epoch would be expected to possess. There was a Corot, a Daubigny, three Millets, and two by Delacroix. One painting, however, was so extraordinary in the scene it depicted that it boggles the mind to imagine the reactions of the multitudes who flocked past it at the Columbian Exposition.

It is not surprising that, shortly after Alfred's death, which occurred three years following this showing in Chicago, Elizabeth Clark would get rid of the painting in question. But what is completely astonishing is that, some forty years later, Robert Sterling Clark would choose to reac-quire it—which is why today it is one of the highlights of the collection in the museum he funded in Williamstown.

The painting was the other work by Jean-Léon Gérôme that hung in the dining room on Twenty-second Street, on the opposite side of a door-

way from *The Gladiator.* With cinematic vividness, *The Snake Charmer* presents startling subject matter. The canvas is exotic not just in the intense ornamentation of the setting, a courtyard richly decorated with colorful mosaics and Arabic lettering, but also in its scenario that is unimaginable in the Western world. The central figure is a young naked boy whom we see squarely from behind. He is the person nearest to us; our eyes fall upon him first. Each and every onlooker in the assemblage of men who study the front of the youth in the opulent Moorish setting is riveted.

The boy is completely smooth-skinned, his lack of body hair making him seem about twelve years old, just at the brink of puberty. His lean, well-proportioned legs and tight buttocks glisten in the sunlight. A large, fearsome snake is wrapped around the upper part of his torso; he holds the snake's head in his left hand, which is elevated toward the audience. If the python-like creature were stretched out, it would be a good six feet long, but it is curled over the boy's right shoulder, and then around his chest and stomach and back; the boy holds the deadly creature's tail next to his right hip so that, were he to let it go, it would snap in front of the boy's penis, which is patently visible to onlookers but not to us.

The people staring at this model/performer include a very old bare-chested man playing the instrument known as a fipple flute, potentates in turbans and robes, able-bodied men the age of soldiers, and a single youth holding a large staff. None of them can take their eyes off this naked youth who has tamed the monstrous snake. They see, of course, what we do not. While we glimpse the lad's profile and look at him from behind, they observe his front: his eyes, chest, and genitals. Gérôme surely knew he was titillating certain viewers of the canvas with his presentation to them of the boy's youthful buttocks as the focal point of the scene; he also illustrated a scene of the excitement of others, adding to the drama by implying but simultaneously concealing from view the source of their fascination.

For a man who was drawn to boyish toughness to have coveted this painting is no surprise. For a prince of New York City, who lived in all propriety with his wife and four sons, to have it on view for others—and to lend it, with his name attached, where crowds would scrutinize it—is something altogether different. All of Alfred's tastes were manifest here: not just his sexual preferences, but his craving for other worlds, for the exotic, for the confrontation with danger, for ruggedness. Having

entered the kingdom of beautiful art and rich music and strong young men, Alfred Corning Clark was beyond the point of wearing a mask.

ON JUNE 15, 1895, Barnard wrote Alfred, "I have felt a nearness and love toward you as no man but my own Father has ever drawn from me."[107] Even if Alfred's interest in the sculptor had slackened considerably since Barnard's marriage, "the Governor" had remained a lifeline to the younger man. Alfred's sudden death less than a year after Barnard wrote him so effusively would devastate him personally; it would also leave him in the lurch financially, with yet another large commission, for which the patron had covered only half the costs to date, half finished. Now he lacked the wherewithal to complete the commission.

But although there was a significant hiatus, the relationship between the gifted, impoverished sculptor and the family of Alfred Corning Clark was far from over. Sterling and Stephen linked forces on few things, but in time they would play a major role in supporting this eccentric, highly personal aspect of their father's legacy. If they suspected that the subject matter of naked men lunging toward one another and that their father's support of young singers and young sculptors revealed a side that was utterly taboo, or if there was anything about all these connections that made them uncomfortable, their qualms or reservations certainly would never show. All that is certain is that the facts, and the people's responses to them, were hazy and cloaked in silence. It was George Grey Barnard who would guide Alfred's sons when, in 1913, the two brothers who were interested in buying art—Sterling then thirty-six, Stephen thirty-one—met in Europe on a journey that launched both as collectors. Stephen willingly allowed the degree to which Barnard impressed him: "How handsome he was and how filled with the fire and enthusiasm which he carried with him through life."[108]

Barnard's passion for medieval art would, years after Alfred's death, lead him to collect remnants of French Gothic and Romanesque architecture, which he assembled near his home in Washington Heights, at the northern end of New York City. In time that assemblage would evolve into the Cloisters and become part of the Metropolitan Museum. As with Josef Hofmann, someone who benefited from Alfred Corning Clark's largesse in his youth would in turn make a major mark on civilization. Sterling and Stephen Clark—seeing, years after their father died, this direct connection between Alfred's support and the amazing gift to

American civilization that the Cloisters is—would have a legacy to live up to.

Yet even if Alfred's sons picked up aspects of their father's life, and on one hand greatly outdistanced him by acquiring art of a quality rivaled by few other collectors of the twentieth century, their father was the truer Medici: a patron of geniuses at work in his own lifetime, his support enabling them to exist.

For if Sterling and Stephen Clark would buy treasures and hence affiliate themselves with the people who made them, Alfred Corning Clark, even if he had a less discerning eye and allied himself with artists whose ultimate achievement was nowhere of the caliber of El Greco or della Francesca or Cézanne, was moved by the act of enabling creation rather than acquiring its results.

He donated to institutions, but he also supported struggling musicians, sculptors, and painters. As would be written in the wake of his death, "He gave lavishly, munificently," and "his generosity was guided and controlled by sound judgment."[109] The extent of his true philanthropy was such, and the combination of his good heart with his stratospheric fortune so significant, that it put him in a class of his own, beyond that of all the better-known philanthropists in New York at the end of the nineteenth century.

Alfred Corning Clark is, to this day, one of the best-kept secrets of the charitable world, more of a surprise than his better-known sons. In 1891, in the keynote address at the fifteenth-anniversary meeting of the New York Railroad Men, the speaker surreptitiously singled Alfred out when he boldly declared, at great offence to many of those assembled before him, "I do not think that the men who have the great fortunes in New York are doing their full duty to this community. I know of but one man in this city. . . . He deliberately said, 'I have got enough.' Every dollar of his income, beyond that which is required for a very modest support of his family, is appropriated to public and private charities."[110] Abram Hewitt, the speaker, knew Alfred Corning Clark well enough to leave out the philanthropist's name, but confirmed, when Alfred's memorial tributes were written following his death a few years later, that this was who he had in mind.

For all of his retreating ways, Alfred had, however, his own father's strength of opinion. He was an eager but discerning theatergoer, openly disapproving of "the frivolity, vulgarity—and worse—which today dis-

honour our stage,"[111] but passionate for what he deemed sufficiently serious. When we read the observation by one of his contemporaries that he was "powerful in opposition to whatever involved a principle with which he disagreed,"[112] it becomes clear that this was a family trait and one that he would certainly pass on to the son who, we have reason to believe, tried to oust a president and felt himself totally in the right in doing so, and the other, who helped terminate the services of one of the last century's most innovative museum directors.

Yet even if Alfred was certain of his opinions on moral matters, he also was famously modest. "According to his own estimate of himself, he knew little or nothing, and had but few qualities which deserved consideration."[113] It was not a trait he passed on to his sons, especially Sterling. The love for the riches of European culture and the wish to have society benefit from the family's wealth would extend from father to son; the restraint and lack of self-esteem would not.

But what has, in a range of guises, been a consistent family trait—and is carried on by the charitable foundations Alfred's sons started, even more than the museums they enriched—is the true sense of service to the underdog. Sterling, we will discover, has long been known for his cantankerousness and sense of entitlement; what is less recognized is the degree to which he perpetuated the family desire for the greatest good for the greatest number of people. Stephen, we will see, was considered cold and aloof; but he, too, had a more generous heart than his demeanor suggested. Usually the opposite is true—the generosity recognized, the personality flaws cloaked. In this case, by looking at the father, and then behind a few doors, we will discover that men who were sometimes seen as monsters, and who presented themselves as tougher than they were, had far sweeter sides.

Alfred, Thomas Moran would write in *Alfred Corning Clark: A Man Who Lived for Men,* "gave himself to men—not merely his money, but himself. He bore more burdens than any one man should bear. . . . He trusted men, he believed in them, he never lost faith in human nature. . . . Simple, cordial, gentle, strong; scrupulously conscientious; free from all assumption; unchangeably loyal; absolutely sincere—he had the happiness to be honored and beloved as few men have been."[114]

III
ELIZABETH

One does not know the inner life of Elizabeth Scriven Clark while she was bringing up her four sons under such compli- cated circumstances. Besides her husband's long absences every summer while he led his other life in Paris and Norway, there were the brief episodes when he would nip into Skougaard's apartment, even- tually used by Barnard, down the block. Clearly Alfred Corning Clark's wife was a woman of great character and strongly held values. Those qualities became even more apparent to others after April 8, 1896, when her husband died at age fifty-one and she came into her own as a public figure.

When Alfred Corning Clark died of pneumonia he was at home on West Twenty-second Street. "His fortune, at the time of his 1896 death, surpassed the scale of J.P. Morgan's legacy when that great banker died seventeen years later."[1] But the people who read about the death of this secretive man who left an estate of nearly fifty million dollars learned lit- tle about him. *The New York Times* reported, simply, that "He did not continue in active business when he inherited his fortune, but lived a quiet life, devoting much of his time to books and music."[2] It was still a month shy of the time of year when, if he had not succumbed to illness, he would have been in Paris or Milan or Norway rather than in the fam- ily fold with his wife and sons nearby; few people had a sense of his other existence.

Nor did they necessarily understand the reasons for which he had named Jens Skougaard, Lorentz Severin Skougaard's younger brother, one of his trustees, and bequeathed him a hundred thousand dollars and "six properties in Manhattan, including all the possessions in Clark's house at 64 West Twenty-second Street"[3] and Alfred's house in Norway.

Alfred's father, however, had seen to it that at least what was in Coopers-town could not possibly pass out of family hands.

Alfred's son Sterling would eventually find a lot to fault with his father's will. That Skougaard became a trustee would be a source of rage to him. But Alfred had left most of his estate in a straightforward way. The man whom he had first met at the all-male Mendelssohn Glee Club and in whom he had entrusted so much—Frederick Bourne, president of Singer & Company—was the other trustee. All the Singer shares, Alfred's primary asset, were in a trust to be divided among his widow and four sons. Given the amount of interest those shares generated, and the worth of such an income at the end of the nineteenth century, they were all in a position of rare spending power as well as the freedom never to have to think about earning a living.

At age forty-eight, Elizabeth was now left alone in a new way to bring up her and Alfred's four sons, aged twenty-six, nineteen, sixteen, and

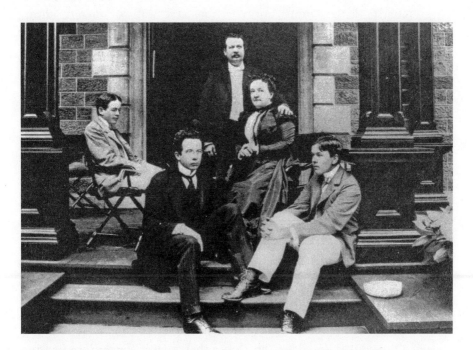

Clockwise, from upper right: *Elizabeth Scriven Clark, Stephen Carlton Clark, Robert Sterling Clark, Frederick Ambrose Clark, Edward Severin Clark* (standing), *c. 1897.*
Following her husband's death, Elizabeth would devote herself to building churches and low-income housing with the same zeal with which her four sons would live well and collect art.

fourteen. Stephen, the youngest, would be the most directly affected by his father's death and his mother's role as his sole parent, but everyone in the family was succored by Elizabeth's fortitude and steadfastness. The language close to her own epoch used to describe her—"a woman of exceptional gifts of mind and benignance of character"[4]—is well suited in both its soft strength and its old-fashioned tone.

Benign, perhaps, but clearly she was someone of rare mettle. And in the resort community where the Clark family reigned supreme, she was a force to be reckoned with. It doesn't take much imagination to read between the lines about the woman of whom it was written, "In Coopers-town Mrs. Clark became an arbiter of the social and moral virtues, and the things that she frowned upon were usually not done. She had a wholesome influence in resisting certain excesses which not seldom appear in communities partly given over to the pursuit of pleasure."[5]

How this pillar of virtue reconciled herself to her husband's way of life, what she knew or acknowledged to herself about it, is anybody's guess. On the one hand, Alfred was everything she was and believed in: deeply charitable, generous, unpretentious. He was not merely unim-pressed with his own wealth but crushingly uncomfortable about it, and shared his wife's wish to help the broad spectrum of humanity. The aspects of his life that others might have thought lacking in "moral virtues" were entirely private matters, and it's possible that his wife had the rare wisdom to perceive them as such. That she disapproved of people too given over to selfish pleasures—the partygoing, card-playing, coun-try club ways of Cooperstown's well-to-do—was a totally different mat-ter, and had nothing to do with Alfred, whose life was devoted to a considerable degree to acts of goodness, and who was more likely to be translating from Swedish or reading a scholarly tome than playing bridge the way most of his contemporaries were.

In the domain where Elizabeth Clark made judgments, she did not compromise. She so objected, for example, to the intrusion of automo-biles in the calm of upstate New York, and so detested encountering them as she was driven in her horse-drawn carriage, that she made clear that she would gladly have banished them. This obsession would become Ambrose's as well, but even if Sterling and Stephen might not care specifically about the issue of cars, what they would clearly inherit from their mother was her huffiness, and the belief that they could legislate what was right and wrong for others.

If, in Cooperstown, her husband was rarely seen walking outside the

grounds of the family's homestead at Fernleigh, Elizabeth Clark ven-
tured further afield. She was known for her fast gait and look of purpose-
fulness as she took off around the village, generally in a white dress and
"carrying a white parasol above her head."[6] All eyes were upon the
woman who with her husband had been instrumental in the founding of
the local park, library, and other civic institutions, and who preserved the
nearby forests for the benefit of the population at large. Their mother's
perfect comportment as the ruling figure of the royal family of the town
certainly contributed to Sterling's and Stephen's growing up to think of
themselves as princes, even if they would wear their crowns in very dif-
ferent ways.

Shortly following Alfred's death, Elizabeth built one of the most spec-
tacular mansions ever constructed in Manhattan. Alfred had not lived to
see it conceived, but he was indirectly responsible for the choice of archi-
tect. It was Alfred, after all, who had introduced his fellow member of
the Mendelssohn Glee Club Frederick Bourne to his father. Edward
Clark had hired Bourne to oversee the completion of the Dakota, and,
following Edward's death, Alfred had appointed Bourne head of Singer &
Company, to take on that position in Alfred's stead and with his com-
plete confidence.

Elizabeth's mansion was designed by the Paris-trained architect
Ernest Flagg, whom Bourne had first hired in 1896 to build a new Singer
headquarters. His design looked like the Parisian architecture of the day,
complete with mansard roof. While that project was under discussion,
Bourne introduced Flagg to Alfred Corning Clark's widow. Something of
an architectural chameleon, in 1898 Flagg jumped at the chance to
design a Neo-Palladian house for her, which he completed in 1900.

It's understandable that Elizabeth wanted to start life afresh. For more
than twenty-five years, she had lived in the house built by her husband's
father on Twenty-second Street, with Skougaard installed just down the
block until the singer died. Following Alfred's death, she was ready for a
major change and could not have anticipated that little time would lapse
before she found another husband. The residence where the widow
moved, and which became home to her sons, had an understated
grandeur that boggles the imagination.

It was in a completely different part of the city from where the Clarks
had been living before. On a bend in Riverside Drive, the house was at
the corner of West Eighty-ninth Street—even farther uptown and
removed from the city center than the Dakota. Set at an angle on the site,

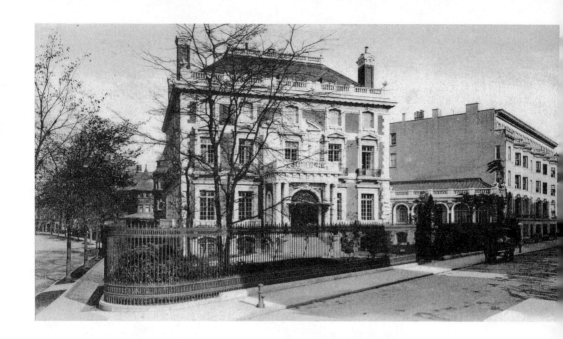

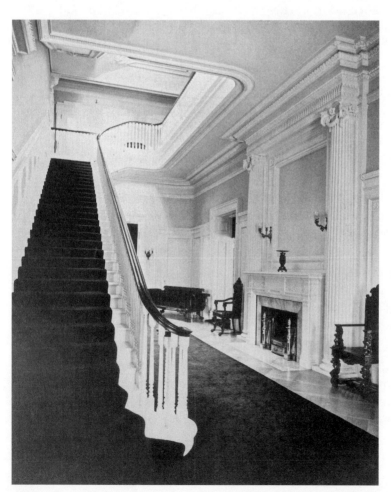

ABOVE: *Elizabeth's house on Riverside Drive at Eighty-ninth Street, New York, c. 1905. After Alfred died, the widow decided to change her life, and built one of the most spectacular mansions in New York history.*

LEFT: *Main staircase of the house on Riverside Drive. Inside and out, Elizabeth's new New York residence was like a sprawling English country house.*

the structure was like a palatial country house. Its four-story redbrick facade was animated by glistening marble porticos, decorative urns, fluted pilasters, and heavily dentiled cornices. The balustrade running along the top and another such balustrade crowning the mansard roof were also marble. Four chimneys emerged from this imposing mass, and there was a sprawling wing running off of it. Splendid front steps under a glass canopy led to a great entrance hall that opened to a library and sitting room that were each twenty-two feet wide.

The family must have felt as if they were in a Georgian mansion of the type familiar in English hunt country, though when they walked out their front door they were at the edge of a metropolis. Their stately palace has since been demolished, but this was where Sterling and Stephen Clark and their brothers spent some of the pivotal years of their lives and assumed their sense of who their family was in the eyes of others.

ELIZABETH CLARK, on the other hand, was not the sort of person to think only of her own surroundings. Like Alfred, she was someone with enormous moral conscience.

One of the greatest crises facing humanity as the nineteenth century ended and the twentieth began was the desperation of life in tenement housing, of the sort that proliferated in New York. A count in 1900 showed 44,850 tenements in Manhattan and the Bronx. Of these, 2,143 were rear houses, constructed in backyards, often back to back with the rears of buildings on contiguous lots. These dark, damp dwellings with little sunlight had a death rate, especially among infants, that was double the already high mortality rate in front tenements. "One in every five babies had to die; that is to say, the house killed it."[7]

The Tenement House Commission termed such dwellings "slaughterhouses" and requested that the legislature abolish them, especially after the deaths during a blistering heat wave in the summer of 1896 made clear that people living in more hygienic conditions had a far better survival rate. The government, however, was largely ineffective about doing anything. It took the efforts of private individuals to make any significant improvement in the lives of tenement dwellers.

A group of wealthy capitalists interested in tenement-house reform, guided by Robert Fulton Cutting, president of the Association for Improving the Condition of the Poor, banded together to form the City

and Suburban Homes Company, an organization that raised a million dollars by public subscription and set out to build decent homes for working people and their families. "Mrs. Alfred Corning Clark"—as Elizabeth Scriven Clark was always known in public—was the first person to rally to the cause in a significant way. She bought a tenth of the stock of the new company in order to erect improved tenements on nineteen lots west of Tenth Avenue on Sixty-eighth and Sixty-ninth streets. It wasn't much of a walk from the vast apartment building her father-in-law had built and her eldest son had inherited, and where she had a large apartment; the contrast between the soaring spaces of the Dakota and those rough structures for the poor was not lost on her.

In 1902, Jacob Riis, the well-known reformer and spokesman on the issue, wrote about the results of that act. "The Alfred Corning Clark buildings, as they were called in recognition of the effort of this public-spirited woman, have at this writing been occupied five years. They harbor nearly four hundred families, as contented a lot as I ever saw anywhere. The one tenant who left in disgust was a young doctor who had settled on the estate, thinking he could pick up a practice among the many. But he couldn't. They were not often sick, those tenants."[8] The occupants of the Clark buildings—for the most part Italian immigrants—were now accommodated in airier, lighter surroundings than their previous dwellings, with steam heat, fireproof staircases, and heavier partitions to ensure privacy between apartments.

IN 1902, six years after their father's death, Rino, Robin, Brose, and Stephen Clark saw their philanthropic mother remarry in a match that only added to her public-spiritedness. Their stepfather did not rival their father in his fortune—few men in the world could have—but he outclassed Alfred in other forms of distinction. Elizabeth's second husband was the Episcopal Bishop of New York, Henry Codman Potter, sixty-seven years old when he wed the fifty-four-year-old widow. His first wife had died the previous year.

It was big news for a bishop to remarry. On the other hand, the press made it clear that the match would only strengthen his capacity to perform good deeds. A news article announcing the engagement in *The New York Times* said of Mrs. Clark, "Although possessed of great wealth, she has never been at all prominent in society. She has devoted herself to works of benevolence and to church interests."[9] Her good deeds were

enumerated. Elizabeth, who had long been one of the bishop's parishioners, had funded Neighborhood Houses and a YMCA. A few months prior to becoming engaged to Henry Potter, she had gotten to know him far better when he had laid the cornerstone of the Alfred Corning Clark Memorial Church on East Thirty-first Street, on which the widow had spent about a hundred thousand dollars. The linking thread of the marriage seemed to be a devotion to community service.

In her new capacity as Mrs. Potter, besides attending to her and her new husband's large combined family—the Bishop had five daughters and a son—the former Elizabeth Clark instantly became associated with charitable giving on an even grander scale. A month after her wedding, she announced that she was giving the East Side Community House to New York City.

The youthful-looking bishop, meanwhile, was busily working on the development of the Cathedral of St. John the Divine, the vast edifice in northern Manhattan whose construc-

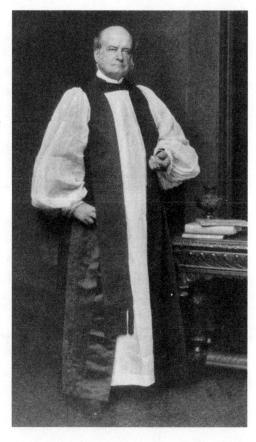

Henry Codman Potter, c. 1908. Elizabeth Clark's second husband, the Episcopal Bishop of New York, began construction of the Cathedral of St. John the Divine.

tion he had initiated. Having moved into Elizabeth's mansion on Riverside Drive, he was now, weather permitting, near enough to walk the twenty-five blocks to the site to oversee work on that great Gothic structure which remains one of Manhattan's landmarks. When Henry Potter died in 1908, only six years after marrying Elizabeth, the second-time widow again paid for a church in her husband's memory, this time funding St. James' Chapel in the cathedral.

When Elizabeth Scriven Clark Potter died the following year, the funeral was, however, held downtown, in the church where the Clarks had routinely worshipped on Madison Avenue at Thirty-fifth Street. The service had to be deferred for several weeks following her death, until

two of her four sons had time to return from Europe, but when the cortege entered to Wagner's funeral march from *Götterdämmerung*, the church was overflowing. The servants from the deceased's various houses took up a number of rows on the left side of the nave; the family's many friends and admirers filled the remaining pews or stood.

Few people there would have guessed the unusual nature of this great churchgoing woman's life. Nor could they have anticipated what lay ahead in the lives of her four respectable and well-bred sons as the fortune that would now come their way, and the problems that so often accompany great wealth, began to have their effects.

When their mother died in 1909, the sons of Alfred Corning Clark and Elizabeth Scriven Clark Potter became among the richest people in the world.

The legacy of these four men aged twenty-seven to thirty-nine consisted, however, of a lot more than money. The family's impact was especially visible in New York City and in Cooperstown. Not only was there the palatial house on Riverside Drive that had, the moment it was completed, become one of the city's landmarks. Beyond that, Singer & Company had recently built what was, for a while, the tallest building in the world. Alfred Corning Clark had been indirectly responsible for both of these behemoths by having put his old friend from the Mendelssohn Glee Club in the seat of power.

In 1902, Flagg had designed, at Bourne's behest, a loft building for Singer & Company on Broadway near Prince Street. This "ingenious and sophisticated mix of frankly exposed structural terra cotta, steel and ironwork, with whimsical red and green coloring" was a lively breakthrough in the possibilities of industrial architecture.[10] Then Bourne had acquired more land so that the ever-growing company could have something even larger. Flagg, who disapproved of the current style of Manhattan's skyscrapers—denouncing them for the darkness they imposed on city streets as a result of the way they rose straight up along the borders of the land they occupied—recommended a tall building that went a very different route. The way to avoid the "wild-Western appearance"[11] of these imposing buildings would be with a skyscraper set back from the sidewalk, with its tower occupying only about a quarter of the land and rising gracefully.

Ernest Flagg was a visionary. Between 1906 and 1908, the Singer Company built as its headquarters his design for a graceful redbrick and bluestone tower that, at 612 feet, was not topped anywhere in the world.

In lower Manhattan, at Broadway and Liberty Streets, the great Beaux-Arts skyscraper would be surpassed the following year by the Metropolitan Life Insurance Company Tower, but it still made history in its day.

In 1967, it would gain distinction as the tallest building ever to be demolished, when it was torn down to make way for 1 Liberty Plaza. But, based on photographs, the Singer Building was a bold and noble structure, the quintessence of the triumph of American industry and the strength of lower Manhattan.

The interior testified to great architectural imagination. In the lobby, "A forest of marble columns rose high to a series of multiple small domes of delicate plasterwork, and Flagg trimmed the columns with bronze beading. A series of large bronze medallions placed at the top of the columns were alternatively rendered in the monogram of the Singer company and, quite inventively, as a huge needle, thread and bobbin."[12]

Not only did Flagg achieve this feat of architectural panache in the Singer headquarters, but he went on to be a major advocate for zoning laws that called for staggered setbacks.

Alfred Corning Clark had discovered Frederick Bourne; Edward Clark had empowered him; then Alfred had placed him as president of Singer; Bourne gave rein to the spectacular creativity of Ernest Flagg; Flagg changed the skyline of New York. It's no surprise that Sterling and Stephen Clark grew up feeling that they could make a difference to American culture, and bring some of the greatest achievements of western Europe to the United States.

IV
STERLING

The legacy of Robert Sterling Clark benefits great numbers of people through the marvelous museum and its collection that bear his and his wife's names, and through a foundation that gives away nearly five million dollars a year, primarily to causes associated with women's reproductive rights and to theater and dance companies. But the founder of an institution that shows paintings that celebrate life at its most sublime, and of a brave philanthropy that advances progressive causes, was at times a volatile reactionary obsessed with a belief that others had done him evil and that no vengeance was too harsh.

A true enthusiast of artistic beauty in well-crafted silver as in great pictures, and a generous benefactor to the institutions he believed in, Sterling could be as vituperative as he was warmhearted. He also was rumored to be a major force behind one of the most extraordinary episodes in American history: a serious attempt to overthrow a president he thought was hurting the country. This second son of Alfred and Elizabeth Clark was given to whims, contentedly outrageous. Those personality traits prompted both wise and silly decisions, which, though they resulted ultimately in phenomenal gifts to society at large, risked incurring major damage. He ultimately left a superb charity and marvelous art donations; he might have helped destroy a government believed by others to be saving America. People who worked for him loved him, but once someone was his enemy, there was little chance of reconciliation. With Robert Sterling Clark, nothing was by half measure.

Sterling's grandfather Edward was the stern and straitlaced cliché of a Sunday-school teacher; his father, Alfred, a man of excessive refinement, intellect, generosity, and vulnerability. Sterling was entirely different

from both—a fun-loving, impossible character, kinder than he let himself seem, warmer than his rages would suggest, more sensitive than his drill-sergeant veneer implied. He sounded like a despot but was kind in person; his apparent harshness was the way he adapted to his fragility.

Sterling's bearing and the look on his face were of someone full of himself—admirably so, when he was spreading joy by dedicating a museum or giving refuge to needy people; less pleasantly when he lashed out at other family members and acted as if it was his inalterable right to say or do anything he pleased even if he radiated hatred. Opinionated, feisty, and brash, Alfred and Elizabeth's second son was bold, sometimes ebullient, sometimes cantankerous, seemingly unaware of the effects of his outrageousness; he went his own way about everything. He came not merely to detest his own brothers, and to cease speaking with them for more than thirty years, but to take pleasure in wishing them ill; he also could be uproariously funny and, with a totally different persona, as generous as his father.

More than any other member of the family, Sterling was the one who could make us laugh. He was coarse where his father had been refined, the ruffian son of an aesthete, but he had, in totally different form, Alfred's engagement with life. Unlike his father, Sterling was neither circumspect nor scholarly, but, very much like his father, in a world where men mostly used their free hours to play cards or golf or tennis when they weren't in their offices, he spent little time either at these diversions or at any traditional form of work, and devoted himself totally to the pleasures of culture, even if the sound of thundering hooves on the racetrack was to him what concerts had been for Alfred.

STERLING'S CHILDHOOD in Cooperstown and New York City had had most everything privilege could offer. Born in 1877, seven years after his elder brother, Edward Severin Clark, or "Rino," he spent winters in the family's two great residences in New York—the house on Twenty-second Street and the Dakota—until his mother moved into the spectacular mansion on the Upper West Side when he was twenty-one. In the summers he was in Cooperstown at Fernleigh, the family's enormous country abode. Everyone in the family called him "Robin."

It was a luxurious and well-structured existence, apparently unruffled by the long absences of his soft-spoken, gentlemanly father. His mother

was a clearheaded and competent woman of strong values and definite opinions, emphatic that her sons work hard and be considerate of others, and even if they were the royal family wherever they went, the boys were expected to assume their positions with good manners and a keen awareness of their responsibilities.

At the right age, Sterling went off to study engineering at Yale University, where his nickname was "Frowsy." Shortly after graduation, he joined the U.S. Army Ninth Infantry Regiment. He fought in the campaign of the Spanish-American War that captured the Philippines as an American colony. He then was among those to lay siege to Peking (Beijing) and capture Tientsin (now Tianjin) in 1900–01 during the American invasion of China to quash the Boxer Rebellion, a populist effort to wrestle China from foreign domination.

Following his military service in the Philippines and China, Sterling returned to the United States to work for the Department of War in Washington. The comforts of his life during the interlude in Washington would have tempted most young men to stay. When the twenty-five-year-old lieutenant gave a pre-Christmas ball for four hundred people at the New Willard Hotel, it was such a splashy event that *The New York*

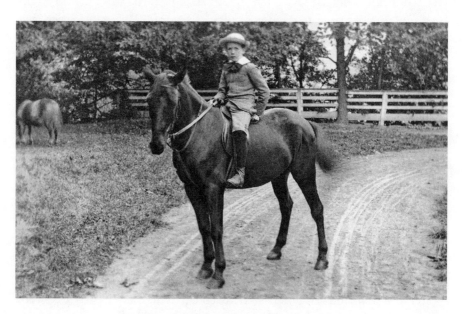

*Robert Sterling Clark, c. 1887. "Robin" grew up
in the lap of luxury in city and country alike.*

Times devoted a long article to its coverage, declaring the assemblage "the largest and most fashionable the season has yet known."[1]

The Clark family was not to be equaled when they entertained. Four hundred guests filled both of the capacious ballrooms at the lavishly decorated 389-room Beaux-Arts hotel that had been completed the previous year. The New Willard replaced the establishment where, at another ball, the Napier, held in 1859, leaders from the North and the South socialized together for the very last time before the Civil War, and where Abraham Lincoln had chalked up such a high tab during the ten days before his inauguration that he could cover it only after receiving his first presidential paycheck. Extravagance in an auspicious setting was very much to Sterling's taste.

The dinner parties that had preceded his ball included one at Sterling's own house on Connecticut Avenue. His two younger brothers, F. Ambrose and Stephen, as well as Ambrose's wife, were present. (Their mother, by then married to Bishop Potter, was absent because of a mild illness.) The guests at another of the dinners included just the sort of crowd the *Times* liked reporting on and its readership enjoyed reading about, the names and titles all conjuring the epitome of position and wealth: "Mrs. Herbert H. D. Peirce [sic], wife of the Third Assistant Secretary of State, and Mrs. William Sheffield Cowles, wife of Commander Cowles and sister of President Roosevelt, . . . two English visitors, the Hon. Geoffrey Howard, younger son of the Earl of Carlisle, and Arthur Stanley, nephew of Dean Stanley, the Russian Ambassador, and Countess Marguerite Cassini, the Chargé d'Affaires of France and Mme. De Margerie, the Belgian Minister and Baroness Moncheur, the Persian Minister . . . Count Quadt of the German Embassy, Baron Von Ritter, Senator and Mrs. Lodge, . . . the Misses Hitchcock, daughters of the Secretary of the Interior, etc."[2]

If the guests had not eaten enough on those occasions, they feasted at a midnight supper hosted by Sterling before a cotillion at which a fifteen-member Hungarian band, imported from New York for the occasion, performed. "Small silver trinkets for both men and women" were given out; Robert Sterling Clark had already developed what was to be a consuming passion for that precious shiny metal crafted elegantly, and liked acquiring it in quantity.

Sterling was not satisfied, however, simply to cavort with people with glamorous titles who were considered important mostly by dint of who their relatives were. He was an intrepid adventurer, and needed to do

things on a grand scale. In 1905 he returned to Peking in order to pre-pare for an expedition he would lead to the remote reaches of northern China to undertake topographical and biological research.

The wealthy young man had to prove himself, and he had to be in charge. For now, he would do so with his ambitious travels. Later in life, he would put the same energies into art collecting, breeding racehorses, and trying to exercise control, via the back door, in national politics.

The expedition to China was as challenging as the soiree in Washing-ton was posh. Sterling belonged to the tradition of colonialist explorers outfitted at Abercrombie & Fitch or Fortnum & Mason and well served by a vast crew that would assemble tents and create marvels on their camp stoves, but he did not travel simply as a tourist. He was someone who always needed a goal and purpose and wanted to achieve something. His journey followed in part the steps of Marco Polo as he tried to map out unknown wilderness, make a geological survey, collect animal speci-mens, and photograph and identify a range of Buddhist temples, pago-das, and other monuments. Sterling was infinitely energetic; as unlike his father as he was on the surface, as uncouth his manners and fiery his disposition, as inclined to feud and rages, he shared with Alfred the way in which he did everything in the extreme. He was a deliberate he-man with a proud stride and bellowing voice in contrast to his doelike parent, but he had in common with the previous generation his unwillingness to sit back and simply accept what came easily. Like Alfred, he let nothing stand in the way of his wish to do as he wanted.

The trip he led to China tells a lot about the willpower and organiza-tional skills with which Sterling would subsequently collect art and start a museum. "Planned with military efficiency, this extraordinary feat required the logistical support of 8 ponies, 44 mules, 5 donkeys, 30 Chi-nese and Indian bearers, a doctor and meteorologist, an artist, an inter-preter and general manager, the English naturalist Arthur de Carle Sowerby, and a Punjabi surveyor named Hazrat Ali."[3]

As with much that he did in his life, the journey was a competition. Clark envied Hazrat Ali his marksmanship, for the surveyor could shoot down more birds than the number of shotgun cartridges he used. But this young man who liked military action and shooting also became extremely sensitive to the pleasures of artistic representation. In the course of this journey he demonstrated a fondness for images of beautiful women as strong as his father's passion for sculpture of perfect young men. He supervised fantastic photography of the *Goddess of Mercy* in the

Cave Temple at Yenan Fu, Shensi. Sterling wrote, this Indian-influenced "beautifully carved figure . . . in a reclining attitude called forth our special admiration"; it was an "exquisite piece of work."[4]

The goddess is indeed beguiling. With one leg elevated, her right wrist resting on her right knee, and her legs seductively spread beneath her flowing robes, she made a great subject for the camera work Sterling commissioned. The meditative glance of this beautiful embodiment of mercy puts her in another, distant world, while her physical loveliness grounds her in the present one. She had just the attributes Robert Sterling Clark would prize in artwork for the rest of his life.

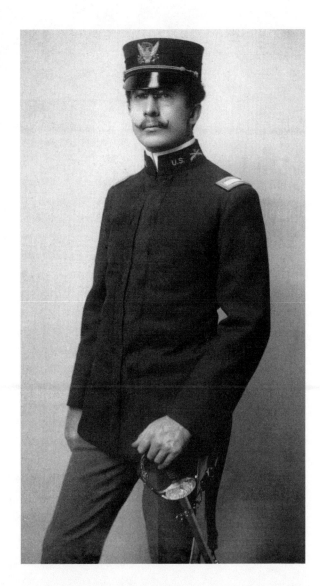

Sterling Clark, c. 1900. Sterling fought in the Philippines before returning to Washington, where, as one of the city's most eligible bachelors, he was known as "the millionaire lieutenant."

Sterling (second from left) *with his team of explorers in northern China, 1908.*
The expedition he led to China would make great headway in research on both art
and the natural sciences until it was cut short by an unsolved murder.

Sterling's account of the China trip betrays his intensely personal response to color. "Round the villages the beautiful pink and white ibis waded knee-deep in the black oozy mud. The pleasure afforded to the eye by a green field, after the yellow, grey and brown of a North China winter, cannot be expressed."[5] That the author of these words would go on to collect masterpieces of impressionism is no surprise; he took in hues and luminosity as vitamins to his well-being.

It was in China that Sterling discovered, in his own way, the value of art collecting. He became obsessed with the Emperor K'ang-hsi, who ruled from 1661 to 1722. The emperor formed a vast collection of stone reliefs that he had made from transcriptions and pictures on paper that were deteriorating and inevitably would have disappeared with time. Thus these ancient artworks were saved on stone. As Sterling admired this treasure trove, the seeds were planted for what would become his life's work.

But the trip ended dramatically. Hazrat Ali was murdered—an event that remains clouded in mystery and that "brought the expedition to a premature conclusion."[6] Sterling and the others packed up, and from

there the rich young heir moved to Paris. In 1910, he bought himself an imposing house in the heart of one of the most elegant and stylish neighborhoods in the French capital, on the rue Cimarosa, just off the avenue Kléber, from which it was a short walk to either the Arc de Triomphe in one direction or the Trocadéro in the other.

The three-story house, built in 1881, with its Doric columns, rows of French doors and balconies, and lively grillwork against an imposing marble facade, epitomized wealth and dignity. Camp life, even in the poshest of tents, was a thing of the past. Sterling devoted himself to refurbishing the mansion, hiring and firing one distinguished decorating firm after another. While redoing his new home, the bachelor owner settled down to writing up the China trip and enjoying the cosmopolitan life that had eluded him in the field. His account of his adventures, *Through Shên-Kan: The Account of the Clark Expedition in Northern China* would be published in 1912.

STERLING'S GENERATION was more comfortable with the Clark wealth than their father had been. Their inheritance defined them; like Alfred, the brothers accepted the responsibilities that came with it— that they must continuously provide generously to those who were less fortunate—but none of them was as embarrassed, or as compulsive in his need to bestow gifts on others, as had been the man who had his agents find out the names of strangers whom he knew had suffered misfortune, so that he could help them. Sterling devoted himself to spending, and did so unabashedly. Sometimes it would be for political causes or on behalf of the public good, but mostly it was on objects he liked and other forms of personal luxury. Stephen would be an imaginative and generous philanthropist, but he too devoted himself to his own houses and comforts and to the amassing of an art collection with a level of indulgence Alfred, for all of the splendor of his surroundings, would probably never have entertained, since most of the occasions when he bought artworks were associated with his wish to assist a living artist.

In the aftermath of their mother's death, the boys initially tried to be good to each other. All four sons of Alfred and Elizabeth Clark made a concerted effort to do the right thing and wear the cloaks of their inheritance properly, working in harmony on the management of their jointly owned properties, business trusts, picture collections, and the other matters that befell the rich. But it wasn't long before a certain testiness

began to develop between Stephen—who, although the youngest, assumed the role of the serious and responsible one—and the bumptious Sterling, who said pretty much whatever came to mind.

Sterling was following in his father's footsteps by basing himself in Paris, but his life there was totally different from Alfred's—their main point in common being the rare ability to live without having to worry about earning money. Sterling spent his days primarily fixing up his house and taking lessons in boxing and Arabic as he planned his next great expedition, this time to Egypt. But he also began, for the first time, to take an interest in his parents' art collection. He had been in the distant reaches of Asia, and quite uninterested in household possessions, when Stephen, who, as a lawyer and the most methodical of the brothers, had overseen the distribution of Alfred's and Elizabeth's pictures and furniture among their four sons. Now, suddenly, Sterling wanted certain things—and began to buck his younger brother's assumption of authority.

At the start of 1911, Stephen wrote him—c/o Morgan, Harjes & Company's Paris office—a letter that characterized the way they related to one another. On stationery from his office in the Singer Building, Stephen addressed his elder brother as "Robin," but signed off with a businesslike "Very sincerely yours, Stephen C. Clark." Stephen explained that two pictures "belonging to my mother" that he had inherited—landscapes by Julian Rix and Giovanni Boldini—didn't look right in his own house, but, since they might do better in Sterling's digs in Paris, could be bought by the older brother at their combined inventory value of $6,750.

Tension began to build. Both the price and the idea of the purchase irritated Sterling. It quickly came out that, to begin with, he had not gotten as many paintings as he had expected to. Stephen, the organizer, the logical one, explained that when the original division was made, no one thought Sterling would have a house in which to put them. Brose and Rino, who never seemed to be fussy about things, had made their choices and ended up with what they wanted. Stephen himself was not complaining; he had gotten the Jacob van Ruisdael and the more recent minor works that suited his and his wife's taste. These included pastels by Robert Frederick Blum, best known for the two gigantic murals *Moods of Music* and *Feast of Bacchus* that Alfred had commissioned for Mendelssohn Hall.

Sterling was miffed. The division of Alfred and Elizabeth's collection had been made in his absence, and in the spring of 1911 it began to mat-

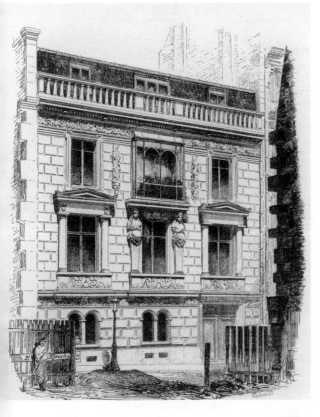

LEFT: *4, rue Cimarosa, Paris,
before Sterling's renovation. Like
his father, Sterling chose Paris as
the place to indulge in his pleasures
of choice, although while Alfred
focused on the arts, Sterling's
interests extended to boxing, horses,
cooking, and a knowledge of wine.*
BELOW: *4, rue Cimarosa,
following renovation. Sterling
threw himself into redecorating
this house, not far from the Arc
de Triomphe, with the same zeal
that he had led his expedition
to China.*

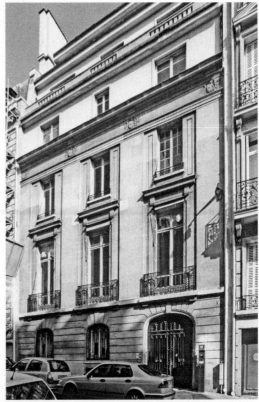

ter to him. It was new for him to be preoccupied by the act of possession and the choice of artworks, but now that his days as a soldier and an explorer were over and he needed a project, the decoration of his house in Paris and the selecting of what would go in it became in effect his full-time job. If previously he had not cared about what he might have had from the paintings that graced the palatial houses on Riverside Drive and Eighty-ninth Street, now it was desperately important. Although Stephen had given him the ones he thought Sterling liked, when he got back from his travels and saw what had been set aside for him, he found that the only one he liked was one by the Spanish painter Mariano Fortuny; he was not happy with either *The Gladiator,* by Gérôme, or the Jean-François Millet that had been designated to him.

Art was the currency of the Clarks' lives. It had a significance that blended the material and the spiritual; its worth in money counted, but it also had an aura that simple cash or investments lacked, as if its value were multiplied into some other sphere, that of an emotional possession. It mattered like inherited objects in the poems of Robert Browning or the novels of Henry James: the owners could have bought replacements or equivalents; they had the funds; but paintings and objects already in the family carried the family spirit in them, and were like holy relics, endowed with special properties. Now that he had a house, Sterling was very particular about what he wanted to be looking at in it.

The issue wasn't just the paintings themselves, but his idea of what was fair and just. Sterling felt he should have had second choice as second son. The important thing was for everyone to be happy, himself included, and he felt that Stephen, for all of his judicial correctness, had missed that point. Sterling let Stephen know that he was worried about Rino, and about how lonely Rino had been since their mother had died. He broached a touchy topic. The eldest son was hurt because of his feeling that Stephen's wife, Susan, never wanted him around. Sterling decided to take the risk of telling Stephen, while asking him to handle Susan with kid gloves. "I will trust you not telling Susan anything. Women misunderstand no matter who they are, and in the end comes trouble, the very thing I would avoid at all costs."[7] Sterling, with a warmth lacking in Stephen's missives, signed the importuning letter "your loving brother."

When Sterling had something bothering him, he became obsessed. That spring, he continuously wrote Stephen about two subjects: the need to keep a watchful eye on Rino, and the division of pictures. "The old Boy has his peculiarities and if we had suffered half as much as he had we

would have them too,"[8] he wrote Stephen a month after delicately raising the issue of Susan's treatment of her brother-in-law. Whether Rino's suffering had to do with his health problems—Rino was physically crippled, with accounts varying as to whether the cause was polio or a fall—or with their parents' marriage and the circumstances of his being named for Skougaard, is uncertain, but Sterling's heart went out to him.

Sterling calibrated things according to his ideas of right and wrong. Brose had not received more pictures because he didn't want them. That was clear. But Stephen had ended up with all the art Sterling wanted for himself. Sterling allowed that he had given Stephen first choice to show his appreciation of Stephen's work on the estate, but now he was beginning to feel duped.

He accused his younger brother of having given him "a long sermon" on the matter. In return, he gave one of his own. Sterling pointed out that the jewels he had given "Mamma" had now all gone to Stephen's wife, Susan, and to Brose's wife, Florence. Yes, Stephen had made a great sacrifice, he was more than willing to acknowledge, but Sterling remained annoyed not to have gotten at least one good portrait.

At the same time, Sterling was determined to be above it all. "I do not want a few cursed pictures to make any feelings between us, and I assure you that I would willingly have given them up to have avoided the discussions which we have had on the subject."[9] Having pled for the art he wanted, he was embarrassed to have been brutal. For Robert Sterling Clark was a man of strong heart and conscience, with a leaning toward self-analysis. He put down everyone else, but he put himself down too. "Do not try to read too much sore head in it," he urged Stephen. And when he signed his letters, as he regularly did, "Effectionately"—always with the same spelling mistake—the sentiment was genuine.

Stephen was never as warm in response. Though he generally called his brother "Robin," the discussion of artwork now prompted him to write, "Dear Robert: I wish to acknowledge the receipt of your letter of April 4th in reference to the division of the pictures belonging to my mother."[10] This was another of Stephen's invariable references to the late Elizabeth Scriven Clark as "my," not "our," mother in his missives written from his office in the Singer Building, which were invariably signed, "Very sincerely yours, Stephen C. Clark"; he never left out either the middle initial or the last name.

Even when the youngest of the Clark brothers purported to be helpful, he was condescending. In his efforts to see Sterling take on some gainful

employment, he wrote him, "In fact what you ought to do when you go off on these trips is to write from time to time certain articles for the magazines illustrated by your photographs. You have great powers of observation, and although your literary style might not be very good to begin with, this part of it could be easily fixed up and we could get the articles put in a presentable form."[11]

This was how the personalities were panning out, at least in Stephen's eyes. Stephen saw himself as the grown-up. He was in charge of paying all their parents' old servants and of running Fernleigh, which cost a fortune—even then, eighteen thousand dollars a year. Neither Susan nor Stephen wanted to live there—they would have preferred something simpler—but they occupied the rural castle as if it were their moral obligation.

Stephen wanted Sterling to recognize his burdens as the keeper of the family flame, writing the gadabout in Paris, "Here in this office for instance, if I were looking at the matter from a purely selfish point of view I would cut loose and have an office of my own."[12] Stephen was in the position he was in because he had taken the weight of family responsibility on his shoulders.

If Stephen was the voice of sanity and control, Sterling was the one who said whatever he thought, and who thought only in extremes. While Stephen was the more serious one, the lawyer and manager of things, Sterling was more volatile, if also more amusing, and certainly not a person anyone else would put in charge of things. Stephen often sounded self-righteous in his claim that he had offered clarity, although it's understandable that he would be driven to that, given that his brother was perpetually flying off the handle at someone or something.

Sterling was sometimes outrageous, not because he intended to be, but because he joked and mouthed off and lashed out. But whether he was discussing real estate issues like the disposition of Mendelssohn Hall or arrangements for old family retainers, he wanted everyone to be happy. One-on-one, he was immensely friendly, and, in these first years after Elizabeth's death, he was devoted to his brothers and their families in spite of all the little disputes. Over time he would become tactless and downright callous, but initially he was solicitous and diplomatic.

Stephen, on the other hand, was totally stiff even then, at least in his relations with Sterling. In 1911, the same year they began arguing over who had inherited which paintings, Stephen had just bought a large house on East Seventieth Street, between Madison and Park avenues, and

determined that certain artworks would not fit in there. He offered some Blum pastels to Sterling at three hundred dollars each, saying they were a bargain at that. This further provoked the older brother, since that figure was more than the inventory value.

Nonetheless, at least in those early years, Sterling still tried to be lighthearted, even jovial. If there was a problem brewing, he made it his business to try to patch it up. To Stephen's fusillade, he said the younger sibling had not read his letter "in the spirit it was meant. . . . I tried to write as nice and as brotherly a letter as possible. . . . I do not want you to feel sore, the last thing I desire to do."[13] Always warm and making an effort, wishing the only of the brothers to have healthy children the best of luck with them and eagerly seeking advice on presents he might get for the latest baby, he was inclined to send "best love"—a sentiment he never received in return.

Sterling was also funny and fun-loving in the accounts of life in "Gay Paris" to the more puritanical New Yorker. In a letter he asked Stephen to tear up after reading it, he reported about the lady friend of a work associate of theirs saying she looked like someone in a harem, dressed in "a salmon colored gown extremely low-cut—I could see ⅔ of them—and what remained was only covered by the lightest kind of tulle. So light was this covering that across the table I could not only make out the projecting portion but also the rosy ring which forms the base!!"[14]

In those years, women vied with art, money, and the management of family property and the care of their parents' servants as the brothers' main topics of interest. Stephen recommended married life to his older brother. His advice was clear: "The two chief requisites are common sense and a sense of humor in a lady. The so-called intellectual woman is to be avoided like the plague—because they are never really intellectual at all." But even a nonintellectual woman did not strike Sterling as a good idea. His life in Paris did not allow time for a constant relationship; he felt he was too busy with his three or four hours a day devoted to learning Arabic, and the boxing that was part of his daily routine. The Arabic was "the hardest damn thing I have ever tackled. . . . As to the marriage proposition I do not think that it is for me. I was not built for it. There are times when I do not want to see women for a long time and moreover I travel somewhat."[15] He neglected to mention that he was, by then, often living with a fetching woman who had been acting with the Comédie Française before she had moved in a year earlier and he had begun supporting her.

Thirteen years after receiving this letter recommending marriage, Sterling would annotate it bitterly. By then, he had resolved that he and Stephen must stop speaking entirely. Part of his irritation with his brother was centered on the idea that Stephen's wife, Susan, had too much control over him. Across the top of the letter he had chosen to reread, the older brother wrote, "*Quite remarkable.* Stephen's ideas on married life. And intellectual women. August 30, 1911. Remarkable what a change has taken place in his mind to date, Feb 3, 1924!!"

But in 1911, he still took a warm interest in Stephen's domestic life. Sterling was concerned that the baby clothes he sent were good, and "not too effeminate for a boy."[16] He loved buying gifts for the people he knew; one of his main projects in Paris, he told Stephen, was to determine what would be best to get for their parents' old servants. This love of giving took many forms among members of the Clark family, but whether it came through in Alfred's tracking down an indigent child, Sterling's finding just the right object for someone he liked, or Stephen's eventually offering a lifeline of support to the new Museum of Modern Art, it was the pervasive family trait.

Now, in 1911, in his generous-spirited and warmhearted way, Sterling had decided what he wanted to do for Susan in the new house that she and Stephen were fixing up. He had resolved to furnish her boudoir completely, as a surprise. The devoted brother-in-law asked Stephen to send plans and an elevation and all the details to him in Paris so he could proceed. Nothing excited the former soldier who had not so long before led an expedition into the distant reaches of northern China more than to work with French cabinetmakers on the designs of panels and custom-fitted furniture in order to export a bit of Belle Époque style to his brother's wife in New York.

As usual, Sterling heaped love; his extended family delighted him. He teased Stephen by writing, "You are not a proud enough Father,"[17]—for Stephen had not even reported on the baby's eye color; it was as if the ties of blood were what mattered more than anything else in the world.

THE RELATIONSHIP OF MATERIAL OBJECTS and those familial connections became more intertwined than ever. Now that Sterling was back on the scene, there was an intense dialogue about who would get which rug, which statue, which picture, from their mother's vast house on Eighty-ninth Street. Sterling acted as Rino's and Brose's

protector, insisting that because they had the least interest in the issue he wanted them always to have first choice, but Sterling also had a mounting passion for interior appointments and how certain things looked in certain places, and his preferences began to consume him. He was obsessed, in a way that few men of his equivalent milieu would be today, about who would get the silk rug and, once the decision was made, how it would look in the place where either he, Stephen, Brose, or Rino was living. He carefully weighed the question of whose house would best suit the bronzes or the Italian embroidery.

It wasn't just the aesthetics that counted. Sterling was sentimental about family life; each bibelot or piece of furniture had its own legacy. While Stephen was trying to disperse everything in the estate that didn't quickly find a home with one of the boys, Sterling remained desperate that a table lamp not be sold because he remembered it was the one "Mamma used constantly."[18] The associations of objects were an integral part of them; this would be equally true when, as an art collector, he noted the provenance and history that were part of each piece.

IN THIS PERIOD when he was furnishing his vast and splendid house in Paris and working out aspects of the family inheritance, Sterling was emerging as the personality he would always be. The energy he had put into military and research campaigns now went into the acts that constituted the everyday living of a bon vivant and connoisseur. Sometimes he was plainly ecstatic; sometimes he was desperately determined to alter a situation that displeased him; nothing was by half. He hired a superb woman cook he called "a simple marvel." He negotiated, item by item, who would get what from their old New York life. He enjoyed bounty with a bounteous spirit.

Sterling approached everything in life consistently—evincing total forthrightness, and wanting it in return. This would be the governing spirit behind his art collecting. The pictures he bought had to be robust, clear, alive to the sharpest physical and emotional truth; the fruit dishes had to be fully molded, the flesh tingling. He never waffled; nor did the pictures he liked. That attitude was there, equally, in his unequivocal, borderline boorish, approach to all sorts of events that would have left weaker souls trembling.

Consider the way he described, to Stephen, an operation on his nose: "After cocaining me several times to make sure they laid me out on the

floor and did the trick, I being held down by one doctor and a nurse and thinking I was going to be hurt like hell at every minute. You would have thought by the looks of the place they were slaughtering a pig. And I did not feel a thing except the sock, so I was entirely disappointed in my expectations! They did not do a thing but take out a piece of cartilage about two inches long. When I saw that coming out I thought that I ought to be hurt and made frantic contortions with my legs the only part of my anatomy available for exercise at that moment."[19] This was the essence of his personality and his preferences; he was bold, direct, tough, and funny. He also liked effectiveness—the operation had resulted in his breathing much better—just as he admired painting that was totally competent.

Sterling envisioned himself as the crass one, as opposed to the sensitive one; he seemed to define himself as a gentle brute. In late November 1911, he wrote Stephen: "I know that you are an artistic cuss." On the other hand, he did not rule himself out of the same domain. "I know that your taste corresponds with my own in a longing for simplicity."[20] And he also saw the making of aesthetic choices in tandem with the idea of rendering other people happy. His determination to furbish his sister-in-law's boudoir perfectly only mounted that autumn; nothing else mattered as much.

But in spite of Sterling's requests for plans and details of the space into which the paneling and custom-fitted furniture would go on Seventieth Street, Stephen ultimately responded that it would not work. "I am very sorry that we cannot avail ourselves of your suggestions in regard to the paneling,"[21] he wrote his older brother at the start of December. Stephen, as always, seemed somewhat detached and formal. When, in that same letter, he informed Sterling, "I believe that I had the same operation performed on my nose myself two or three years ago, and my recollection is that it was not particularly pleasant,"[22] the voice and remove were the essence of the personality difference between the two brothers.

That variation in tone is probably the key to the reason the paneling wouldn't work. Sterling's taste was evolving in the direction of Parisian style with lots of fanfare and flourishes. What he wanted to ship to his sister-in-law in New York was probably her idea of what belonged in a bordello. The house into which she and Stephen had moved was dark and Gothic; it bespoke seriousness in every diamond-shaped leaded window-pane. Susan was known for her style, but it was one of utmost reserve and

understatement. She would hardly have wanted to apply her makeup in front of a mirror that suited a Parisian courtesan.

In time, what would separate Sterling and Stephen Clark was a divide far greater than the distinction of one's being without reserve and the other's being taciturn. A schism that had all the vehemence of the worst sort of family war would bring them to the point of total noncommunication, a feud so harsh that these two sons of the same parents would, after not seeing one another for a dozen years and then being seated at adjacent tables in a fashionable New York restaurant, act as if the other was not there. But for now they were simply two very different people dealing with the incredible advantages as well as the undiscussed pressures of shared childhoods that made them both powerful in the world, intense in their emotional needs, and devoted to artistic objects as the carriers of the creative, the beautiful, and the familial.

BY THE MIDDLE of the following year, the one Clark brother who had been absent for the division of his parents' pictures turned into a collector with gusto. Having inherited no portraits, he now negotiated with his siblings to be the owner of the one of their father by William Jacob Baer, an illustrator who was a colleague of the family favorite Robert Frederick Blum; in New York he had bought a van Dyck of an Italian nobleman, and in Paris a Hyacinthe Rigaud of an unknown man. His taste perfectly reflected his personality; he liked art where bravura outdistanced subtlety. Rigaud had been the official portraitist in the court of Louis XIV; if one wanted a picture that evoked human power, embellished by flourishes and pomp, flaunting worldly success, one could do no better. Anthony van Dyck was a painter of immense dignity and sureness who endowed his subjects with a forceful presence. The portrait that helped launch Sterling's collecting of the Old Masters had a beguiling charm while revealing a technical virtuosity and grasp of the wonder of true style, both the subject's and his portraitist's. The Baer, of course, was more personal: a painting by a minor painter, but one that evoked Sterling's father as the sensitive, pensive, deeply human, and vulnerable creature he was.

Sterling stormed the best galleries in the three art centers of the world: London, Paris, and New York. At Colnaghi's in London he fell for a Matteo di Giovanni *Virgin and Child with Two Angels* that was an exqui-

site early-Renaissance panel, delicate but with grit. His taste was not confined; that distinguished London dealer also sold him Hobbema's *Woody Landscape with a Farm* and Jacob van Ruisdael's *View on the Seashore* that are as much the quintessence of rugged, masterful Dutch landscape painting as the Matteo di Giovanni is of the charms of gold-leafed Italian primitivism. Rather than lock himself in to one style or epoch, Sterling simply liked the best of the best. Hobbema was without equal at evoking, with consummate painterly skill, the depths of northern European woods; Jacob van Ruisdael was unrivaled at capturing the force of the ocean in tandem with a wide sky and the eternal horizon.

Launched in his quest for beauty and quality, Robert Sterling Clark picked up steam rapidly. In New York, he quickly became a regular at Knoedler's, often dropping in three times a week. He would puff his cigar contentedly as salespeople placed one masterpiece after another in front of him on the special velvet-covered showroom easels. He soon snagged a second major Italian primitive *Virgin and Child,* this time a panel by the Master of the Legend of St. Lucy. The luminous gem placed the Holy Mother in a landscape as celestial and otherworldly as the one in the Dutch pictures was real. But Sterling was attracted to domestic, intimate themes of everyday living along with religious scenarios and portraits of lofty subjects; in Paris he got Fantin-Latour's *Peaches and Grapes,* a small canvas by the French nineteenth-century master of still lifes that renders the ordinary exceptional, both as an achievement of nature and a pleasure to the eyes. In his attraction to a range of subjects created in multiple civilizations, Sterling's sole requisites were excellence and an embrace of life.

These, certainly, were the qualities of the two paintings he now managed to get from his parents' collection. Ambrose had inherited Théodore Géricault's *Trumpeter of the Hussars.* It's easy to see why Sterling is said to have swapped him land and a house in Cooperstown in order to get it. No one evoked human energy and the fervor of revolution better than Géricault. This short-lived artist was truly Byronic, plumbing emotion to its depths, and he wielded his brush as surely as the fastest racehorse moves its hooves. Of course Sterling wanted and needed this painting, which, now that his own military engagements were in the past, evoked the same unbridled energy, the thrill of combat, which he had tried to make his own.

This small canvas that Géricault painted just after Napoleon's defeat at Waterloo has a dramatic sky and a mix of billowing white clouds and

gray smoke that conjures Tchaikovsky's *1812 Overture*. Sterling was passionate for horses; the one carrying the trumpeter has a shimmering white coat and superb physique. The trumpeter himself is in fine regalia, with just the sort of military dash that made Sterling's heart leap. A snowy white plume emerges from the soldier's brilliant red hat, and those colors are echoed majestically by the horse and his paraphernalia. It's a powerful image, painted with courage and vigor.

The second work from his parents' collection that Sterling now acquired was Millet's *Water Carrier,* which had gone to his elder brother, Rino. His determination to have it is telling. The Millet is far more sentimental than the work of artists like van Dyck or Géricault; other collectors might have deemed it sappy for its story-telling element. But it had in common with the stronger art it joined on Sterling's walls that it, too, was testimony to noble spirit and physical energy. It was not a masterpiece of the same level, but it was executed with painterly finesse, and its theme was human intrepidity. Sterling negotiated until it was his.

THE PLEASURE OF LOOKING and buying and owning was not enough for Robert Sterling Clark. From the very start of his collecting days, he wanted others to enjoy what he enjoyed; he had no wish to hoard his treasures in private. The collecting that had come to define his existence was part of a bigger picture, connected with the family idea of making the world a better place for other people. If he had not succeeded in giving a modest room to his sister-in-law, Sterling had not lost the will to bestow and to build.

In 1913, even with his art collection still relatively small, he became determined to create a museum for the larger public. His initial idea was to found a gallery in Cooperstown. The family mantle of public service had fallen naturally on his shoulders; it was the Clarks' role to share their own good fortune and give culture to the masses, and there was no better place to do so than the familial dynastic seat.

And it was Stephen's role to disagree and know better. The younger brother suggested that Sterling have his museum in New York instead. In response, Sterling said he was against Stephen's idea because he was uncomfortable with the recent changes in the city's population and what felt to him like a foreign invasion.[23] Moreover, in the melting-pot city, the artists who would see the work might not be the type Sterling cared to encourage. To have it in Cooperstown, on the other hand, would both

help the town, and "educate the really American elements."[24] There the work would be seen primarily by landscape painters—an idea that appealed to Sterling immensely as he sat ensconced on the axis between the Trocadéro and Place de l'Étoile, and contemplated upper New York State and the bucolic delights of his childhood.

Sterling had a clear notion of his museum audience. "My object is to encourage art among the American element of the population, as they are the ones who are more capable of real inspiration. For instance, look at George Barnard. He is no city bred man."[25]

A plan was hatched. Even if they could not agree on where Sterling's museum should go, and there were already differences between them, that spring, the two of the four Clark brothers who most cared about paintings and antiques would meet in Paris. Thirty-six-year-old Sterling and thirty-one-year-old Stephen had a specific goal, which was to get serious in a new way about the art collections each had begun to amass in bits and drabs. Their mother had died four years earlier; their father had been gone seventeen years; their vast fortunes were their own. There was nothing to stand in the way of their doing this as well as possible.

To begin in earnest this acquisition of art of professional standards, they needed a guide. They chose the same man whose name was conjured by Sterling as the exemplar of good tough American values—their father's late-life obsession, George Grey Barnard.

Sterling and Stephen decided to let Barnard be their counsel in the same haunts where their father had kept him afloat some three decades earlier. The sculptor with whom, as little boys, they had shot marbles on Twenty-second Street was, they recognized, the perfect adviser. The motives and relationships were nothing like those that had connected their father with Barnard, but the continuity appealed to the brothers. In some very significant way, they were reaching back to Alfred's sensibility.

George Grey Barnard had had major professional and financial struggles in the years since he had moved back to America. His marriage and Alfred Corning Clark's death two years later had left him without the support that had enabled him to work so successfully in Paris. Barnard's *Pan,* which Alfred had proposed he make for the Dakota, but was then intended for Central Park, had been refused. Barnard made a large statue of Abraham Lincoln in Cincinnati, but it was the least idealized image of Lincoln that anyone had ever seen, and had been highly controversial. He

had a major commission for a sculptural group for the capitol building in Harrisburg, Pennsylvania, but, originally slotted at three hundred thousand dollars, it had been reduced to a hundred thousand dollars.

Meanwhile, although he had married a woman of some means, Barnard now had a family to support. After the period of not consummating his marriage, he and his wife had managed to have three children, which meant he now had an obligation to earn more money at a time when, without Alfred, he had less. He also, as had been predicted, longed to get back to France. Fortunately, the Harrisburg project had enabled him to uproot himself and his family in 1906 and return there to do the work in Moret-sur-Loing, near Fontainebleau.

During the year back in the country where he had discovered his personal fire, Barnard had begun to search for medieval antiques. He had collected remnants of Romanesque and Gothic cloisters for himself, and also traded objects to make money. Sterling and Stephen knew this, and believed that both his eye and his knowledge of market values would make him a good coach.

Barnard was also well respected in certain artistic circles in Paris. In 1910, his *Love and Labor* and *The Burden of Love* were exhibited at the Grand Palais in Paris, to loud hosannas. But money was still an issue, especially given his new collecting mania, and when the invitation came from the sons of his former protector, the sculptor accepted quickly.

STEPHEN HAD INITIALLY PLANNED the 1913 trip so that he could discuss some vital Singer & Company questions with Sterling. But by the time he and Susan arrived in Paris, that purpose assumed second place to the serious business of collecting.

Stephen and Susan had sailed from New York on the *Rotterdam*, accompanied by their thirteen-year-old daughter, Elizabeth, and two-year-old son, Stephen Jr., as well as a lady friend of Susan's. Once they arrived in the French capital on March 26, Susan and her friend and the children were taken care of by staff and happily occupied with the usual diversions accorded tourists in Paris, while Stephen and Sterling and Barnard threw themselves into a frenzy of buying. By working their way around antiques shops and galleries and meeting private dealers from early morning to midnight, they managed, in the first week, to spend forty thousand dollars on art and antiques.

Barnard was pleased to realize that his commission money would

ABOVE: *George Grey Barnard,* Pan, *clay, 1895. Back in America, Alfred Corning Clark's protégé continued to make powerful sculptures of the male body.*
BELOW: *George Grey Barnard,* Pan, *bronze version, 1898. The work intended first for the Dakota and then for Central Park was rejected by both locations.*

enable him to pay back money he owed Frederick Bourne, who, in his capacity as Singer president, and with a loyalty going back to Alfred's discovery of him at the Mendelssohn Glee Club, had advanced the sculptor funds. Barnard also calculated that, at the rate the Clarks were buying, with his getting ten percent on each purchase, once his work was done he would be able to continue acquiring remnants of cloisters in the south of France. But he was frustrated. The Clarks were mainly purchasing Gothic tapestries. Barnard was buying some too—the prices were half what they would have been in New York—so that he could eventually sell them at a profit, but on April 7 he wrote Edna that he was desperate to be looking at more modern stuff.

STERLING WAS NOT HAVING an easy time either. On April 12, Barnard reported, "All of Robert's Greek collection are imitations made in London—$40,000 worth. I discovered it, and he was ill over it. . . . I am sick of antiques."[26] It was a lesson the young collector would never forget.

Determined to develop a more discerning eye, within little time Sterling would have arch opinions about what was fake and what not. He also would come to consider himself a connoisseur who knew which periods and styles were best within a given artist's oeuvre. Not everyone would agree with him—even concerning the work of Renoir, supposedly Sterling's area of expertise, there are experts who to this day believe that the few bought by Stephen were better than the many bought by the older brother—but, with some justification, he considered himself an authority. After that first setback, which Barnard pointed out to him, he became compulsive in his determination to train his eye and his consequent, generally warranted insistence that he knew better than the dealers, scholars, or curators who were the purported experts in their fields, and often disparaged the offerings of renowned dealers like Lord Joseph Duveen. In New York, Sterling would go to the Met or to the house of another rich collector and then write in his diary that the attributions of the work he had just seen were without merit, but that of course other people were too foolish to know the difference and recognize authenticity or its lack as he did; he more than made up, he believed, for his early mistakes.

But for now Sterling was mainly a rich man being guided, and paying willingly for the tutelage and other forms of aid. Beyond coaching and

leading his clients to dealers on and off the beaten track, Barnard did all the organizing and shipping. Quickly the amount that Barnard had helped the brothers spend had risen to fifty thousand dollars. In the process, the sculptor had also been able to acquire a lot of objects for himself that he knew he could resell in America at substantial gain. As he wrote to his wife, now the commissions and profits would also enable him to buy a house for them back in the United States, where for the time being they had only been able to afford to rent one. Whatever the frustrations of the excess of antiquities, it was worthwhile; he wrote Edna, "But the Clarks are fine to me and we are great friends."[27]

From Paris, Barnard led Stephen and his family to Florence, where they settled in at the elegant Savoy Hotel in the center of the Renaissance city. Sterling stayed behind, but the younger brother and their adviser continued hard. On April 17, Susan Clark wrote to Edna Barnard to say what a wonderful time they were having with George. The sculptor had taken her and her friend "out for a walk after dinner to see Florence by midnight. He told us all the mysterious things that had happened in the different parts of the city as we walked through them. . . . I shall always remember that evening with a great deal of pleasure."[28]

Stephen's wife was gracious to a fault. The intense connection of the previous generation with a struggling sculptor who cooked rice over a kerosene lamp had now evolved into something that surely would have fascinated Alfred. The relationship between the well-mannered, good-hearted debutante married to his youngest son and the more settled, worldly sculptor-turned-merchant-collector had the gentle pace of a second act. "With Mr. Barnard's help I have gotten such lovely things for my house and I can hardly wait to get them home and unpacked. . . . Mr. Barnard you will probably be glad to hear is looking splendidly and seems to have more energy and strength than all the rest of us put together."[29]

George Grey Barnard, meanwhile, was writing the same Edna about his torment. He was so rushed he could not think. His frustration was rising at not having seen what he considered real art. He was "sick to death" of antiques, desperate never to attend another auction of them, and eager mainly to get to Greece that summer, although he knew that his wife was, for her own reasons, opposed to the trip. Nonetheless, he was making money. While he was in Florence traveling on the Clarks' ticket, he bought a Luca della Robbia, which, he told Edna, he hoped to sell to add to the coffers for building their house.

. . .

WHEN BARNARD RETURNED TO PARIS, he had a Domenico
Ghirlandaio for Sterling. Sterling would eventually make all his own
choices, but not yet. For the time being, he willingly accepted the sculp-
tor's judgment, and let Barnard be the deciding force behind what was to
be his first major purchase of a High Renaissance masterpiece that would
remain in the collection (color section 1, page 3).

Barnard had found the work, and did the negotiating. The seller, Pro-
fessor Elia Volpi, came to Paris with his business partner to meet with
Sterling and the sculptor in the house off the avenue Kléber. Barnard got
the price lowered from a hundred and fifty thousand dollars to a hundred
and ten thousand dollars, and Sterling bought the picture. For his role as
intermediary, the sculptor netted for himself ten thousand dollars as his
commission, to which was added the gift of a painting. Despite Sterling's
eventual discovery that the work had been retouched, contrary to Bar-
nard's assurances that this was not so, he had started his collecting with a
tour-de-force. With her ruby red dress and luminous skin, the Italian
noblewoman in the late-fifteenth-century Ghirlandaio portrait has a
beauty that is immortal and worldly at the same time. She is clearly a
person of rank in her world, her fine features and perfect bone structure
embellished by her elegant dress, splendid necklace, and all the other
marvelous accoutrements of her station; at the same time, she could be an
enticing young lady from any place or epoch.

This marriage portrait of the bride of a prominent merchant represents
a breakthrough in artistic approach by being more charming and less
hierarchical than previous work in the same tradition. The woman with
her handsomely proportioned face is fetching in the most human way;
she is approachable and relaxed, in marked contrast to the rigid formality
of Renaissance portraiture up to then. And, thanks to a sort of imagery
with little precedent—the delicate orange blossom in her hand and the
marvelously colored winding landscape behind her—the agreeable bride
belongs to a fresh and bucolic world. There is a warmth here and a vivac-
ity. These qualities were very much to Robert Sterling Clark's taste; he
had never before written a check for more than a hundred thousand dol-
lars for a painting, and one can readily see why he jumped to do so.

On the other hand, Sterling did not make this sort of decision lightly.
The previous year, without anyone else's guidance, he had already ven-
tured boldly into the arena of collecting Italian Renaissance paintings

when he bought a Giovanni Bellini *Madonna and Child*, c. 1476, for seventy thousand dollars. He had ended up returning it when, after not too much time had passed with the painting installed on the rue Cimarosa, he found that he could not tolerate its condition and traded it back to the dealer from whom he had bought it. The Bellini ended up going to Isabella Stewart Gardner, and is in the museum named for her. Sterling would always remain aware of his dissatisfaction with this work, which had Bernard Berenson's imprimatur; he never trusted the so-called expert's views again.

EVEN THOUGH, in his taste in art as in the decor of his house, Sterling was drawn to what was warm and pleasant, he had a nasty temper. Barnard was staying with him, and on April 27 they had such a major fight that the sculptor packed up to leave. The diplomat was Stephen, who persuaded Barnard to stay on. Sterling was "deeply repentful."[30] There would be periodic flare-ups between the two; Sterling could not harness his bluster, but his will to make up was a saving grace.

After the Stephen Clarks sailed back to America on May 2, Barnard, flush with the commissions he had earned on all of the brothers' purchases and the profits he foresaw from his own investments, continued to the south of France and kept amassing Gothic art. When he had emptied the pockets of his torn clothes in front of Alfred Corning Clark in the lavish hotel suite nearly thirty years earlier, he certainly could never have anticipated such a moment. But his time with the heirs left him less content than the meetings with "the Governor" had. Toward the end of Sterling and Stephen's tour, he wrote his wife, "My trip dear has been anything but an art trip, to me. I have seen nothing of my art, only antiques, and sick to death of them!"[31] Susan Clark had been buying things for her new house; Sterling had, except for the Ghirlandaio, mainly been acquiring Gothic sculpture. Alfred, by comparison, had devoted himself to giving away money to strangers and to commissioning Barnard to make his own work.

Sterling nevertheless was showing signs that, like his father, he did not just want to buy old things but was also interested in making the new possible. He was nurturing the idea that the museum he intended to build should be decorated by George Grey Barnard. The trip to Greece about which Barnard had written his wife and of which she disapproved was an excursion that Sterling had proposed they take together. One of the reasons was to consider those decorations. Sterling wanted to follow

his father's suit as the sculptor's patron, and had repeatedly urged Barnard to let him take him on that journey.

Barnard again wrote his wife to get her okay for the idea. "He expects to give me his museum building with its decorations to do, a Life Work. Also I am to sell him at his order now maybe the first marble after my trip to Athens. . . . Robert + I get along fiercely but finely [sic] we have become good friends—for Life I believe."[32]

The two men did not make it to Greece, but that summer Robert Sterling Clark ordered a *Venus and Cupid* statue from Barnard. While Alfred Corning Clark had had the Michelangelesque Midwesterner carve muscular young men for him, Alfred's son commissioned the sculptor to create the ideal of female beauty in the company of the god of love. The price was lower than the sums Alfred had paid over a quarter of a century earlier—Barnard became annoyed with himself for not having asked for twenty thousand dollars rather than the ten thousand dollars upon which they agreed—but he took on the task anyway.

Then came trouble. In December, Barnard wrote Edna, "Robert Clark refused to pay anything on his order of the Venus group, although he had me order marble by cable, so I set my lawyer on him."[33] The lawyer came

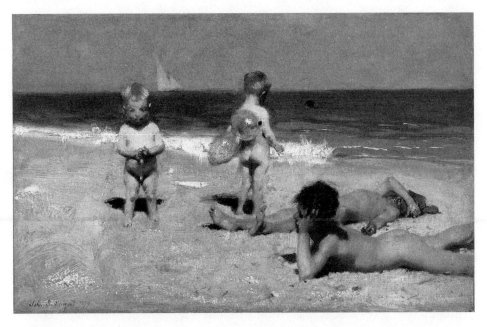

John Singer Sargent, Neapolitan Children Bathing, *1879. From the time he began acquiring art, Sterling opted for bold yet tender representations of human flesh.*

from Stephen. But what might have become a disaster in the brothers' relationship somehow escaped turning into one. "Mr. Taft," a friend of both Robert's and Stephen's who was in effect a family retainer, took over the task of helping Barnard with all financial matters, and on December 24 Sterling signed a document guaranteeing six thousand dollars for the Venus group.

With the perpetually diminishing sum, it was less and less like the old days of Clark family patronage. Nonetheless, Sterling now began taking various friends, as well as his brother Rino, to Barnard's studio. It gave the sculptor comfort to show them the large portrait bust he had made of Abraham Lincoln and which, because of its unglamorous depiction of the sixteenth president, was there rather than in the spot for which it had been intended in Cincinnati. Three of the four sons of Alfred Corning Clark were now engaged with their father's "kept boy."[34] Stephen ordered a fountain from Barnard for his conservatory; the following summer, Barnard produced a second piece for him, as well as a small bronze for Rino.

THE WARM AND SUPPORTIVE RELATIONSHIP would continue between George Grey Barnard and the Clark family until Barnard's death in the late thirties. In 1935, the sculptor would make a piece as a wedding gift to one of Stephen's children. But Barnard would never again thrive as he had when he was making his greatest work with Alfred's support, and the likes of Princess Bonaparte and Rodin recognized it as such.

Barnard did land the occasional commission in America thanks to the circle of people that stemmed back to that first reception Alfred gave him at the Dakota. For John D. Rockefeller Jr. he made a twenty-five-foot-high *Adam and Eve* out of Carrara marble. Barnard remarked about his Eve figure, "She is the Mystery of sex, in days when sex shall not be something to snicker about, but to reverence."[35] Even his public failures had their champions: Roger Fry said of the Lincoln, "The outcry against the statue is on account of its merits."[36] Yet he would spend most of his life preoccupied with a work that he did not complete, and which created one difficulty after another for him. This was his enormous *Rainbow Arch,* a monument to peace. It was to be a hundred and twenty feet high, constructed of granite with a rainbow of colored mosaic glass over it. One side was a towering pyramid of twenty-nine nude figures, all young men,

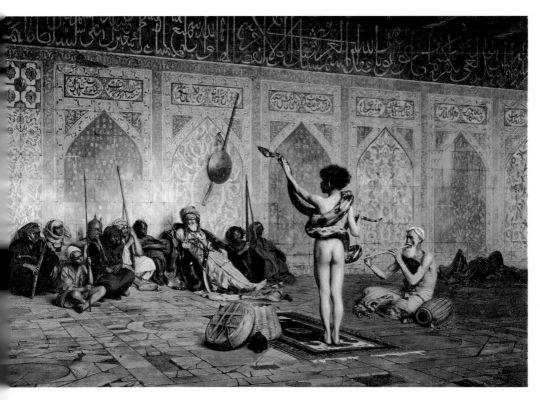

Jean-Léon Gérôme, The Snake Charmer, 1870 *(Alfred's collection, later Sterling's).*
This painting was prominently displayed in Alfred and Elizabeth's house on Twenty-second Street.

LEFT: *Anna Bilinska's portrait of George Grey Barnard, the man who called Alfred Corning Clark "the governor" and who eventually helped Sterling and Stephen begin their art collections.*
BELOW: *Jean-Léon Gérôme,* The Gladiator, *1872 (Alfred's collection). This may well have been the model for* Brotherly Love, *one of the most important sculptures of the following decade, which Alfred commissioned.*

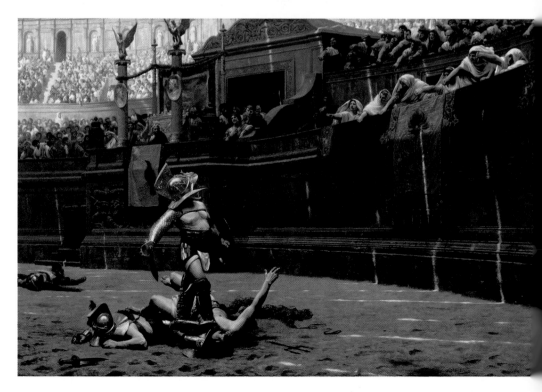

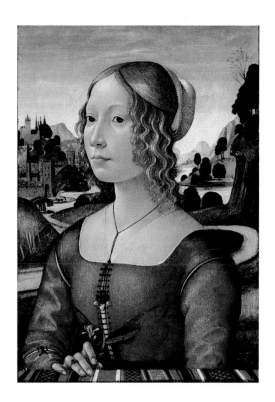

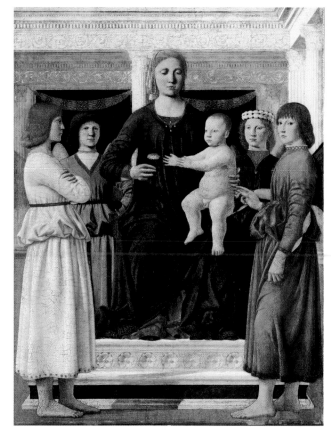

ABOVE: *Domenico Ghirlandaio,*
Portrait of a Lady, *c. 1490
(Sterling's collection). This
was the beginning of Sterling's
collection of Renaissance master-
pieces.*

RIGHT: *Piero della Francesca,*
Virgin and Child Enthroned
with Four Angels, *c. 1460–70
(Sterling's collection). For forty
years, Sterling would have the
pleasure of turning down offers
from far richer people who
wanted this altarpiece, the
greatest of Piero's work in
America.*

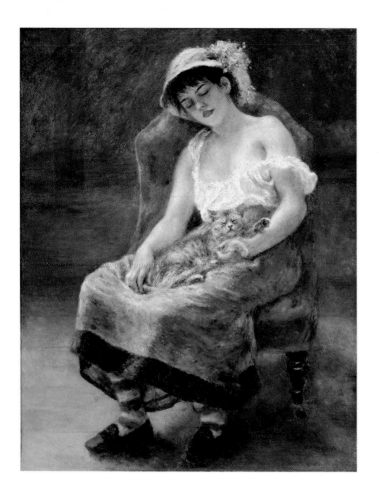

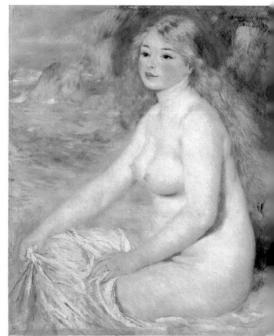

ABOVE: *Pierre-Auguste Renoir,*
Sleeping Girl with a Cat, *1880
(Sterling's collection). One of the
strongest of the paintings by the
artist of whose work Sterling was
a connoisseur without equal.*
RIGHT: *Pierre-Auguste Renoir,*
Blonde Bather, *1881 (Sterling's
collection). He owned thirty-nine
Renoirs in all, many of them
showing women with pink-tinged
flesh.*

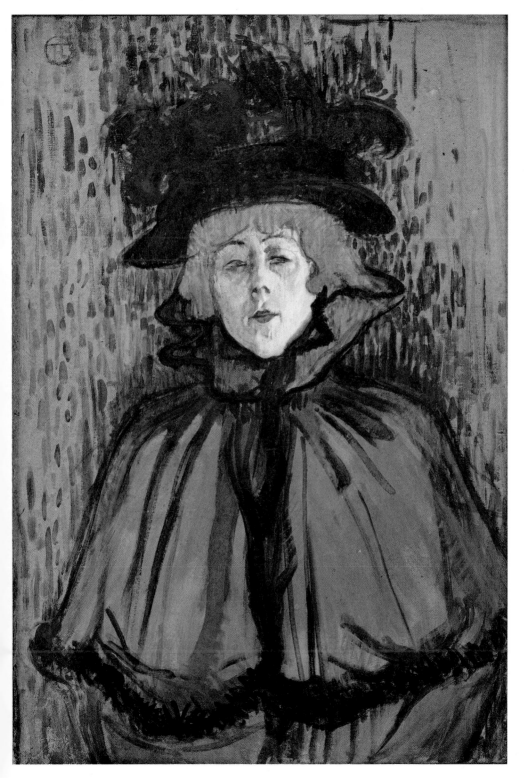

Henri de Toulouse-Lautrec, Jane Avril, *c. 1891–92 (Sterling's collection).*
His fascination with French actresses led to his marrying one.

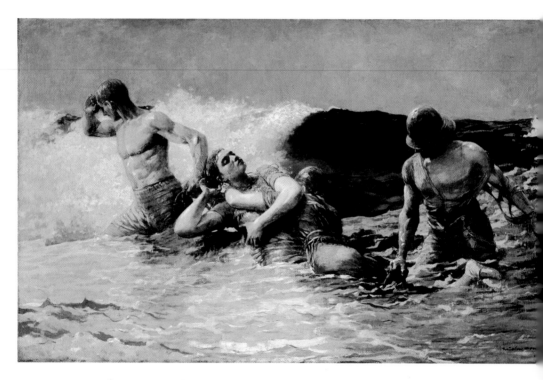

Winslow Homer, Undertow, *1886 (Sterling's collection). Sterling had an eye for some of the boldest works in the history of American art.*

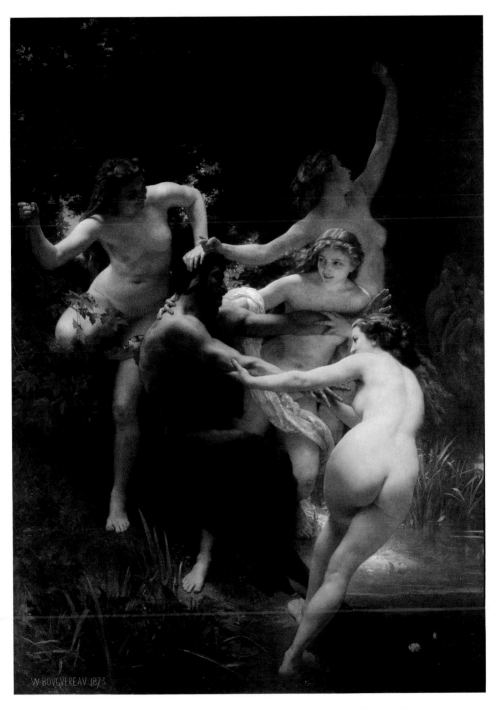

William-Adolphe Bouguereau, Nymphs and Satyr, *1873 (Sterling's collection).*
This work was once considered so scandalous that its previous owner
had bought it only to hide it from public view.

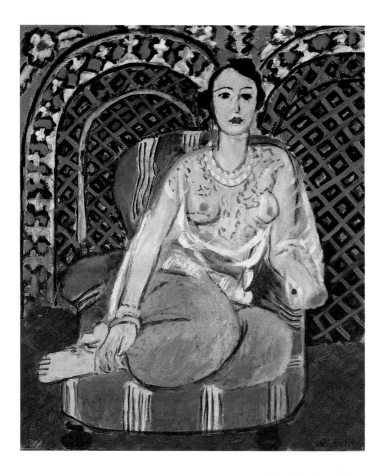

ABOVE: *Henri Matisse,* Seated
Odalisque, *1926 (Stephen's collec-
tion). One of the dozen Matisses
Stephen owned before the Museum of
Modern Art had even been conceived.*
RIGHT: *Henri Matisse,* The White
Plumes, *1919 (Stephen's collection).
The model bore an uncanny resem-
blance to Stephen's only daughter,
who died tragically young.*

the top one reaching toward the rainbow. The other side consisted of women of all ages—to suggest these men's mothers and young wives—and old men. Barnard explained that the healthier male specimens were "the immortals" reaching toward hope, while the women and old men were the mortals—the human beings who suffer the most from war. The figures were all to be carved of white marble against the blue granite arch.

Barnard had started the great arch in 1918, in the aftermath of World War I. He was still working on it obsessively twelve years later when his studio lease ran out. The order to vacate his studio premises in November of 1930 devastated him. Magazine articles described the sculptor fighting to hold on for three or four more years, which is the time he said he needed to complete this gigantic work which he intended to give to the city of New York.

Finally, when Barnard realized it was a losing battle and he had to give up his workplace for a parkway that would run through the exact spot where it stood, he said he would leave his work "for the wreckers to dispose of as they saw fit."[37] That's what happened. He would never achieve his goal of allowing the naked men to assume their immortal role, to be the gods whose hopefulness would outlive the plight of the rest of humanity.

At least what remained of Barnard's Gothic collection was spared and crated. In 1925, the space Barnard had constructed to display his medieval architectural fragments and sculpture had been purchased by the Metropolitan Museum of Art. In 1938, on the sculptor's former property, alongside the thruway that had cost him his studio, Barnard's collection and the setting he built for it became the basis of "the Cloisters," an offshoot of the Met.

Today the collection of this rough-hewn sculptor is one of the true treasures of New York City—another way in which Alfred Corning Clark and his heirs affected, at least indirectly, the culture of America. Half a century earlier, George Grey Barnard had gotten his feet on the ground thanks to Alfred Corning Clark; then, in 1913, the rough-hewn sculptor had made advances in his foray into the realm of medieval art thanks to Alfred's sons. Had Holman-Black not introduced Alfred to Barnard in Paris, and had the sculptor who sublimated sex for his art not been the perfect person to memorialize Skougaard, and had Alfred's children not been enlightened enough to maintain the connection with their father's strong-willed friend, the Cloisters might never have been conceived.

. . .

HAVING GOTTEN HIS START with Barnard's guidance, Robert Sterling Clark continued to grow his collection. To the Domenico Ghirlandaio *Lady* he had added, by Domenico's son Ridolfo, a portrait of a man he got at Knoedler's in New York. Then, at the Paris branch of that renowned gallery, he bought a John Singer Sargent *Venetian Interior* that is still considered one of the masterpieces by the American painter. The Sargent is a perfect evocation of the light of the great city on the Adriatic, and of the unique confluence of Byzantine and Italian decoration there. It casts these sights in a Henry Jamesian atmosphere, subtle and worldly; like James's fiction set in Venice, it is an American vision, fresh and innocent in its way, of its heavily layered European subject.

The same year that Sterling bought it, he finally succeeded in having his name on the painting of his parents that was the one he wanted most of all—and that was, in this case, as American as you can get. The work was Gilbert Stuart's *George Washington*—a perfect image of patriotism and of what was most noble in American revolutionary strength and military effectiveness.

Other paintings were coming in a swell, from Byzantine panels to recent landscapes, from unknown artists to recognized ones, the sole criterion being Sterling's complete sureness that he wanted them. Advice or instructions from experts did not interest him; the decisions were his alone. Sterling collected the way he drank wine and ate good food, with gusto and an appreciation for quality and his own sense of it; no one else could tell him what was good or bad, what would rise or sink in value, what counted historically or might add balance to the collection.

On the other hand, he was more than willing to proffer advice, especially to Stephen. And he also now turned against the one person whose advice he had taken. If Stephen's notions of where to put a museum fell on deaf ears, Sterling did not hesitate to instruct Stephen about art collecting—and to do so with dripping condescension—while taking a jab at Barnard at the same time. When, in 1914, Sterling urged Stephen to acquire a Vincenzo Catena he was considering, he wrote, "I think that you have the same idea of most Americans, that it must cost a certain amount or it cannot be good. Barnard takes you over here and sticks you to beat the band and I tell you he did stick you." He accused Stephen not only of following trends blindly and letting their mutual adviser dupe him, but of making many mistakes. He said that his younger brother's

so-called della Robbias were only "school of della Robbia," not worth a quarter of what Stephen had paid for them. "Your so-called Giovanni di Paolo; I do not believe it for a minute. It is merely a school piece and at the outside would bring $2000 at auction and you paid $10,000 for it."[38]

It wouldn't be long before Sterling and Stephen would no longer communicate directly, and Sterling would issue his broadsides about his younger brother's mistakes only to a third party. But for now he continued to assault Stephen directly and to implicate Barnard with increased vehemence. Even if this was the man with whom he had wanted to travel to Greece the previous year and whom he had briefly intended to decorate his museum, Sterling now felt that the sculptor who lived off their family's wealth had deliberately misled Stephen.

Barnard had told Stephen that the Louvre and the famously shrewd Belgian-born art dealer Georges Demotte had both offered a lot of money for a *Joan of Arc* statue that he, Barnard, had found for Stephen and arranged for him to buy at a lower price than either of these distinguished parties had proposed paying. Sterling thought that this was nothing but slimy salesmanship, "in the highest degree fishy. Barnard for his sculpture all right but you keep your eyes open wide in anything else. That is my advice to you." He also strongly urged Stephen not even to consider going to Joseph Duveen for pictures. There "you will pay anywhere from three to fourteen times the price." Sterling said "fourteen" because Duveen had offered him a picture "of which I had the gravest doubts"—and for which the price, Sterling had discovered, was fourteen times what Duveen had paid for it.

The groundwork was being laid for how Sterling would function as a collector. He would become obsessed both with authenticity and with a keen sense of financial value. He also was determined not to be cheated in what he perceived as a world of crooks. The only way to proceed was to develop and trust his own artistic judgment, and to work only with the dealers he knew would not mark things up unreasonably. In these ways he was unusually independent and prudent.

THE TIME WAS APPROACHING when Sterling would gloat if Stephen made a mistake or lost money. Once Stephen's collecting took its own distinct, and very different, direction, and relations between the brothers deteriorated to animosity, Sterling's competitiveness would

turn vicious. But, for now, in spite of the sting of his quips when he made them, he did so as the watchful elder brother. He was advising caution with the same generosity of heart as when he ordered special stockings for Susan in Paris or went shopping for baby clothes for their children—always with his brother's happiness in mind.

What fun they had: these two rich young men who, in spite of their spates of testiness, enjoyed being good to each other. Sterling would shop in Europe for things he thought Stephen would want. He helped his younger brother acquire a School of François Clouet painting from Colnaghi—at least there was no false claim that it was Clouet himself—and some Whistler prints. Stephen was especially drawn to the subtle tonalities and richly somber mood of this American artist. He had been buying Whistler pastels, and said that one of his reasons for doing so was that he could not afford Renaissance work, the implication being that James McNeill Whistler, who had died only in 1903, offered some of the same masterly quality.

As the one who was certain of his own eye, Sterling advised Stephen strongly about Whistler: "I would not have given over ten thousand dollars for the two portraits that Frick bought at such an enormous price and if I had I should have sold them the day after. They were so rottenly drawn that I could not have stood for them. Because Whistler's name is affixed to something means nothing to me."[39]

It was not the name so much as the mysterious mix of modernism and tradition that attracted Stephen, however. In his text, "The Gentle Art of Making Enemies," Whistler had said, "Paint should not be applied thick, it should be like a breath on the surface of a pane of glass."[40] Stephen felt an affinity for the artist's wonderfully atmospheric works, with their amorphous quality of being in a unique realm somewhere between air, light, and matter; the youngest of the Clarks was beginning to show signs of the strong taste for the groundbreaking and the experimental that would distinguish his collecting.

The brothers were unlike their father in the guiltless ease with which they had and spent money and devoted themselves to their investments and their collections as if to do so were their inherent right, but they resembled him in their rare seriousness about artistic quality. Other rich people just bought what Duveen and the other prominent dealers of the time told them to get, and followed the popular wisdom about value and taste, without making independent judgments; the Clarks, Sterling especially, approached the business of acquiring as if it were their profession.

In 1914, as most of Europe was heading toward world war, Sterling was happily filling up the Paris house with wonderful objects. He relished the bargains he could get on Whistler etchings and lithographs, bought lots of work by artists who are today unknown (Pierre-Georges Jeanniot, for example), and acquired some important Rodins. The French sculptor, then seventy-four years old, was recognized as one of the greatest artists alive. The frank revelation of passion in his intensely emotional work appealed to the operatic taste of the times. Having bought a bronze and a plaster of each of two subjects by this master who was working in his studio on the other side of the Seine on the rue de Varenne, Sterling demonstrated his brotherly generosity by proposing that Stephen have first choice and keep the bronze of one and the plaster of the other. "We will then have the advantage of both being able to enjoy both," he jauntily explained.[41] Besides, as he told Stephen, owning the plaster conferred the right to make further casts, so each would be able, if he wanted, to have a bronze, or more than one, from the one he took in clay.

Alfred and Elizabeth Clark's high-spirited second son was buying art and advising his sibling with the same consuming enthusiasm with which he had spearheaded his campaign in China. As the winds of war intensified, he was constantly in and out of the elegant Colnaghi Gallery in London's Mayfair district. In the course of that one year, he bought nine museum-quality paintings there, among them a major Frans Hals, a Luca Signorelli, a Montagna, a Perugino, and the masterpiece of his collection, the Piero della Francesca.

He was also obtaining more minor work, pictures by Félix Ziem and others; the act of acquiring, particularly at this dire moment in history, seemed to add to the energy with which he woke up in the morning. But it was that one picture above all, the Piero, which would provide the greatest emotional sustenance to him, especially because it gave him the luxury of identifying himself with a treasure that would ultimately be beyond what money could buy, unavailable to people who had far greater financial fortunes than his own.

PIERO DELLA FRANCESCA'S work has a completely singular position in the history of art. The mesmeric restraint and order of Sterling's *Virgin and Child Enthroned with Four Angels* (color section 1, page 3) are exemplary of the painter's unique qualities. The refinement of the

muted coloring distinguishes it from the gilded panels of Piero's prede-
cessors and from later pictures by artists like Tintoretto with their more
vibrant sheen. The ambient calm, a result of the beatific expressions on
the characters' faces and of Piero's eye for order and his impeccable organ-
ization of forms and space, is equally distinctive.

There are reasons that, until the modern era, the work of this fif-
teenth-century painter was mostly out of favor. The aspect of detach-
ment, the poetry and quietude, were not what most people expected of
their Italian Renaissance art. Piero's art lacks the ceremony of Raphael or
the robustness of Michelangelo; it has, rather, an aspect that might be
associated with Asian art, a Zen-like sense of space. This is why Robert
Sterling Clark had the opportunity to buy one of the artist's rare paint-
ings when he did; Piero's work was not yet acclaimed as it would be
when qualities of this sort were esteemed for their synchronicity with the
prevailing contemporary aesthetic, as would happen in the mid-1920s
when streamlined design and minimalist clarity entered the mainstream.

Sterling was lucky to be offered this painting; it was his good fortune
to walk into Colnaghi's on the right day. The work came from a private
English collection where it had been for more than forty years. And
though it was a great deal of money for the time, he was also fortunate
that the price he paid was not more—the equivalent of about one hun-
dred seventy thousand dollars. A few years later, a painting of this caliber
would certainly have gone directly to a museum.

He was, however, as perspicacious as he was lucky, for he recognized
the merits of something that was not yet everybody's taste. It's hard to
believe that there was ever a time when Piero was not right up there in
the pantheon with the other great names of Italian painting, but in 1914
there was only one major book devoted to his work. When Robert Ster-
ling Clark came upon the altarpiece at Colnaghi's, he was not buying
what would today be called a "blue chip" masterpiece; rather, he was tak-
ing a risk, and showing himself a savant. Today it is that act of courage
and clear vision that makes Williamstown and The Sterling and Francine
Clark Art Institute a pilgrimage point for serious painters and all true
lovers of art. But what has come to be the quintessence of taste was not a
shoe-in at the time.

That lack of popularity is why remarkably little is known about Piero;
his dates are elusive, the main biographical information remaining about
him being that he was the rare painter named for his mother rather than
his father. People who need the backup of vast scholarship and a plethora

of facts are out of luck with his work. But if the sight before one's eyes suffices, *Virgin and Child Enthroned with Four Angels* is a feast. The painting is defined in part by the power of its geometric underpinnings: the sublime grid formed by the horizontal band of all the subjects' eyes, the further bands of horizontals receding into distant space from top to bottom, the verticals established both by the marble columns of the setting and the angels' limbs, with the stone and flesh being remarkably of the same hue. The graceful layout calms and steadies the viewer, as do the knowing expressions on the faces of the participants and the beatific state of otherworldly grace in which they exist with such ease. The exquisite deployment of colors, and the quietly rich nature of the hues, enhances these qualities of the lines and of the human scenario.

Other, more minor, works by Piero have found their way into American private collections and from there into museums, but, in spite of two excellent small panels at the Frick, this is the only substantial work by the painter in America. When Robert Sterling Clark made the decision to buy it, he probably had little idea of what its future importance would be; he knew mainly that he liked it immensely. Later, when Lord Duveen and others tried every trick in the book to get him to sell the masterpiece, he would be very proud of his trophy. He relished his position as the owner of something that people of far greater wealth wanted but could not have. But, initially, something else, something far more significant than a sense of personal triumph, had led this rich young bachelor to make such an astute selection.

On some level, for all the bombast of his personality, Sterling had a level of sensitivity, a feeling for the exquisite, the ability to be penetrated to the depths of his being by aesthetic response, which made him truly his father's heir.

THE MAN WHO WAS SUFFICIENTLY CULTIVATED to have bought this sublime picture certainly used a lingo that was at odds with his delicacy of perception. His letters to Stephen included remarks like "Rino got a corking Corot at $12000." This was what he and the art he liked were all about: jovial, expansive, and warm, if also at times uncouth. It was all part of the same human being: someone who believed in himself, or desperately wanted to think he did, and so was sharply opinionated about everything.

There is a temptation to see Sterling simply as the jolly collector of

Old Masters and Renoirs, the aficionado of the track, the enjoyer of fine wines—and nothing more. But knowing that he wrote and saved those diaries in which, day after day, he lashed out, and that he harbored sharp opinions, sometimes strongly negative, it would be shortsighted not to consider the whole picture. For what corroded him was in some way, however difficult to understand, the same sensitivity and vulnerability that drove him with such fever to the reassuring beauty and strength of his pictures and silver and books. At the same time that, above all in his own mind, he struggled mightily against his own flesh and blood as well as people he mistrusted, he kept acquiring mementoes of life's beauty, and figuring out how best to share them with the multitudes. The unusual wiring was all connected.

In his pervasive belief that he generally knew what was right, Sterling perpetually felt that America was going to the dogs, and opted for the candidates he thought could make things right. In 1916, he fervently hoped that Teddy Roosevelt would again be president; a man with such complete confidence and swagger was his sort of person.

Sterling's culinary bent and preferences in wine were like his taste in painting; he liked what was bold, robust, and assured. And, as with art, what he enjoyed, he craved—both for himself and for others. He had a particular passion for good Burgundies; he indulged in them himself, and also delighted in shipping cases to Stephen.

His advice on the subject was like his counsel on art, aimed to ensure that his brother was getting the best deal and having maximum pleasure. In one letter from Paris, Sterling urged Stephen to drink up everything in a recent shipment; some of his was already corked. How generous he was when he wasn't being curmudgeonly, writing, "I have got some perfectly splendid Burgundy at about the same price—it just warms your heart but I do not know whether it would not be a bit too strong for you. However it is mighty clever stuff to take a glass or two of in the cold weather."[42] Even though it was only March when he wrote this, he wanted to send some as a Christmas present.

Sterling's passion for the pleasures of the table went so far that he wrote his own cookbook. His recipes were a bit like his taste in art; he didn't go for understatement, and considered nothing over the top. His favorite ingredients seem to have been thick cream, butter, and bread crumbs; by today's standards, his preparations for "tournedos" and caramel custard were inconceivably rich, and his more original special-

ties included "potato doughnuts" and "smelts au gratin."[43] This was not a man who believed in skimming the surface.

It was all part of a life devoted to pleasure. Most mornings, Sterling would go horseback riding in the Bois de Boulogne. In his spare time, when he wasn't cooking or collecting art, he studied Spanish, having switched from Arabic. In spite of his own forays into the kitchen, he depended mostly on his private chef and was utterly thrilled with the one he had in those years, writing a friend that he had fantasies of himself as Louis XIV, sending a cordon bleu, the famous mark of culinary merit, to this master after a good lunch. And Sterling also now had—quietly, in a way known to the family but still kept very much under wraps—a girl-friend who was on the scene a lot of the time. He was a man determined to enjoy himself.

STERLING'S ART COLLECTING was slowed down only slightly by the war. He was snapping up Delacroix drawings—as well as work by a lot of artists we no longer know, like Henri Monnier and Joaquin Sorolla—almost as readily as he was acquiring Burgundies. Even in 1915, a comparatively lean year for him, he bought a major Goya in Paris and another Sargent in London. The fortune made thanks to his grandfa-ther's shrewdness and acumen had a bottom line, but Sterling denied himself little. He couldn't accumulate paintings in the same quantity as wine, but he continued to acquire with zeal. In 1916, while adding to his Old Masters with a Jan Mostaert and a David Teniers the younger in London at Colnaghi's, he also branched out by purchasing, in New York, his first Winslow Homer and his first Renoir, *A Girl Crocheting*. He would over the years buy thirty-eight more paintings by the artist.

In March 1917, Sterling resumed his military service. Appointed major–inspector general, he was a liaison officer with the French army on behalf of the Americans, and until the start of 1919 he served in this capacity in Paris and Bordeaux. It didn't slow down his collecting. Flaunting his uniform in the best galleries of Paris and London, in 1917 he added quintessential works by first-rate English artists to his hold-ings. A powerful Thomas Gainsborough portrait evoked the grandeur of eighteenth-century London, and a Richard Parkes Bonington depicted an enchanting scene in a rural village. Sterling also bought another Goya, a dramatic church interior showing mass being performed.

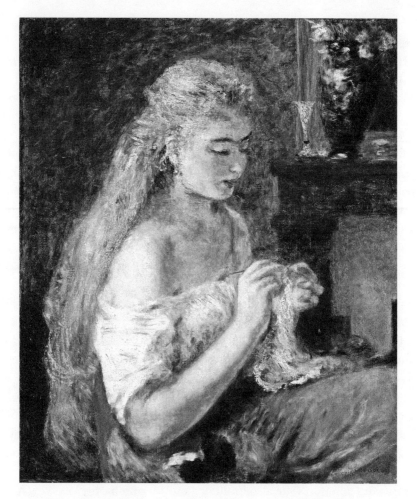

Pierre-Auguste Renoir, A Girl Crocheting, *c. 1875. Sterling's eye for Renoir's work made him among the greatest collectors of the impressionist best known for his paintings of his female subjects on the brink of womanhood.*

Whether something was American, French, British, or Spanish, was from the sixteenth century or the nineteenth, illustrated a religious scene or a domestic one was all beside the point. What mattered was that paintings had depth and verve, and conveyed life convincingly. Sterling was drawn to the healthier aspects of human existence, to imagery that was upbeat and essentially celebrative, to noble and dignified behavior. He liked to see human beings at the apogee of their aliveness, as rendered by history's most capable artists at the summit of their powers. Intellec-

tual explanation, art-historical significance, or symbolic iconography might have interested other people; he cared mainly for beauty and craft, and for the revelation of the splendors of the earth.

Because he cherished formal grace and the picturesque, he was attracted especially to the French school of painting of almost every epoch. In 1918, Sterling acquired a significant work by the greatest of seventeenth-century landscape painters, Claude Lorrain; no one could be more luminous or make atmosphere more seductive. This late canvas by the master depicts Jacob taking his flock of sheep and herd of cattle into Canaan.

Neither Sterling nor anyone else involved in the transaction realized, however, what scene was being illustrated here. It had more bearing on contemporary events than Sterling would have imagined. He had bought one of the most touching images of Jewish exodus imaginable, without recognizing the subject matter, which was only established after the collector's death. While most Claude Lorrains depict New Testament subject matter, this one renders that Old Testament scene as being both brave and poignant. Jacob is virtually in rags; his feet and shoulders are bare as he strides forward, staff in hand, leading his animals. The crystalline landscape, which features Roman ruins and trees of feathery foliage as only Claude could paint them, has an ineffable beauty. In this impeccably balanced painting, the rich landscape setting of verdure and receding stream and the vast blue sky with its smattering of white clouds dominate, but the human action, which Claude, as usual, has painted as if it is only a detail, manages, through the perfect color accents and sureness of placement and articulation, to be deeply moving.

Other members of Sterling's family had supported the arts lavishly and bought artworks large and small, but he, yet again, had found and acquired a painting of a totally different caliber. *Landscape with the Voyage of Jacob* was of the same quality as the masterpieces by Claude that hung in Paris at the Louvre, in St. Petersburg at the Hermitage, and in London at the National Gallery. For a bon vivant bachelor with no particular tutelage in the history of art to have purchased it was a remarkable achievement.

By the following year, in part because of the restrictions of wartime travel and his own military service, Sterling was doing more and more of his shopping in Paris, at Knoedler's, and getting French work closer to his own era. These included pictures by Corot, Degas, and Jean-Louis

Forain—all of whom would become his staples. But that immersion in nineteenth-century art and the difficulties of civilian travel didn't stop Sterling from acquiring, in London, a Hans Memling portrait and what was allegedly a Rembrandt *Crucifixion*. The Memling, like all of the Flemish master's work, has the marvelous rendering of human flesh as well as man-made surfaces that are the hallmarks of northern Renaissance painting; at the same time, it has that quality particular to the work of Memling alone, whereby the sitter is in a somewhat transfixed state, as if somewhere between the earthly and heavenly spheres of existence. And though the Rembrandt would in 1984 be reattributed as "School of Rembrandt," it has the palpable drama of all of his biblical scenes, in which the energy of the loaded brush and the interchange of physical mass and light-charged atmosphere imbue the subject matter with the unequaled intensity that defines true religiosity.

If Sterling was continuously plunging into cultures ranging from that of Italian hill towns at the dawning of the Renaissance to seventeenth-century Holland to Winslow Homer's rural America, his heart was, however, in the country where, at least for the time being, he had chosen to settle. France and its civilization were the apogee of pleasure for him, never more so than in 1919 when he married Francine Clary. One year his senior, she had been an actress in the Comédie Française, was extremely pretty and beguiling, and had a child when he met her. In short, she was everything a naughty and sophisticated French woman should be, and perfect proof of what a man he was by allowing his attraction to her to make him thumb his nose at what was expected of him. Both his Sunday-school teacher grandfather and his stepfather the bishop would have been aghast. His brothers and their wives certainly were. To marry a former actress, let alone one with an illegitimate child, was the sort of thing Isaac Singer did, not a member of the God-fearing Clark clan.

In the eyes of the milieu into which Robert Sterling Clark had been born, Francine hit one bad note after another. For one thing, although Sterling never referred to her in his many letters or diaries of the period or let on to her presence in any way, it seems that she had been living with him starting in 1910, when she retired from the Comédie Française. If the bishop's wife had still been alive, that probably wouldn't have been possible, even though Elizabeth Scriven Clark was used to turning her back on carryings-on in Paris. But now that he had only brothers in the family, Sterling could get away with it; in June of 1912,

Francine Modzelewska, c. 1900. The woman with whom Sterling Clark
would live in Paris and ultimately marry was from a background
that was completely unacceptable in the eyes of his family.

a Steinway grand was delivered to "Madame Clark" on the rue Cimarosa, and two years later Tiffany's Paris branch delivered some silver coffee cup holders to "Madame R. Clark" at the same address.[44]

On the other hand, in 1917, the woman who was "Madame Clark" on the rue Cimarosa still had separate digs under her maiden name in a boardinghouse a few blocks away. She and Sterling may have thought it advisable for her to maintain a separate residence, not least because she had a young daughter to care for. The child's full-time presence would

not have been considered de rigueur on the rue Cimarosa as long as her mother and the master of the house were not married. Nevertheless, Sterling was sufficiently devoted to his girlfriend that, with his perpetual fear of catastrophe, when he was in New York and about to set sail on a transatlantic trip back to Paris in 1917, he gave a sealed envelope to Stephen and Edward in which he left a hundred thousand dollars to Francine Clary in the event of his death.[45]

By then, Stephen knew about his brother's lady friend. He described her in a way that said everything about the attitudes of most of the Clarks to the former actress: Francine, Stephen wrote in a private memoir, was "pretty . . . with perfect self-possession, agreeable manners and a good deal of apparent refinement. . . . She was, however, the kind of person one would never get to know."[46]

Her background, at least what was known of it, was Polish, and she was Catholic. She carried her mother's maiden name, Modzelewska; her birth certificate simply indicated "daughter of a father unnamed."[47] Francine's mother, Françoise Modzelewska, a dressmaker, was twenty-two years old when she gave birth to the baby she brought up alone. By the time she was twenty, that child had studied drama and started an acting career; when she was twenty-five she gave birth to her own baby daughter, Viviane. There were some people who would say that Viviane's father, who died two years after the baby's birth, was the reason Francine took the last name Clary, but even if that was so, Francine was still "Mlle" when, in 1904, she signed up with the Comédie Française. There she played a number of roles, in plays by, among others, Dumas fils and Pierre de Marivaux.

If the idea of an actress with a shady past was not what his brothers and their wives expected of the wife of a Clark, for Sterling the marriage to a woman with whom he mostly spoke in a language foreign to his own seemed perfect. Francine was as fetching as the women by Renoir, and remarkably high-spirited. She was as candid in her views as he was, and she was mischievously witty. Moreover, like the art he acquired, she was part of his definition of himself as someone different from those in the milieu in which he had grown up.

More subtly, the stunning theater woman was an indication of how different Sterling was from his father. Sterling was flagrantly proving himself the lover of women. This marriage at age forty-two, late by the standards of the era, was a declaration. Sterling was so determined to give the impression that he liked the ladies that, rather than simply conform

to the expectations for someone of his station and make a conventional marriage, he was man enough to hazard a touch of a scandal. Sterling's father had kept his Paris life and its attractions relatively, although not completely, private; having previously declared to Stephen that he was not the marrying type, Sterling was now letting it be known that *his* Paris attractions were of a very different sort.

WHEN STERLING WAS FEELING EXPANSIVE, there was no stopping him. In one fell swoop he bought, from Colnaghi's in London on a summer day in 1919, drawings by Perugino, Dürer, Rembrandt, Rubens, and Watteau. Each was a masterpiece of the more intimate side of these great artists' work—moments when they are capturing their immediate response to a subject and at the same time formulating a future painting. Robert Sterling Clark was amassing a collection of drawings of fantastic range and caliber.

Following his marriage, however, he tamed some of his furies as an Old Masters collector that had been unleashed in his bachelorhood. In the twenties, he would acquire one more work each by Lorrain, Ruisdael, and Rembrandt, but for the most part he focused on paintings that were more recent and less expensive.

In 1921, Sterling and Francine decided to spend more time in New York, in spite of the family's *froideur* to her. While keeping the house in Paris so that she would never feel isolated from her homeland, they took an eighteen-room apartment on Park Avenue at the corner of Fiftieth Street. They also ventured further into the social milieu in which Sterling had been raised by building a house in Cooperstown, which they called Red House Farm.

With the base in Manhattan, the shopping really took off. Sterling's main source of pleasure in life was to look at objects, evaluate them, and, whenever the spirit moved him, buy them. As a married man, he may have stopped, for the most part, acquiring the big-ticket items, but he began to consume on the level of royalty and potentates voyaging to distant lands and filling the hulls of multiple ships with bounteous treasures at every stop.

It would be many people's fantasy. Now that the newlyweds had begun to spend the winter months in New York, Sterling, occasionally with Francine at his side, but mostly with her simply hearing about the days' trophies after the fact, began to collect impressionist paintings, as

*Sterling in 1921. As a newlywed, Sterling switched his
art collecting from Old Master paintings to important
drawings and art painted closer to his own time.*

well as drawings, rugs, silver, antiques, rare books, and household objects
as if their selection and acquisition were a profession at which he wanted
to emerge the master. With an incredibly discerning eye, he made it his
daily routine to visit his favorite purveyors in each of these areas of his
collecting.

They were generally the most esteemed dealers in their fields, and
because he was one of their most active clients, they knew what he liked
and always had something special to show him. He could never be talked
into anything, but, if he so decided, he might, on a good morning, buy a
rare first edition for a couple thousand dollars, a choice silver teapot for
three times that amount, and a Renoir for fifty thousand, with stops for
good cigars in between. Then, after a leisurely lunch with his pleasure-
loving wife at one or another of New York's best French restaurants, he
might, batteries recharged, go off to look at jewelry for her and then
check in at one of his preferred art galleries, where, for a mere four hun-

dred dollars, he could end the day's buying with a Winslow Homer watercolor.

The energies he had put into his China campaign were now devoted to considering these purchases, negotiating with dealers, and organizing storage or shipment of the day's catch. Some acquisitions went directly into the rooms he kept at the Manhattan Storage Company—which was a bit like an apartment building for collections, the work readily accessible in the tenants' personal units—while quite a bit got shipped back to Paris. It was pretty much Sterling's full-time occupation to manage all of this, when he wasn't overseeing his other investments, and he wrote a detailed diary about the looking and buying. The lengthy entries, while spiked with Sterling's unique comments, are as detailed as the well-kept minutes of meetings of an ongoing corporation that must report to its stockholders. He explained each and every choice both aesthetically and financially. For all that he bought, there was far more that he declined, and he liked providing the reasons.

IN THIS PERIOD of happy living at the start of the 1920s, Sterling and Stephen Clark would periodically go to galleries together. Sterling was always quick to make up his mind about what he wanted, Stephen more hesitant. One spring day in 1923, the two were at Knoedler's when Stephen wondered where he might put a Degas bronze. His quandary was what Susan would permit.

Sterling—who had just been stocking up on Renoirs and Winslow Homers, had recently bought his own Degas as well as a marvelous little Manet still life, and had also in the preceding weeks acquired work by assorted nineteenth-century French practitioners ranging from the academic Jean-Louis-Ernest Meissonier to the Barbizon painters Alexandre Decamps and Théodore Rousseau—could not imagine being henpecked by a wife who would tell you what you could or could not buy. Even if his acquisitions ended up going straight into his storage vault, he bought what he wanted. Although he had high regard for his own wife's eye for art, he thought that what Susan Clark "would really like the best, if it were not for her snobbishness, would be bad Bouguereaus's!!"[48] The Stephen Clarks had met Augustus John, and arranged for the English painter to do Susan's portrait; Sterling did not approve, thinking they had chosen a name rather than talent, and advised them to select the lesser-known William Orpen for the task, as they did.

In this, Sterling showed considerable discernment as well as his usual willingness to make up his own mind, but he also betrayed the sense of superiority he perpetually wielded over his younger brother as a collector.

Sterling was generally snide not just about Stephen's aesthetic judgment, but about his sense that Stephen's collecting was part of a way of life that was too connected to social pretenses and to Stephen's compliance with Susan's blind adherence to the fashions of her milieu. When Stephen had the good judgment to like a Sargent *Venetian Interior,* Sterling declared himself "surprised, for it is the least showy"[49] of the Sargent works they viewed together. Sterling forever disparaged Stephen's taste, confiding in his diary that his brother would never dream of buying a good Ispahan rug, yet would willingly pay too much for two threadbare ones if Susan recommended that he do so. Of a prominent dealer in American art, Sterling wrote in his diaries, "This fellow Rehn has bad manners & is an awful bluffer. Just the kind of a man to sell bum pictures to Stephen."[50]

Sterling got his brother all wrong. Stephen would end up being an extraordinary art collector, both brave and discerning in his choices. Stephen ultimately made fewer mistakes of judgment than did Sterling, and he had an amazing eye that was connected with a remarkable affinity both for painters and institutions that were truly groundbreaking and that braved completely new territory. Stephen would, to a remarkable degree, advance America's appreciation of some of the glories of modernism, and help an entire society to enjoy art that had originally been considered beyond the pale. Sterling, however, recognized none of these strong points—either of the work by Cézanne, Bonnard, Picasso, and some of the other pioneering artists whose paintings Stephen would buy and generously make available to others, or of his brother as a human being. Rather, he saw Stephen's decisions only as manifestations of personal shortcomings.

What counted most to Sterling was the relationship between them; for it to have been as he wanted it, Stephen would have had to be more his follower. Sterling, who had always tried so hard to steer his brother toward what he considered the best, felt that his role had been undermined. He believed that Stephen listened to the wrong people—most of all his wife—and that the voices that controlled him represented a sort of moral corruption. The issue of power was central. He could not tolerate what he considered to be Stephen's willful subordination. When Stephen sold Auguste Rodin's *Man with a Serpent* because Susan did not like it, to

Sterling this simply meant that his brother's wife was having more and more influence, and that such a situation was a recipe for disaster. It didn't seem to occur to him that marital tranquility might depend in part on shared taste, and that there might be wisdom in a man's deciding to divest himself of something his wife did not like.

The younger brother, in fact, was as independent in his judgments, and as true to his personal preferences, as the older one was; it's just that he had very different taste. But Sterling's perceptions and behavior were clouded by the issue of personal identity and a need to assert himself that affected his every move. He assessed Stephen unfairly because he felt wounded by him. And eventually his views snowballed to the point where not only did Sterling reject his brother but he disdained the Museum of Modern Art and its artists and a lot else that he associated with Stephen. Sibling rage would take on a life of its own.

In the early 1920s, tensions were mounting between the brothers on the issue of their inheritance. Francine alerted Sterling that Susan was getting worried that he was spending all his money. The various Singer trusts from which the family benefited were organized in such a way that, as long as Sterling remained childless, the bulk of his fortune would, in the normal course of events, go to Stephen and Susan's children upon their uncle's death. Brose had a daughter, but because she was severely mentally handicapped and had a limited life expectancy, Sterling discounted her from his calculations. Between 1909 and 1918, Susan had borne Stephen a daughter and three sons. The more Sterling spent, the less these children would eventually inherit. His having paid sixty-five thousand dollars for the Ruisdael in 1922 and a hundred eighty thousand dollars for the Rembrandt the next year had alarmed Susan, Francine informed him.

While mischievously reporting Susan's apprehensions to her husband, Francine was his cheerful partner in crime. She in no way urged him to cut back on his spending. It wasn't the major pictures that interested her so much as the smaller objects. Every day was a chance to come into contact with fine things and make them part of their own lives. When they took to the shops together, they managed to make an impressive dent in the dealers' stocks. One day, for example, they bought, in the course of a morning, an Augustus Saint-Gaudens statuette, some rugs, and some fireplace brasses before celebrating the pleasure of the purchases over a leisurely lunch. Francine had known nothing of this sort of luxury before she met Sterling, and she relished it.

When Sterling's daily routine didn't have him buying precious objects, he devoted himself to clothing and cigars, and to keeping his wine cellar stocked in his favorite Pommards. Here the decisions were easier than when he was adding to his fantastic silver collection. But the challenges of finding the creamers that exemplified the best of the craft, or the coffeepots that stood most lightly on their delicate feet, delighted him. He enjoyed every encounter which confirmed that his salver was the best one, bought for a lower price than inferior examples, just as, when he went around to museums and galleries, he virtually gloated in his faith that his Manet still life had better tonalities and a more perfectly rendered form than did any of the other ones he saw.

Sterling didn't just accumulate things; he lived with them in style. An evening in 1923 when he drank a 1915 Pommery Champagne with an Adams silver centerpiece in the middle of the table, and with his amiable younger brother Brose there admiring it, was the sort of thing he cheerfully recorded in his diary. His record of everyday life in those few shining years might have been called "A Wealthy Man's Many Pleasures."

On the other hand, his rage was mounting at the idea that neither his wife nor his stepdaughter would inherit the corpus of his fortune. The idea that Francine had fostered in him that Susan was always angling for money had his blood coming to a boil. He did not seem to recognize that Francine, born to completely humble circumstances in opposition to the comfortable ones of Susan's own background, mother of a child who stood to inherit nothing from the trusts when Susan's would, might have had her own ax to grind. If the terms of Edward's and Alfred's estates, well outside the purview of the current generation, seemed irrevocable, Sterling's wife certainly shared his interest in challenging that fact.

Sterling worked himself into more and more of a lather. He believed more and more that his parents' youngest son, who was active in the Singer corporation, was acting increasingly in his own interests and that of his children; moreover, he had lost confidence in his trustees, who he thought were more concerned with what was good for the Singer Manufacturing Company than for the Clark heirs. In the spring of 1923, Sterling tried to get Brose and Edward to join him in actions that would give each more control over his own trust. He hired a lawyer to pursue the matter. In all of this, he assiduously avoided Stephen.

On June 15, when they met in the office that managed the family's financial affairs, Stephen and Sterling both snapped. Sterling was about to walk out of their meeting when Stephen rose from his chair and said

that of course it was Sterling's right to consult anyone he wanted but that it had been disgusting of Sterling "to sneak around behind my back."[51] Sterling instantly hit Stephen on the mouth; Stephen struck back "until I had him on the floor with blood all over his face."

Shortly after the incident, Sterling withdrew whatever accounts he controlled personally from the managers employed by Stephen, Rino, and Brose and opened an office at 11 Wall Street. This was mainly to handle his own financial affairs, although it gave others the impression that he was a banker or stockbroker or both. It was the beginning of a schism that would never mend.

ON THE OTHER, happier, side of his life, he continued to acquire art. In his impassioned response to color and plastic force, to painters' issues more than the peripheral themes usually discussed by art historians, he was rare as a collector. Sterling took his delights seriously. When, in late 1923, he first came upon Winslow Homer's *Early Morning after a Storm at Sea,* he wrote in his diary, "An excellent picture and different from any I have seen by Homer of the sea. An enormous wave breaking is coming in over rocks. It is in general green slate colored. The mass of the wave is very powerful."[52]

Sometimes he latched on to greatness, sometimes to inferior works, but Sterling always saw with his own eyes. He was completely contemptuous of trends, and didn't care in the least about the taste of others except as something to observe. He felt that most Americans would like Bouguereau more than anyone else, but "they are told by art critics or self-styled art critics that Monet & Renoir are the things to admire. Therefore like a flock of sheep they do lip worship to these shrines and they try hard to understand by reading piffle art books and end up by knowing when these painters were born & died & it all ends there."[53] For him, art had to be something more directly connected with one's own passions. The depth of that personal interchange with the work separated him from most other people, but it was, for all of the differences of taste, part of the legacy he had from his father.

Over breakfast in their nice, well-located apartment, Sterling and Francine would plot out the day's campaign of acquisitions for their consideration. Sterling noted in his diary that January 19, 1924, was a bright and relatively mild winter day. It was a pleasure to walk from purveyor to purveyor. "To Revillon's. Ordered Coonskin coat split for riding.

To Knoedler's . . . F & I agreed we must buy the Goya."[54] They weren't just getting expensive paintings; Sterling also believed in buying work to encourage younger artists, like the artist Clarence Johnson, who had a landscape he bought for twenty-five dollars from Dudensing. (Unlike Knoedler, Dudensing focused on contemporary art.)

When he was offered a Titian that winter, Sterling realized in a new way how much he now preferred art closer to his own time. He pretty much disdained all forms of modernism—it didn't occur to him to consider work by the likes of Kandinsky, Klee, Picasso, Mondrian, or any of the other artists associated with the Bauhaus, dada, or surrealism—but he found the art that had been popular twenty-five years earlier completely irresistible. In both Paris and New York, he was acquiring a lot of Boldinis, further Renoirs and Sargents, a Daumier, an Adolphe Monticelli, several Charles Daubignys, and more Winslow Homer watercolors.

The emphasis had changed from the days when he collected the Old Masters, but the nature of the art had not; just as Sterling continued to be excited every time he bought a case of Pommard, one of the richest and boldest of all of France's noble Burgundies, he liked his art energetic and celebrative. Boldini, in many ways a society painter, was hardly on the level of some of the other artists, but his work had verve and panache, and his subjects were pretty, which was vitally important to the happy collector. When Sterling selected art of a very different caliber from his masterpieces, he did so as part of his effort to keep the pleasures of European life, so dear to him, alive in his American existence.

BUYING IMPRESSIONIST PAINTINGS and silver by the caseload was not cheap, even if the prices Sterling paid were insignificant compared to current values, and not just because of the rate of inflation. The habit of taking home the countless rare books that caught his fancy was also catching up to him; to shell out twenty-five hundred dollars for a good first edition of *Gulliver's Travels* was the sort of thing he did on an almost daily basis, and although Sterling could well afford it, he wanted more cash. In 1925, he initiated a lawsuit to contest the taxability of stock dividends received by the beneficiary of a trust.

In 1890, Alfred Corning Clark had created trusts for his sons consisting mainly of Singer stock. The issue now was whether, given that Sterling's legal residency was in Cooperstown, he had to pay state income tax when the law stipulated that a federal tax on such dividends was waived.

In his fight against the New York State Tax Commission, one of his attorneys included a former governor, but even then he did not prevail, and the groundbreaking decision of the Appellate Court in Albany determined that, for state tax purposes, the dividends counted as part of Sterling's taxable income. "Many Millions Involved," declared *The New York Times* headline.[55]

The uneasy feelings between him and his brothers were also beginning to turn into a full-fledged battle. The formerly amiable one who had put his energies into buying gifts for Stephen's family and into trying to patch up feuds and get everybody to be nice to everybody else was increasingly furious. He may have been annoyed that his brothers, who would have benefited as well if he had prevailed in his case against the New York State Tax Commission, had not joined him in the costly battle, and that, when he lost it, his name was the only one attached to the failure. Increasingly, he believed that the others were greedy and manipulative about family trusts and various financial arrangements.

His collecting served to cheer him up and remind him of what made him happy. Whether he was in Paris or New York, Sterling would saunter into the best galleries with or without Francine, light up a cigar, and look intently as one painting after another was placed before him. A day in late March 1926, described in his diary, was typical. The couple was in New York, and spring was in the air at last. They had moved into a splendid new apartment a few blocks up Park Avenue at No. 375; appropriately for the grandson of the man who built the Dakota, the building was called the Montana. From there it was only a short walk for Sterling and Francine to go to Durand-Ruel so that he could show her the Renoirs he had seen the day before. The former actress and her prosperous husband, both dressed to the nines, voiced their opinions freely to the attentive merchants. She simply did not like one of a woman in black, and felt that, in another, a sail on the Seine was too strong an element in the overall composition. But she and Sterling both thought that a nude painted by Renoir in Naples in 1881 was "a marvel."[56]

Then, at lunch at Voisin's, one of New York's most elegant restaurants, without equal for classic French cuisine, and with the white linen impeccably starched and the crystal and silver glistening, they decided that "it would probably be tiresome to live with" the nude. "It is marvelous paint, never saw finer, but it lacks line and is only a ¾ length & all the great nudes have line & all are full length Titian, Giorgione, Velasquez. The price is very high at $100,000."[57] It was almost as satis-

fying to reject something as to buy it; the act of thinking it through was a big part of the pleasure.

The following day, at Knoedler's, Sterling decided to take a Constable of Malvern Hall for seventy-five hundred dollars, having decided that the yellow of the grass in the foreground was not too shocking after all, and then he went off to his favorite silver purveyor, Crichton's, to buy a "pair of fine tea caddies, Geo. II, strong Regence influence, for $600."[58] When Edward Clark had been fighting tooth and nail to get dubious patents for Isaac Merritt Singer seventy-five years earlier, he could not possibly have imagined the daily life he would be making possible for his grandson.

MORE AND MORE, Pierre-Auguste Renoir was the artist most on the mind of Robert Sterling Clark. On April 3, he offered a hundred thousand dollars for *Sleeping Girl with a Cat* (color section 1, page 4) at Durand-Ruel. Meanwhile, the salesman "went on in rhapsodies on the Nude. I pushed all rhapsodies aside & said first the price must be reduced very substantially and second I must have it at my apartment for a week at least."[59] This was the sort of service art galleries provided in those days, and that afternoon the accommodating dealer showed up at Sterling and Francine's apartment and hung and lit the painting.

It's easy to see why Sterling found both of these canvases—the one of the innocent child, and the other of the voluptuous nude—irresistible. *Sleeping Girl with a Cat* is Renoir with rigor; the beguiling subjects, both the child and the feline cradled in her lap, have a toughness to them, a very grounded presence. The coloring is far stronger than the more pastel-like tones of most of the artist's work. The child has something of an urchin about her; her clothing, unlike the lacy dresses in which Renoir dressed his little girls holding their mother's hands, is relatively simple, the skirt denim-colored, the flimsy top refreshingly lacking in adornment.

There is nothing ambivalent about the quality of sheer seductiveness of this fair-skinned adolescent. One of the straps of that minimal top has fallen off the gamine's shoulders, and the immodest garment reveals cleavage. The wicked-looking cat adds to the salaciousness.

The scenario has been rendered with restraint and a tightness of structure unusual in Renoir's work. The plastic presence of everyone and everything is remarkable; the chair has palpable weight, and the air around the assemblage plausibly circulates. Renoir has given his domes-

tic enchantress, caught in the reverie of sleep, the solidity of a Renaissance sculpture.

Regardless of his annoyance at the salesman's pitch, Sterling bought the nude, called *Blonde Bather,* at just about the same time as *Sleeping Girl with a Cat.* This canvas is the far more familiar aspect of Renoir, with lots of pink-tinged naked flesh, and sunlight streaming through the subject's mass of flowing hair. Unlike the younger subject of *Sleeping Girl with a Cat,* who appears to have been discovered unaware by the artist, this time the woman displays herself in a proud pose. She assumes the role of a goddess. Yet that act is by no means a conceit; rather, it is a joyful celebration of pleasure. In her attitude, as in the way that light breaks up the pigment throughout the canvas, we have impressionism at its apogee.

In this consummate example of the artistic style that approached the nature of seeing and the evocation of visual experience in a new way, the background is clearly suggestive of a waterfall and some rocks, but it is almost completely abstract; we are looking at atmosphere as much as matter. Today the artgoing public has become so accustomed to that sort of approach that impressionist pictures are public favorites, but when Robert Sterling Clark bought this picture, a classic of the genre, it took courage and commitment to opt for it over the nineteenth-century academicism that was still the mainstay of taste. The unabashed sensuality of this sun-drenched image of a woman who so openly celebrates the joys of the flesh was even more at odds with the cultural climate of the day, especially in America, than was the radical technique of painting. But nothing daunted Sterling when he liked what he saw. For viewers for whom Renoir is too sweet and cloying, this would not be a first choice; for those drawn to sheer prettiness, it is a complete winner.

THE DAY FOLLOWING his Renoir shopping, Sterling visited the Metropolitan Museum of Art. His observations there distinguished him from most of the other visitors. First he noticed cracking on a Renoir, two Manets, and a Sargent; the condition of artworks obsessed him, and, rather than simply regarding pictures for his personal entertainment or edification in the manner of most museumgoers, he always inspected them with an expert's eye, judging the state of their surfaces as if through a magnifying glass. Any sign of fading or deterioration afforded him a certain pleasure; it confirmed the superiority of his own possessions by the same artists. Then, at the Met, he deemed the Old Masters "a fearful

lot of rotten stuff." A number of the paintings the great museum now owned, having acquired some by purchase and others by gift, were works Sterling himself had turned down when they had been offered to him in the marketplace. In one of his characteristic quips, he noted, "Either the authorities are ignorant or they graft."[60]

Two days later, his love of the beautiful and the good led him into another domain. He started the day at Tiffany's. His first activity at the great jewelry emporium was to buy Francine a diamond bracelet. Then he had a cigar case tightened so that his cigars would stop falling out. Next, he made a careful study of bead and silk bags. Here Sterling was again totally different from the ordinary rich man out to make a purchase. His perpetual connoisseurship extended to everything visual. Sterling decided against one of the beaded bags because "the clasp was a trifle too light for the volume of the bag" and then determined that in another the clasp was "too vivid in color for the petit point."[61]

His dissatisfaction left him feeling empty. To console himself, he walked down Fifty-seventh Street to one of his favorite silver dealers. There he again had the thrill of finding a "lovely open work cake or pie knife"[62] where, even if the precise purpose was unknown, the qualities of balance and optical harmony were as they should be. He bought it instantly. His spirits were further buoyed when the owner of the shop told him he knew more about the different epochs of French design than any other customer, a compliment he readily committed to his diary.

Like his mother when she glided through the village of Cooperstown, Sterling walked at a fast gait in his perambulations around midtown Manhattan. He claimed to do a mile in fifteen minutes. From the silver dealer's that April morning, he went on to Durand-Ruel's and then to Knoedler's. This was all before lunch, during which the morning stop at Knoedler's had him fired up so that he then returned to the gallery ecstatically. In the course of the meal, he became resolved to purchase a van Dyck portrait of Inigo Jones. It had not taken him long to make up his mind, but he had needed just that bit of extra time to be sure.

This was how Robert Sterling Clark functioned all the time: weighing aesthetic qualities, discerning the difference between what was merely good and what was great, acquiring only those objects in which every element was exemplary. Writing about the van Dyck, he demonstrated his particular perspicacity, the eye that made him so different from most of the other clients of the New York galleries in these heady days of the

1920s when most people spent money with nowhere near the same amount of deliberation. "Every stroke of the brush was visible and the grey ground was utilized in the half tones. . . . A magnificent piece of paint."[63] Astonished to learn that the Museum of Fine Arts in Boston had turned down the fine portrait of the great architect, but not the least bit daunted by this mark of disapproval, which would have put off a less certain collector, he snapped it up for four thousand dollars.

This was, of course, not the first painting Sterling had bought by the great Flemish artist who was a studio assistant of Peter Paul Rubens. The work of Sir Anthony van Dyck had the robustness that invariably moved him. But by acquiring this work he so lustily declared "a magnificent piece of paint," he had taken his holdings into a new realm. Inigo Jones, who was van Dyck's contemporary in the first half of the seventeenth century, was regarded as the first major English architect. He had designed the Banqueting House at Whitehall, which in its grace and quiet grandeur is one of London's greatest buildings; Sterling knew it well. Van Dyck, who did more than one portrait of Jones, knew the architect because Rubens—with his assistants helping him, of course—had painted the Banqueting House ceiling.

The portrait that Sterling decided to get over lunch was, as opposed to more refined portrait commissions by the same painter, a true evocation of artists at work. What attracted Sterling was the physical process of making art, the honesty of the strokes, the lack of sham. The sitter was not one of van Dyck's usual nobles with a grand title; rather, he was another hardworking copractitioner in the field of art. Sterling was drawn to all this: the reality of the process, the creators' engagement with artistic technique, the craft essential to the work of art and architecture. It excited him in much the same way as the pounding of horses' hooves on the turf—when capability, and the alignment of the mental and the physical, were at an apogee.

Aesthetics motivated him; so did the wish to have the winner. Like horse racing, for which Sterling was developing increasing fondness, collecting was a competitive activity. The objective was to own the best and to add to one's private wealth along the way. He liked having what he considered to be the top of the pile, whether he was buying work by recognized museum-level masters like van Dyck or by artists who are today unknown, like Stanislas Lépine. And even though he rarely sold what he owned, he relished the knowledge that one of his pictures by Degas or

Manet or Renoir had, in little time, doubled in value, or that one of his Old Masters, although not cheap when he bought it, had now reached the stratosphere.

Financial growth, however, was not the main issue. As an investor he was brilliant to have grabbed up, a few days after buying the van Dyck, Winslow Homer's remarkable watercolor of a girl and boy on a farm fence—a tender evocation of everyday life, masterfully rendered in delicate brush—for four hundred fifty dollars, the price for these gems now having risen a hefty fifty dollars since he had bought the previous one; today it is in all likelihood worth over three hundred times that amount. But the thirty-five hundred dollars he shelled out for the Lépine is probably substantially more than it would fetch on the current market. If Sterling knew these relative values today, he presumably would just grin and shrug his shoulders. Evidence of his business acumen in the realm of art invariably pleased him, but proof that he often lacked it did not bother him; after all, he bought art because he liked it, not to make money.

THROUGHOUT THOSE YEARS, Sterling was not only a connoisseur; he managed his collection as if he were registrar and shipping clerk as well. Every exchange with the people who helped him in these processes gave him a chance to voice his arch opinions; he was always immensely proud to say just what he thought and issue absolute judgments. When, three weeks after he bought the van Dyck, a man came from Durand-Ruel's to the hotel to take a Renoir and ship it to France, Sterling gave him cocktails (the art dealer had two to his "1½ myself") and then held forth. In his mildly intoxicated state, the dealer attempted to tell the collector "how Renoir dreamed. I brought him to earth with 'I don't care a damn about painters' dreams. What I want is paint. For instance I don't care what Cézanne, Matisse and Gauguin thought or what they wanted to express. I could not give tuppence for all the pictures they ever painted or hoped to paint. The rules of painting cannot be broken. Renoir would have painted just as well in Titian's time. He, Degas, Manet at his best, Corot, etc. are brothers of Titian, Van Dyck, Rubens. The others are just bad painters and fakirs [sic].' Then we got down to sense. Asked him if he wanted to see a good piece of paint & took him to see the Van Dyck of Inigo Jones."[64]

He liked what was robust and well made just as he spoke what was on his mind. He was as excited by his latest red wine—a Romanée '94, "as

good a burgundy as I have ever drunk"—as by the pictures he cherished
from precisely the same era. Day after day, this bon vivant and his attrac-
tive French wife went about New York enjoying the material pleasures of
existence, relishing fine things as an integral part of everyday experience.
If the goal of having money is to be able to partake of the sensuous
delights of seeing, eating, and imbibing, they were exemplars of fulfill-
ment.

On a day when Sterling was making the run of his usual antiques deal-
ers near Fifty-seventh Street, buying whatever silver object caught his
fancy, and then going to his rare book dealers to compare fine editions of
Gulliver's Travels or Oscar Wilde's *Salomé* or another of his favorite tomes,
he might, in between, drop into Tiffany's to pick up a further gift for
Francine. Whatever he looked at—cake knives, first editions, jewels—he
made comparisons, seeking quality and value. When his usual salesman
at Tiffany's offered him a sapphire ring for six thousand dollars, not a
modest sum in 1926, claiming that the stones were blue at night, he
gave it a try, but then he returned it the next day saying that the "stone
was not blue enough under night light. Told him some day when he
found it I would like a rather shallow sapphire of some 20 carats which
would be blue at night for a simple brooch."[65] Sterling was a perpetual
connoisseur, always with an ideal fixed in his mind. One can hardly
imagine shoppers or art collectors today with such an eye, even if they
matched his pocketbook.

The same day that he returned the sapphires to Tiffany's, Sterling saw
"an excellent [Joshua] Reynolds portrait . . . in wonderful condition not
used or retouched. Very fine. But a shadow between chin & lip had
turned black & was out of value. I saw it the moment the picture was
turned towards me. It was not a retouch. Had I the picture I should have
it carefully lightened with water colors."[66] No salesman could instruct
him; no one knew better than he did; no one had eyes as sharp, or, at the
very least, had as strong a belief in his own discernment.

Often Sterling would go visit certain paintings for a second or third
time, seeing if they held up to his memory of them. On January 5, 1927,
a brisk, cold day, he strolled to see an Angoulême tea set that was "a
gem" and that he bought immediately, before rejecting a Sargent he was
considering, but taking, instead, an earlier work by the same painter, a
portrait that was "a very powerful, sculpturesque sort of thing & nice &
blond." The dealer told him it cost twenty-five hundred dollars; "Told
him to send it around. It was very much superior to a portrait of Prof.

Joachim done in 1905 at $20,000. I had it alongside the Reynolds & the Degas & it made the Reynolds flatten out."[67] This was how the sewing machine heir saw things: with his visceral reactions, his experience of the visual world that was like that of a wine connoisseur, his perpetual passion for art that was strong and demonstrative of competence and sureness of hand.

IT IS FROM THE VIEWPOINT of Charles Durand-Ruel that we really get a picture of Sterling. The Durand-Ruels were among the most distinguished of all French art dealers, back then as well known as Wildenstein or Duveen, although geared more to nineteenth-century art than Old Masters. Charles's father and uncle, of the same last name, had sold Sterling one of his first Renoirs—with the wonderful title *Onions, Naples, 1881*—in 1922. Charles saw Sterling practically on a daily basis, and found him "a wonderful man."[68]

First of all, whether they met up in New York or Paris—Durand-Ruel had galleries in both places, just as Sterling had residences in both—Sterling had the endearing American habit of calling Charles and his brother and their wives by their first names. They would often dine with him in the large house on the rue Cimarosa or in whichever apartment he then had in New York, and he was perpetually engaging and entertaining. "Physically, he was tall, slim, very well bred, a handsome Anglo-Saxon type with blue eyes that looked you straight in the eye."

Charles was well aware that his client had fought against the Boxers in the U.S. Army and concluded, in his own refined way, that this was why Sterling still had "a certain coarseness and picturesque manners." This came through both in Sterling's language—"son of a bitch" and "stick in the mud" were par for the course, and had a special ring to the listeners for whom French was their first language—and in his unique ability "to spit long distances." Sterling "never missed the large ashtrays placed in our private offices." It must have been quite a sight in a room full of impressionist pictures to see the client spit across the room and invariably score a bull's-eye.

Francine was very much her husband's opposite. She was "distinguished, refined, and discreetly elegant," "had a soft, well-modulated voice," and "was skilled and pleasant at conversation." Whatever cracks in the marriage would become apparent through Sterling's journals—

and there was a lot of pain on both sides—from Charles's vantage point, Sterling and Francine "adored each other. He only had eyes for her and she regarded him lovingly." But everyone in the gallery knew that none of this made her acceptable to her husband's family. Without even realizing that she had an illegitimate daughter, they knew that she was Catholic, that her family had originally been Polish, and that she had performed at the Comédie Française; the French understood snobbery sufficiently to realize that this was enough to invalidate her for most of the Clark clan.

Over the years, the Durand-Ruels would sell Sterling twenty-eight of the thirty-nine Renoirs he bought. Thus they saw him at his happiest and most engaged, for no artist fired him up as much, and no other acquisitions brought such delight. One of these would be the *Portrait of Mademoiselle Thérèse Bérard.* It belonged to Stephen first. The dealers wrestled it from Sterling's brother without his knowing who the next owner would be, although this was not Sterling's idea, and he could not understand why Stephen parted with such a stupendous painting. Charles reported that the negotiations were lengthy and complex because Stephen, while "a courteous man with whom we had very good relations, was rather difficult in business affairs."

Charles was biased, of course, for Robert Sterling Clark as much as anyone helped keep the family business going. But in his eyes Sterling, in contrast to Stephen, made financial dealings easy. Regardless of Sterling's bargaining, the art dealer considered Sterling not just the exemplar of "moral and intellectual integrity" but also of a "friendship" and "affection" that came through in their business dealings. He never forgot something that happened when the international financial depression was at its worst. Everyone was feeling the effects, but, relative to most people, the Clarks were suffering less. In January of 1933, Sterling bought some artworks with the agreement that he would pay two hundred thousand dollars by the end of the year. On March 6, at around 8:00 in the morning, Charles was shaving in the bathroom of his apartment on the eighth floor of the same building on Fifty-seventh Street where the gallery was. At that hour, he was surprised to hear the elevator stop on his floor. Then Sterling charged into the bathroom without bothering to knock. He instructed Charles, who was in his underwear, to get dressed immediately and go with him to Morgan's Bank. The former soldier bellowed out the reason: "You have sold me paintings payable in

dollars, but your family lives in France." The dollar was being devalued, and Charles would suffer the consequences if they did not do something right away.

Sterling's chauffeur-driven car was in front of the building. Once they reached Wall Street and the bank, Sterling stormed the director's office just as he had burst into Charles's bathroom. He handed the banker a certified check for two hundred thousand dollars and issued an order that the amount be cabled immediately to the branch of Morgan's on the Place Vendôme—a place well known to Sterling—and put into the account of Durand-Ruel et Cie.

The banker said it would suffice to post the check by mail, which at the time meant on a ship. Sterling exploded. "Brandishing his cane in the face of the director, he chewed him out and threatened to close his account with the bank if his check wasn't cabled within five minutes."

Almost ten years later, during the Second World War, there was a similar incident. In 1942, the Durand-Ruels were in Paris during the Nazi occupation. For this reason, the company's assets in the United States were monitored by the American government. Sterling, as eager to thwart Washington during the Roosevelt administration as to help a friend, offered to buy the American branch of Durand-Ruel in its entirety and sell it back at the same value whenever the family could return to New York. It didn't happen, but the Durand-Ruels never forgot their client's generous intentions.

THE JOYS OF earthly existence were mainly in these interactions with art dealers and the canvases he put on his wall and in the silver he held in his hand. Robert Sterling Clark certainly needed such evocations of life's perfect moments all the more strenuously, because in 1927 the family relationships that were already under strain took a nosedive.

Sterling was still fuming over the results of his lawsuit two years earlier concerning taxable dividends. He and Francine were also increasingly at odds with his brothers and their wives. He was determined to figure out another way to bolster his income and, at the same time, to prevent his family members from getting his money in the future. The only solution was to seek to break a trust he had executed in 1910.

In one of those highly public controversies that often besmirch the lives of very rich families with multiple heirs, Robert Sterling Clark tried to gain more control of his megafortune than was allowed by one of

R. J. CLARK FIGHTS A $20,000,000 TRUST

Holds Fund Containing Singer Dividends Is Illegal — $80,000,000 Rests on Decision.

The New York Times, *October 22, 1927. The family's lawsuits and financial disputes were often everyday reading for the American public.*

the trusts that managed it. Sterling's name had often appeared in the business pages of *The New York Times* and other newspapers when he sold valuable real estate that was part of his inheritance, or for his attempts to lessen his tax payments, and his contentiousness was well known, but this was the first time that differences within the Clark family made the daily newspaper.

As readers of *The New York Times* discovered over their morning coffee on October 22, 1927, the second of the four sons of Alfred Corning Clark had brought suit against "Sir Douglas Alexander, President of the Singer Company, and Jens C.L. Skougaard as trustees, and his brothers F. Ambrose, Edward Severin and Stephen Carlton Clark, and the children of his brothers." What was at issue, beyond Sterling's willingness to stir up problems and his making the dimensions of the family fortune public, was that, beyond a great deal of other money and additional Singer shares, after Alfred died (the newspaper mistakenly referred to him as the Singer founder), seventeen thousand shares of stock had gone to each brother and to their mother, and upon her death the boys had divvied up what she had received, so that now each of them had, held on his behalf in a trust, more than twenty-one thousand shares valued at a hundred dollars a share. The original trust designated that, while these shares were held in trust with the brothers getting the income, "upon the death of each son the principal goes to his issue, and if there are no children the

shares are to be divided among the surviving brothers and their issue."[69]
Therein lay the crux of the problem.

Those who followed this sort of story would discover that although
the millionaire had married in 1919, even his wife—let alone her illegit-
imate daughter, about whom there was no information in the morning
paper—would not get a penny from the trust. "Clark Trust Funds Put at
$80,000,000," the newspaper headline declared, so this was not pocket
change; money of that scale boggled the imagination, and the public was
duly fascinated.

What was at stake was what Sterling had received as dividends rather
than the corpus of the initial trust. His contention was "that when he
agreed to put in trust all of the shares of the Singer company and its sub-
sidiaries received as dividends on the stock left him by his father, he was
not told that he was not obliged to do so, and that the assignment of a
property he was to receive under a legacy would be invalid."[70] He was
now trying to extract the disputed shares from the trust so that he could
own them free and clear and control their ultimate disposition.

Sterling lost. Moreover, in the course of the newsworthy lawsuit, the
State Supreme Court Justice declared that neither Sir Douglas Alexander
nor Stephen Carlton Clark, the primary defendants, had to disclose their
evidence in pretrial examination. It's just the sort of matter that alters
family relations forever.

As with all family feuds, there were different versions of the story, but
the upshot was that Robert Sterling Clark, having gone against every
member of his family and spared no one as his target, would never again
speak with his brothers. Family relations were permanently torn asunder,
and even if the others would have forgiven him, Sterling would sustain
his unequivocal rage almost to the end of his life.

THE MAGNITUDE OF STERLING'S BITTERNESS was on a
par with everything else in his mind. The older he got, the less inclined
he was to temper his feelings, whether it was his views on a painting or
his sense of injustice and wrongdoing. If, as a younger man, he readily
made up his spats, now he would not mollify anything. He began to
speak of Rino, Brose, and Stephen as "dear charming brothers!!";[71] his
sarcasm had a Shakespearian vehemence. Nothing could diminish his
wrath; when a lawyer transmitted the message, in 1929, that the others

"would like nothing so much as a reconciliation," his comment was sim-
ply "Balls."[72] He believed that "Stephen lied in his letter when he said he
had consulted no lawyer."[73] In 1929, when a conciliatory proposal was
brought to him by an intermediary suggesting that his brothers "guaran-
tee the payment of the inheritance tax on the Singer Stock in Trust going
to them or their children & not have it paid by my residuary estate,"[74] he
rejected it totally, reasonable as it sounded. He simply intended to sever
all relations.

A mutual acquaintance of Sterling and his brothers pointed out to
him that he had become sadder since the break; it was in the interest of
his own well-being to find an amicable solution. He replied that he only
wanted vengeance: "May God curse them all for their double dealing
with a trusting man like myself & may I see them suffer morally & mate-
rially."[75]

"That swine and treacherous sneak Stephen"[76] was the one he blamed
most of all. Sterling became convinced that Stephen was in cahoots with
a surrogate in the legal proceedings who had been responsible for the dis-
appearance of key papers. He felt completely victimized by this sibling
with whom he had once had the possibility of the greatest closeness but
whom he now regarded as a complete cad. A typical diary entry, from late
January, 1929, reports: "I trusted Stephen as a brother & friend and never
suspected him once as he had the same fortune as myself & was always
harping on our all having too much money!!! May God curse him on
earth as well as in heaven!! . . . Lunch. Told F. [Francine] I had been
under a lucky star in 1923 to have escaped from Stephen & my lawyers
without having had the skin removed from my back!!"[77]

Sterling envisioned "the probability of my surviving Rino & Brose,"
whom he considered simply pathetic next to their younger brother's vil-
lainy.[78] If this were so, and they had no offspring, regardless of what hap-
pened to his portion of the family's wealth, a fortune would go the way of
Stephen and his family. Anticipating that scenario, Sterling, in his
diaries, provided a scathing portrait of the two brothers closest to his
own age. "Rino impotent. Likely to go off from apoplexy. Brose likely to
die from drink. Brose used to look 10 years younger than I did. Now peo-
ple always say with surprise, 'Why I always thought Brose was older than
you are'!! . . . people said Brose drank like hell."[79]

Sterling's calculations did not pan out. Although Rino's days were
numbered, Ambrose Clark would live longer than any of his other sib-

lings. Brose guzzled his Champagne even more than Sterling sipped his Burgundy—he was famous for the quantities of bubbly he regularly imbibed—but if it affected his health, it was perhaps for the better.

STERLING WAS AS OBSERVANT as he was stubborn. At the end of January, about two weeks after writing this diary entry, he was walking up Madison Avenue between Fifty-fifth and Fifty-sixth streets when a woman rushed out of a lingerie shop toward her chauffeur-driven car parked in front. He saw her see him, hesitate, and then continue toward the car. "As I stepped aside to pass I saw by her eyes, she could not help but look, & their extraordinary blue that it was Susan Clark." It was such a cold day that, between her hat and scarf, Susan's face was "so covered up I could not have recognized her except for her blue eyes. I of course did not turn."[80] This was the woman whose boudoir he had been so desperate to design and give her.

Something vital had changed inside Sterling. He had always been quirky and difficult, but now the same obsessiveness that had made him go nonstop in his pursuit of beauty as a collector overtook him not just in his rage at his brothers but also in his preoccupation with income taxes. He was forever seeking schemes to avoid paying as much to the government as he did. Sterling calculated that if he gave up his New York apartment and put the Cooperstown house in another name, and established legal residency in Kentucky, where he was spending time because of his horse-racing interests, he could save thirty thousand dollars annually in state income tax. After years of profligate spending, this was among the first of his many ideas for how to save money; the one route to that goal he would never entertain was to stop collecting.

In this period at the start of 1929 when everything was so dire to him, Sterling's marriage was stumbling as well. He and Francine were having frequent spats; he began to suffer physically from all the upset. "If only she would not complain so. It started my colon jumping again."[81] "She never does anything whether it is Sunday or not. She seems to have lost interest in everything. At least everything that I am interested in. Besides she does not seem to like people except in parties. . . . I cannot get her to ride. I have tried so many times I have given up. Therefore I just ride alone. . . . If I exercised as little as she does I would die, and she does not listen for a moment when I tell her so. . . . I have to exercise or I feel like hell. Now she has made my colitis worse by having me do this &

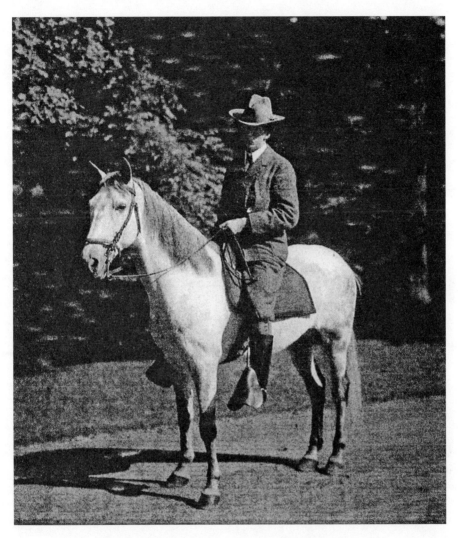

Sterling in Cooperstown. Sterling disapproved of popular forms of
recreation like bridge and golf but had a passion for horses.

do that. All the household affairs, business, even telephoning, inviting
people all devolves on me. And this has been steadily growing worse &
not better for 9 years."[82]

The glamorous life of one of America's richest men had become
increasingly tragic. The art with which Sterling continued to grace his
existence was upbeat and full of charm, but almost everything else was a
source of anguish. His elder brother was faring even worse than he was;

in Cooperstown, a local woman reported to Francine, "Rino in an awful state, fearfully fat, could not walk, now in Dakota in New York . . . very despondent & melancholic, surrounded by masseurs & doctors."[83]

If at other moments Sterling wished only damnation on all of his siblings, he regretted the plight of this one. Sterling felt that the village of Cooperstown would suffer terribly if Rino did not return there that summer, yet that, sadly, it was unlikely he would be able to do so. He had a firm notion of who was who in the family; Rino was the innocent victim, while he, Sterling, was the most decent and amiable one. "Myself & Francine the only people who ever took any pains over Rino. And what he has lost by staying with the others!! I am the most liked of any of the brothers in the village."[84]

What an odd mixture Robert Sterling Clark had become: still with his sweet side, ever anxious about the feelings of the townspeople for whom his parents had been like royalty, but totally taken over by rage.

PERHAPS IN REACTION to his internal strife, Sterling began to buy and sell grand houses manically.

In the spring of 1929, he bought, in the heart of American horse country, Walnut Springs Farm, a splendid property on the outskirts of Lexington, Kentucky. He immediately began to renovate the main house, taking the same delight in the process that he had when he had gutted his Paris town house and begun to decorate it. Not a year had passed when, undaunted by the stock market crash, he bought another country residence with perfect grazing land for the racehorses he loved—this time in France, in the region of Normandy where the apple brandy called Calvados is made. The estate, called La Lisière, was on the outskirts of the town of Livarot. The grand manor house was flanked by barns and outbuildings surrounded by splendid gardens and sprawling lawns, set within one hundred twenty acres of farmland and pastures.

The year after that, he sold the place in Kentucky, in spite of all the work he had undertaken there, while working zealously on the one in France. To the manor house in Normandy he added a new kitchen and laundry room and redid the roof, stonework, and all the utilities. He also built new houses for the overseer and the caretaker of the farm, and added stables.

Both in France and America, Sterling was getting more and more seri-

ous about racehorses. With what seemed like bottomless pockets even in the depth of the financial depression, in 1932, only a year after beginning the overhaul in France, he now bought land in the fashionable community of Upperville, Virginia, a hub for the rich horse lovers who could afford to live in this beautiful region south of Washington, D.C. That year, Sterling "registered his colours, cerise and grey stripes, quarter cap, blue sash, for English racing."[85]

He named the forty-six-acre farm in Virginia "Sundridge." There he constructed another large house, this time Colonial, with a fantastic semicircular horse barn. The property, adjacent to that of Paul Mellon (who would buy it after Sterling's death), was yet another stab at enjoying life as much as possible even when he felt that so much was going wrong, in the country as well as within his immediate family.

STERLING'S ART COLLECTING also continued in these years of lawsuits and marital strife, though it lacked the oomph it had once had. He was still buying beautiful works by Degas, Sargent, and Renoir, but not in the same volume as before. Overall, the quality level of his buying had slackened as his life lost much of its charm. He acquired more and more pictures by comparatively minor artists like Alfred Stevens and Théobald Chartran, and there were more Boldinis and Daubignys coming in as well; it was as if he was primarily trying to fill himself up on surface prettiness, almost like an unhappy child gorging himself on candy.

The problems with the marriage were probably exacerbated by both husband and wife's having recently turned fifty and being at a time of life many people find intrinsically difficult. They were both at low points. Sterling and Francine went to Kentucky that May, yet although she insisted on going, she remained in their hotel room once they got there, and he could "not go shooting or fishing because she does not want to go. . . . I want to travel to outlandish places. I can not. I wish to have a place in Kentucky & live some of the time there. Cold water. I try to interest her in her affairs. Nothing doing."[86] In the solitude of the diary that seemed his sole companion, the lonely husband lamented that it was his task to do all the organizing of their lives. He was the one to schedule dinners, telephone other people, and write letters; she was, at least for the time being, mainly a thorn in his side. "Woman was not made to be the companion of man but to be in a harem. At least that is what it seems to

*Sundridge, the house in Upperville, Virginia. Away from the proximity of his brothers
in Cooperstown, Sterling and Francine built luxurious residences with fields
and stables as he became a breeder of champion racehorses.*

me at the present time. I do hope it will change but if it does not it
means that there will ultimately be a separation. I pray that things will
remedy themselves."[87]

How incredibly different Sterling was from his subtle and circumspect
father! Alfred's second son had become a pathetic combination of vitriol
and hopefulness, the main consistency being that he felt out of control of
his own destiny. However complicated a life Alfred himself had led, in
his quiet way he had always kept everything under wraps. Sterling, on
the other hand, made no effort at all to conceal his emotional extremes.
When he was cheerful, when life was bounteous, he was as expansive and
celebrative as the sunniest Renoirs that graced his walls. At other
moments, he was consumed by contempt for the people around him.

Today his deep rage would probably be recognized as a symptom of
depression, and he might have been helped to see it in perspective. No
one suffered more than he did from his own explosions. He paid the
greatest price of anyone for the anger he was perpetually venting in his
own mind and recording in his diaries, and proper counsel or treatment
might have helped him deal with it better to spare himself as well as his
family members. Alas, no one else helped him find balance.

His main scapegoat for his misery remained Stephen. Shortly after these laments for his and Francine's situation, Sterling gleefully wrote, "It must burn Stephen's heart out to see Rino spending so much money which he thinks should go to him & his children!! I do hope Rino will leave most of his fortune in a Trust Fund Endowment!"[88]

The reasons for wanting an endowment, of course, were twofold. Sterling was eager that nothing extra go to Stephen, Susan, and their children; he also believed that the family's wealth should be used for the good of the greater community. Ironically, he and Stephen had in common, even more than their love for art, a deep wish that the public benefit from their fortune. Each had inherited from his parents the belief that Singer and Clark money should be used for the betterment of the world. Each in his way would ultimately do amazing things for thousands upon thousands of people they did not know, even if they could not work out problems with one another.

Complex attitudes—ranging from despair and rage to the loftiest altruism—swirled simultaneously in Sterling's head. With that wish for the well-being of others, Sterling, like his father, could not tolerate the life of the idle rich, people who did not make an effort to break free in some way. But where Alfred and Elizabeth might have shared some of his annoyance or impatience with people who hoarded their wealth, Sterling was completely unlike them in his pathological anger as well as in his coarseness of expression and his guttersnipe blasts at the world around him. If one reads through the fury, though, one sees the flip side—why this man who was so hard on so many people ended up being a truly great philanthropist and benefactor of humanity. His rage came not just from some deep sadness within him, but also from a belief that there was some real possibility for good in the world, the violation of which was intolerable. All of these factors would color what he said and did, generous and cruel, in this period when his emotions were so particularly raw after he failed to secure his own fortune on the terms he wanted.

IN HIS WARPED VIEW of the world around him, Sterling was obsessed not just with the moral corruption of the rich but with issues of masculine power and of his ideas of the appropriate roles of the sexes. As he considered selling his farm in Cooperstown in June of 1930, Alfred Corning Clark's son wrote in his diary that the local society had become "broken down men, old maids or dissatisfied women, and parasites of the

worst kind. . . . young men who have married rich women . . . or Jim Cooper with all his worshippers of Sappho or his sons without balls. None have any interest in things concerning the country or taking them seriously. All lose money on their farms. Seem to think they ought to have them."[89]

Like his father, he considered himself apart from most other rich people. But whereas Alfred gave no evidence of being bothered by the habits of others born to privilege, and questioned his own right as much as anyone else's to inherited money, Sterling derided what he saw as the decadence, in particular, of the other summer people in Cooperstown. His father might have held the same views, but would certainly never have voiced them with the same bitterness: "Very few are interested in anything other than congregating together and gaming. Golf for gaming and exercise, bridge to fleece one another. The older women never let up and play morning, afternoon & evening." He and Francine were complete outsiders: "We have very very few interests in common and certainly no friends and even more surely no one we care about."[90]

Sterling had devolved into a level of hostility that was destroying him. Consumed by his bitterness, citing the reasons for which people he knew were becoming senile, Sterling wrote, "Besides one meets over & over again the same people and there is never a breath of fresh air from the outside in new people. Or if there are new people they are the same ilk or sapphists or parasites one does not wish to receive in one's house. It is a village of the idle rich principally my brothers or the idle moderately rich who hang on for want of better to do & eke out an existence composed of sleep till 11 a.m., boredom, golf, provided by the Clark Estates, or bridge to please one another. Nothing comes from the soil as it should in the country. . . . And year by year it is worse. The Sapphists increase, the parasites increase & the tarred roads increase."[91] Even Dostoevsky's most tormented landowners had no rival in the ability to put intense, unguarded fury into words.

Above all, he fulminated against those denizens of the village he most assiduously avoided—his brothers. "Brose from his drinking and vanity, Stephen should be the same, grows more common & vain year by year."[92]

IN THIS STATE OF MIND where he was like someone who had been poisoned, Sterling began to contemplate giving up his Coopers-

town residence completely—not only to change his tax base but also because of how livid such an act would make his brothers. The prospect of their consternation delighted him.

At the same time, he was continuing to try to wrest greater control of his trust. In the summer of 1929, he initiated proceedings against Jens Skougaard as a trustee. Not surprisingly, he considered the brother of his father's beloved companion "weak as water, a straw man. To hell with him."[93] He was fueled by contempt; after the stock market crash that October, Sterling had one main reaction: "I only wish Stephen would be well caught in the stock market & lose several millions."[94]

Sterling's life had its flip side, however. In the midst of this tempest of bitterness, he was still focused on what he loved, and buying remarkable artworks. In 1930, when cash was scarce for most people, he acquired two fine Corots. If he had deliberately sought all the qualities that were lacking in his own life, he could have done no better. The subtle canvases are splendid evocations of peace and tranquility, their voice gentle and muted. Everything about Corot's work bespeaks calm and resolution. And he and Francine latched on to a charming Renoir of a dog, that was sure to bring a smile to viewers.

On the other hand, Gérôme's *Slave Market,* which Sterling also bought in 1930, was something else. More than his father's beloved *Gladiator* and *Snake Charmer,* this was a typical work by the nineteenth-century French painter who was the darling of the salons, and had wielded enormous influence at the École des Beaux-Arts for forty years, because it presents, in sharp focus, a scene in which naked women are offered for sale to a gloating crowd. One could say that Sterling was drawn above all to the technical virtuosity of Gérôme's taut drawing and perfect, smooth surfaces, but surely he could not have been blind to the subject matter. Possession and power and, concomitantly, oppression and helplessness were displayed unequivocally.

The Gérômes that had graced the dining room of his parents' house had, of course, focused on male beauty. One portrays the bravura of a muscular Roman gladiator; the other celebrates the glowing buttocks of a teenage boy. By buying a painting in which it was naked women who are put on display, Sterling was asserting his difference from his father. If one could ever have penetrated the complex workings of his mind, the sources of his rage and his confusion as well as his marvelous receptiveness to beauty might all have been as clear as the rendering of skin and drapery and marble in the Gérôme.

. . .

ART WAS STERLING'S BALM. With his enviable station in the world, he continued to sustain a sense of well-being that counteracted many of the conflicts in his life by acquiring masterpieces. In 1932, at Knoedler's in New York, Sterling purchased J. M. W. Turner's magnificent *Rockets and Blue Lights*. It was his luck to have cash when many other rich Americans were seeing their fortunes depleted; this painting belonged to Charles M. Schwab, who had to sell it for half of what he had been offered for it in the twenties. What a revelation of imagination and atmosphere this 1840 canvas by the British master is! The swirling ocean and explosive sea spray are so real that one mentally gets soaked just looking, at the same time that the rendering is clearly paint, and the illusion of art is frankly glorified rather than concealed. The drama of the scene, with the rockets being fired from a pier to warn ships of dangerously low water, was Sterling's sort of thing; so was the celebration of the artistic process, the physicality of the paint—the same qualities he had admired in van Dyck's *Inigo Jones*. If Robert Sterling Clark wanted to be jolted from the gloom of his familial struggles, he could hardly have found a more forceful or vivid rendition of the energies of the universe.

THE OLDEST OF Alfred and Elizabeth's sons, Edward Severin Clark, died in 1933. Having not spoken to his brother, now sixty-three, since the rift six years previously, Sterling was completely thrown. Time and again, his heart had gone out to the tragic Rino. Now he only felt spurned. In his diary he noted that an article about Rino's estate in *The New York Times* had not even mentioned his name, while reporting "30 million charity bequests all to Brose & Stephen."[95] Rino left Stephen the Dakota as well as his property in Cooperstown. Sterling summed up his feelings by reporting his siblings "had done me dirt."[96]

At least things were better between him and Francine. She regularly went back to France without him to see her daughter and other family members, and check up on the house on the rue Cimarosa, but when she returned to America that November, just after he had been brooding over Rino's estate, and he greeted her ship, the reunion was magical. "Lord how good it is to have her back & she is so happy as I am—We played young lovers all over again—nuit d'ivresse de premier ordre."[97]

The former actress brought great solace to the sewing machine heir. Sterling was pleased when Francine reported that "everyone in Paris is persuaded Roosevelt is crazy,"[98] for he heartily concurred. For one thing, by his account, with an annual income of about three million dollars, he claimed to be paying eighty percent in state and federal taxes.

His solution, if he couldn't recoup tax money in court, was to get involved in politics. He offered fifty thousand dollars a year to Al Smith, a vocal opponent of the New Deal. This was his first effort to vanquish Franklin Roosevelt, a wish that would, like everything else about which Robert Sterling Clark had an opinion, turn into a preoccupation.

For now, he was content simply to bankroll the opposition and to call Roosevelt "Rosenfart." It was still to be seen how far he would actually go in his efforts to depose the man he believed was destroying America.

ROOSEVELT AND HIS BRAIN TRUST were swindling the country; the modernists were violating all that was good and truthful in the art of painting. At Knoedler's one day, Sterling decided to see the "new art." "The Matisses sell at $2000 to $6000. Awful things. Mere daubs of grotesque figures. It seems Stephen loves them and has several."[99] And bad as Matisse was, others of the new generation of painters were even worse. The Museum of Modern Art had now opened its doors, with his brother as one of its first trustees. Although it was, in this early stage, on Fifth Avenue and Fifty-seventh Street, on the same block as some of the galleries Sterling visited on a daily basis, he would not set foot inside, and when he saw work by some of the heathens featured there, he hit the roof. After going to an exhibition at Durand-Ruel of Matisse, Picasso, and Braque, he wrote of the cubists, "I would not give $10 apiece for them—Matisse still holds to semblance of human form but Picasso & Braque impossible to guess what they are."[100] He seemed, however, to give slightly more credence to a Modigliani—by saying it was not worth twenty dollars.

He was also now often angry at dealers, thinking they had rooked him. At least, if they had overcharged him for a Goya, he had underpaid them for a Degas, but the game infuriated him. And when Sterling felt ire, there was no holding him back. In 1934, he learned that Knoedler's had sold, for six hundred pounds, a van Gogh promised to him for four hundred and fifty. It was an unpardonable offense.

Before hearing the news that it had gone to a different owner, Sterling

had received a telegram saying the work was his and no longer for sale. Once he was informed otherwise, he gave Knoedler's a week to put the painting in his hands. Otherwise, he insisted, the firm where he was such a major client had seen the last of him. He told his personal salesman there "that I did not permit such liberties by little mountebanks."[101]

When the van Gogh still did not come his way, the relationship with the art gallery at whose London and New York branches Robert Sterling Clark regularly bought up to half a dozen important paintings annually came to a full stop. But, unlike his rift with his family, the feud with the gallery quickly had a reconciliation. Sterling never explained why in his diaries, but it was only a matter of months before his records reported a resumption of purchases at Knoedler's; when art was at stake, he could patch up his differences.

He was again buying pictures in droves. In the year of his elder brother's death, the midst of the period when he was most at war with his family as with the U.S. government and its tax laws, when life itself was full of foes for him, Robert Sterling Clark let himself go as never before with a string of purchases of art that celebrated natural beauty and the power of the artistic imagination at a peak. In that single year, the man who, on one side of his existence, was plotting against family and deploring the world around him, bought, as if testifying to the possibilities of life well lived, three Monets, a Pissarro, a lovely Sargent, another sugary Alfred Stevens, and six fantastic Renoirs, including one of *Mme Monet Reading.*

ONE OF THOSE MONETS was *Cliffs at Etretat.* A more vivid image of wild natural splendor would be hard to imagine. In other paintings Claude Monet revealed nature tamed and controlled. The scenes of gardens, manicured ponds with handsome footbridges, and ladies in parasols looking at rows of flowers show life at its most cultivated. But the Etretat view presents the earth as it has been for thousands of years on a rough bit of coastline at the edge of a roaring sea. Invariably bold in his manner of dabbing paint on canvas so as to evoke light and atmosphere as well as physical substances, here was Monet focused on a subject the force of which rivaled his own at his craft.

Whatever else was happening in his life, for Sterling this masterpiece of energy and joy was an infusion. To acquire it brought rare pleasure, just as, years later, to give and house it for the public would.

And he did at last buy the van Gogh that had been the object of the dispute three years ealier: the 1886 *Terrace in the Luxembourg Gardens.* If Stephen would buy one of the most unsettling van Goghs ever, the one Sterling bought was a pure essay in impressionism, its colors soft, the imagery picturesque, the brushwork such that one could mistake this for a Sisley or a Pissarro, but it was in some ways his most modern picture.

In 1934, however, Sterling's pace of collecting slackened slightly. He was in and out of his usual New York galleries—Durand-Ruel, Knoedler's, and Scott & Fowles—at a steady pace, and bought in the course of the year paintings by Manet, Renoir, and Sargent (one by each) as well as groups of pictures by his preferred lesser-known artists, but some of his energies were going in a very different direction.

For, although he would strenuously deny it, Robert Sterling Clark was publicly accused of being part of "a plot of Wall Street interests to overthrow President Roosevelt and establish a fascist dictatorship, backed by a private army of 500,000 ex-soldiers and others."[102] *The New York Times* gave the story on November 21. A retired U.S. Marine Corps officer, Major General Smedley D. Butler, whom Sterling Clark had known ever since serving with him in China, had told all to the House of Representatives Committee on Un-American Activities in special hearings on the attempted putsch.

The accusation was major national news, although its validity was cast in doubt. "There were immediate emphatic denials by the purported plotters." General Hugh S. Johnson, a former NRA administrator who "was scheduled for the role of dictator" as the person to run the country once Roosevelt was ousted, countered that no one had ever approached him with the idea "and if they did I'd throw them out the window." A partner at J. P. Morgan & Co., said to be backing the plot, called the accusation "Perfect moonshine! Too unutterably ridiculous to comment upon!" One of the heads of another stock exchange firm, Murphy & Co., also cited as supporting the putsch, insisted it was "A fantasy! . . . absolutely false." And Gerald P. MacGuire, a bond salesman for Murphy & Co., who Butler said had asked him to head the proposed Fascist army, said it was "a joke—a publicity stunt . . . made out of whole cloth."[103]

If the story is to be believed, however, Robert Sterling Clark was a major player in it. General Butler said that after MacGuire approached him in the summer of 1933, MacGuire had then arranged for Sterling to visit him at his home in Newtown Square, Pennsylvania. He insisted that Sterling had been among the people to provide part of the three mil-

lion dollars already raised to back the plot and, beyond that, had promised half of his sizable fortune to cover the costs of assembling an army of half a million men to execute it.

THE PLAN AS ADUMBRATED by General Butler was simple enough. The show of force in Washington would inspire Roosevelt to leave office peacefully, in much the same way that the king of Italy had shipped out when pressed by the militants who backed Mussolini. If the president did not comply, then the insurgents would give him as well as the vice president and secretary of state no choice but to leave, while having Roosevelt appoint Johnson, their chosen dictator, "as a new Secretary of State, who under the Constitution would then succceed to the Presidency."

Butler's testimony to the House Committee, which was played down in the newspaper and magazine accounts at the time, and made to seem largely specious by influential commentators, seems credible about the attempt to overthrow and replace FDR, and Robert Sterling Clark's role in it. Butler's claims, moreover, were supported by the committee's subsequent investigations and conclusions.[104]

The House Committee conducted hearings between April 26 and December 29, 1934, in Washington, D.C., New York, Chicago, Los Angeles, Newark, and Asheville, N.C. They examined hundreds of witnesses about the matter and accumulated over 4,300 pages of testimony. A lot of the material was subsequently suppressed, with entire sequences of pages removed from the transcripts, and, to date, no one has been able to obtain a complete record of the hearings, but the investigation, which seems balanced and objective, was quite conclusive.

In a secret executive session of this Special Committee on Un-American Activities, held in New York on November 20, 1934, the day before *The New York Times* piece appeared, Butler testified for about two hours. The chairman and vice chairman of the committee—Representative John McCormack of Massachusetts, eventually Speaker of the House, and Representative Samuel Dickstein of New York, who would become a New York State Supreme Court justice—conducted the hearing that day. McCormack opened by establishing General Butler's credibility as two-time recipient of the Congressional Medal of Honor. Butler then revealed that he had his first inkling of the plot on July 1, 1933. Having retired after years of active military service to a secluded house

in Newtown Square, Pennsylvania, he was visited that day by Gerald MacGuire and Bill Doyle, two commanders of the American Legion, the veterans' organization that had been founded in 1919 and was backed by big business. The Legion was generally known for its support of strike-breaking at the behest of industry and its reactionary policies against civil rights.

Butler, "a wiry bantam of a man . . . his hawk nose prominent in the leathery face of an adventurer,"[105] had no idea why the two men, who had arrived in a chauffeur-driven Packard limousine and wore impeccably tailored suits, but who claimed they represented "the plain soldiers," had shown up.[106] They said that they wanted him, as a distinguished general, to make a speech at an American Legion convention in Chicago for the purpose of "unseating the royal family in control of the American Legion"[107] and persuade the Legion "to adopt a resolution calling for the United States to return to the gold standard,"[108] but, as he testified to the House Committee, he told MacGuire, "I don't know a damn thing about gold."[109] He suspected that something more than gold was on his visitors' minds.

MacGuire had talked nonstop, ostensibly about problems within the current administration of the American Legion, but also about how President Roosevelt had personally opposed Butler's attending the Chicago convention. Given that the president had been pleased with the retired general's participation in the Republicans for Roosevelt organization, Butler was puzzled.

"It crossed his mind that the purpose of the story, true or false, might be intended to pique him against the Roosevelt administration."[110] But he said nothing at the time.

MacGuire was a $150-a-week employee for Grayson Murphy, the brokerage house head who would be quoted in *The New York Times* as calling the plot "a fantasy." Murphy was a West Point graduate who had given the Legion $125,000 to get started in 1919 "and who had extensive industrial and financial interests as a director of Anaconda, Goodyear Tire, Bethlehem Steel and a number of Morgan-controlled banks."[111]

"Murphy's personal appearance was impressive—tall, heavy-set and giving evidence that in his younger years he must have been quite handsome."[112] MacGuire was his perfect foil: "a short stocky man tending toward three chins, with a bullet-shaped head which had a silver plate in it due to a wound received in battle; his close-cropped hair was usually topped by a black derby, the popular headgear of the day. A reporter

described his bright blue eyes as glittering with the sharpness of a fox about to spring."[113] Butler described to the House Committee how dazzled he was when MacGuire showed him a bank book with deposits of forty-two thousand dollars and "suggested that he gather 200 or 300 men and pay their expenses to the Chicago convention, the purpose being at the proper moment to have these men recognize Butler and demand that he make a speech and that then Butler was to make the speech on behalf of the gold standard, which he says had been handed to him."[114] Butler asked MacGuire about the source of the money, but MacGuire offered only an ambiguous response; subsequent testimony would indicate that it had come from Robert Sterling Clark.

Butler was clear as to why "some wealthy Americans might be eager to use the American Legion as an instrument to pressure the Roosevelt Administration into restoring the gold standard."[115] Many rich people objected to the way that the government had abandoned the requirement of backing up paper money with an equivalent amount of gold. But conservative financiers feared that the inflationary currency would weaken their fortunes and lead "to national bankruptcy. Roosevelt was damned as a socialist or communist out to destroy private enterprise by sapping the gold backing of wealth in order to subsidize the poor."[116]

Butler testified that he met with MacGuire again in a Newark hotel room in September 1933, at a reunion of the Twenty-ninth Division. MacGuire took out his wallet and threw eighteen thousand-dollar bills on the bed and repeated his request that Butler go to the convention and make his speech. Butler mocked MacGuire for thinking he might accept the cash, while, as he told the House Committee, he "realized that MacGuire was only an agent" for powerful backers, whose identity he demanded.[117] MacGuire replied that one of the people who had contributed generously to the fund and was eager to send the general and his trainload of Legionnaires to Chicago was Robert Sterling Clark—whom the general remembered as "the millionaire lieutenant" who had served with him in the Boxer campaign in China.

When Butler told the committee that MacGuire's chief funding source had been his second lieutenant from the Ninth Infantry he went on to describe Sterling as "sort of batty, sort of queer, did all sorts of extravagant things. He used to go exploring around China and wrote a book on it, on explorations. He was never taken seriously by anybody. But he had a lot of money."[118]

That September, Sterling himself phoned Butler and said he would like to visit him at his Pennsylvania house. Butler described the reunion at the local train station to the House Committee. "I had not seen him for 34 years, but I could see that he was the same man, a long, gangling fellow."[119] As Butler told the House Committee, "Clark . . . reminded me that we [had] served together in China and the Boxer trouble in 1900."[120] At lunch, after reminiscing about the good old days, "Clark got down to the business of the visit." Sterling told Butler that he would be going to the American Legion convention in Chicago in a private car attached to the Pennsylvania Limited. He would stop en route to pick up Butler so that they could go to Chicago together. Butler would be staying in a fine suite at the Palmer House, the best hotel in the city.

Sterling then made his case for the restoration of the gold standard. Ostensibly, the reason was that when the Legionnaires received their bonuses as veterans, it would be "in gold-backed currency, not in worthless paper."[121] But Sterling was candid with the general that it was more than those bonuses that he cared about. "He had a personal fortune . . . and he was greatly worried about losing it to a Roosevelt inflation-runaway government spending unbridled by the need to back each paper dollar with gold."[122]

In his testimony under oath to the House Committee, Butler quoted Sterling joking about the Legionnaires' visit to give Butler the text of the speech. Sterling was full of his usual bluster. "Did those fellows say they wrote the speech?" he asked.[123] When Butler said that they had, indeed, claimed to have written it, Sterling "laughed and said, 'That speech cost a lot of money.' . . . He thought it was a big joke that these fellows were claiming authorship."[124] According to Butler, Sterling explained, "I have got 30 million dollars and I don't want to lose it. I am willing to spend half of the 30 million to save the other half."[125] Sterling believed that if Butler made the speech in Chicago, soldiers would back the return to the gold standard. He assured his former general, "We can get soldiers to go out in great bodies to stand up for it."[126]

Butler recognized that if Sterling was talking about spending $15 million, and cared so deeply about all this, he had more on his mind than just the event in Chicago. As he told the House Committee the following November, "This was the first beginning of the idea, you see, of having a soldier's organization."[127] At the same time, Butler could not imagine

why Roosevelt would give in to the tactics proposed by Sterling. According to the Public Statement eventually issued by the House Committee, "although Clark offered the use of a private car," Butler completely rejected the proposition "to get soldiers marching around."[128]

The sewing machine heir, however, persisted. "Clark expressed confidence that Roosevelt would yield because he belonged, after all, to the same social class that was solidly behind the gold standard."[129] The president would be more than pleased to be re-allied with "his fellow patricians" once he had protected their interests.

In testimony in the House hearing that was censored at the time, Butler quoted Sterling saying, "You know the President is weak. He will come right along with us. He was born in this class. He was raised in this class, and he will come back. He will run true to form. In the end he will come around. But we have got to be prepared to sustain him when he does."[130]

Butler angrily accused the former soldier of exploiting the veterans for his own purposes, trying to use them "to undermine democracy" rather than "to defend it."[131] A crimson-faced Sterling simply responded that "the mortgage on Butler's house could be taken care of for him, and in fully legal fashion."[132]

The attempted bribe was more than Butler could bear. He flew into a rage, bellowing in a way that Sterling would have taken from nobody else. Sterling not only apologized, but phoned MacGuire in the general's presence to explain that the general would not make the trip. By the time Butler drove Sterling back to the train station, they were again reminiscing about the good old Boxer days.

THE MATTER was far from over. For one thing, MacGuire and his backers succeeded, even without Butler giving the speech, in campaigning the conventioneers with so many telegrams that they passed the gold standard resolution. In December, MacGuire went to Europe, backed by the same people. "In the eyes of America's industrialists and bankers, the President, if not an actual secret Communist, was dedicated to destroying the nation's capitalist economy by the New Deal, which they labeled 'creeping socialism.' Many believed that unless FDR were stopped, he would soon take America down the same road the Russians had traveled. They were horrified by his recognition of the Soviet Union on November 16, 1933, seeing it as a sinister omen. They were equally appalled by his

speech six weeks later promising that the United States would send no more armed forces to Latin America to protect private investments."[133] For these reasons, "some business leaders envied their counterparts in Italy, who had financed Mussolini's rise to power."[134]

Butler told the House Committee that MacGuire sent him postcards from Italy, Germany, Spain, and Paris in the first half of 1934. Then, in the summer, General Butler received a phone call from MacGuire saying he had an urgent matter to discuss. On August 22—three days after a German plebiscite had given Adolf Hitler his power as führer of Nazi Germany—Butler and MacGuire met and had a lengthy conversation in an empty dining room at the Bellevue-Stratford Hotel. Butler described to the House Committee how MacGuire revealed to him the purpose of the seven months he had just spent in Europe.

"His backers had sent him abroad to study the role that veterans' organizations had played in working for and bringing about dictatorships."[135] In Italy, where MacGuire had spent more than two months, it had been the veterans in the Black Shirts who had made Mussolini dictator and who were "his real backbone, the force on which he may depend, in case of trouble, to sustain him."[136] MacGuire had also gone to Germany "to see what Hitler was doing, and his whole strength lies in organizations of soldiers, too."[137] This tour of Europe had been paid for by none other than Butler's former "millionaire lieutenant."

Not that MacGuire advocated the sort of paramilitary organizations that were behind Mussolini and Hitler. What he had observed in Mussolini's and Hitler's leadership and its backing by veterans "would not do in the United States."[138] But MacGuire "insinuated that it was 'time to get the soldiers together' "[139] in America as well.

In France, MacGuire "found just exactly the organization we are going to have. It is an organization of super-soldiers."[140] This model army of veterans was composed of about 500,000 noncommissioned officers and officers, each of whom had the ear of ten citizens so that it represented 5 million votes; it was called the "Croix de Feu." A recent insurrection backed by this group had succeeded in bringing down the government of Prime Minister Edouard Daladier. The McCormack-Dickstein Committee had in its possession a report about the Croix de Feu that MacGuire had sent Robert Sterling Clark and his attorney, Albert Grant Christmas, from France on March 6, 1934.

MacGuire asked Butler, " 'Did it ever occur to you that the President is overworked?' . . . He went on to say that it did not take any constitu-

tional change to authorize another Cabinet official, somebody to take over the details of the office: a secretary of general affairs—a sort of super secretary."[141]

MacGuire amplified. General Hugh S. Johnson, whom Roosevelt intended to fire as head of the National Recovery Administration, could assume the position as "secretary." " 'We will start a campaign that the President's health is failing. Everybody can tell that by looking at him, and the dumb American people will fall for it in a second.' " Butler testified that after outlining the plan for President Roosevelt, which would "take all the worries and details off of his shoulders, [so] that he will be like the President of France," MacGuire said, " 'I have been traveling around—looking around. Now about this superorganization—would you be interested in heading it?' "[142]

MacGuire anticipated that it would take about a year for Butler to assemble the 500,000 veterans necessary. "Such a show of force would enable the movement to gain control of the government fully in just a few days."[143] When MacGuire added that he already had $3 million with which to launch the effort, and could get up to $300 million, and Butler asked about the source for this funding, MacGuire replied, "You heard Clark tell you that he was willing to put up 15 million to save the other 15 million,"[144] and that this funding would enable them to "give privates ten dollars a month and destitute captains thirty-five."[145]

Butler now realized that when MacGuire and Robert Sterling Clark had visited him the previous year, they had already been scheming about this "creation of a Fascist veterans' army."[146] Butler recognized that as "the most popular and charismatic military figure in the United States, he also suited the plotters' plan perfectly because he was noted for a brilliant hard-hitting style of oratory that, they undoubtedly reasoned, could be put to the service of demagoguery in the same spellbinding way Hitler and Mussolini had magnetized millions into following them. His rasping voice and fiery spirit captured audiences and held them hypnotized."[147]

The plan was simple in the eyes of those who had conceived it. The veterans' army would march on Washington and install General Johnson. "MacGuire explained that the President would be induced to resign because of bad health. Vice-President Nance Garner, who didn't want to be President, would refuse the office. By the rule of succession, Secretary of State Cordell Hull was next in line, but he was far too old and could easily be set aside to make way for a Secretary of General Affairs to take

Roosevelt's place as President."[148] James Van Zandt, the national commander of the Veterans of Foreign Wars, was also "to serve as a leader of the new superorganization."[149]

MacGuire allowed that he had a vast power structure behind his effort. People at J. P. Morgan and Company also wanted to create a paramilitary group, although their first choice to head it was Douglas MacArthur rather than Butler. MacGuire told Butler that in little time an organization would be formed to achieve the objectives he had charted; when, the next month, Butler read about the creation of "the American Liberty League," he realized that this was what MacGuire had been referring to. The league's goal was "to combat radicalism, to teach the necessity of respect for the rights of persons and property, and generally to foster free private enterprise" in opposition to the "unscrupulous money changers" now at the helm in America and destroying it with the New Deal.[150] The treasurer of the American Liberty League was Grayson Murphy, MacGuire's boss, who had an office in the same building on Wall Street as Robert Sterling Clark. Sterling himself was one of the main people financing the league, whose other contributors included "Du Pont and J. P. Morgan and Company men, . . . Andrew W. Mellon Associates, and the Pew family (Sun Oil Associates)."[151] Additionally, Al Smith was behind it.

No one would ever be able to make a direct connection between the American Liberty League and the attempted putsch, but to General Butler this was the basis of MacGuire's leap from the $15 million offered by Sterling to launch the effort and the $300 million MacGuire said would be available once the campaign was under way.

In Butler's testimony to the House Committee, he quoted MacGuire as presenting the scheme as the means of assisting a U.S. president in need. MacGuire couched the plot as an act of loyalty to Roosevelt. "We want to support the President. . . . We have the President with us now. He has got to have more money. . . . Eighty percent of the money now is in Government bonds and he cannot keep this racket up much longer. . . . He has either to get more money out of us or he has got to change the method of financing the government, and we are going to see to it that he isn't going to change that method. . . . This is to sustain him when others assault him."[152] Butler described to the committee how, after explaining "that the President was overworked" and needed " 'a secretary of general affairs' . . . to take over the many heavy duties,"[153] he asked Butler to head the new superorganization that would put these changes in place.

The House Committee intended to subpoena Robert Sterling Clark. But the sewing machine heir was in Europe at the time, which conveniently protected him from the obligation to appear, since the House's subpoena power did not extend beyond American borders. One of the people who was at hand, however, was Paul Comley French, a reporter for the *Philadelphia Record* and the *New York Evening Post* who followed General Butler on the witness stand. Under oath, French described a conversation with MacGuire that had taken place on September 13—slightly two months prior to the hearing—in the offices of Grayson Murphy & Co. MacGuire told French, " 'We need a Fascist government in this country to save the Nation from the Communists who want to tear it down and wreck all that we have built in America. The only men who have the patriotism to do it are the soldiers and Smedley Butler is the ideal leader. He could organize one million men over night.' During the conversation he told me he had been in Italy and Germany during the summer of 1934 and the spring of 1934 and had made an intensive study of the background of the Nazi and Fascist movements and how the veterans had played a part in them. He said he had obtained enough information on the Fascist and Nazi movements and of the part played by the veterans, to properly set up one in this country."[154]

French's testimony was crucial. He told the House Committee that in his conversation with MacGuire, MacGuire "continually discussed the need of a man on a white horse, as he called it, a dictator who would come galloping in on a white horse. He said that was the only way; either through the threat of armed force or the delegation of power, and the use of organized veterans, to save the capitalistic system. . . . He warmed up considerably after we got under way and he said, 'We might go along with Roosevelt and then do with him what Mussolini did with the King of Italy.' "[155]

THE NEXT WITNESS before the House Committee was MacGuire himself. The name of Robert Sterling Clark came up continuously throughout MacGuire's testimony. He testified about funds he had received from Sterling for the "Committee for a Sound Dollar and Sound Currency." He also allowed that he had been given money by Sterling for his travel expenses to Europe. But he did his utmost to protect Sterling with regard to any plan to topple the government, and denied the sequence of events described by Butler and French. Congressman

McCormack and his colleagues, however, exposed him as an unmitigated liar.

The amounts of money Sterling gave and the real purpose of that money preoccupied much of the House hearing from that point forward. After claiming that Sterling had mainly helped fund the Committee for a Sound Dollar and Sound Currency, MacGuire was unable to provide the necessary bank records to show concomitant deposits on behalf of that organization. The tracking of funds and the examination of bank records, and, over the course of MacGuire's testimony, the revelation of MacGuire's consistent falsifications dominated the hearings: MacGuire minimized Sterling's financial involvement to $30,000 when it was actually over $100,000, claimed uses for the money that he could not prove, and gave reasons for his trip to Europe that were then disproved by letters he wrote Sterling and Christmas.

MacGuire contradicted a lot of Butler's testimony by saying that he had never arranged for Sterling to meet Butler; nor had Sterling phoned him from Butler's house to say that the general would not go to the American Legion convention. Initially, he also denied further payments from Sterling, but then "suddenly remembered" that Clark had given him an additional twenty-five thousand dollars in conjunction "with some bond transactions."[156] The activity within MacGuire's bank accounts, the tracking of payments from Sterling to MacGuire and back to Sterling or Albert Christmas, the existence of a letter of credit provided by Sterling on MacGuire's behalf, were all examined, with MacGuire eventually recalling having "sold bonds to the value of approximately nine million dollars for Clark,"[157] and then recalling additional payments from Christmas.

The following day, from France, Robert Sterling Clark issued a vociferous denial of his involvement in all of this and said he would return to defend himself.

While Sterling was denying any connection with MacGuire beyond their mutual wish to reinstate the gold standard, the Congressional Committee was in the Yellow Room of the Association of the Bar at 42 West Forty-fourth Street, reviewing letters written to Sterling and to Christmas from Europe the preceding spring. The official public statement on the hearings would conclude, "What MacGuire wrote to Clark and Christmas about foreign veteran groups tallies with what Butler claims MacGuire told him, but which MacGuire denies he did."[158] At the start of 1934, MacGuire had written Clark and Christmas about the

Croix de Feu that it was a "very patriotic" organization useful for a "coup d'etat." MacGuire assured them that, "These fellows are interested only in the salvation of France, and I feel sure that the country could not be in better hands. . . . They are a cross section of the best people of the country from all walks of life. People who gave their 'all' between 1914 and 1915 that France might be safe, and I feel sure that if a crucial test ever comes to the Republic that those men will be the bulwark upon which France will be saved."[159] As such, they were the equivalent of those "real Americans" for whom Clark had always wanted to build a museum.

The letters and the copious bank documents brought into the hearings served as solid evidence to confirm Butler's testimony, and to paint a clear portrait of MacGuire himself as someone who both obfuscated the truth and conveniently forgot pivotal details about where he had been at what time, and when he had received substantial amounts of money. Having claimed only that he received $30,000 from Clark for the Committee for a Sound Dollar and Sound Currency, he was shown to have been given "approximately $75,000 more, which MacGuire reluctantly admitted on being confronted with the evidence."[160] MacGuire had claimed not to be able to find key receipts and bank statements, and it was only after checking account statements from Central Hanover Bank and Manufacturer's Trust were presented as exhibits that the extent of Clark's and MacGuire's financial connection became apparent. MacGuire palpably angered the House Committee by trying to focus on his role as a bonds salesman for Sterling, only to fail to present any evidence; for all of the payments that he claimed were intended for such purposes, he never bought a single bond on behalf of his client. After substantial testimony, Samuel Dickstein simply said to Gerald MacGuire, "You have got me all puzzled with your bookkeeping."[161]

When he walked out of the hearing room later on, Dickstein volunteered to reporters that MacGuire was "hanging himself" with his contradictions and feigned memory lapses.[162] Ultimately, it became apparent to the committee that MacGuire was trying to divert them with accounts of bond transactions that preceded Sterling's visit to General Butler and that following that visit, and during his time in Europe, MacGuire had received large sums of money from both Clark and Christmas with no record of how it was used and no written receipts or accountability to them. Although MacGuire had worked with Sterling for some eight years previously, it was only now that, for the first time, he began to receive large sums in cash. It became apparent that the thousand-dollar

bills that had been offered to Butler in the hotel room were probably given to MacGuire by Albert Christmas on Sterling's behalf.

The session with MacGuire ended with Chairman McCormack losing all patience with the witness. McCormack exposed MacGuire for claiming to have deliberately implied he'd been talking about attending a Catholic mass in Paris rather than the meeting of the Croix de Feu that preceded it. He focused on the letters from MacGuire to Clark and Christmas and got MacGuire to admit that when he addressed them as "gentlemen" in these reports, it was to conceal their identities. He was unable to find the expense record of his European trip. He was shown by a Mayflower Hotel bill to have lied about his whereabouts, having claimed not to have been in Washington at the time. Finally, he was unable to confirm his own signature on a receipt. McCormack exploded, "Don't you know if it is your signature!" The question that McCormack asked MacGuire time and again was "You can't recall that?"[163]

When MacGuire tried to obfuscate about another mysterious payment concerning a line of credit provided by Clark, the exchange fired up:

THE CHAIRMAN: And you can't give the committee any information as to where that check for $15,075 came from?

MR. MACGUIRE: No, sir; I cannot.

THE CHAIRMAN: Whose check it is?

MR. MACGUIRE: No.

THE CHAIRMAN: It certainly isn't a check out of your special account, is it?

MR. MACGUIRE: I think, Mr. Chairman, that that is merely a typographical error.

THE CHAIRMAN: No, no! Wait a minute.

MR. MACGUIRE: Well, now, you have asked a lot of questions. I have a right to—

THE CHAIRMAN: If you start thinking now, we are not taking that testimony.

MR. MACGUIRE: I have a right to think, and you have a right to ask me.

THE CHAIRMAN: Do you know what that is?

MR. MACGUIRE: I think it is—

THE CHAIRMAN: No, no! Do you know?

MR. MACGUIRE: I do not.

THE CHAIRMAN: You do not? I think that is all.[164]

The committee heard testimony on November 23 from Claude M. Adamson, from the letter of credit department of Central Hanover Bank, and reviewed bank records provided by Adamson, revealing many more certified checks given to MacGuire by Christmas on Clark's behalf than MacGuire had acknowledged. In charting MacGuire's visits to this New York bank, Adamson also made clear that MacGuire had lied in saying he was in Chicago when he was actually in New York, compounding the loss of credibility caused by the forgotten Washington trip.

Testimony followed from James Haggett, of Lawyers Country Trust Company, the bank where Albert G. Christmas kept his special account. The next witness was Francis A. Rempe, a public accountant, who told the committee that he was an employee of Robert Sterling Clark's. Rempe presented records showing that all the funds that MacGuire had received via Christmas had originated with Sterling, and that Sterling— who had a personal account, a custody account, and a revolving account—had directly made payments to MacGuire from all three, and had funded a $50,000 line of credit on MacGuire's behalf from the custody account. Now the amount MacGuire had received, directly or indirectly, from Sterling was shown to be $153,996.86. Out of that amount, $56,489.50 had been repaid, and $30,000 had gone to the Committee for a Sound Dollar and Sound Currency, but, as Chairman McCormack pointed out, "between $65,000 and $67,000" was unaccounted for.[165] McCormack said, "the committee would subpoena Clark as soon as he returned from Europe." Three days later, on November 26, Representative Dickstein confirmed to the press that they "would definitely call Clark."[166]

FOR THE NEXT FEW MONTHS, the news media would treat interested readers to a tale full of twists and turns. *Time* presented an imaginary scenario of General Butler on a white horse leading the 500,000 veterans into Washington, while "General Douglas MacArthur, who only a year before had been the Army's Chief of Staff, trotted jauntily behind him," with the banker John P. Morgan and his partner also in tow. After arriving at the White House, General Butler tells the president, " 'You may continue to live here at the White House and draw your salary but you will do and say only what I tell you. If not, you and Vice President Garner will be dealt with as I think best. In that event, . . . I

shall succeed to the Presidency.' The President nodded assent and the
U.S. became a Fascist State."[167]

On the other hand, *Time* cast serious aspersions on the veracity of
"Major General Smedley Darlington ('Old Gimlet Eyes') Butler." The
retired Marine had the habit of making public accusations. Having been
hired in 1924 by the city of Philadelphia "to clean up that city's boot-
legging, the hot-headed general resigned the following year, declaring
that he had been made the respectable 'front' for a gang of political rack-
eteers."

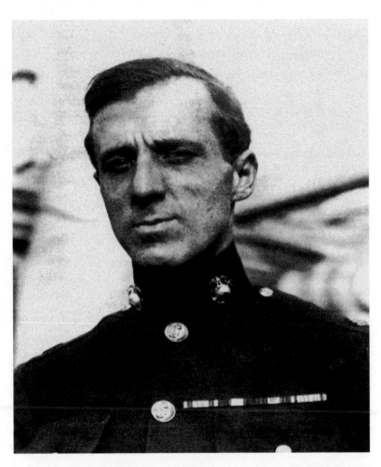

Major General Smedley Darlington Butler, U.S. Marine Corps photo.
General Butler publicly accused Sterling Clark of having tried
to hire him to lead an attempt to throw President Franklin
Delano Roosevelt out of the White House.

While *Time* clearly had the intention of making Butler sound silly, the novelist Mary Roberts Rinehart, who had studied Butler's cleanup of Philadelphia, cast it in a very different light. She portrayed the general as a brave and effective man in the face of corruption. "He put the fear of God into the gamblers and dive keepers. He cut down the enormous graft which they paid year after year. . . . I watched Butler and admired him; the same sheer ability, energy and knowledge of men which had succeeded at Brest were evident in all that he did."[168] But *Time* showed no such respect. The national news magazine belittled Butler as a crank by informing its readers that, in 1931, the general had been "almost court-martialed" for publicly claiming that "Benito Mussolini was a murderous hit-&-run driver." That same year, a Haitian minister insisted "that a fort General Butler said he had captured in Haiti had never existed," embarrassing Butler to such an extent that he resigned from the Marines.

It was in that context that *Time* then reported that the general had been approached by MacGuire for the first time as an emissary for Robert Sterling Clark. Clark had offered Butler $18,000 "to address the American Legion convention in behalf of hard money." Butler refused, but MacGuire, undaunted, then "broached the big plan for the Fascist coup. Du Pont and Remington were putting up the arms." Morgan & Co. and G. Murphy & Co. would provide the $3 million necessary for funding the army that would make it all work.

Sterling was said by *Time* to acknowledge that he had wanted to get "Butler to use his influence with the Legion against dollar devaluation." On the other hand, from Paris, the sewing machine heir "stoutly declared, 'I am neither a Fascist nor a Communist, but an American.' He threatened a libel suit 'unless the whole affair is relegated to the funny sheets by Sunday.'" Both the adamancy and the quip were vintage Sterling.

NOT EVERYONE MADE LIGHT OF THE STORY. "The General's reputation for honesty and patriotism made what he had said under oath impossible to ignore. The Secretary of War and the Secretary of Navy, U.S. Senators and Representatives urged that the Committee get to the bottom of the conspiracy."[169] Commander James Van Zandt of the Veterans of Foreign Wars said the plot was real, telling the press that

"agents of Wall Street" had "tried to enlist him in their plot."[170] Astute pundits pointed out the reasons that various wealthy people in America would have wanted Roosevelt out of office. The DuPonts, who had the largest armaments business in the world, were upset by a potential Senate investigation of the influence of the munitions industry in America's decision to enter World War I. The Morgans were bothered by the Securities Acts that had been passed in 1933 and '34 that called for far closer scrutiny of companies in the business of selling stocks. And people like Robert Sterling Clark were especially concerned about the current government having gone off the gold standard—a move taken in part to bolster relief programs—out of fear that this devalued their own fortunes.

The trip abroad taken by the man who had allegedly approached Butler to head up the putsch remained at the crux of what interested people with regard to Sterling's involvement. It was implicit that MacGuire and Sterling were in cahoots, and the travel that Sterling had funded for MacGuire had been for the study of paramilitary organizations.

Having blurted to the press that he would return to America to refute Butler's claims, Sterling now let the House Committee know from France "that he was delayed 'for business reasons.' "[171] When, at the end of December, Albert Grant Christmas returned from Europe at the committee's request to appear as the last witness in the hearings, the focus of the investigation turned to the use of between $65,000 and $67,000 for MacGuire's travels. It was nearly ten times what MacGuire had acknowledged having been given. McCormack homed in on the lack of accountability, on the number of unnecessary financial transactions with which sums went back and forth only to end up in MacGuire's hands, and on the contradictions between Christmas's and MacGuire's testimonies, with MacGuire claiming to have returned the money that he had in fact kept. Christmas claimed that Sterling had spent over $100,000 with the idea that its sole purpose had been to fight inflation—while never asking for an accounting of how the money was actually spent. With regard to the approximately $65,000 to $67,000 that could not be specifically traced, Christmas said that MacGuire had simply offered an oral explanation that it was used for entertainment and traveling while abroad. And whereas MacGuire had denied that Sterling had called on General Butler, Christmas acknowledged the visit; he also acknowledged the phone call, which MacGuire had denied, that Sterling had made regarding Butler and the American Legion convention. Finally, Christmas told McCor-

mack that he personally had been the author of the speech they had wanted Butler to give on that occasion.

Again, Chairman McCormack became testy with a witness—in particular when tracking down a mysterious $25,000 payment from Sterling to MacGuire:

> THE CHAIRMAN: It was not given for the purpose of buying bonds, was it?
> MR. CHRISTMAS: I would say not primarily.
> THE CHAIRMAN: Now you are quibbling.
> MR. CHRISTMAS: I did not intend to quibble with you, sir.
> THE CHAIRMAN: Well, you are. Was that money given to Mr. MacGuire with the intention of buying bonds? Yes or no.
> MR. CHRISTMAS: No.[172]

Then McCormack turned his focus to the real purpose of the trip. "Mr. Clark was not spending a hundred thousand dollars or thereabouts without knowing what was going on, was he?" the Chairman asked Christmas.[173] Christmas hedged. He said that he had thrown out the reports that MacGuire had sent from Europe. When confronted by the House Committee with the letters in which MacGuire had reported on the Croix de Feu and the other fascist groups in Europe, Christmas claimed that they had been addressed to him alone, not to him and Sterling. McCormack asked why, then, they had been addressed to "Gentlemen" in the plural. The chairman then read aloud the letters in which MacGuire championed the use of veterans "to call forth a coup d'etat," including MacGuire's praise of "the type of man belonging" to the Croix de Feu and MacGuire's description of it as a model paramilitary organization to put a new government in place and provide "salvation."[174]

Christmas replied by comparing the Croix de Feu to the American Legion. The remark infuriated McCormack, who described himself as a legionnaire and insisted that Christmas make a distinction between "a superveteran organization" like the Croix de Feu—"One of the purposes of that organization over there is, if necessary, to assume control of a government in crisis?"—and the American Legion.[175]

Christmas then admitted that he had handed over to Robert Sterling Clark "most of" the letters MacGuire had sent from Europe. McCormack continued to read aloud excerpts from MacGuire's letters, concluding,

"These reports addressed to 'Gentlemen' all embrace some reference to the fascist movement in the European countries that he visited," and said that MacGuire "waxed warm" especially over the Croix de Feu.[176]

McCormack then asked Christmas, "Was [MacGuire] not the front man for you and Clark?" McCormack pointed out that Sterling "did not disclose to anyone that he was making the contribution" that MacGuire received. "And it would have been concealed unless this committee had not uncovered it?" McCormack asked.[177]

The chairman of the House Committee then came back to the issue of the "$64,000 that has not been accounted for," and, referring to the reports made from the trip asked Christmas, "These letters show, do they not, that you and Clark were also interested in agitating discontent in some respects throughout the country?" McCormack also read from a letter Christmas had written to MacGuire, addressing him as "Dear Gerry," in which he described an account of events from a Dr. Wirt, superintendent of schools in Gary, Indiana. Christmas had reported "that members of the Brain Trust had told [Dr. Wirt] they were conducting a revolution, . . . that Roosevelt was the Kerensky of the revolution, that they had him in a swift current where there was no turning back, and they looked ultimately for the strong man, or Stalin, to come forward."[178]

Christmas admitted having written this and having accompanied the letter with a sizable payment to MacGuire while MacGuire was in Paris.

McCormack then drew the hearing to a close. The people who still today claim that, in involving himself with MacGuire and going to Butler, Robert Sterling Clark's sole intention had been to fight inflation by supporting the Committee for a Sound Dollar and Sound Cur-

Representative John McCormack. Eventually Speaker of the House, McCormack headed the House Committee that, in 1934, investigated the claim that Sterling and other wealthy men had tried to establish a vigilante army to depose the President.

rency, and the gold standard, will find no evidence of Sterling's $65,000, given to MacGuire, ever reaching the committee's coffers. And there is ample reason to believe that that money had been essential to MacGuire's research into the sort of organization that might topple an American president.

Months after the hearings, Smedley Butler exploded on the radio and blasted the committee "for bowing to the power of Wall Street and for censoring his remarks." An exposé in *The New Masses* declared the investigation a cover-up of true treason. Regardless, the matter was dropped, although, on November 30, President Roosevelt thanked Dickstein for his preliminary report and said he hoped the committee would proceed with its investigation. Roosevelt was said to take the attitude that the putsch scheme had been concocted by a bunch of eccentrics and was not a cause of real concern. He "regarded all these rich grumblers as absurd, bumbling malcontents and never attached the slightest credence to anything they said or did."[179]

McCormack's findings were submitted to the House of Representatives on February 15, 1935. There was "evidence showing that certain persons had made an attempt to establish a fascist organization in this country. There is no question that these attempts were discussed, were planned, and might have been placed in execution when and if the financial backers deemed it expedient."[180]

As for General Butler's testimony about having been approached to lead a fascist army, the House was informed: "MacGuire denied these allegations under oath, but your committee was able to verify all the pertinent statements made by General Butler, with the exception of the direct statement suggesting the creation of the organization. This, however, was corroborated in the correspondence of MacGuire with his principal, Robert Sterling Clark, of New York City, while MacGuire was abroad studying the various organizations of Fascist character."[181]

The Committee concluded its statement by saying, "Armed forces for the purpose of establishing a dictatorship by means of Fascism or a dictatorship through the instrumentality of the proletariat, or a dictatorship predicated on racial and religious hatreds, have no place in this country."[182]

Roger Baldwin, director of the American Civil Liberties Union, would immediately make a public statement. "The Congressional Committee investigating Un-American Activities has just reported that the Fascist plot to seize the government . . . was proved; yet not a single par-

ticipant will be prosecuted under the perfectly plain language of the federal conspiracy act making this a high crime."[183] Not only was the attempted putsch essentially ignored, it was mocked. Ten days after the committee made its report, *Time* showed a photograph of General Butler with Jimmy Durante over the caption, "Schnozzle, Gimlet Eye. Fascist to Fascist?" A footnote on the same page said that the House Committee was convinced "that General Butler's story of a Fascist march on Washington was alarmingly true,"[184] but the note was set in five-point type.

In 1964, as Speaker of the House, John W. McCormack mentioned the plot in a speech at the Democratic Convention. Few people understood the reference—even though these events had in part inspired the recent novel and film *Seven Days in May*. As for Clark's role, it was still on McCormack's mind in 1971 when Jules Archer interviewed him. The Speaker explained that the reason Sterling had not been subpoenaed at the executive session was because it had been held outside Washington, and the law denied "power to subpoena anyone to executive sessions outside the Capital."[185] That technicality may be what, in effect, spared Sterling. McCormack's recommendation that the law be changed was ultimately followed. McCormack was unequivocal about the conspiracy. "There was no doubt that General Butler was telling the truth. . . . Millions were at stake when Clark and the others got the Legion to pass that resolution on the gold standard in 1933. When Roosevelt refused to be pressured by it, and went even further with the gold standard, those fellows got desperate and decided to look into European methods, with the idea of introducing them into America. They sent MacGuire to Europe to study the Fascist organization. We found evidence that Clark and Colonel Grayson Murphy . . . were involved. . . . If General Butler had not been the patriot he was, and if they had been able to maintain secrecy, the plot certainly might very well have succeeded. . . . When times are desperate and people are frustrated, anything like that could happen. . . . If the plotters had got rid of Roosevelt, there's no telling what might have taken place. . . . This was a threat to our very way of government by a bunch of rich men who wanted Fascism."[186]

It was one aspect of European culture that Robert Sterling Clark did not succeed in bringing to America.

IN SPITE OF REPEATED JABS at "Rosenfart" and references to meetings with Christmas, nothing about the alleged putsch or its denial

made Sterling's diaries—assuming they have not been altered since he wrote them. There his subjects were the same as ever. Reading the journal of his daily existence, one would think that his sole occupation in the period when others said he was trying to help overthrow a U.S. president was to compare objects and artworks and buy those he selected. Other than that, he devoted himself to an observation of civilization's decline. Like his mother, he had developed an obsessive dislike of motorcars and their effects. He also resented an increasingly negative press; he was annoyed when the *New York Herald* reported which ship he had crossed on from Europe. He was thinking about moving to an apartment where people would be less aware of who he was.

The greatest irritants, of course, beyond Roosevelt, were his remaining brothers and their wives. Sterling still kept an eye on them from afar, even if he no longer exchanged so much as a brief hello with any of them. Stephen was the main culprit, the one whom he blamed for everyone else's suffering. And Susan was now the object of complete contempt. If twenty-three years earlier Sterling had been trying to take charge of a boudoir for his sister-in-law, now, more than ever, he belittled her as being superficial and demanding. "She had been crying all one summer about her diminished beauty & had to be taken abroad by Stephen,"[187] he noted.

Sterling was pleased by the effects of the financial downturn on Stephen and Susan, who now lived in the cottage at Fernleigh rather than the main house because they had been forced to reduce their Cooperstown domestic staff from twelve to four. After all, Sterling thought, Brose had to dismiss twenty servants; this wasn't so bad. Besides, Stephen and Susan had just inherited ten million dollars from Rino. While he was in a perpetual furor because of all he bemoaned shelling out in taxes, Sterling could not see why Stephen was, apparently, depressed because he thought he had lost everything.

His own income in 1934 was, after all, nearly three million dollars. Regardless of the Depression, and even without the gold standard, the Clarks were not the same as other people.

IT WAS TIME TO GET OUT of Cooperstown completely. In 1936, Sterling decided to give his property there, Red House Farm, to Otsego County, where Cooperstown is situated, with the idea that it would be for the use of indigent children. It sounded like the sort of thing his

father would have done. When Stephen Clark Jr. was dispatched to try to buy it from him and to prevent the gift from going through, Sterling was delighted; this was evidence of what he had hoped for, which was that his family would be tortured when he sold the farm. But Sterling was determined; not only did he turn over the house and land but he accompanied it with a significant gift of cash so that the children's home would function.

His brothers, he believed, wanted property for themselves; he wanted it for the public good. In this same period, Sterling also saw to it that the local park and library would be named for their mother, while making it clear which of her sons had funded it. The library bore a plaque stating, "Erected by Elizabeth Scriven Clark for the Citizens of the Village and given to the Village by Robert Sterling Clark."

Again, news of feuds within one of the richest families of America was there for everyone who wanted to read about in the newspaper. A head-line in the November 26, 1936, *New York Times* ran, "Clark Land Fight Splits Heirs Anew." The word *animosity* was in the first sentence. The way the story was told, what came across was that Sterling was the gen-erous and warmhearted one, while his two remaining brothers simply wanted to increase the size of their land holdings. Without making refer-ence to the reasons for which *Times* readers had been reading about the heir and financier two years earlier, the paper reported how Sterling, who had moved to Upperville, Virginia, was trying to give the county Red House Farm, which consisted of eighty-acres with five houses as well as outbuildings, and six acres on Otsego Lake, in addition to two other parcels of land, one of twenty-five acres, and twenty-five thousand dollars on top of all this, so that the Red House property could become "a home for dependent children now being 'boarded out' in private homes." The gift was to come without strings: even if this use was his intention, the county would receive it without restrictions.

In response, Stephen and Ambrose said they wanted to buy the six acres on the lake from the county for five thousand dollars so that they could give it to Cooperstown as a recreational center. This was an odd move: as if two of the boys favored sports for the local citizenry, while the other wanted to help out disenfranchised urchins. Then Brose tried to buy back Red House Farm for seventeen thousand, five hundred dollars. It adjoined his Iroquois Farm, and it seemed that this time there was nothing charitable at all about his intentions.

Sterling in response came up with a further twenty-five thousand dollars to make sure that the Red House could become a children's home. And he gave the village yet another twenty-five thousand dollars so that it could buy those six acres on the lake from the county and fix it up.

It was like an auction or a game of cards, each party trying to win control.

Sterling prevailed. The village bought the six acres to fix them up. On top of everything else, Sterling magnanimously gave ten thousand dollars a year to fund the children's home. The man who had no children of his own was certainly showing his heart. He publicly blasted Brose for offering so little for Red House Farm. He was quoted in the *Times* as saying that a more appropriate sum would have been a hundred thousand dollars, which he knew Ambrose could well afford. He suggested that if Ambrose would pay that amount, and the county, to which he had given the property, took the sum, he would add an additional hundred thousand he had already given so that the children's home would get off to a great start at another location.

News coverage of family scandals does not usually proffer opinions, but the Clark dispute was something else. The *Times* piece had a remarkable last paragraph. "It is the opinion of those more intimately in touch with the whole situation that it is the real ambition of Robert Sterling Clark not so much to deprive his brothers of the ownership of any of his former holdings in Otsego County as it is to carry out the establishment of a worthy home for unfortunate children."[188]

By now the Clark brothers' feuds were often in the newspapers. And Sterling was constantly angry. He resented Stephen's and, to a lesser degree, Brose's real estate transactions—that they were buying additional parcels of land in Cooperstown rather than giving them away. Periodically he ranted about his exclusion from Rino's will. He also spewed vitriol about the people running the country; they were, he wrote in a typical diary entry, a "bunch of mountebanks & shysters & Reds."[189] His solace, as always, was in buying art.

In the course of the 1930s, he was acquiring, in greater volume than ever before, pretty pictures by European artists who were recognized in the nineteenth century but whose names mean little to us today— Madrazo y Garreta, Félix Ziem, Luis Fernandez. The artists were from different countries and worked in varying styles, but the titles, regardless of who painted them, had a remarkably common thread: *A Girl in*

Red, Mother and Child, Woman in White, Woman with a Bouquet, Girl with Roses, Mother and Child before a Mirror. There had been no little girls in Robert Sterling Clark's childhood. Nor did he have any children of his own, other than the stepdaughter whom he saw only irregularly. But in his collecting he compensated mightily for the lack. He also was getting some admirable Barbizon pictures: landscapes by Théodore Rousseau and others, as well as, in 1937, another fine Fantin-Latour, of roses, along with a painting of roses by Henri Fantin-Latour's lesser-known wife, Victoria Dubourg. And there was the usual run of Alfred Stevens, including four canvases of the seasons, in this constant attempt to give life a prettiness and gentle aura it was lacking in his own mind.

Whether buying high or low, no one was sharper in his views about what was good and bad. Other rich people bought their paintings; Sterling was the one to go into the gallery of Durand-Ruel and tell them about "Claude Monet and the unevenness of his work." When the dealer suggested he had made a mistake by disliking Monet's paintings of Rouen Cathedral, rather than accepting the idea that he had been proven wrong because others thought them great, Sterling was proud of the consistency of his own taste: he recalled that he had seen them when he first saw one at the Academy of Design forty-five years earlier, and still felt the same way. On the other hand, he still liked what he considered to be Monet at his best, and bought, for ten thousand dollars each, Monet's *Spring in Giverny* and *Tulip Fields at Sassenheim, near Leiden.*

Sterling loved having a winner. In March of 1937, he felt himself the victor of collectors when, shortly after returning to New York from Paris, he had a phone call from Lord Duveen, who was in New York and invited him to see some pictures. He guessed what the invitation was really about; Duveen, the most renowned of all art dealers—and with whom Sterling resolutely refused to do business—was forever trying to buy the Piero della Francesca altarpiece from him. He delighted in refusing, even as the price became more and more exorbitant.

Although he had no intention of altering his stance, this time he accepted the proposal to visit the dealer. Sterling delighted in discrediting Duveen, but he felt bad for him, for he knew the renowned art merchant was suffering from rectal cancer.

First they looked at what the great dealer in Old Masters had to show him. Sterling's evaluations of Duveen's wares were merciless. There was

"a reputed Fra Angelico, certainly not. . . . A Giotto, certainly a primitive Italian Virgin & child ill drawn & ugly done by a country boob.—A shaved Castagno *Resurrection* & well shaved at that—Asked about prices—All virtually sold!!!!"[190] Then Duveen said to him, "You have some fine pictures. One I would like to have. I would give you 500,000 cash for it. That's a fair offer."[191]

The painting, of course, was, as Sterling had anticipated, the Piero. Sterling delighted in the blunt truthfulness of his own reply. The price offered was, in fact, high—he would never have paid that much for the work or for any other—but he could not consider it, because he would lose so much in capital gains tax that it would be more loss than profit. He blamed this on uniquely American laws, saying that if he were an Englishman the situation would be different. He also declared to Duveen, "I am a buyer & not a seller."[192]

That statement was largely true, but there had been exceptions, like the Giovanni Bellini that he had returned, if not exactly sold, in what had been another instance of his feeling a notch above Duveen since this inferior work had subsequently gone to Duveen's great client and protégée Isabella Stewart Gardner. But he meant it about not selling the Piero. It satisfied him greatly that both Helen Frick and Andrew Mellon were after the painting, and that, with fortunes so much greater than his own, these clients of Duveen's could not have what he had. Sterling believed that, because this was the only Piero in private hands, and that, since rarity conferred a disproportionately high value on something, he could get as much as a million dollars for it. But, even if he was not rich enough to buy art in that price range the way they could, he was rich enough so that he did not have to sell it.

Duveen was not one to give up easily, whether buying or selling. When he and the Singer heir "reached the door, Joe tried again for the Piero." Sterling let the dealer know in no uncertain terms that there was no use talking about it—ever.

EVEN IF THE CLARKS' WEALTH didn't match that of the Mellons or the Fricks or other heirs to America's greatest steel and railroad fortunes, Robert Sterling Clark was, by his own calculations, wildly rich. But he could not get over the extent to which he was losing the bulk of his fortune to taxes, for which he directly blamed "Rosenfart." Sterling

calculated that after he signed his 1936 income tax form, he was "left after Fed & State taxes with about 20%." As a result of this, that year his income was "20% to 25% lower than it was in 1899 in Gold Dollars!!!!!"

Somehow he knew that the previous year, 1935, he had been "one of 4!!!!! to pay a tax over a million!!!"[193] He lamented having sold some tax-free bonds that would have reduced the number. The exclamation marks that he chronically used in long series were a fair reflection of the hyperbolic working of his mind.

There was another tax question involving some Singer stock. Eighty percent of the dividends had been earned abroad, and there was a question of whether taxes had to be paid on that income. Now Sterling's interest was not so much in trying to skirt the payment for himself but in considering the possibility of Stephen's getting in trouble for having done so.

Not that he knew whether or not his brother had avoided those payments. But he could always hope for the worst. "It would amuse me to see Stephen up before a Congressional Committee on the charge of evading the Income Tax!!!!"[194] It was an interesting notion given his own skirmish with such a committee.

Again he was in a period of frosty times with Francine. When she was with him in America, he struggled with her hypochondria—his diaries of the period are full of woe about her complaints—yet he hated it whenever she left to return to France. As always, his comforts came through what today would be called "retail therapy"—although in his case it was more wholesale. In 1938, he bought so much fine whiskey and brandy that, being far more than he could consume, it, too, went into storage. He was purchasing so many pictures at Durand-Ruel that he stored some fifty works at the gallery itself, not even bothering to ship them. His collecting of the late thirties, on into the forties, was more zealous than ever as Sterling countered the struggles of his life, his rages at family and government, with his consuming love for what was, in the case of the art, beautiful, or, with the liquors, satisfyingly luxurious.

Sterling's obsession, his "master better than Titian," his robust celebrant of light and flesh and paint and color, Pierre-Auguste Renoir, continued to dominate his collecting. In 1937, for example, he added many late-nineteenth-century pictures to his holdings, among them a major work by the academic Lawrence Alma-Tadema, but the masterpieces were his five Renoirs, most especially *Mademoiselle Fleury in Algerian*

Dress. The following year, Sterling showed some restraint, and kept himself down to two works by his impressionist favorite, but, on the other hand, this was the occasion of his buying a major Degas, *Before the Race*— a mesmerizing and elegantly colored image that combined his love of horse racing and artistic excellence—as well as an important Toulouse-Lautrec and over a dozen paintings by artists including Bouguereau, at the most fashionable side of things, and, with a return to the Old Masters, the wonderful, earthy French brothers Nain.

On a November day in 1936, when much of America was still feeling the confines of the Depression, he settled more modestly on a Queen Anne teapot for eighteen hundred dollars and a salver for three thousand dollars as the day's quarries. This was because the Manets and Millets he saw that afternoon were, to his delight, inferior to his own in quality and now priced higher than he had ever had to pay. And the more modern works the dealers were trying to foist on him were of no interest. When, at one of his regular galleries, the salesman tried to get him to look at work by Matisse, Sterling simply said he had never seen a good one, and these were no exception. His knowledge that his brother Stephen was collecting Matisse in depth was further proof of their weakness—not that he had ever entered Stephen's house to see them.

Gauguin was another painter he considered worthless. This was a sign that it did not require Stephen's choosing an artist for Sterling to dislike him—Stephen had shown no special interest in Gauguin either. Robert Sterling Clark simply loathed most work by artists who did not paint with a tradition of verisimilitude and old-fashioned prettiness. At the start of 1937, he had the good fortune to see the extraordinary collection being assembled by Duncan Phillips in Washington, D.C.; Sterling's account of the event in his journal was: "Matisse, Braque, Segonzac, Bonnard, Cézanne, Picasso, etc.—And none good of course for none of them ever painted a good picture!!!"[195]

Even among the artists he did like, Sterling was certain of what was worthy and what not. In May of 1937, he went with the Knoedler salesman with whom he worked all the time, Henschel, to a major Renoir show at the Met. This exhibition of work by his favorite of all artists was nothing better than "okay"; there was only one great painting in the entire large show. He was especially critical of the Renoirs Stephen had lent; none of them was first-rate, and all had been purchased at exorbitant prices. From an objective point of view, the differences between the Renoirs owned by the two Clark brothers were like the variances in their

personalities. Stephen's were more restrained and more intellectually substantial. They were, in effect, thinking people's Renoirs. Sterling's were more exuberant, prettier in the way of French decoration in the Gay Nineties. They were endowed with a happier spirit and had richer surface qualities while betraying less evidence of the underpinnings of form. Rather than see these nuances, Sterling simply deemed his Renoirs of superior quality.

He was probably also highly annoyed that he had not been asked to lend any of them to show. And he may well have resented that Stephen was a trustee of the Met; there is no sign that Sterling, whose personality was well known, had ever been asked to be the same. In any event, for whatever reasons, his response to the show in the institution that was supposed to confer standards of excellence and be the arbiter of quality distinctions was for Sterling simply to be convinced, or at least to say, that he had far better work at home: "If my personal collection of Renoir had been in another room it would have made the exhibition look like 2 cents!"[196]

ACCORDING TO ROBERT STERLING CLARK's diaries for 1938, the event of a day might be telling a silver dealer he did not want the pair of Cromwellian porringers, or spending a morning at Durand-Ruel while the black assistants took out some of his Renoirs in storage, or checking in at Manhattan Storage, where he had his art in cases, or going into Parke-Bernet to look at some of William Randolph Hearst's American furniture ("good but not up to my standard").[197] On one run-of-the-mill morning he dropped into James F. Drake, Inc., one of his rare book dealers, and paid three thousand dollars for Francis Wheatley's *Cries of London,* continued at his fast walking pace to a favorite furniture dealer to look again at an American eighteenth-century drop-leaf table he was considering, and then studied an emerald at Tiffany's that, at seventy-five thousand dollars, was too expensive even for him. While he was not communicating with Stephen, he was still keeping up with his brother's art purchases, learning from Knoedler's that the younger Clark had bought "2 fine Cézannes, a fine Seurat, a Renoir."[198] Day after day, his own diary entries were about silver and furniture and pictures, offers left with dealers where there was inevitably a slight bargaining process, and quips he made in which he clearly relished the acidity of his own tongue. Sometimes he landed a big-ticket item—like Renoir's *Girl with Flowers* of

1878–79, irresistible even at sixty thousand dollars ("A big price to be sure but what quality")[199]—and at other moments he was equally preoccupied with a mundane necessity of his collecting, like the bare-bones bookcases he had to find for his storage room so he could put his silver on it.

The point of it all was to compare and buy and service his hobby, and to record the data diligently. He wrote down, like someone noting minutes of a meeting, details of an outing with Francine where she bought him, for the upcoming Christmas, a tie clip at Cartier's. The same day, he went to great pains to have a different jeweler find turquoise brooches for her, Cartier's not being up to standards. Whether the issue was jewelry, art, politics, or taxes and trusts, he always had an ideal in mind. It was rarely met.

This may be why Sterling changed his mind so often. When he ordered gray jodhpurs at his favorite emporium for riding wear, he had no question as to the color and fit he wanted, but the issue of what art to purchase and where to acquire it was full of variables. He was resolved to stop buying Old Masters; then he started again. Again sulking at Knoedler's because he felt they had misrepresented a picture's price history, he announced he would never return; within weeks he was going back through the gallery doors on a daily basis.

When he wavered about artistic quality, however, it was not out of fickleness. Sterling looked at artwork so passionately and conscientiously that he was susceptible to the different responses that only occur to the rare few who engage with art so intimately that emotional variables are inevitable. Looking at an 1872 Renoir self-portrait he had long liked but fallen short of loving enough to have to own it, one day Sterling "discovered in changing its position that the reason for not liking it more was because we have always had it under too strong a light, which pales out the very light rose on skin & flattened face—The face is extremely light & background dark which was what deceived us!!!!"[200] This was the close involvement with which he looked and remembered paintings and their settings.

Sterling could afford his candor. No one was likely to challenge him; he had the obligations neither of an art dealer to appear to like what he wanted to sell, nor of an art historian to defend his views and withstand critical scrutiny. He also had the consuming commitment to looking that precluded mincing words or holding back on his beliefs. He was

convinced that Renoir was good until 1913, "when he commenced to see red flesh. His really great year, the 'apogee de son talent' was 1881 — Something occurred in that year or in 1882 sexually—Some day I shall find out—But from then on he drew and composed less well . . . the drawing & models became worse & worse with common women & dreadful nudes who looked as though their arms & legs were inflated bladders. . . . But right up to the red period 1913 his color never lacked in harmony . . . even if after 1881 that inimitable freshness of hope & youth lacked—But what a great Master!!!! Perhaps the greatest that ever lived."[201]

The four exclamation points, the sureness of view, the enthusiasm for painting as an evocation of energy and youth, were the quintessence of Robert Sterling Clark's artistic taste. So was his conviction that as a colorist Renoir was "never equaled by anyone—No one as far as we know ever had an eye as sensitive to harmony of color!!!!"[202] Rarely has a collector been so personally fired by what he loved, and responded to it with such sheer gusto. "Of course Rembrandt gave more volume, Van Dyck had more elegance in line, etc. etc. but I would much rather live with 20 Renoirs than 20 Rembrandts!!!!" When he wrote this in 1939, he knew whereof he spoke; he already had twenty-seven Renoirs.

CONCOMITANT WITH THOSE STRONG OPINIONS, while Sterling liked buying at fair prices, he never considered art as an investment, but only to suit his taste. He often noted in his journals that not all artworks increase in value. On one occasion he was matter-of-fact that a painting by the artist Wazermann for which his mother had paid fifty thousand dollars forty years previously was now worth a tenth of that at best. This was not a lament, but an assertion of priorities; one bought artworks for pleasure, not financial growth—even if it was gratifying when it occurred.

His strong opinions went into every domain. In 1939, he disparaged the Museum of Modern Art totally for its display of "dreadful junk"[203] throughout. In August 1939, on one of his and Francine's trips to Paris, Sterling went to an exhibition devoted to the French Revolution at the Musée Carnavalet. Looking at the panoply of historical characters, he made observations that few other people could possibly have uttered: "No doubt they were all abnormal. For instance, Saint Just looks like a pretty

woman—No question of a doubt as to his sexual practices!!!!—I had never happened to hear of that before—Robespierre had something of the same look!!!! . . . Marat is terrible—Sadistic—But what is beautiful in the museum are the fine boiseries of the Regence, Louis XV, Louis XVI."[204] This was vintage Sterling in its prejudices—with their source closer to home than he probably acknowledged even to himself. It also revealed the extent to which he connected art with actual life and saw the personages of paintings as being every bit as real as the people he knew. And the conclusion of those remarks is especially telling, announcing as it did Sterling's preference for those boiseries, formed from exquisite material and crafted impeccably, over the issues that made him uncomfortable.

As France was preparing for war, Robert Sterling Clark was changing his mind about figurines in the Musée des Arts Décoratifs, and admiring a "beautiful collection of fans"[205] there. International events were no impediment to his visiting galleries and acquiring reminders of the pleasures of peacetime and life when it could be lived more happily. In 1939, he purchased four more Renoirs—he almost always got them at Durand-Ruel in New York—as well as a Goya and an Elisabeth Vigée Le Brun.

Among the Renoirs was a small oil sketch markedly different from the pictures of buxom young women and members of affluent families. This was a Renoir self-portrait. It was painted c. 1875, three years after the more finished one Sterling realized he had always been looking at in too strong a light but had not, in any case, decided he needed to own. This vigorous, brushy oil—a study more than a finished work—is painted in earthy browns that offset a fantastic mix of flesh tones. The animated painting technique reflects the toughness and rigor essential to the making of art for the painter who was invoking not only his own face but his life's work.

There is another astonishing factor about this canvas, a point that may or may not have been lost on Robert Sterling Clark. That is the resemblance of Renoir to Sterling's father. The similarity derives from more than the painter's beard and exceptionally large eyes. It also stems from the look of battle. Intoxication with beauty is not, it is clear, an easy thing; nor are the struggles to do one's very best in life. Pierre-Auguste Renoir and Alfred Corning Clark not only looked like each other; for all the wealth of pleasure in both their lives, they shared an intensity that brought its share of anguish.

We will never know if Sterling noticed the aspects of Renoir's face that were like his father's, or saw the personal points in common. It's unlikely that a conscious comparison in any way prompted his fondness for the painter overall. But, in Renoir, Sterling had found, in a form he could accept, Alfred's love of the grand and beautiful, his consuming sensitivity, and his vulnerability.

THERE WAS NO SLACKING OFF in Sterling's rate of acquisition in 1940. Besides four more Renoirs, he added a lovely Boudin of Dunkerque, and further fine works by Corot and Fantin-Latour. Clear articulation and a quality of the picturesque were the chief components of these solid, enticing works. Whether the subject was the distant landscape, as with the Corot, or a vase full of roses seen close up, as with the Fantin-Latour, nature was extolled, and art executed with panache and a staggering sureness of technique. This was how the same Robert Sterling Clark who spent much of his time fulminating could restore his sense of well-being and pleasure in life.

In February of 1940, he also acquired Toulouse-Lautrec's *Jane Avril* at Wildenstein's in New York (color section 1, page 5). For the man who had married a woman of the French theater, it was a summoning of a world that had long cast its spell on him. But the Toulouse-Lautrec goes far beyond the fanfare and merriment of those forms of Parisian entertainment meant above all to charm and divert its clientele. This poignant and evocative picture shows the actress Jane Avril, one of the artist's favorite performers and subjects, at a moment of pensiveness and vulnerability. In this sketchy oil on cardboard, she appears just to have left the music hall; one imagines that the stage door has swung shut behind her only a moment ago. Having changed from her performing clothes or at least covered them, she is in the regalia with which she can face the world—a broad and towering hat, a stylish cape—but she is completely absorbed by her own thoughts.

Francine, once a denizen of the same milieu as Jane Avril, had urged Sterling to buy it. The painting belonged originally to Franz Jourdain. The architect (along with Henri Sauvage) of La Samaritaine department store in Paris, Jourdain was a major figure in the French art world. He was president of one of the important salons that showcased recent art and helped a number of great figures, among them the young Le Corbusier, to

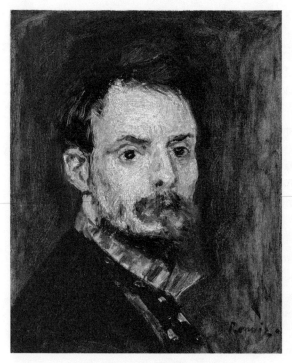

Pierre-Auguste Renoir, Self-Portrait, *c. 1875.*
In his features and demeanor, Renoir bore a surprising
resemblance to the young Alfred Corning Clark.

get their start in Paris. One can see why he, as a savvy professional in the field, acquired this particular portrait by Toulouse-Lautrec. The vivid sketch is not a finished image but, rather, a brave attempt to work things out.

Looking at the modestly scaled yet dazzling work, one feels the deformed, crippled Toulouse-Lautrec wielding the brush enthusiastically to evoke the allure of the star he adored. He is undisguised in his engagement with the making of art, using the rough paper as part of the whole, allowing his brush strokes to be clearly what they are—pigment swept across paper—rather than concealed tools of illusion. And he uses that technical virtuosity to give his beloved Avril noble bearing.

The work to which Jourdain, and then Robert Sterling Clark, were drawn, is also a superb bit of color orchestration. The subtle palette consists mainly of a dusty mauve, a radiant sapphire blue, the gold of Jane Avril's hair, and the pasty white of her face. Different as Sterling was from his father as a collector, like Alfred he responded to sheer artfulness—qualities of balance and counterpoint, a sense of rhythm. Both men knew what it was to feel elevated by these devices, whether in music or in painting. They felt the particular transport from everyday vicissitudes and from the struggles of one's life that aesthetic experience can provide. They knew that what we see or hear can give well-being, even radiant joy.

Sterling responded passionately to both candor and to artistry; he needed them to sustain himself. This gem by Toulouse-Lautrec, to an even greater extent than the artist's more finished work, was, with its

intensity and freshness, just his sort of thing. Like the van Dyck of Inigo Jones, it reveals the physical process of creating a picture while simultaneously being a highly charged, emotionally laden result of that act.

DURING WORLD WAR II, Sterling continued to do his bit to preserve the wonders of a civilization that was fighting to save itself. From 1941 to '45, he again acquired the Old Masters, along with the more recent artists whose work he had been amassing for the previous decade.

How different he was from the collectors who feel they need to own a work by this or that artist to have a thoroughly representative collection, or who take their cues from someone else. Sterling followed his passions as devotedly as he continued to drink his Burgundies. With his return to the broader sweep, the roster of artists went back to some of the enchanters of the eighteenth century. He bought a Francesco Guardi of *The Customs House in Venice,* a Jean-Honoré Fragonard of *Pygmalion and Galatea,* a Gainsborough double portrait, a strong and respectable Thomas Lawrence portrait, and two Nicolas Lancrets—pictures that have that dash of pure pleasure that Sterling found irresistible.

On the other hand, his pace of Renoir acquisitions slackened considerably, with only two in 1941, three in 1942, and then, until 1946, none at all. No wonder: among the museum level paintings he added to his collection, mostly by artists whose work he already owned, there was more work by, in the French school, Boudin, Corot, Fantin-Latour, Pissarro, Courbet, Corot, Daumier, Millet, and Manet, and by the Americans Childe Hassam, William Merritt Chase, Frederic Remington, and Winslow Homer. He also added a Bonington.

Another category in Sterling's stable that he continued to build during the war years consists of artists who were among the stars of their times but whose work had already declined in popularity when he bought it. These are painters whose canvases have subsequently been relegated to the secondary rooms or storage of museums. Some of these painters—Alfred Stevens, Bouguereau, Henri Harpignies, Gérôme, and Boldini—would be grouped under the rubric "academic." Then there were the practitioners whose names are obscure today except to specialists, who never made it to the higher ranks, but who were certainly accomplished painters, once recognized and respected if not touted. What is significant about the degree to which Sterling amassed the work

in this category—by people like Pierre-Joseph Redouté, F. Barbour, Paul Lewis Clemens (a contemporary artist of celebrity portraits, whom Sterling invited, along with his wife, Ruth, on a cruise by luxury yacht to Haiti and Cuba), Narcisse-Virgile Diaz de la Peña, F. W. Edmonds, Jules Dupré, H. P. Smith, Jean-François de Troy, S. Leighton, Auguste Toulmouche, and Eugène Fromentin—is that it is evidence that he invariably bought whatever he liked, so long as it had the evidence of skill, the qualities of artistic dexterity and pictorial vivacity, the connection with life lived energetically and nature seen alertly, that were his requisites for art.

This last category of artists could, of course, equally, be considered evidence that Sterling often got it wrong. If one considers what Sterling paid for paintings by these lesser names compared to what they are worth today, he fared badly. But those criteria have nothing to do with his intentions. Sterling embraced what he liked as completely and absolutely as he loathed the people by whom he felt let down; it was all a matter of instinct, and personal emotion, not of anyone else's standards. And while to many of us a lot of the pictures Sterling chose lack the excellence or originality of his masterpieces, it is still fair to say that virtually everything he bought reflects recognizable skill and artistic competence, and an attitude of honest picture making.

STERLING'S ADDITIONS to his collection during the war years included two paintings that were intensely erotic. The difference between the sexual sensibilities they invoked could not have been more pronounced.

William Bouguereau's 1873 *Nymphs and Satyr* is a large canvas, six and a half feet high, of a powerful, bearded man-goat encircled by four playful and robust women (color section 1, page 7). The naked ladies—all with long limbs, full breasts, and streaming hair—drag the muscular satyr, with his human upper half and his hairy goat's legs, toward a river. These nymphs display their bodies with total naturalness, their flesh luminous in the brilliant sunshine that spotlights it.

Years earlier, Sterling Clark had deprecated his sister-in-law Susan by accusing her of preferring Bouguereau if left to her own resources. It was a nasty swipe, clearly intended to demonstrate his own superiority as a connoisseur. The name Bouguereau was synonymous with rich people's bad taste and with the idea of what once was fashionable but now was

completely out of style. At the end of the nineteenth century, Bouguereau had been among the most touted painters in Paris; now he was démodé. Sterling in all likelihood knew van Gogh's description of the academician's pictures as "soft, pretty things."[206]

In 1942, however, Sterling did not hesitate to buy from Durand-Ruel this bawdy work that was unique in the oeuvre of an artist who mostly painted mythological and religious scenes. Most of what Bouguereau did, even when it depicted nudes, had a tone such that the old-fashioned aristocrats and people with new money who bought it were not afraid of upsetting the visitors to their lavish houses, where the artist's work fit in perfectly with the coffered ceilings and proliferation of elaborate ornament. *Nymphs and Satyr* was different, in part because it was so much fun.

When Bouguereau painted the large canvas in 1873, he instantly considered it one of his masterpieces. It was the talk of the salon in Paris where it was first seen, and was quickly sold to an American collector. By the end of the nineteenth century, it was installed at the Hoffman House Hotel in New York in the barroom in which only men were permitted. The gigantic canvas went from floor to ceiling. Among the people who frequented the bar and gaped at it were Buffalo Bill Cody, Ulysses Grant, and P. T. Barnum.

After titillating such distinguished viewers, the picture was bought, in 1901, by a religious moralist who acquired it for the sake of censorship. This god-fearing individual kept it at the Manhattan Storage Company, where it remained out of view for forty years.

This was where Sterling Clark saw the painting for the first time. It was 1934, and he had gone into the upmarket warehouse, which was practically another home to him, in order to retrieve some wine. He purchased the work eight years afterward, for $12,650.00 after one of the principals at Durand-Ruel rediscovered it in a storage room for pianos.

In 1943, the painting went on view at Durand-Ruel's New York gallery—the one Sterling had offered to buy temporarily to assist its foreign owners during wartime—in a benefit for the Fighting French Relief Committee. Visitors paid twenty-five cents to see the swarthy satyr being pulled to the river by the four voluptuous nymphs. But they did not know who owned the entertaining canvas. Sterling had lent it anonymously; there had already been more than enough talk about him on the part of a public hungry for tales of the odd ways of the rich.

When the show ended at Durand-Ruel, Sterling installed Bougue-

reau's great canvas in the dining room of his New York apartment. It hung behind him, so he could relish the sight of viewers peering at it over his shoulder. Whether they were excited or embarrassed, it was amusing for him to study their reactions. Looking at all that naked flesh and the vivid struggles between the sexes, people came alive.

The imagery was startling to most everyone who saw it, but it was also oddly familiar. Going back to its days at the Hoffman House Hotel, the canvas had become an icon in the culture. Before people were concerned with copyright issues, details from the lusty Bouguereau had reappeared in a range of forms: on bathroom tiles, dinner plates, cartoons, and pieces of silver. The religious moralist who had bought it to conceal it had failed utterly in his attempt to keep a pleasure-hungry public from what it wanted.

For all the attention the Bouguereau got, however, it's unlikely that Sterling would have imagined that, more than a quarter of a decade after he bought it, this painting would become one of the most popular of all the works at the Sterling and Francine Clark Institute in Williamstown. By some estimates it is the single most visited artwork there—more, for example, than the Piero. Nor could Sterling possibly have anticipated that his picture would appear on the Internet home page of a former Playmate of the Month. The hoydenish redhead stands in front of the canvas as if she is kin to the four nymphs.

Knowing Robert Sterling Clark's humor, he most probably would have been delighted. Pleasure, after all, was to be flaunted. If art awakened the senses, it succeeded.

WHAT IS EVEN MORE REMARKABLE is Sterling's acquisition, also in 1942, of a canvas painted three years before the Bouguereau. This was none other than Jean-Léon Gérôme's *The Snake Charmer*—the painting of the naked Arab boy that had been one of his father's treasures. His mother had, understandably, been quick to sell it after Alfred's death, and for more than forty years no one in the family had seen the picture.

This was one of the few occasions when Sterling bought something at auction. Were it not for that event, it would have been a typical day in the life of the financier who spent more time in galleries and shops than in his office down on Wall Street. With Francine at his side, he had begun the morning making the run of dealers on Fifty-seventh Street. As usual, he bantered with the salespeople and proffered suggestions—on

this particular day advising Knoedler's to offer Renoir's *Peonies* to the Art Institute of Chicago, and giving them all the reasons why they must do so. Then he went on to one of his favorite antiques shops, where he contemplated the purchase of a Charles II Chinese decorated porringer. It was a "very fine piece & not dear at $3000," but he hesitated nonetheless. When "Francine spoke up & said she would present it to me—I accepted cheerfully,"[207] he reported in his diary. The couple then went on to a gallery to see, again, a small Jules Dupré landscape on which Sterling was considering spending a hundred dollars; it had not responded to cleaning as he hoped, which made him realize that the painter had "used too much bitumen!!!!"[208] From there, they went on to another dealer's to check up on a Fantin-Latour that had had its varnish removed at Sterling's request, and determined that parts needed more stippling. In any event, this picture, too, was not what he had hoped it would be. Next, the couple circled back to Knoedler's, where Sterling got into his second animated discussion of the day about Renoir. Rambling on about the works he owned, making comparisons to the Old Masters, discussing the qualities that made the work of the mid-1880s so much better in his eyes than the late work, he spoke with the knowledge of an aficionado and the gusto of a sports fan.

Their morning's activities complete, Sterling and Francine stopped in for a leisurely lunch in the splendid restaurant on the ground floor of the Ritz-Carlton, then one of the lithest skyscrapers gracing New York, adjacent to the Carlton House, where the Clarks had a capacious apartment, and conveniently located near Tiffany's, Knoedler's, and their favorite silver shops. They ate an excellent *civet de lapin*—that traditional bistro dish made with rabbit's blood being one of Sterling's favorites. And then they took their constitutional up Madison Avenue to Parke-Bernet, at the time the main auction house in the city. In its handsome headquarters between Seventy-sixth and Seventy-seventh streets, there was work from assorted undistinguished collections on view for a minor sale. Sterling had no reason to anticipate anything great, but one never knew what one might find in the hodgepodge ranging from flea market quality up.

There, to his surprise, Robert Sterling Clark saw the painting of the smooth-skinned Arab youth, a python wrapped around his naked body, with which he had grown up at 7 West Twenty-second Street fifty years earlier. The painting was no longer in pristine condition, but there, still, were those firm buttocks catching the light at center stage for the viewer

of the canvas, with the sight facing the crowd of male onlookers, in front of whom the swarthy youth is performing, left to the imagination. The catalogue indicated that this painting by Jean-Léon Gérôme was to come up at the end of the sale, and carried an estimate of five hundred to seven hundred dollars.

It was a paltry sum in Sterling's eyes, not just because his parents had owned the picture, but because it was one of the nineteenth-century academician's masterpieces—even if Gérôme was no longer remotely in style. Sterling made up his mind to go to a thousand dollars.

He didn't need to think that high. The salesman from Durand-Ruel who had accompanied him to the sale and bid on his behalf had raised his hand for the last time at five hundred dollars when the hammer fell to his bid.

In Sterling's childhood, *The Snake Charmer* had hung opposite Gérôme's *The Gladiator,* the painting of the Roman arena with its imagery closely related to George Grey Barnard's *Two Natures of Man.* Ambrose had inherited that one, but, Sterling noted in his thirteen-page diary entry written on that January day when he bought *The Snake Charmer,* Brose "liked it so little that he lent it or gave it to the 'Racquet Club' where it is now hanging!!!!"[209]

Both works had been highly esteemed in the era when Alfred and Elizabeth Clark were still alive. *The Gladiator,* of course, had achieved such popularity that it was used for a brand of cigars. But in 1942, these exceedingly realistic, theatrical scenes by Gérôme were completely out of favor. *The Snake Charmer* would have been to the taste of even fewer collectors than *The Gladiator;* most people buying art would not have even remotely contemplated the idea of displaying an image of a naked youth performing so provocatively.

Whatever Sterling made of the subject matter, he adored the work as an object. After buying it, he quickly had the glass removed, and was thrilled with what was revealed once he could really see the vibrant canvas. "Academic Yes, tight, yes but what drawing & mastery of the art!!!! And good color particularly so for a Gérôme—A masterpiece for that kind of painting as it used to be considered and is today!!!! Everything in its place—Ingres rarely painted anything better except in one or two cases!!!!—I can not think of a composition of Ingres which is as fine!!!! . . . Had it been an Ingres it would have brought $50,000!!!! It shows what fashion has to do with paintings!!!! I do not know what my Father paid for it but I am sure it was over $15,000."[210]

Sterling recollected that his father had paid twenty-five thousand dollars for *The Gladiator*. He also remembered that, after his father's death, his mother had asked him whether he preferred *The Snake Charmer* or *The Gladiator*. He had said *The Gladiator,* and it was then that she sold *The Snake Charmer*. It's easy to see why, as a much younger man, he could not countenance this painting he now took back into the fold.

Sterling's evaluation of its quality, of course, was very much his own. To see the Gérôme as the equal of Ingres's work is to fail to recognize the dimensionality and mystery and subtlety of one painter as compared to another. The Gérôme is, indeed, a fantastic rendering of surfaces, like a fine enamel, but it lacks the breathability of an Ingres.

The elaborate mosaics, floor tiles, even the wool of the rug testify to the artist's splendid craft. So do the fabrics of the turbans and robes of the onlookers, and, above all else, the boy's taut naked skin, its smoothness emphasized by the sheen of the lethal snake wrapped around his chest. His mass of kinky hair, glowing in the light that pours into the courtyard, is reproduced with the meticulousness of a fine engraving. But there is a complete absence of the air that circulates in an Ingres painting, and of spatial depth. Everything has equal weight; there is none of the clear articulation of foreground and distance that characterizes the superior art of the true masters of the nineteenth century. Nor is there any of the mystery. One can read the hieroglyphics on the courtyard wall, but the painting is missing any area of quietude, or the overarching judgment that elevates work by Ingres or David to the greatness that Gérôme lacks.

What Gérôme was good at, in general, was eroticism tainted by issues of danger and power. There is an irony that his canvases are visually so refined and controlled, because their themes are anything but. Gérôme's work often has an implicit violence—as in his vivid canvas of a naked Greek at a cockfight—as well as a bent for spectatorship and voyeurism. He didn't just paint nudes; he painted harems and slave markets. His naked people are in situations where they are possessed by others or on offer, where they are meant for delectation more than their own pleasure, and where there is an element of aggression. Generally, he specialized in women, but, with either sex, he was especially adept at his tender rendering of buttocks. (It's no surprise to learn that Thomas Eakins studied with him.)

As a connoisseur of paintings of naked human flesh, Sterling generally opted for painters who were more openly painterly than Gérôme. His

artists from Rubens to Renoir made clear the illusion of their craft by candidly revealing brushwork and pigment in their suggestions of pink-tinged skin. Precisionist art like Gérôme's, where the craft of the illusion is concealed so as to lend reality to the scene, was quite another category. But it betrayed immense capability, and, bizarre as *The Snake Charmer* is, it is also remarkably powerful—both for its photographic verisimilitude and its provocativeness, not least because of its connection with the mysteries of Sterling's posh childhood.

FOR THE WEEK AFTER THE SALE at Parke-Bernet, Sterling checked on his new acquisition on a daily basis. Annoyed that all labels—the best evidence for detective work on the history of a painting once it has left its maker's studio—had been removed from its back, he had Knoedler's search for information in the files to see if they had any record of its being sold. Alas, he could find out nothing about who had owned *The Snake Charmer* in the intervening years since his mother had gotten rid of it. He determined, simply, that the picture had been badly relined—this being a conservation procedure used to strengthen a canvas that has lost its tautness on its stretchers—and required a light cleaning, for which he authorized an expenditure of one hundred twenty-five dollars.

Then, at Knoedler's, he bought another Gérôme—*Fellah Women Drawing Water*—as if he could not have enough of a good thing. Once Sterling was on a tangent, there was no stopping him. And as the modern world went its way, the excesses of the nineteenth century were, more and more, his personal escape route into a private realm of contentment.

His diversion was to be a professional consumer. By the late 1940s, he was said to own five thousand works of art. Everything in his life was a comparison; the cassoulet at the Chateaubriand Restaurant on Fifty-sixth Street was almost as expensive as at the Ritz-Carlton. At least in the worlds of food and antiques, he had control, whatever the variables. Human relations offered no such assuredness. "Funny things women! A man never completely understands them,"[211] he wrote in his diary in 1947. Francine, he now observed, was marked mainly by her innocence: "My mother was the same way."[212]

AT THE SAME TIME that Sterling offered to help Durand-Ruel when the firm's owners were in Nazi-occupied Paris, and that he was

putting his Bouguereau on view in their New York gallery, the collector showed some of the worries that would affect both his relations to his family and the ultimate disposition of his art collection. He and Herbert Elfers, who was the director of Durand-Ruel's New York branch, were afraid that New York would be bombed in an attack originating from German submarines.[213] Together they "rented an immense strong room set up in the mountains near Denver, Colorado."[214] Both Sterling and the gallery sent all their important paintings there for safekeeping. For similar reasons, in 1938 he had shipped a lot of his possessions out of Paris, putting the paintings, rare books, and silver into storage in Montreal. When Sterling eventually created his museum of marble-sheathed concrete in the Berkshire Hills to house his collection, some of the same motives were in place.

Sterling was conscious of the direct effect of the war on his younger brother Stephen. Because Nelson Rockefeller and Jock Whitney, two other rich men who were Stephen's fellow executives on the Board of Trustees of the Museum of Modern Art, had had to give up their positions at the museum to serve in the war effort, in 1942 Stephen began to serve as both president and chairman of the board of the thirteen-year-old museum. In the years when Robert Sterling Clark was buying his Gérômes and other mementoes of the artistic values of a previous century, Stephen Carlton Clark was focused on more recent, groundbreaking art. Stephen was a rigorous supporter of progress—the institutions that revealed it, and the artworks that exemplified it—while Sterling was mining the past. The younger brother was helping put the work of Picasso and Matisse in front of the American public; the elder one was collecting Boldinis and other art of the tradition against which the artists endorsed by the Modern had so violently rebelled.

Sterling saw Stephen's role at the Modern in the most cynical light. If he had any sense of the immense dedication behind it, he would not say as much. Rather, he considered his brother's position at that pioneering institution only as the result of the corruptness of a society in which money bought prestige. "I'll bet he has spent some money for the honor,"[215] he quipped in his diary about his brother's having assumed the presidency of the institution dedicated to the new art.

Sterling's wounds were still as fresh as if the break in the family had just occurred. "He, Stephen, is a swine of the deepest dye & Susan is worse if anything—They have always been jealous since I married Francine & returned here—When we parted on the Singer trust issue in

1923 it was not the whole of the story—Jealousy had a lot to do with it!!!!—Francine was too good looking and too attractive!!!!"[216] he fumed in 1944. More than two decades had passed since the brothers had feuded over Singer trusts and the two couples had been sundered, but Sterling had sustained the anger as an inimical part of his identity.

Just a few months after Sterling had penned this typical diatribe in his diaries, the Sterling Clarks and the Stephen Clarks both dined at the elegant garden restaurant at the Ritz-Carlton Hotel. The unknowing head-waiter had inadvertently put them at adjacent tables. Susan and Stephen were with another couple, and the arrangement was such that Sterling was seated practically next to Susan. On that beautiful June evening, the setting luxurious, everyone impeccably dressed, he was determined not to acknowledge his sister-in-law's presence.

Just at the moment when Sterling recognized the woman who had been seated next to him as his brother's wife, "Francine said she felt someone was looking at her intently & looked up to find it was Stephen C. Clark Sr."[217] It was evident to her that, in spite of the more than twenty years since they had laid eyes on one another, Stephen knew who she was.

Everyone looked straight ahead. The people at one table did not so much as nod hello to the people at the other. But Francine was cheerful. She gaily told Sterling how young he looked compared to his brother. From appearances one would assume the reverse of the truth of which of the brothers was older, she assured her husband.

Then the former actress of the Comédie Française laced into the American socialite her brother-in-law had married. "As to Susan she looks like 'La fée carabosse' you were quite right about that when we ran into her on Mad. Ave 2 years ago. Her face is thin. Her cheek bones stick out and she has very thin hair!!!!"[218] Sterling was so delighted with his wife's observations that he recorded them verbatim in his diary.

Appearances were a reigning issue as the heirs of one of America's richest families sat there that evening without openly acknowledging one another in any way. Sterling also wrote that Francine "said Stephen had more floating chin than I." While the mother whose only child, her illegitimate daughter, back in France was older than the woman who had raised her three sons and daughter in the world of New York debutante parties, she and Sterling were both pleased that she looked younger. Sterling then calculated that his younger brother would be sixty-two that August. Mortality, the passing of time, vanity: for all their millions of

dollars, these were the issues that weighed on the Clarks most heavily as they made their way through dinner determined to keep their distance.

IN 1944, Sterling acquired another picture that was already in the family—only this time it was one of Stephen's. And in this case the object in question had never left the Clark family once it had entered it.

That provenance was no small factor for this man who had such complicated human connections. Beyond the quality of the objects themselves, there were many factors that made Sterling want to own artworks that had long figured in the lives of his relatives.

The painting was Corot's 1835–40 *Castel Sant'Angelo*. The acquisition of this marvelous early-nineteenth-century painting was a particular victory for Sterling. It was he who had initially acquired it. He had purchased it in 1914, through Knoedler's. Then, shortly after buying it, Sterling had given the painting to his elder brother, Rino. That was before relationships went sour.

When Rino Clark died in 1933, Stephen inherited it. By that point Sterling had become estranged from all of his siblings—and inherited nothing. Of course it rankled him greatly that the gift he had made so generously now went to the sibling who had become his archenemy.

On June 10, 1944, Sterling had been wandering down Madison Avenue when, on reaching Sixty-fourth Street, he noticed that the door of the imposing town house of the Wildenstein Gallery was open at an unusual hour. With Daniel and Georges Wildenstein, the two French-born brothers who ran that distinguished institution, he looked at works ranging from marvelous Winslow Homer watercolors to a Courbet he had recently bought, but that the gallery was storing for him, to some Lancrets. Then, in an office, Sterling happened upon an early Corot, *Bassin à Honfleur,* and was overwhelmed.

When Georges Wildenstein said it was the best Corot ever painted, Sterling "grinned"[219] and named other Corots he considered as good or better. To prove his point, he mentioned the *Castel Sant' Angelo*—using its French name, *Château Saint-Ange.* This gave him an idea. He suggested that Georges Wildenstein try to see if he could get it from Stephen, so that he, Sterling, might buy it.

"Georges burst out, 'That man is impossible. He always comes around here looks at pictures goes away & always wants to buy at half the price.' "[220] Sterling could not have been more delighted with the

description, which he quoted in his diary later that day. Again he grinned, confirming the take on his younger brother and explaining that they had not spoken for twenty years.

Not that Sterling thought he was telling Georges Wildenstein anything new. He realized, of course, that the dealer, like most people in the New York art world, was familiar with the family rift, which is why Wildenstein would not have worried about deprecating Stephen in front of his brother. "Everybody knows . . . that he played me a dirty trick—Besides they see what I am like & what he is like—It is funny how the shoe has turned since the first break in 1923!!!!"[221]

Wildenstein told Sterling that they just might be able to accomplish his goal. The reason was that Stephen wanted to buy a Renoir, the *Kasbah*, "Daniel added with a smile, 'We advanced the price from $125,000 to $150,000'—Meaning as I understood it for Stephen's benefit!!!!"[222]

There was little Robert Sterling Clark relished more than the idea of his younger brother getting hoodwinked, especially because, although the Renoir was "a marvelous picture of a crowd & beautiful color," it was not salable, which is why the gallery had had it in stock for four years without finding a buyer. Moreover, he had been offered it for eighty-five thousand dollars when they first got it in; how marvelous to think that Stephen would need to pay more than half the amount again, forcing him to sell back the Corot.

According to Stephen's diary, all went according to plan. Stephen bought the Renoir, using the Corot as part of the trade, and Sterling ended up with a painting he both loved for its merits and desperately wanted back, even if he had to pay a second time to have it and to right what he considered a wrong that had been upsetting him for more than a decade since Rino's death.

Whatever the other reasons were for his longing to own it, unlike the Gérôme, this splendid work reveals Robert Sterling Clark's eye for art of the surest pictorial values. With the Tiber running gracefully through the main field of vision, it includes the imposing tomb of Hadrian, the distant dome of St. Peter's basilica, an aqueduct that seems to lope across the river with a dance-like rhythm, and a quiet assemblage of local buildings, some modest, some substantial, that meld into the land with the comfortableness of the best indigenous architecture.

This all-encompassing scenario measures a mere thirteen and a half by eighteen and a quarter inches. Yet every element is clear and resolved. The homogeneous whole is dappled by a warm summer sunlight that

unifies the elements that Corot, with his particular mastery, brings together in a beatific calm.

In the foreground of this quiet gem of a painting, we are treated to a simple scene of everyday life—figures standing around on the riverbank, a modest boat being pulled into the shore. They exist in the same harmony as the distant scenario that combines both unidentifiable buildings and monumental ones; thanks to the evenness of tonality and the grace of the brushwork, the balance of the muted coloring, and the strong yet quiet grid that orders the picturesque whole, everything has a unity and equilibrium. And the sense of atmosphere—the real space of the earth, the presence of air in spite of its invisibility—causes the fortunate viewer of this work to breathe with a depth and ease that pictures which are more simply surface, like the Gérôme, inhibit.

WITH PAINTINGS OF THIS CALIBER, Sterling Clark had become one of the foremost collectors in America of French nineteenth-century painting. On the rare occasions when he liked the taste and personality of other such collectors, he relished the chance for friendship, which was otherwise sadly lacking in his lonely life.

One of the collectors he befriended just after the war was Chester Dale. Dale's collection today hangs in the National Gallery in Washington, and is of such a high caliber that it is often compared to that of the Clark brothers combined. Dale was, at the time that Sterling got to know him, trying to figure out where to leave it; the Metropolitan was one of the museums being considered. "Chester remarked, 'You are the only Clark who makes sense to me. Why if you cut Stephen's veins there would be a flow of ice water.' " Stephen, according to Dale, had been among those who had the Met refuse Dale's gift there, because he "did not wish his collection overshadowed by Chester Dale's."[223]

Sterling and Dale liked eating well and drinking well together. "We all had a great evening jollying one another. I told Chester he was queer but only queer people were interesting and he returned the compliment." Dale told Francine that "she looked 40 & not 69—That I looked my age—But why hadn't we met Before!"[224]

Sterling wrote this in November of 1945. He and lots of other people were in a mood of postwar euphoria. The following spring, Charles Durand-Ruel and his wife returned to New York. Sterling, happy to be able to offer American bounty to friends suffering the deprivations that

still plagued Paris, invited them to lunch at the Ritz-Carlton on Good Friday.

Charles explained that they were fasting. Sterling's way of handling this was to say that he and Francine also were abstaining from eating meat. He enticed the dealer to have a koulibiac of salmon; as always, the meal was accompanied by wines from the collector's private cellar. When his life was good, and he could forget people like Roosevelt and his brothers, no one enjoyed himself more.

IF ON ONE SIDE OF HIS LIFE Sterling's shipping dockets had names like van Dyck, Piero della Francesca, and Rembrandt, in the early stages of World War II, they began to have entries like Galaday and Galatea II. When the Germans were advancing in France, Sterling had been able to ship his horses from his Normandy farm to the United States in space on American ships that had arrived with materials for the Allies and would otherwise have returned empty.

He got his prize racing animals out just in time. The German troops occupied the house and used it for a cavalry regiment. In July 1944, the Allies bombarded and destroyed most of the property.

Once peace was declared, even if the house was as good as gone, he could now turn to the equestrian activities he had pursued there. Sterling's love of the turf grew so intense that he began to send his racehorses to Harry Peacock, an expert trainer in Yorkshire, England. Yet again, America was not the place for him; the New York Jockey Club would no longer register the racehorses born to the Arab mares he owned.

In December 1945, not long after the armistice, Sterling shipped Whistling Wind to England, and the next year the horse raked in four trophies. The success of his prize possessions at the racetrack validated Sterling and made him immensely happy. It was a bit like seeing his paintings rise off the charts in value.

Of course things did not always go his way. In May 1947, Whistling Wind was the seven-to-one favorite in the important Lincolnshire Hand-icap when he fell behind and wasn't even in the money. But in spring 1948, Sterling's Sugar Bun won a five-furlong race for two-year-old fillies by one and a half lengths, and paid five to two. A month later, Sugar Bun beat the field by six lengths to win the Scurry Plate, and the following day Sterling's Singing Grass was victor at the Grand Stand Handicap. That fall, things improved for Whistling Wind, who won a big race in

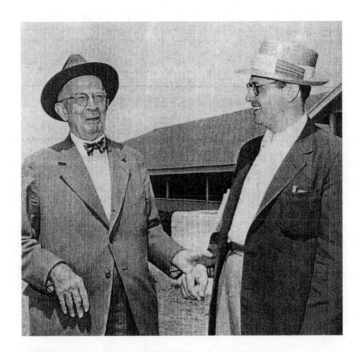

Sterling with George Blackwell, a yearling judge, in 1950.
When the New York Jockey Club made it difficult for Sterling's
horses to run in America, he began to race them in England,
and his winnings exceeded the Queen's.

Scotland and paid four to one. And in October Singing Grass took the
Stewards Handicap.

If readers of American newspapers had once known Robert Sterling
Clark as the sewing machine heir who was perpetually in one or another
sort of dispute, now those of them who read the sports pages constantly
came across his name as owner of the fillies that were winning major
races all over England. There was one triumph after another in the early
1950s. And then, in June of 1954, Robert Sterling Clark's Never Say Die
won the 170th Epsom Derby. The three-year-old was only the second
American horse ever to win; the previous one had been Iroquois, who
belonged to tobacco tycoon Pierre Lorillard and won in 1881.

The prize worth $47,485 might have amused Sterling, but of course it
was the sense of success that counted. The handsome chestnut was the
son of a British sire, Nasrullah, and an American mare, Sterling's own
Singing Grass. Sterling, who had long been as obsessed with horses'
bloodlines as with the conditions of paintings, had had Singing Grass

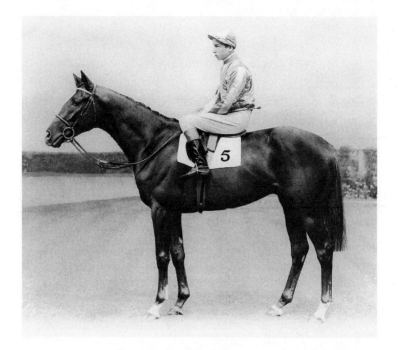

*Never Say Die. Sterling's great racehorse was only the second
American-bred winner of the Epsom Derby.*

shipped to Ireland in 1950 to be mated with Nasrullah before being
returned to Kentucky to be foaled. Sterling considered it "the crowning
glory of 35 years of efforts in thoroughbred breeding."[225]

Never Say Die had been a long shot at thirty-three to one. But jockey
Lester Piggott had made it all look easy. As enthusiasts all over the world
read in their morning paper the next day, the splendid colt "navigated
sharp Tattenham Corner like it was a simple gallop on the Downs, hit the
head of the stretch full tilt and romped home a two-length winner."[226]
Robert Sterling Clark himself was not there to witness this, but Queen
Elizabeth, whose own horse only finished eighth, was watching from the
royal box with her mother and with her aunt, the duchess of Kent.

Sterling was back in New York in the hospital for what was said to be
a routine medical checkup. His employee Humphrey Finney, who took
care of his horses, reached him with the news. "I called the hospital, and
got hold of the old man. When I told him Never Say Die had won the
Epsom Derby, he sort of grunted."[227] Sterling was in no mood to make a
statement to the press. But then Finney pointed out to him that he had

done what other American breeders had long been trying to do but at which all the others had failed. Adding to that glory, one of those who had not succeeded at the same goal was William Woodward, in Sterling's eyes a culprit in his battle with the Jockey Club. When Sterling realized that he had vanquished a foe, he was sufficiently pleased to grant Finney his request. "All right, tell them anything you want to tell them. Give all credit to McElligott; he planned the breeding."

Then the newspapers wanted a photo of Sterling. Since there was nothing on file, Finney approached him again. " 'No photographs,' he barked."[228] Finney asked about one on the mantelpiece in the apartment, but Sterling said Francine didn't like it. Then, again, he relented. And that afternoon he had his secretary phone Finney back and invite him to Doctor's Hospital for a celebration.

At that hospital with its ambience of a fine hotel, Francine, now white-haired, arrived with champagne, and someone else found paper cups. First they toasted the horse, then the trainer and men at the farm, and then the seventeen-year-old jockey.

Sterling recalled how the winner had gotten his name. He had sent about twenty possibilities to the Jockey Club for the son of Nasrullah and Singing Grass, but they had all been turned down. As he fell into a funk, his secretary, Miss Dwyer, had done her best to encourage him. "Don't worry, Mr. Clark. Never say die."[229]

"That's it!" Sterling had shouted. This was one name the Jockey Club said was still available.

When Never Say Die won the long and grueling St. Leger Stakes in Doncaster, England, that September, Sterling was less reticent in his response. As *The New York Times* reported in a banner headline the next day, he burst into tears. This time he was on the scene at the muddy, rain-soaked track. When his three-year-old chestnut colt completed the nearly two-mile run twelve lengths over the next horse, the crowd watched as Sterling proudly "gave 'Never Say Die' a big kiss and hug in the unsaddling area."[230] Weeping for joy before two hundred thousand fans, he then fed the colt a mouthful of candy.

"I'm too old to celebrate, but I'm just about the happiest man in the world today,"[231] Sterling said after the race that had lasted a little over three minutes. It was the first time in history that an American breeder had won both the Derby and the St. Leger.

That double success poised Sterling for another form of victory. By the end of the month, when Sterling's two-year-old filly, Castalia, won the

five-furlong Ann Hathaway Plate in Birmingham, Sterling took the lead over Queen Elizabeth as the top money winner on British tracks that year, with his winnings soaring to $109,505 over the queen's $107,632.

Following the St. Leger, Sterling and Francine Clark returned to Paris. The horse breeder immediately sent a cable with instructions to retire Never Say Die. "He'd won all that was asked of him, and I didn't want to hurt him," he later told Finney.[232] He gave the splendid colt to England, where it was accepted for the National Stud by the Minister of Agriculture.

That donation to a foreign country required Sterling's paying a gift tax to the U.S. government. But for once he didn't succumb to rage. Rather, he simply told others he hoped he would get to see Never Say Die's progeny race someday.

He didn't live long enough. But in spring of 1955, shortly before the opening of the Sterling and Francine Clark Art Institute in Williamstown, he wrote a revealing statement about his own mind. "I am not absolutely sure whether I am a-foot or a-horseback. I certainly had several thrills over Never Say Die, but I do wish he would attend to all the writing I have to do on his behalf. Bursting into flame all of a sudden is hard on the brain as well as on one's constitution."[233] His colt was what his brothers had never been for him: a soul mate in his headstrong battle to beat out the field.

IN THAT SAME PERIOD of postwar euphoria when he was shipping his racehorses overseas and hanging around with Chester Dale and other great art collectors who were trying to determine the ultimate disposition of their art, Sterling decided that he wanted a museum of his own that would be the equivalent of the Frick. The idea had, after all, been simmering for most of his lifetime—at least since 1913, when he had approached George Grey Barnard about going to Greece with him so that the sculptor could give ideas for decorations for a museum Sterling intended to build in the countryside, probably near Cooperstown. Now Sterling decided he wanted his repository in the heart of New York. If he remembered that Stephen had argued in favor of that location more than forty years earlier, and that he had pushed the idea aside, saying that he wanted it to be in the country for real Americans rather than the new population that had flooded the city, Sterling now overlooked both these factors. In 1945, he bought three buildings at the southwest corner of

Park and Seventy-second Street so that they could be torn down and replaced with a new museum to be called the Robert Sterling Clark Collection. A will he signed the following year left all of his art to his wife and two other trustees for this purpose.

Not only would the museum have been within just a few minutes' walking distance of the Frick Collection, it would also have been little more than a block from the house where Stephen and Susan Clark had been living for more than thirty years. Sterling must have delighted in the idea of their walking by and seeing his name emblazoned above the entrance.

Knowing his collection would go into the public domain upon his death, he continued to acquire art with his usual zeal. However, 1946 was his last year of buying in volume. He added a dozen significant canvases to his holdings, among them another Corot, a Guardi, a George Inness, a Millet, a Sisley, and, as if for old time's sake, a further Renoir. But, from then on, his collecting petered out, and he was generally down to between two and four paintings a year.

In 1950, he changed his mind about locating his museum in New York and sold the three buildings on the corner of Park Avenue. But he

Buildings at the corner of Park Avenue and Seventy-second Street. These three houses were purchased by Sterling to be demolished for space to build his museum.

still worked on creating the collection he intended in theory to leave to the public. Now if he went to the trouble to buy a painting, he generally did so because it was a gem—a work of such a high caliber that it must have seemed essential to the perfection of his holdings in their entirety. Sterling had become interested in Monet in a big way, and by 1952 had added three more major ones to the collection. He still could not resist Renoirs when he saw ones that met his quality standards and that took his holdings into a new realm; even though the prices were now significantly higher than when he had started, he bought, in 1950, a study for *Tannhäuser,* and, in 1951, *Apples in a Dish*—this delicate still life being his last acquisition by the painter who remained his passion of passions.

He also was buying major Winslow Homers, including *The Bridle Path, White Mountains, Seascape: Storm,* and a superb watercolor, called *Playing a Fish.* For pictures that evoke rural American life and the pleasures of the great outdoors in the epoch of American civilization before things had gone to rack and ruin, Sterling could have done no better. Homer captured the premacadam United States, the era of unpolluted air and simple pleasures, with a finesse and lightness of touch virtually unrivaled in our national painting.

In 1949, he had visited Williamstown, Massachusetts. The setting was not unlike that evoked by Homer's paintings, and the following year Sterling bought a hundred acres of woods and fields not far from the village center and what was then the all-male college there. He decided that this was where he would build the Robert Sterling Clark Art Institute. Nonetheless, in New York, because the Carlton House, which was where he and Francine had an apartment next to the Ritz-Carlton Hotel, was about to be demolished, they moved to a duplex apartment at 740 Park Avenue, near Seventy-first Street, only half a block from the buildings he had bought for his intended museum in Manhattan. Then, in 1951, he and Francine sold the house in Paris. It was in America that the sewing machine heir would leave his legacy.

IN 1952, just as Robert Sterling Clark was managing his art collection and racehorses with an intensity he might have hoped could compensate for the lacunae of his overall existence, Stephen's son Bobby—another Robert—died at age thirty-four. It was the end of August, the time of year when Stephen and his extended family were in Cooperstown, just as most of the Clarks had been summer after summer

for their entire lives. The exceptions to that rule had only been Alfred, when his sons were growing up, and now Sterling, since it was no fun to walk past his relatives on the village sidewalk, or run into them on the boat dock, when they were no longer speaking.

We don't know how Sterling found out about his nephew's death. There were, however, enough people who worked for the family and its interests in Cooperstown and on Wall Street that it was probably one of them who let him know. Sterling and Francine immediately sent a telegram and a large bouquet of flowers.

For all of his tempestuousness, and the stubbornness with which he had maintained his rage and silence for over a quarter of a century, Sterling was, beneath that gruff facade, a man of warm heart. Even if he had not met his nephew since he was a little boy, he was moved by Stephen's loss so that, at last, his strain of sweetness and generosity, and simple decency, overpowered his vituperative side.

On August 31, 1952, Stephen wrote "Robin"—the nickname that conjured the childhood when they would play together—to thank him for being in touch so warmly at the time of Bobby's funeral. This time, Stephen wrote by hand. In the correspondence that had ended more than twenty-five years earlier, he had been the stiff lawyer who dictated, from his office, typewritten formal missives to his elder brother in which, even when they were still communicating, he discussed investments and property division as if he were dealing with the wayward beneficiary of a trust for which he was the competent manager. Now, in this more intimate and personal note by pen, he used stationery from Fernleigh. Stephen lived in the so-called cottage on the property rather than the vast house their grandfather had built, but it was still the property where the Clark boys had spent the summers of their youth. The name alone was enough to evoke that period when their father was in Paris and Milan and Norway with his beloved Skougaard and the four brothers developed their own camaraderie.

Stephen thanked "Robin" for "the telegram and the beautiful flowers."[234] The "beautiful" counted: the way things looked never escaped a Clark. He then allowed that his son's death was a terrible shock. To his elder brother, Stephen provided details of its circumstances: the iron lung and emergency tracheotomy at Albany Hospital, and the blood clot that killed the young man just as he was getting better.

At age seventy, to the seventy-five-year-old sibling with whom there had been nothing but silence for a third of their lifetimes, Stephen

betrayed an emotional honesty that he had rarely evinced. He remarked that Bobby was "in a certain sense like a child who never grew up. But he loved everybody and bore no malice toward anyone; and he possessed an amazing quality for inspiring affection on the part of all sorts and conditions of people. The family servants and the townspeople of the resort village all loved the young man, and at the funeral the church, overflowing beyond capacity, was filled with flowers from the rich and poor alike."[235]

"I wish that you might have been there," Stephen then wrote Sterling. He still felt that tie to his older sibling—regardless of all that had sundered them.

The usually taciturn Stephen underlined the last line of his letter. *"All of which goes to show how transitory life is and how trivial are so many of the things we strive and struggle and fight about."*

"Give my best to Francine," Stephen then signed off, before according his brother an "Affectionately." Ironically, this was the same word that Robert had used, and misspelled, in their regular communications forty years previous. It was a significant step up from the "Very sincerely yours" that Stephen habitually used before signing with his full name as if in a business letter.

These scarred, unusual men were each doing their best to cope with the estrangement of lives in which, like their father before them, they had used art as their way of feeling and expressing emotion they could not address head-on.

If only, like the Robert Vanderpoel Clark who had just died, Robert Sterling Clark had been able to live without malice, and Stephen's hidden tenderness had emerged as now, in the shock of his loss, he permitted it to.

IN 1955, Robert Sterling Clark bought, at age seventy-eight, two paintings that would be among the gems of the museum he was forming. One was Corot's *Louise Hardain in Mourning,* a painting that had the distinction of coming from the collection of the painter André Derain. The other was Rubens's *Holy Family under an Apple Tree.* Robust, competently executed, vividly colorful, these canvases done two centuries apart and in different cultures had the masterfulness and embrace of life that was always, under the layers, dear to Sterling's heart.

When the collector died the next year, his estate was worth slightly

more than eighty-four million dollars. In current spending power, this would be about half a billion dollars. The obituary in *The New York Times* showed him with a large cigar held in the corner of his mouth, its ash ready to fall off. With his nose that had been reduced by surgery, his gray crew cut, large ears, and wire-rimmed glasses, he looks very much "the hell raiser."

Robert Sterling Clark, the obituary pointed out, had spent the last year of his life, between a stroke in October 1955 and the one that killed him fourteen months later, supervising completion of the museum he had built in Williamstown—and which had become the Sterling and Francine Clark Art Institute.

The museum would allow Sterling's thirty-nine Renoirs and seven Winslow Homers and masterpieces by Goya, Turner, Sargent, della Francesca, and Courbet to be seen free of charge to anyone who got there in the bucolic mountain setting in the heart of New England. Sterling had stuck to the dream he had first nurtured nearly half a century earlier when he contemplated building a public gallery in Cooperstown. The proximity to Williams College, the alma mater of the grandfather who had made the family its fortune, would assure that his preferred sort of Americans would reap the benefits. The college administration had lobbied hard to convince him of the many benefits of the site.

Francine and Sterling had thought carefully about the location. They "were convinced that a 'crossroads museum' would entice summer motorists who might never go near a big city art show. They also chose the college town because it was far from urban centers that might be targets for atomic bombs. Reinforced concrete used in the construction of the museum was designed 'to withstand an atomic explosion one-tenth of a mile away.' "[236]

According to recent revelations, which some consider legend and others claim as facts, while the building was under construction, Sterling led a new way of life, which he kept entirely clandestine. Like his father, he had an alternate existence, but unlike Alfred, he managed to shake off his real identity completely. In North Adams, a neighboring town, Sterling "had a secret career as an occasional mechanic" at Vic & Paul's Motor Sales, which sold imported English sports cars like MGs and Austin-Healeys, as well as Morris Minors. Vic & Paul's advertised, "We specialize in carburetor and ignition work, general automobile repairing, batteries and accessories." Under the name of "Joe," Sterling "worked for nothing, did expert repairs, and ran errands for the rest of the staff"—

ABOVE: *Sterling and Francine Clark Art Institute, Williamstown, Massachusetts.*
Sterling decided to commission a museum in the countryside to house his collection
in a structure strong enough to withstand a nuclear bomb explosion.
BELOW: *Sterling and Francine at the opening of the Art Institute in 1955.*

who had no clue who he was or where he lived. To get to his nonpaying job, Sterling "would ride in his chauffeur-driven Cadillac and have himself dropped off at a safe distance from Vic & Paul's."[237]

It was only when the insurance agent for Vic & Paul's was invited to the opening of the Clark Institute that the repairman's identity became known. "I was struck speechless when I saw the host, Sterling Clark. He was 'Joe,' the eccentric mechanic." It soon came out that there were many occasions when Francine would know Sterling's plans for the day only from his morning attire, which, in addition to a mechanic's uniform, included clothes fit for a stable hand and a "truck driver disguise. Clark did not actually drive trucks, but would hang out at truck stops, chat with other drivers, and bum rides to interesting destinations. When playing as a stable hand, Clark wouldn't let on that he was an expert rider and owned race horses himself. He would be content with assignments to sweep stalls or be an 'exercise-boy' with the horses."[238]

On weekends, however, he would don his gray suit and top hat and appear at the site of the monument he was funding. The three-million-dollar building on a hilltop in the northwest corner of Massachusetts, where construction was generally of wood or brick, was faced in marble on top of that shock-absorbing concrete. Marble was the same material in which the ancient Greeks had built their monuments. This was the stone with which George Grey Barnard had memorialized Lorentz Severin Skougaard as a muscular Antinous in consort with the slightly older male figure that embodied Sterling's father. It was also with marble that, thirty years after Barnard had been their father's ward, Sterling had intended the sculptor to decorate the first museum he had conceived.

Human life, as Stephen had reminded Sterling in the letter following Bobby's death, was transient; concrete and marble, one hoped, were not. Sterling, the same person who had shipped his art to Colorado during World War II in case submarines attacked the harbors of New York, had remained ever fearful of what the wrong governments might do. He had deliberately built a safe house. Having, according to many authorities, tried to help finance his own invasion of Washington, now, with the advance of armaments, Sterling was emphatic about the need to survive a nuclear bomb.

The artworks that would be housed in this sturdiest of substances had, one would hope, the immortality its makers and its owner lacked. This museum, and those marvelous paintings, would keep the richness of living, and of vision, alive.

V
EDWARD AND AMBROSE

If Sterling and Stephen Clark believed that the collecting and donating of art to public institutions would confer immortality on their names, they were completely right. Their two brothers have for the most part passed into oblivion. They made charitable contributions on a scale that warranted at least a plaque or two that would brandish their names well after their deaths, but neither of them was associated with a major museum, which is why the world has remained far less aware of them. Yet Rino and Brose were equally a part of this extraordinary family.

Rino—Edward Severin Clark—was the first of the sons born to Alfred and Elizabeth. He was given the "Edward" for his powerhouse grandfather. The "Severin" was, of course, for his father, Lorentz Severin Skougaard, the "Rino" a derivative of Skougaard's stage name of Severini. Rino was born in France in 1870, in the place and at the time period where his father, who had met Skougaard four years earlier, had his other life.

Rino, it seems, suffered from a physical handicap that began in his childhood, although this doesn't get discussed, and the details are difficult to parse. George Grey Barnard had written about an illness and quarantine when Rino was sixteen. According to the son of a close family friend, he was crippled as a result of polio, but the malady also gets reported as having been because of a fall he took as a child. He had some sort of mental infirmity to which people vaguely allude without being specific. Although he had inherited the Dakota and had a twenty-two-room apartment there, he spent most of his life at the family's Fenimore Farm on the shore of Otsego Lake, where he had a second nickname of "the Squire." As an adult, he was obese. He never married or had children, and, either because of his medical condition or his personality, he

ABOVE: *Edward Severin Clark as a boy. The oldest of
the Clark boys, "Rino" got both his middle name and
nickname in honor of his father's beloved "Severini."*
BELOW: *Rino, c. 1900*

was not active in the way of Sterling or Stephen, but he was beloved by the townspeople of Cooperstown.

When Rino died at age sixty-three in 1933, the flags were lowered to half staff throughout the village. Ten years earlier he had given the town its first motorized fire engine to replace its horse-drawn hook and ladder. With Stephen he had also built the large Otesaga Hotel on the lake there; bought and operated another hotel, the historic Fenimore, when it was about to be demolished; and given the town a second Alfred Corning Clark Gymnasium. He was buried in Cooperstown, near his father: two men with bank accounts beyond most people's imagining, and lives little known to others. His grave monument is a small version of George Barnard's *Brotherly Love,* the sculpture his father had commissioned as a memorial to the man for whom Rino was in part named.

A lot was murky; what *was* known, however, was that Rino left the part of his estate he controlled—including the Corot that Sterling had given him—to Stephen and his family, and that the bulk of his trusts ultimately went their way as well. Frederick Ambrose Clark, the third son of Alfred and Elizabeth Clark, who had also inherited some properties, but less than Stephen did, did not appear to mind this, even if Sterling had a fit. For Brose had pretty much the life he wanted and needed no supplement to have more than enough money to continue it in style.

The "Frederick" was for Frederick Bourne, Singer president and his father's Mendelssohn Glee Club friend—and the "Ambrose" for his maternal grandfather, Ambrose Jordan. But beyond bearing their names, he had little in common with these men who had full-time jobs and were known for their accomplishments in the workplace.

Brose could have been cast as Uncle Willy in *The Philadelphia Story:* the endlessly amusing ne'er-do-well and bon vivant. His name hardly ever gets mentioned—whether by family members or in the *Country Life* sort of magazines where it would appear—without the word *Champagne.* His great-niece Anne Peretz remembers him having a magnum of bubbly at the breakfast table before he jumped into the saddle.

Sterling had been sure that Brose's high living would take its toll and he would die young, but in fact he lived the longest of the four sons of Alfred and Elizabeth, and died in 1964 at age eighty-three. After being told he could not return to Columbia College following his sophomore year, he spent most of that long life foxhunting, racing his steeplechase horses, driving his four-in-hand, collecting sporting art, and charming most everyone he met. He was ruddy-faced, immensely broad-shouldered,

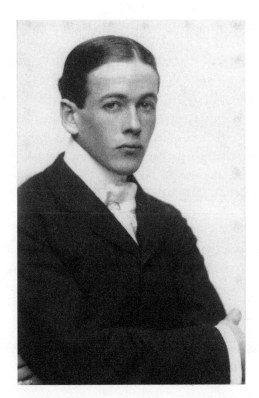

Frederick Ambrose Clark, c. 1900. Brose would
be the family playboy, at whose wedding all the
guests received solid gold horseshoe nails.

and heavyset, almost always in a gray bowler hat and dashing tweeds with
a bright handkerchief flashing from his breast pocket. He seemed more
like a character out of *Tom Jones* than someone in the twentieth century.

Brose did not even pretend to concern himself with the management
of the fortune he had inherited and that facilitated his way of life. "I'm
not a money maker. All I know is horses. Why should I go puttering
down to an office to meddle in something another man can do a hundred
times better?" he asked a friend.[1] He didn't need to worry about cash; in
1902, when he was twenty-two, he married Florence Stokes, who shared
the love of horses and was the daughter of the president of the Manhattan
Life Insurance Company. Her own wealth added substantially to Brose's
own inheritance, itself estimated at thirty million dollars.

Ambrose and Florence's wedding in "the old English reception room"
of her parents' country house on Long Island Sound in Mamaroneck gave

a sense of how they would always live. The ceremony, at which Brose's stepfather, Bishop Potter, officiated, was performed under a canopy of a thousand roses. The *New York Times* article made note of the diamond and pearl pendant the groom had recently given the bride, and which she wore for the occasion, as well as of the summer residence in Cooperstown that was Brose's mother's present. These were happier days for all the Clark brothers; Sterling, in his lieutenant's uniform from the Ninth Infantry, and Edward and Stephen were among the ushers. Ambrose and Florence's wedding cake was in the form of an enormous horseshoe, and was studded with enough solid gold horseshoe nails that each guest had one to take home.

Brose was an amateur steeplechase rider and good polo player when he was young, but was thrown from horses frequently enough to have to give it up. In 1910, he broke his collarbone; twenty years later, after further falls, he told friends he was "just going over to the vet to get patched

Fenimore House. Rino inherited from his grandfather both the Dakota in New York and the farm on which he built this spectacular mansion in Cooperstown.

up," at which point "he had several silver pins into his spine to hold it together,"[2] which further limited his own riding but by no means put a halt to it.

He and Florence kept horses at Iroquois Farm in Cooperstown, but they also could ride at their estates in Westbury, Long Island; Aiken, South Carolina; and Melton Mowbray in England. They had a town house in Manhattan as well, although spent little time there since they liked to be at places where it was easier to hop into the saddle. Brose stayed on his horses until the end of his life, although he was said to have "broken every bone in his body by the time he was seventy"; at about that age, when he fractured his left hip, he refused to get into the ambulance until he was given a Havana cigar and a bottle of Champagne.[3]

At his estate in England, Brose would regularly go foxhunting with the Prince of Wales, before he was the Duke of Windsor. Kellsboro House in Aiken was best remembered by others for its meals, the stuffed pigs and stuffed young squab being great favorites. Broad Hollow, the 1912 brick Georgian house on Long Island, was, with its enormous entrance portico, the most impressive of all. In that forty-two-room mansion, the Clarks entertained on a large scale, often giving parties for five hundred friends—all the easier starting in 1924, when they added an oak-paneled ballroom for a visit of the Prince of Wales.

Brose and Florence owned separate stables, and sometimes their horses raced against one another. In 1933, he sold Kellsboro Jack, an English horse that had been trained in Ireland and that he had bought for a hefty sum the year before, to his wife for a pound note because he wanted to break the jinx of problems with its training. In 1933, Kellsboro Jack won the English Grand National, at which the horse Brose owned, Chadd's Ford, came in next to last. Florence, a portly woman dressed as usual in a lace-trimmed flower dress and wide straw hat, graciously asked her husband to parade Kellsboro Jack around the winner's enclosure, and he gladly accepted.

A few years later, as World War II began to rage, Brose had the same idea as Sterling, to whom he was no longer speaking, that he should ship his racehorses and hunters back to America for safekeeping. The English countryside no longer felt secure. "Why Brose, how did you know there's a war going on?" Florence asked. His answer was that he had read about it in *The Blood-Horse,* a magazine for breeders.[4]

In spite of having his house in New York, for the most part he avoided the modern world. On the five hundred acres around the great brick

house in Westbury and the twenty-five-hundred-acre Iroquois Farm, this wasn't hard to do. Brose detested automobiles and campaigned against the paving of roads (it is said that car tires never touched the pathways of Broad Hollow), but when he did have to venture out, he did so in the Rolls-Royce he had had constructed specially for him and that had a bed in the back. When one of his horses won the Meadow Brook Cup, the oldest point-to-point race in America, and NBC sent a radio mobile unit to the house in Westbury, he refused to let the truck on the property and made them transfer the sound equipment to a farm wagon. Brose had his stubborn streak; when one of his thoroughbreds wasn't cooperating when he wanted it to run, he put a hot potato under its tail.

Brose had inherited some of his parents' pictures, but his own interest was solely in sporting paintings. The best of these—by the masters of the genre, among them George Stubbs, Benjamin Marshall, and John Wootton—were in the house on Long Island, where the pastures and stable and carriage house all looked as if they had come out of the art on the walls.

After Florence died in 1950, and her horses were put up at auction with the proceeds going to her favorite charities, he had said he would

Broad Hollow. Brose married a woman of substantial wealth who shared his love of splendid houses and loathing for paved roads; visitors to Broad Hollow, on the Gold Coast of Long Island, could approach only on foot or horseback.

LEFT: *Florence Clark in 1933.
Brose's wife Florence kept her own
stables and bred horses that ran
against her husband's on the track,
but when one that she had bought
from him for a pound won a race,
she invited him to accept the trophy.*
BELOW: *Ambrose, c. 1940.
Brose was known to have a
magnum of Champagne served
with his breakfast.*

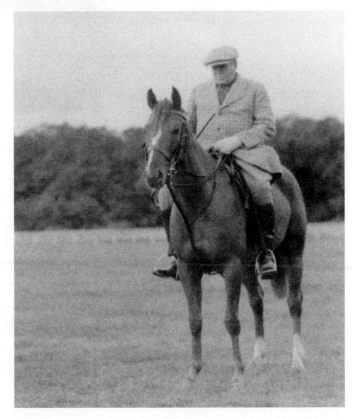

simply observe. He then contradicted himself by buying *"Tea-Maker,* a dark bay son of *Tea Leaves* and grandson of *Teapot."* That way, he was both supporting a cause and acquiring a horse he could not resist. Consistent with his belief in making the most of any situation, the widower went on to remarry when he was in his mid-seventies, taking as his second wife Constance Augusta Miller.

The one relationship he could not work out was with Sterling. Over the years, Brose's horses, like those of the brother three years his senior, took some big prizes, if nothing to rival the Epsom Derby, but the two never met at the track, and if they noticed each other's horses, it was probably only to gloat when their own were the victorious ones. Sterling did not feel as acrimonious toward Brose as toward Stephen, and Florence had made efforts to maintain some sort of connection with Sterling and Francine, but they nonetheless had little to do with one another.

Brose was one of those people who may have had closer rapport with his animals than with other human beings. Anne Peretz remembers that, at the breakfasts in Cooperstown with the magnum of Champagne on ice—where she, a young teenager, sat at one end of the dining room table with the inevitable high-backed chairs and her country squire uncle at the other end—just before the 7:00 a.m. meal, six springer spaniels appeared and hopped into those regal chairs, three on each side. The dogs stayed at perfect attention. The butler had put their bowls of food in front of them, but they kept their distance. Then Brose rapidly mumbled grace. It was only after they heard "Amen" that the dogs' heads went down into the bowls.

Following breakfast, Brose, having consumed most of the Champagne, took Anne to the stables and they headed off into the countryside. They had a routine. They would gallop through the woods and over the meadows until they reached a small graveyard. There were just two tombstones: one for Kellsboro Jack, and the other for Buttons, a particularly beloved dog. Each stone was impressive, with lengthy inscriptions.

Arriving at the site, Brose would dismount. Then, at graveside, he took off his riding hat. For a full five minutes, he stood in perfect silence. Silence was familiar enough to Anne—it was the norm for her grandfather Stephen as well—but this time the quiet was especially loaded.

In keeping with his instructions, Ambrose was eventually buried at the same small cemetery as the dog and horse. But he had a much smaller stone than they did. The inscription simply gives his name and dates, and the words "lover of animals."

. . .

AMBROSE WAS ANOTHER CLARK with a secret. Although family trees show him and Florence as childless, and the various magazine and newspaper articles about him reported him as such, and although in the discussions of trusts and estates no mention is made of his having a child, he had a daughter, who was born in 1910.

Ethel Stokes Clark, however, had a disorder that handicapped her mentally and physically. For this, her parents found a solution. They bought a 250-acre farm with an enormous house from a Mr and Mrs. Sterling—in spite of the name, no relation to the family. They moved "Ambrosina," as she was nicknamed, into it, and she was staffed by nurses for the rest of her life.

The facts are hard to sort out. People who remember Ambrosina refer to her as having been "severely mentally retarded," but clearly she had a degree of functionality, for she played the piano exquisitely. On occasion, visitors would go to the house and hear her perform.

One of the few accounts that mentions Ambrose's and Florence's daughter reports that she died at age nine. In fact, she lived to be thirty-two, even if her mental age may not have gone beyond six, with her ability at the piano being like that of a child prodigy.

In general, "no one ever spoke of her. Ambrosina was discussed even less than Uncle Sterling."[5] The Clarks were always determined to guard their privacy.

VI
STEPHEN

W e know what Stephen Clark looked like in the eyes of his brother Sterling. But this distorted lens provides a vision determined more by Sterling's own demons than by any real sense of who Stephen was.

Stephen comes into slightly sharper focus with his letters. That he was taciturn and immensely reserved is clear in these controlled, correct, and slightly tense missives. So is his guarded heart, and his very serious wish to make sense of life, to kick aside the obstacles to human understanding and achieve true connection, to embrace what is noble and worthy in the soul. He was formal and aloof, but he was driven by his morality, his perpetual wish to do what was best, to advance a good cause and to serve others. These desires emerge in his correspondence on behalf of the Museum of Modern Art as in the tender and thoughtful letter he wrote Sterling in response to his son Bobby's death.

Stephen was seen by others as cold or grim; in the corridors of the Modern, where he was both chairman and president, he was likened to a mortician. The dark-suited lawyer was certainly the most buttoned up of the four Clark brothers, even as his friendly and affable wife, chatty to her family, socially gracious to outsiders, lightened the scene. But if on the surface he was like a J. P. Marquand character who lived according to the Ivy League rule book of the first half of the twentieth century, he quietly struggled with the same complexity of human experience that was manifest in the paintings he bought. Befitting the preponderance of the pictures to which he was drawn, Stephen inhabited his own isolated world.

The youngest son of Alfred and Elizabeth, he was only fourteen when his father died. This made him feel independently wealthy at an earlier age than his brothers, even if his money was held in trust. He also

acquired, at a younger age than they did, the sense of responsibility that passes to a widow's son; strong as his mother had already shown herself to be during the five months annually that her husband spent away from the family, he felt a need to care for her. Stephen wore the family mantle more than any of the other three children did. He was his grandfather's double in his air of propriety, the Sunday-school teacher's reserve, the seriousness.

To a greater extent than Rino, Sterling, or Brose, he was an upright (today we would also say uptight) businessman. He was also a savvy one. Above all else, the Singer Company, in which he maintained a role, continued to grow meteorically, as did, thereafter, his own wealth and that of his brothers. Yet Stephen's main motive was not so much to increase his or the family's wealth as to manage it wisely. For Stephen was his parents' true heir as a servant to society, someone whose sense of philanthropy went well beyond the usual standards of correctness and an abstract notion of right and wrong. His consuming engagement with nonprofit institutions ranging from hospitals to museums stemmed from an abiding wish to make life better for other people. To the generations that followed Edward Clark, the financial wealth was a given; how to use it for the benefit of others was the more interesting question.

Stephen, far more than his father or any of his brothers, and very much like his mother, would approach this task in as rational a way as possible. Whatever the undercurrents of life, however tumultuous the seas, like Elizabeth Scriven Clark, he adhered to the rules of American aristocracy where rank was based not on bloodlines but on propriety and public service.

Unlike his three brothers, Stephen technically had a profession. He was a lawyer, as well as, in his early years, a publisher. He was also the one in the family to maintain the strongest role in the Singer company. As one former employee put it, "Singer had a director, and had a president, and it had a Clark; and everyone knew who had the last word."[1] But his main identification came from how he dispensed his wealth, not how he gained it; it was as a philanthropist, not merely someone who gave away money but who devoted himself to the management of nonprofit organizations, that he excelled above all else.

WERE IT NOT for his father's long absences in Europe, Stephen would have enjoyed a traditional childhood of the type accorded the very rich.

*Stephen Carlton Clark, c. 1890. The youngest
son, Stephen assumed the mantle of family
responsibility even as a young man.*

There were summers full of outdoor pleasures in Cooperstown, where he
was born, and winters in Manhattan—first in the enormous house his
grandfather had built at 7 West Twenty-second Street, with the occa-
sional outing to the family's vast apartment at the Dakota, and subse-
quently in the mansion on Riverside Drive his mother built when he was
sixteen. Stephen was educated by tutors and then at a good private school
before going to Yale when he was seventeen.

As an undergraduate in New Haven, Stephen suffered from the nick-
name "Bathroom Clark." The reason was that his mother had installed a
tile bathroom in his college room, a result of the same blanket enthusi-
asm for building projects that had led Elizabeth to construct housing for
the underprivileged as well as her own grand house. Later in life, there
would be people who would remind Stephen of his nickname at
moments when he wasn't the least bit in the mood to hear it.

He graduated from Yale in 1903 and toured Europe with a friend
before returning to Cooperstown. The following summer, he visited Ster-

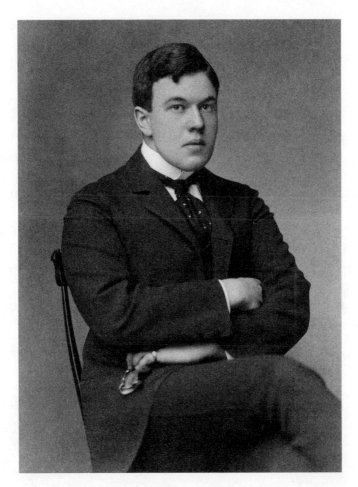

Stephen, c. 1905. At Yale, after his mother organized the refurbishing
of his quarters, he acquired the nickname "Bathroom Clark,"
which would later haunt him at the Museum of Modern Art.

ling in China. The two young men who had had much of the same child-
hood had completely different temperaments. Sterling, who was still in
the army and now stationed in Peking, was full of piss and vinegar.
Stephen was quieter and more reserved. But both brothers were intrepid,
and interested in what they saw, and they felt a considerable rapport as
they tramped around in tandem for three months.

Stephen went to Harvard Law School but, the responsible one who
always did what he thought was best for the family, he transferred to
Columbia so he could be back in New York and nearer to his mother.

Shortly after being admitted to the bar and graduated from law school, he entered the political arena. As a Republican based in Cooperstown he failed in his bid for election to the State Senate but in 1909, at age twenty-seven, was elected to the State Assembly.

The preceding February, Stephen had married a woman who was very much from his same world, albeit with less money and fewer known complications in her family's immediate past. To those who believed to sticking to the milieu of one's youth, there could hardly have been a more perfect match. Susan Vanderpoel Hun, beautiful like a Gibson girl, stylish without being trendy, wonderfully mannered and able to comport herself exactly as befit a young woman of her station, was from a family of lawyers from upstate New York and also spent her summers in Cooperstown. The newlyweds rented a town house in New York on Seventy-eighth Street just off Fifth Avenue and planned to build a country house right on the lake in the resort community they both loved.

But less than two weeks after their wedding, Stephen's mother died. In Cooperstown, she had been living at Fernleigh in the house that was like a small castle, although it technically belonged to Stephen's older

Fernleigh Cottage. When the financial circumstances of the Depression forced Stephen and Susan Clark to dismiss some of the servants necessary to maintain everyday life at his grandfather's palatial house, they moved to this smaller structure on the property.

brother Edward, to whom their grandfather, the first Edward, had left it, with the intermediary generation enjoying the rights to live there. The younger Edward Clark, who also had a farm on the lake, had no wish to move into such a grand and imposing place even if it was by rights his. Stephen took it on just as he assumed the weight of family obligations in every other respect. Fernleigh was larger and more difficult to run than he and Susan wanted, but they felt an obligation to honor the stipulation Stephen's grandfather had made in his will that the family should retain this albatross of which he was so proud.

At the end of 1909, Stephen and Susan had had their first child, a daughter; by 1917, they would have four sons, although one, Peter, died in infancy. The Stephen Carlton Clarks quickly took up the way of life that, regardless of its sumptuous scale, came easily to them, summering in their grand headquarters in Cooperstown and undertaking to build their own double-width town house on the southern side of East Seventieth Street between Madison and Park avenues.

In little time, Stephen, if not Susan, would break from tradition, but not yet. Inside and out, the imposing town house they built had the look

46 East Seventieth Street, entrance hall. The interior of the Clarks' town house was an unusual setting for modern works by artists like Brancusi and Picasso .

of many of the colleges at Yale, a place that was dear to him. The facade was gray stone with a panoply of Gothic ornament; the inside was decorated within an inch of its life in heavy paneling, coffered ceilings, complicated plasterwork, and the revival of one architectural style after another. There was everything except for a hint of blank space. Visually, it was all incredibly serious—very much like the dour young man who

46 East Seventieth Street. In 1911, shortly after he married, Stephen built this double-width Gothic town house between Madison and Park avenues.

built it—while it was also unabashed about its wealth and fanciness, like his fetching young wife. It required ten servants to maintain everyday life there, but Susan organized it all with grace.

STEPHEN BEGAN TO PUBLISH three newspapers that came out of Albany—*The Evening News, The Evening Journal,* and *The Knickerbocker Press.* He would do this until he sold them in 1928 to Frank E. Gannett. If his brother Ambrose could live like an eighteenth-century aristocrat, the youngest of the Clarks was in the modern world. In 1913, he went to the renowned Armory show. There he purchased a sculpture by the contemporary German artist Wilhelm Lehmbruck. Called *Standing Woman,* it cost $1,620, and his acquisition of it made a splash, since this was the largest sum paid for any sculpture in the exhibition. A few months later, Stephen and Susan, now four years into their marriage, made their trip to France and Italy with children and traveling companion in tow in order to be shepherded by George Grey Barnard as they spent some sixty thousand dollars on objects, although now, in order to furnish their new house in suitable style, they turned to the past and bought furniture and tapestries and antiquities of a type that drove their guide to despair. Stephen was definitely on the fence in his taste; sometimes he favored the new, at other moments what was traditional. When he turned to the modern, it was within certain confines: recognizable subject matter which, even if rendered in a pioneering style, also had visible links to artistic tradition.

A unifying element of his taste—whether in the Gothic revival of his houses in town and country, or in modern sculpture—was not only the continuity with the past but also a weightiness. Sterling was attracted to exuberance, Stephen to detachment—and to paintings and objects where intelligence was the guiding factor, frivolity nonexistent. In 1914, he paid fourteen thousand dollars, a significant sum for the time, for watercolors by Whistler, who would remain one of his favorite artists. Muted in tone, restrained in palette, and exemplary as work by an intensely thoughtful artist, they had the atmosphere of feeling to which he instinctively gravitated. In his own life, he would be given to quiet reflection; the same was true of art he bought. This did not mean that the pictures were invariably dark—he might, as in the Matisses and van Gogh and Seurat he would acquire within the next two decades, opt for vibrant colors—but there would always be an underlying thoughtfulness. The

artists Stephen would like all his life—from El Greco to Cézanne to Thomas Eakins to Edward Hopper—would have in common their tortured, unquiet minds, the gift and burden of people who experience life in its highs and lows and are incapable of dissembling about either extreme.

During World War I, Stephen was in the Second Army Corps, serving as a lieutenant-colonel in the Adjutant General's Department and ending up stationed in France. When the American army marched down the Champs-Elysées to celebrate victory in spring of 1918, he was far too serious in his comportment to do handstands and sing as did some of the troops, but he remained in service until February 1919 and would received a Distinguished Service Medal for his accomplishments following the armistice. The citation could have been used, word for word, for his work at the Museum of Modern Art a quarter of a century later: Stephen was honored for "administrative ability of an exceptionally high order. . . . His tireless energy and unceasing devotion to duty assisted materially in the success achieved by the organization."[2]

When he was back from military service, Stephen became the most devotedly "Clark" of the four sons—as was apparent in all of the financial discussions between him and Sterling in the 1920s. Beyond being the only one of them to serve as a director at Singer, he concerned himself with the distribution of objects in his parents' estates and with the well-being of his siblings, to the extent that they would permit, and of the old family servants. He added spectacular gardens, two tennis courts, and a large swimming pool to the spread at Cooperstown. At the same time, he continued to interest himself in the art being done around him. In 1917, he had become a member of the Century Association, where some of America's leading artists were also members and where, in 1920, the Washington-based collector Duncan Phillips lent pictures by some of the most interesting American painters at work at the time. Stephen began to acquire work by a number of these people.

One of them was Arthur B. Davies, who never achieved the fame of some of his contemporaries but was often the choice of people who really knew about and looked at art. Davies was a painter's painter, his work also revered by museum curators. He handled paint with gusto, and his small allegorical canvases were animated with vigor. It was completely consistent that Stephen would also, in time, own an El Greco, for here, in a completely different culture and era, was another painter one hundred

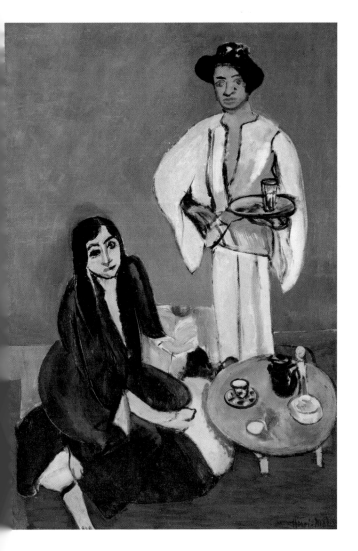

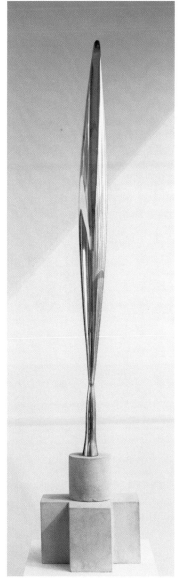

ABOVE: *Henri Matisse,* Coffee (Oriental Lunch),
*1916 (Stephen's collection). In the house on Seventieth
Street, the top floor, previously a playroom for children,
was decorated in colors and patterns from the Matisse
paintings that hung there.*
RIGHT: *Constantin Brancusi,* Bird in Space, *1928
(Stephen's collection). Few people have ever realized that
Stephen owned this revolutionary sculpture, which he
bought four years after it was made and soon gave,
anonymously, to the Museum of Modern Art.*

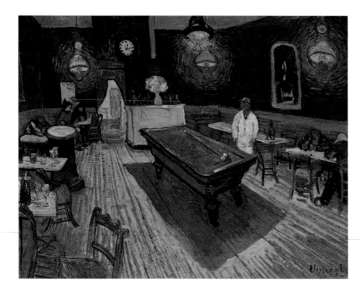

Vincent van Gogh,
The Night Café, *1888
(Stephen's collection).
Van Gogh painted this
to pay the rent for his
room. The vivid image
of dissoluteness has
since become one of the
best-known European
paintings in America.*

RIGHT: *Winslow Homer,*
Old Mill (The Morning
Bell), *1871 (Stephen's
collection). Yet again, Stephen
acquired an evocation of
loneliness and solitude, in a
setting of great visual appeal.*
BELOW: *Winslow Homer,*
A Game of Croquet, *1866
(Stephen's collection). Beyond
the aesthetic delights, the
tensions and competitiveness
are palpable.*

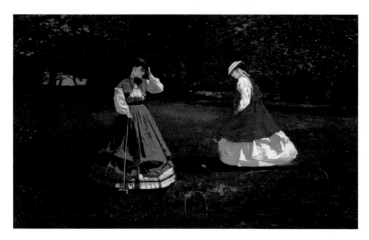

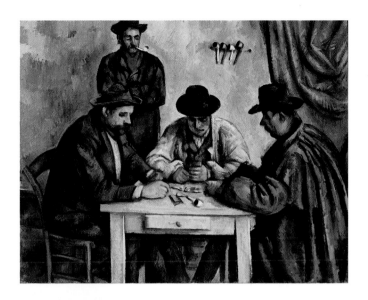

Paul Cézanne, The Card Players, *c. 1890–92 (Stephen's collection). This bold and innovative painting, of stunning visual and psychological truthfulness, is today one of the masterpieces of the Metropolitan Museum of Art.*

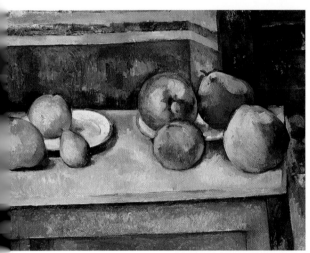

LEFT: *Paul Cézanne,* Still Life with Apples and Pears, *1885–87 (Stephen's collection). Time and again, Stephen would buy an artist's quintessential work, one that brings the viewer into direct contact with fundamental elements of earthly existence.*
BELOW: *Georges Seurat,* Circus Sideshow, *1887–88 (Stephen's collection). Alfred Barr, founding director of the Museum of Modern Art, considered this the single most important painting owned by any museum trustee. Stephen was the Modern's chairman and president, but the painting ended up going to the Met.*

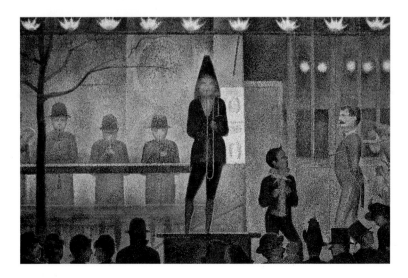

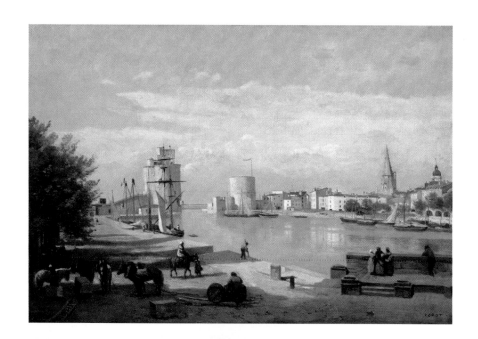

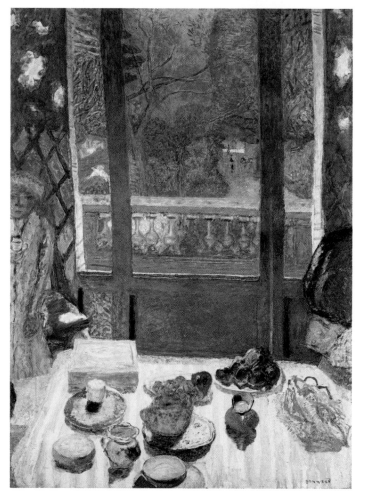

ABOVE: *Jean-Baptiste-Camille Corot,* The Harbor of La Rochelle, *1851 (Stephen's collection). This was one of the many French masterpieces, exquisitely conceived and executed, that Stephen bequeathed to the Yale University Art Gallery.*

LEFT: *Pierre Bonnard,* The Breakfast Room, *1930–31 (Stephen's collection). This sumptuous painting, which Stephen gave anonymously to the Museum of Modern Art when Bonnard was at the peak of his powers, introduced the American public to new possibilities of the splendors of everyday living.*

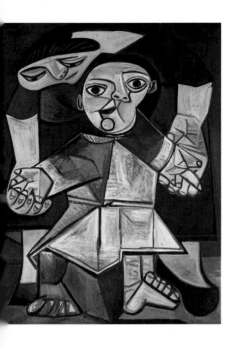

LEFT: *Pablo Picasso,* First Steps, *1943 (Stephen's collection). Stephen's persona seemed dour, but he was often drawn to art of great humor and tenderness.*

BELOW: *Pablo Picasso,* Dog and Cock, *1921 (Stephen's collection). Stephen owned ten major Picassos; he had a surprising fondness for what was tough, brutally honest, and pioneering in artistic approach.*

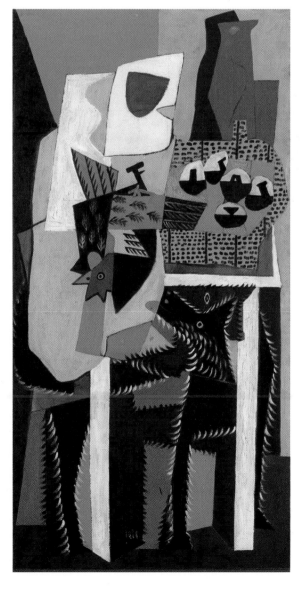

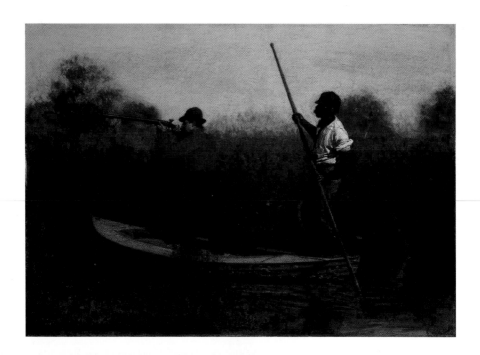

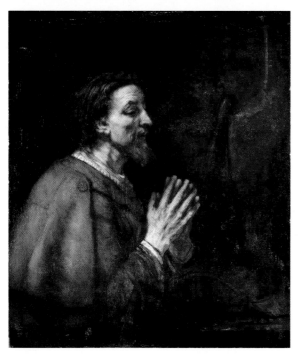

ABOVE: *Thomas Eakins,*
Will Schuster and Black-
man Going Shooting,
1876 (Stephen's collection).
The mathematical rigor
and precision of this paint-
ing, as well as the impeccable
deployment of colors, make
this one of the best of the
many works by Eakins
that Stephen acquired.
LEFT: *Rembrandt van Rijn,*
Saint James the Greater,
1661 (Stephen's collection).
This late acquisition, which
showed that Stephen never
lost his eye for masterpieces,
would have a tremendous
impact on the one of his heirs
with the greatest eye for art.

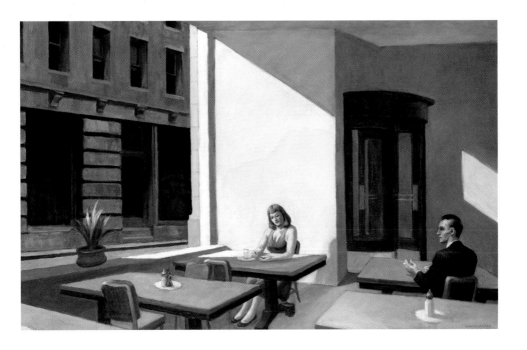

ABOVE: *Edward Hopper,* Sunlight in the Cafeteria, *1958 (Stephen's collection). Stephen lived in splendor, but was drawn to scenes of a very different world from the one he inhabited. Hopper was immensely pleased that his longtime supporter and friend bought this masterpiece.*
BELOW: *Edward Hopper,* Rooms by the Sea, *1951 (Stephen's collection). Stephen was often drawn to works that evoked loneliness and emptiness, illustrated with consummate artistry.*

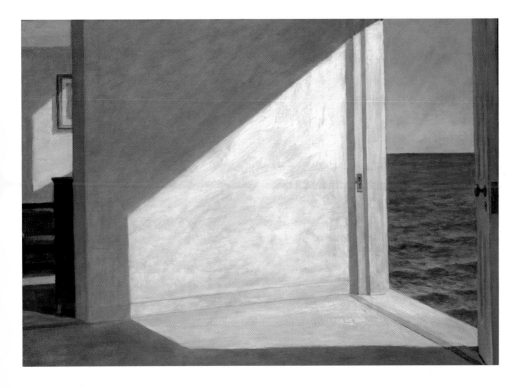

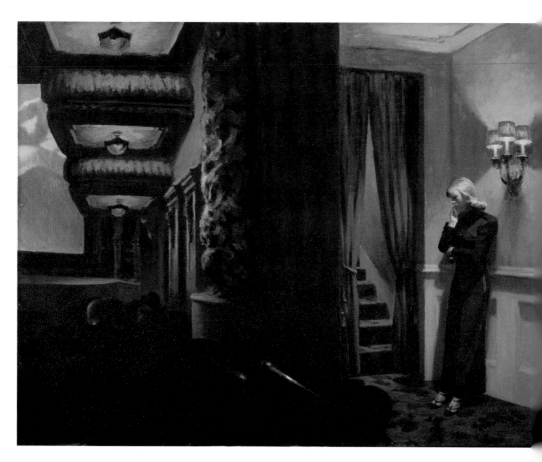

Edward Hopper, New York Movie, 1939 *(Stephen's collection). Hopper was Stephen's exact contemporary. This was the second work by the artist that Stephen gave to the Museum of Modern Art.*

percent immersed in a no-holds-barred approach to painting, every brush stroke a testimony to his personal fire.

One of the few aspects of his collecting that he shared with his brother Sterling was the independence of his eye, and his ability to consider art of a range of cultures and eras where the consistency was in the human qualities rather than any sort of art-historical category. Stephen's taste was completely his own. He would eventually cover the staircase of the house on Seventieth Street with drawings by the *New Yorker* cartoonist Peter Arno; that taste for what was urbane and witty revealed intrepidness on the part of someone who also owned Old Masters and Cézannes, for others would have considered Arno frivolous. At the start of his collecting, Stephen showed that same independence in focusing on landscapes by Louis Eilshemius, the fascinating painter whose work also exerted a magnetic attraction on Joseph Hirshhorn. Eilshemius painted fields and sky as if they were drapery fabric caught in a high wind; a vibrant force, as well as a sense of mysterious underpinnings, animate his paintings. They are as subtle as they are lively, and they reflect an intense contemplation of the craft of making pictures; this was Stephen Carlton Clark's sort of thing.

In 1920, Stephen also bought his first French painting—a lovely Monet of poplars—for which he paid eight thousand dollars. By now he was even more settled into his well-structured existence. He had become vice president of the Safe Deposit Company of New York; he would continue to hold jobs in the financial world while keeping a watchful eye on the Singer company. He and Susan had a routine that they would follow for the next four decades, dividing their time between Manhattan and Cooperstown, engaging in both communities, bringing up their family of four. On occasion Stephen bought art, but, unlike Sterling, he treated it as a sideline. He did not talk or write about his possessions, and while he would acquire some gems, ownership was not part of his definition of himself. The only art he bought in volume was folk art, which he purchased in order to be able to give it to the Fenimore Art Museum in Cooperstown.

Stephen was certainly the one who determined what he and Susan hung at home—when they lent paintings, the work was almost always listed as coming from his rather than their collection—but he deferred to his wife, if not to the extent that Sterling feared. In 1924, for example, Stephen decided against a Gauguin from Knoedler's because Susan didn't

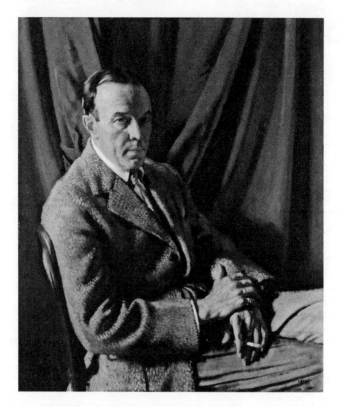

William Orpen, Portrait of Stephen Carlton Clark,
*c. 1921. Stephen was the one of his father's four sons to
take an active interest in Singer & Company, while also
becoming a publisher and having a go at politics.*

like it. He may have been citing his wife's opinions as a convenient
excuse for not getting what he didn't really want, but he was not the sort
of person to antagonize the woman to whom he was married over an art-
work, especially since she rarely interfered with his adventurous taste.
Above all, this was because his real purpose in life was not to amass his
acquisitions, but, in his very serious and methodical way, and while
keeping a certain regal distance, to serve others. He lived in grand style,
but, like his father, he felt the obligation of his wealth, and was deter-
mined to use it judiciously for the benefit, in the long run, of that same
public whose purchase of sewing machines had facilitated the accumula-
tion of the family fortune to begin with. He bought art not so much for
his own use as to be able to lend it, and ultimately give it away to public
institutions.

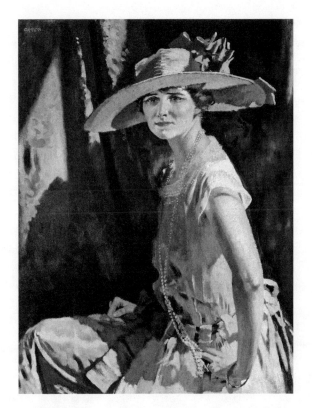

William Orpen, Portrait of Susan Vanderpoel Clark,
*c. 1921. Susan, considered "the perfect lady" and known
for her kindness and elegance, was the mother of the four
children who would carry on the family legacy.*

Stephen Clark's main position in the world—what mattered most to him personally and, eventually, to society at large—was the result of his efforts in the broad arena of museums. That would extend beyond institutions devoted to the fine arts. While he would soon become a devoted board member of the Metropolitan Museum of Art, Stephen would in time also found the Baseball Hall of Fame in Cooperstown, become the main force behind a very important historical society there, and start up a museum with splendid folk art.

For in his own quiet, reserved way, Stephen was exceptionally daring. He bowed to no one else's tastes—no matter what his older brother said about him. He betrayed less emotion than did Sterling, but he had courage and backbone. He showed his moxie both in what he supported and what he bought. He was undaunted in acquiring art that many of his

confreres and family members found laughable—even if today those paintings by van Gogh and Picasso have entered the pantheon of respectability. Moreover, in his banker's suits and with his owl-faced demeanor, he supported, in utterly pivotal ways, what, at its inception, was one of the most revolutionary institutions in the history of American culture, the Museum of Modern Art. This was the place that in the long run would open the country to a new way of seeing, and would elevate names like Cézanne and Matisse from the realm of the heathens and wildmen to their well-deserved status as gods.

In his role at the Modern, Stephen Clark, quietly and resolutely, was among the few who had the intelligence and courage to recognize the incredible strength and beauty of what the majority of Americans initially considered weak and ugly. He had the bravery to do what it took to get the rest of the world to shift course and recognize the wonder of an artistic approach that relied on no precedent, no preconceived notions of right and wrong, but above all on a burning wish for truthfulness. When Stephen disapproved of modernism in its forms that struck him as outrageous, he could be a stick in the mud, the reactionary amidst the radicals, but, given who he was, he had come a long way.

The major moment of Stephen Carlton Clark's life with regard to its impact on modern culture was that period at the start of a terrible international financial depression when a few exceptional people had determined, against the odds, that America needed a new museum dedicated to the artistic revolution.

CENTERED PRIMARILY IN FRANCE, Germany, Italy, and the United States, a handful of painters, sculptors, and designers had, in the course of the 1920s, taken a radically different approach to everything from how one should paint the human body to the design of an ashtray. They had bucked the weight of tradition, thumbed their noses at the academies, and pushed themselves into the outer realms of inventiveness and originality. They bowed to no one. Even as they maintained the greatest respect for ancient Greece and what they deemed the best of the past, they were as radical as the engineering behind airplanes and motion pictures that had recently transformed human existence, and they broke down the barriers between so-called fine art and the latest technology to make an amalgam of stunning force.

Similarly, these artistic pioneers shattered notions of acceptability in

what they revealed of the human psyche. They exulted in the life of dreams and the force of sexuality, addressing these issues not with the guises and theatricality of Bouguereau or Gérôme but with a candor that permeated every brush stroke.

Fortunately, among the upper echelons of society where people had the power to offer forms of endorsement that made the difference between survival and failure, the modernists had a few brave stalwarts. Stephen Carlton Clark was high among those supporters.

His role, until now, has been little known. And in what has been written about his engagement with the Museum of Modern Art, he has been unjustly maligned. Stephen was, in spite of his appearance of self-assuredness, so modest, so uninclined to make a scene, that few have known anything about him other than his being the name that appears on the identification label beneath some great paintings. But he was one of the ones who made the changes happen.

THE INNER SANCTUM of the Museum of Modern Art was, at the start, the domain of rich people who lived outside the realities of their epoch. Its three founders—Mrs. John D. Rockefeller Jr., Miss Lizzie P. Bliss, and Mrs. Cornelius J. Sullivan—had opened the Modern ten days following the stock market crash of 1929. Mrs. Rockefeller and Miss Bliss had met in Egypt the previous winter, and then Mrs. Rockefeller had met Mrs. Sullivan on board a ship on her return to America; the three had determined to found an institution where the latest art, deemed outrageous by many of their social set as well as by the larger population, could be presented.

These intrepid women were aware of the extraordinary exhibitions that had already been organized by a trio of farsighted and courageous Harvard undergraduates—Lincoln Kirstein, Edward M. M. Warburg, and John Walker—in rented rooms over the Harvard Coop, and were determined to follow the example on a larger scale. The Harvard boys had presented the paintings and sculpture of Picasso, André Derain, Charles Despiau, Alexander Calder, Isamu Noguchi, and young Americans like Hopper, Charles Burchfield, and John Marin. They had turned the public on its ear in particular with the work of Constantin Brancusi (one Boston critic compared the Romanian's *Golden Bird* to a "misshapened vase") and Joan Miró, of whose work a local pundit wrote, "You can have the same pleasure from wall paper or children's blocks."[3] They

had also shown photography by Walker Evans, work being done at the Bauhaus, and the latest design projects of Buckminster Fuller, with their inflatable walls and collapsible frames. Now the New York ladies wanted to do the same sort of thing on a far larger scale, with bigger shows for a more inclusive public.

Abby Rockefeller, the richest and most powerful of the founders of the new institution, devoted herself to it zealously. To advance their cause, she had enlisted, first of all, A. Conger Goodyear, a wealthy Yale graduate and art collector who had been voted off the board of trustees of the Albright Art Gallery in his native Buffalo for having purchased a Rose Period Picasso for five thousand dollars and for having borrowed, during his brief presidency of the museum, Katherine Dreier's Société Anonyme collection with its work by Marcel Duchamp and other dada and surrealist artists. Goodyear had, in turn, added three members to the founding committee. One was Frank Crowninshield, the worldly and witty editor of the magazine *Vanity Fair,* who in that capacity had introduced such scions of literary modernism as Aldous Huxley (writing about Thomas Mann), Noël Coward, E. E. Cummings, Clare Boothe, and D. H. Lawrence to the American public, and employed Edward Steichen to photograph Maurice Chevalier for his magazine. Another was Harvard professor Paul J. Sachs, a distinguished connoisseur and collector of drawings who had started life as a banker with the family firm, Goldman Sachs, and then, at age thirty-six, switched to art history, giving a course at Harvard in which most of America's future museum directors received their training. The third was Josephine (Mrs. Winthrop Murray) Crane, widow of a Republican governor of Massachusetts who was the heir to the Crane paper company fortune. A friend of Abby Rockefeller's, she had limited knowledge of modern art but a general love of culture that led her to fund the start-up of the Dalton School and to invite, on a regular basis, novelists and other cultural authorities to speak to her well-connected friends in her elegant living room on Fifth Avenue overlooking Central Park.

The moment the organization had incorporated itself and become official, the founders decided they needed a larger board of trustees. The first person to whom they turned was Stephen Carlton Clark. He was a natural choice. His wealth was legend, even if the popular notion that it was not just from the Singer Manufacturing Company but also from Clark's O.N.T. Thread, was erroneous. Those of the founders who had overlapped with any of his brothers at one or another fashionable watering

spot knew what a different type Stephen was from the other three. Rino, Sterling, and Brose all had their charms as well as access to the same fortune—and people knew Sterling collected art—but Stephen was the only one who could possibly apply himself to the serious business of helping a new institution supporting avant-garde creativity.

There was another driving force that lured the Modern's founders to Stephen. Those who had been to the gray stone house on Seventieth Street and penetrated the Gothic interior—it resembled a large country getaway more than what one expected in the middle of Manhattan—knew that the top floor, a loft that had initially served as a playroom for the Clarks' daughter and three sons, had at least eight major Matisses in it and had been redesigned for them in a highly unusual way. In 1930, no one else in America, except for the Cone sisters in Baltimore and Dr. Albert Barnes in Philadelphia, had shown such an intense interest in this French artist who, with Picasso, was one of the two giants of the modern movement.

The wife of Eugene Speicher, a contemporary portrait painter, had decorated this space at the top of Stephen and Susan's house with details from the paintings. The carpeting was deep rose and covered with small throw rugs—all just as in Matisse's interiors. There were red-checked tablecloths of the type one finds in French country kitchens and bistros, striped upholstery fabrics, silk lamp shades covered with red and white polka dots, and throw pillows in all these patterns, all derived from the art. Vibrant orange and gray draperies, their hues taken directly from Matisse's canvases, adorned the large, studio-style windows. A floor-to-ceiling mirror, framed by a bright green molding similarly based, intensified the great mélange of patterns. The gaily colored porcelain and vases of anemones, poppies, daisies, and cornflowers all seemed to come right out of the paintings as well.

Even though it would be reported in a prominent art magazine that Matisse helped design the space himself, this couldn't have been further from the truth. It was said that when Matisse had visited New York the same year that Conger Goodyear called on Stephen for the first time, and Stephen led him upstairs to the room, the French painter was outraged. Nonetheless, in the eyes of the founders of the Modern, Stephen Carlton Clark was on the right page; if the ponderous-looking house could yield such a surprise, so could its normally taciturn, nonsmiling owner.

The Nice-period Matisses that Stephen owned were of particular interest to the Modern's founding director, Alfred Hamilton Barr Jr. The

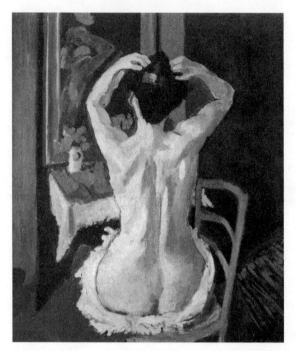

LEFT: *Henri Matisse,* La Coiffure, *1901. This was the earliest of the dozen paintings by Matisse that Stephen owned.* BELOW: *Henri Matisse,* Interior with Phonograph, *1924. Most of Stephen's Matisses were from the Nice period. They added summery warmth and a dash of modernism to the house on Seventieth Street.*

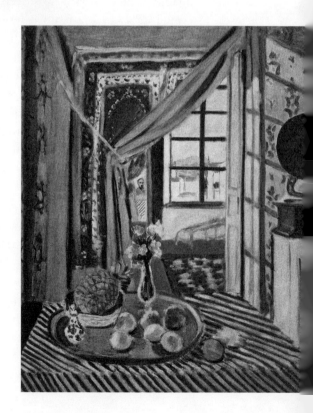

1919 *White Plumes* (color section 1, page 8) hung over the large open fire-place. Painted shortly after Matisse left war-torn Paris for the easier life of Nice, it is a portrait of startling force and simplicity, a bold reduction of forms and colors where the sitter's off-white dress, pale skin, and white feathered hat against two crimsons are like music in their resemblance to a full orchestra in which every instrument has the same high pitch; the painting snaps us to attention, the intensity heightened by the wide-eyed sitter's thoughtful look that is just at the edge of ferocious. The poet Louis Aragon would write of this painting and its model, Antoinette, "not yet twenty years of age," that "her impassive face, her heavy chin, her fixed gaze" were evidence that Matisse "was not only yielding to that strange attraction which he had recognized years before in the models he chose, and which was to obsess him for so long"—in a portrait subject of Ingres's—but that it took Matisse beyond that deliberate reference to Ingres and into the realm of his own cerebral approach to women. The arresting Antoinette "sitting there stock-still"[4] was, to Aragon, proof that Matisse had at last "realized that a woman is never so desirable to men as when they glimpse someone in the background whose thoughts can be guessed at."[5]

In a world that valued style—where the accoutrements of life both added pleasure and could signify daring and panache, at a time when, given the realities of the Great Depression, every possible emotional lift was to be sought out—the plumed hat itself was rife with meaning. It gives this "cold, aquiline beauty with shadowed eyes,"[6] as Alfred Barr called her, a distinct fashionableness, but also the look of someone play-ing a role.

In the summer of 1931, Stephen would lend the painting to a Matisse retrospective held in Paris at the Galeries Georges Petit, a large exhibi-tion space that could be rented for such purposes by commercial gal-leries. There Margaret Scolari, Barr's wife, saw Matisse and his daughter Marguerite and asked "him where in creation he'd got that hat." To this inquiry, the notably reserved painter "laughed welcoming the question and said he'd made it himself. He bought the straw foundation and the feathers and the black ribbon and put it together with pins on the model's head. He said he had too much black ribbon so that he had to stuff it into the crown with dozens of pins."[7]

It's a minor detail, perhaps, but reflects issues of major significance to both the owner and the painter of *The White Plumes*. Matisse came from a textile-making region; his family was in the business. The Clarks were

who they were thanks to sewing machines. The simple stuff of everyday life, and the reality of how to put it together, were an essential part of existence. So was the will to enter the unique realms of pleasure offered by visual dash and the powers of art. The painting that Stephen, with a taste way ahead of his day, acquired, had both.

There was also the matter of daughters and their health. The reason Matisse had so much black ribbon is because Marguerite, the daughter who accompanied him that day, had problems with her thyroid gland and other medical issues that had required a series of operations, leaving a scar on her neck, which she covered with black ribbon. Stephen Carlton Clark's daughter would also develop health problems—Hodgkin's disease that would, in 1945, take her life at age thirty-six. After that he would sell this Matisse as well as the rest of the work he owned by the artist; there may well have been a direct connection. The young lady with long dark hair in *The White Plumes* bears an uncanny resemblance to Elizabeth Scriven Clark (the one who was Stephen's daughter, not his mother, who had the same name), which may well have made possession of the painting unbearable for him.

Another of these Matisses that was so exotic and simplified at the same time was *The Hindu Pose* of 1923, called *Pose of Buddha* at the time that Stephen owned it. Its panoply of patterns, floral and checked, and the sumptuous bouquet of anemones were the source of much of the Clarks' decorating scheme. But the painting is neither decorative nor comforting itself. In the saturated colors, flattening of forms, and simultaneous exaggeration and simplification, it is brazen and startling.

In the Clarks' world, it was not everyone who would put on view a painting in which a partially nude woman, impervious to the world around her, holds her hands crossed at the top of her head while exposing her armpits and allowing her bare breasts to be seen head-on with a string of brightly colored beads between them accentuating their nakedness. Nor was it in the realm of acceptability to paint legs and feet as one single engorged mass of undifferentiated pink beige brushwork, or to render a human face in its most abbreviated form. But like the still lifes and other odalisques and dense interior scenes Stephen and Susan Clark had put on view here, there was evidence of a courage and a passion for feeling and seeing in their most extreme forms that were exceptional. And when the Museum of Modern Art put on a Matisse show in 1931, these pictures, many of which were written about in the important books

about the artist by Roger Fry and Henry McBride," would help form the crux of the exhibition.

WHEN CONGER GOODYEAR initially approached Stephen and asked him to become a trustee of the new museum at the stage that it was only an idea, the sewing machine heir nixed the idea. True to the family tradition, he did not merely refuse. Most wealthy people decline invitations to join boards by feigning too many other things to do, but this would not have suited a Clark. It was a family habit to offer expert opinions, regardless of their effect, and Stephen issued a pronouncement about the new venture. In a letter to Goodyear, he explained, "I am sorry to say that, if I understand your plans correctly, I am in sympathy with only part of your program. The idea of holding exhibitions of modern art appeals to me strongly but I cannot get up any enthusiasm over the proposal to establish a permanent museum along the lines of the Tate or Luxembourg as I cannot see that either of those institutions does very much to encourage the best in modern art."[8]

His jibe at those rather sleepy institutions in London and Paris had its point. Neither the Tate nor the Luxembourg, as they were in 1930, was especially intrepid. Those other museums offered the public pleasant exhibitions, but failed to dig deep into the wellspring of artistic change that, in the late 1920s and early 1930s, had such a lively pulse. The far smaller and less influential Harvard Society, by contrast, was adventurously at the forefront of what was new, reflecting the wish to express human and visual truth with unprecedented candor. Stephen was correct in sensing that the Modern as it was first intended might fail to be as bold, and would, rather, adhere to the models of the London and Paris showcases that he decried.

Paul Sachs had in fact written to Conger Goodyear, "It seems to me mandatory that in America we have something comparable to the Tate Gallery in London and the Luxembourg in Paris."[9] The idea was of a museum as a sort of halfway house in which recent art, having already become acceptable to the public, now became part of a permanent public collection. Goodyear at the time had been in total agreement with Sachs's idea of the Modern emulating those institutions in Europe. But Goodyear, who had served as a colonel in World War I, and would be a major-general in World War II, was not above some calculated strategy.

He craftily wrote his fellow Yale graduate Stephen, "There is certainly no thought in my mind of ever establishing a museum that will be along the lines of the Luxembourg, which is at present moribund if it is not dead."[10]

Less than a week passed between Stephen's refusal to join the new board and his acquiescence. He would have a profound effect on that great institution, assuming the role of a parent who does both enormous good and, many would feel, considerable harm to its progeny. Whether he ultimately damaged or rescued both the Modern and Alfred Barr himself is a question that will beg our examination.

STEPHEN'S INSISTENCE in distinguishing the Modern from the Luxembourg had a direct effect on the Modern's early public relations approach. In the November 1929 *Vanity Fair,* Alfred Barr was quoted as saying that the Museum of Modern Art was being founded "with an *ideal* Luxembourg in mind."[11] He added that the one in Paris "has been hampered by political timidities and inadequate financial support," making it unable to show in full latitude modern art while "it does not pretend to confer any final sanction upon its painting and sculpture." Stephen's negative critique of what was initially seen as the Modern's London and Paris counterparts had probably been the stimulus for Barr to make this point about what now became the competition.

The Museum of Modern Art opened in rented space on the twelfth floor of the Heckscher Building at Fifty-seventh Street and Fifth Avenue in the autumn of 1929. Its first exhibition, a loan show conceived by Alfred Barr, consisted primarily of work by Cézanne, Gauguin, Seurat, and van Gogh. The crowds were more than anyone had anticipated. Henry McBride, the perspicacious critic for the *New York Sun,* recommended that his readers try to get in either on rainy days or at 9 a.m. if the weather was good; "Otherwise you'll be jostled and perhaps not see some of the most important pictures at all."[12] The public desperately needed a lift in those tumultuous days following the stock market crash, and these vibrant and wonderful paintings provided the requisite relief. Stephen had lent a small Seurat oil of bathers, a painting of sublime restraint that was one of the gems of the exhibition.

Although some people referred to the new museum as the "Luxembourg of New York" or "the American Luxembourg," Helen Appleton Read, writing in the *Brooklyn Eagle,* maintained that Stephen's worst fear

about the new institution had been averted. "A comparison between the Modern Museum and the Luxembourg has frequently been made. . . . But in reality it has little in common with what people have so long believed, if erroneously, the Luxembourg stood for: namely, a representative collection of contemporary European art. . . . No, the Modern Museum is happily free from entangling red tape, progressive systems, and official alliances."[13] Rather, the show to which people were ferried by elevator on the twelfth floor of the Heckscher Building avoided all of the entanglements of presenting the most current work from Europe, and focused instead on those earlier masterpieces of modernism—precisely the sort of art dear to Stephen Carlton Clark's heart. And the public had taken to it, with some forty-seven thousand people flocking to the four galleries in the month before the exhibition closed on December 7.

The second exhibition, "Nineteen Americans," was, like the first, the idea of the Modern's independent-thinking, brilliant founding director.

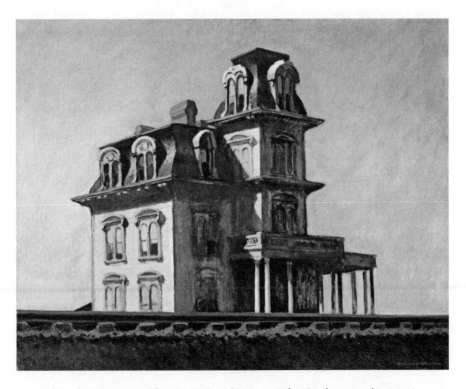

Edward Hopper, House by the Railroad, *1925. When Stephen gave this painting to the Museum of Modern Art, it was one of the first two works that created the nucleus of the Museum's permanent collection.*

But the selection of works by contemporary artists then at work in the United States was, in a way that can best be called ill-advised, up to the trustees. Goodyear seems to have been the one at the helm. Each trustee received a list of one hundred twenty-five contemporary American artists, from which he or she was asked to select fifteen to include in the exhibition. The results were tallied, and a show was assembled with a hundred and five canvases by nineteen painters. The problem was that what should have been an exhibition of the very best American painting of the day—as envisioned by a single professional like Barr—was instead a compendium of choices made by collectors with vested interests. The trustees, after all, could not resist wanting to have work they had chosen for their private collection receive the accreditation that the elevated status of being in a museum show gave it. The financial value of the canvases instantly went up as a result. And while some of the artists Barr would have inevitably included—Charles Burchfield, Charles Demuth, Edward Hopper, and Georgia O'Keeffe among them—were in the show, others of indifferent quality, like Bernard Karfiol and George Hart, were in, whereas more worthy painters, like Childe Hassam and Joseph Stella, were not.

Following that exhibition, Stephen decided to give the new institution two of the paintings he had lent, one by Edward Hopper, the other by Charles Burchfield. They were the first artworks ever donated to the Museum of Modern Art.

Hopper's *House by the Railroad* was a gripping essay in a new form of painterly realism. The artist's haunting light gives a poetic mystery to the desolate scene of a deserted Victorian house alongside a rusty railroad track. Lloyd Goodrich, the great Hopper authority who eventually became director of the Whitney Museum, would, in 1971, begin his Hopper opus with the sentence "When I first saw Edward Hopper's *House by the Railroad* . . . I felt that a new vision and a new viewpoint on the contemporary world had appeared in American art."[14]

Stephen, who was one month apart in age from the artist, had bought the breakthrough picture when its paint had barely dried, just after Hopper completed it in 1926. By giving it to the Modern only four years later, he was advancing immeasurably the cause of artistic honesty and the notion of a uniquely American style.

Burchfield's *Railroad Gantry* had similar attributes. It too focused on an unglamorous, everyday scene of the American landscape, and on a portion of train track: the quintessential symbol of the industrial age and

progress in a restless nation. And Burchfield, like Hopper, worked with a technique that made no reference to European influence. For most people in Stephen's world, the art of choice was second-generation American impressionism—images of ladies in parasols and French-style gardens. To endorse Burchfield was a bold move in favor of a tougher, more unflinching attitude toward both the subject matter of art and its depiction.

This second exhibition of such forthright American art was too harsh and journalistic for an audience that wanted its art to provide diversion and escape. The show was not as popular with either the press or the public as the first had been. But by the time these paintings by Hopper, Burchfield, and their contemporaries were on view at the Heckscher Building, it had become apparent that new headquarters would be needed. Stephen, who was among those who instantly recognized the inadequacy of the cramped galleries in an office building, was appointed chairman of the building committee. With the pressing task of finding better digs, he started the search right away.

At first, in spite of the name of the committee, the initial plan was not to build but to take over the home of one of those rich families that suddenly needed to sell its real estate in the aftermath of the stock market crash. Stephen and Goodyear persuaded the rest of the museum's board to purchase space on Sixty-sixth Street between Park and Madison avenues, where the owner of a town house was desperately trying to sell it at a relatively low price to raise cash. The move to that location fell through, but a third show at the Heckscher Building made it even clearer that new and expanded headquarters were essential.

Again, the attendance was record-breaking. From January 19 to February 16, 1930, the Modern housed a show called *Painting in Paris.* Stephen, who had anonymously lent Matisse's *Pose of Buddha,* observed in a new way the extent to which the sight of beautiful paintings offered hope in difficult times; people flocked in to look at the artwork from France that offered such a diversion from the financial depression that was now clobbering America. The crowds were so great for the exhibition that the trustees had to start to charge fifty cents' admission in the afternoons in order to cut down on the attendance. During the free mornings, however, people were still crushing one another.

Stephen and his family lived at a remove from the larger population, and had funds and access beyond most people's dreams, but the man whose fortune came from sewing machines was keenly aware of the great

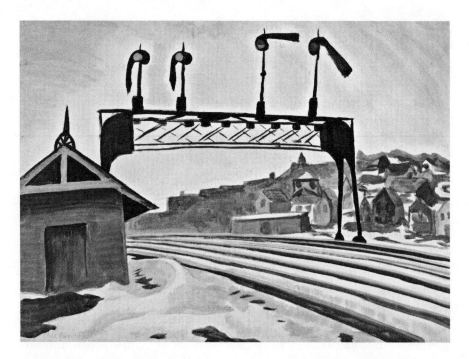

Charles Burchfield, Railroad Gantry, *1920. Like the Hopper, this work by Burchfield
cast a frank look at the tougher sides of American life; it was the other painting
in Stephen's seminal gift to the Museum of Modern Art.*

majority. The effect of the sort of art he liked and was abetting at the
Modern gave him the sense that he was doing the right thing.

Not that he necessarily agreed with museum policies. Having assured
Stephen that the function of the Museum of Modern Art would not be to
serve as a conduit to the established public museums in the same way as
the Tate and Luxembourg, Conger Goodyear now seemed to backtrack.
He announced as the new policy that "The Museum of Modern Art
should be a feeder, primarily to the Metropolitan Museum, but also to
museums throughout the country"—showing, for example, Cézannes,
and then passing them on to these other institutions.[15] Stephen, by con-
trast, believed in the museum's strengthening its own permanent collec-
tion. Having given the Hopper and Burchfield earlier in the year, now he
gave the Lehmbruck sculpture he had bought at the Armory show seven-
teen years earlier.

Lehmbruck's *Standing Woman* is a colossal piece that represents a
woman draped only from mid-thigh downward. True to the German

Expressionism of which it is an exemplary work, her elongated body suggests a noble struggle. But whereas a lot of works from that movement have a tortured aspect, Lehmbruck's is lovely and celebrative; this has a more unabashed joy than most of the sculptor's work. We might take the sensuous figure to be by Aristide Maillol. Given how tapered her body is, her breasts are ample, and her brazen yet graceful stance suggests that she takes great pleasure in her own naked flesh. The soft-skinned beauty shows her well-proportioned torso and buttocks for all the world to see, their nudity accentuated by her scant covering below.

It was big news that Stephen Carlton Clark had presented the bronze to the Modern. The gift was heavily publicized, with the work reproduced in *The New York Times* and a number of well-read magazines. Stephen, who generally did things anonymously, probably wanted his name attached to it for a reason. The sculpture was nearly the same size as George Grey Barnard's image of two muscular male nudes that bore his father's name uptown at the Met. It seems that Stephen unconsciously wanted to make clear that his interests were in beautiful women. Like Sterling with his Renoirs and Bouguereau, Stephen was, whether or not it was his plan, establishing his distance from his father's proclivities.

Three years later, Stephen gave the Modern a far greater sculpture: Brancusi's *Bird in Space* (color section 2, page 1). This time the donation was anonymous, as would be the case with a sequence of generous gifts throughout the thirties. The Brancusi was far and away his most remarkable gift to

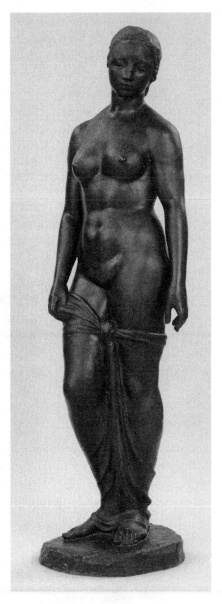

Wilhelm Lehmbruck, Standing Woman, *1916–17. This was the one work that Stephen gave to the Museum of Modern Art with his name attached, rather than anonymously, perhaps in reaction to his father's patronage of images of muscular young men, a way of making public his taste for voluptuous females.*

date. Its lithe, streamlined form was without precedent in the history of sculpture. *Bird in Space* was in the realm of sculpture what the geometric compositions of Mondrian were to paintings and the glistening villas of Le Corbusier were to architecture: a work that made no reference to the past and that used pure unadorned form as a source of immense spiritual uplift. These brave forays into uncharted territory showed the true elegance of modernism. Thoughtful, refined, meticulously executed, they completely transformed the notion of art, architecture, and design.

Constantin Brancusi was a scandalous artist in legal circles. In 1927 and '28, there had been a famous court case concerning another casting of *Bird in Space* when the U.S. Customs Office declared the sleek sculpture a machine part—presumably a propeller blade—rather than an artwork. As a utilitarian object, it would have been subject to import duties. The court had ruled in favor of its being considered a legitimate piece of art, but in the early 1930s, few people had the foresight or wisdom to recognize the Romanian artist's work as great sculpture, given its almost complete abstractness and the impeccable engineering of its surfaces. Stephen was the exception. In 1932, he corresponded with Brancusi directly, and arranged to buy his own cast of the exquisitely tapered bronze on its cruciform marble base. Clearly he responded to the glistening texture and look of sheer energy, as well as the artist's bravery and originality. The notion that mechanical perfection and beautiful art could go hand in hand had immense appeal to the man whose own life had been determined by Isaac Singer's fine-tuning of the sewing machine. Eager for Brancusi's marvel to be seen and appreciated by others, only two years after buying it he gave the sculpture to the Modern, while deliberately requesting that his name not be associated with the gift.

OTHER SUPPORTERS OF MODERNISM wanted to make a fuss; they liked stirring up controversy. Stephen was in it for something very different. He masked his flair, but there was no end to the amazing objects this relatively unknown collector was quietly acquiring. From the start, he was willing to lend a lot of what he bought, regardless of the inconvenience, and he probably had the notion of eventually bestowing them on the public. What courage the quiet, taciturn, seemingly gloomy Stephen had, and what an eye for creative spark!

His contributions to the fledgling museum were not simply financial.

The curatorial capacity that Stephen had assumed to a minor degree when voting on names for the Modern's second show in 1929 had assumed greater proportions in 1933. While Alfred Barr was traveling in Europe, Stephen was given the task of selecting a summer exhibition of French and German paintings. The inclusion of German art that year was especially significant. That same summer, the Bauhaus had closed in Berlin after the Gestapo padlocked its doors. To put German and French art side by side was proof that art transcended politics, that its qualities were universal rather than nationalistic.

Stephen liked rolling up his sleeves, and while at times he would sign generous checks for the museum, he was determined to make it clear that he was even more eager to give time and ideas than money. In the museum's first major fund-raising campaign in 1934, members of the Rockefeller, Warburg, and Carnegie families proved exceptionally generous with cash gifts of between one hundred thousand and two hundred thousand dollars each. This was what was expected of major supporters; the assumption was that Stephen would match them. But those who knew Stephen knew better than to argue when he felt strongly about something; it was recorded in official documents about the campaign that Abby Rockefeller "decided to take 'no' for an answer from Mr. Clark."[16]

THE MUSEUM OF MODERN ART was not the only beneficiary of Stephen Carlton Clark's largesse in 1930. The same year that he gave the Modern the Hopper, the Burchfield, and the Lehmbruck, he donated paintings to the art gallery at his alma mater, Yale. Here too he did so anonymously. At least so he intended; in spite of his intention to have the source of his gift unknown, his name appeared in an article about it in *ARTnews,* much to his annoyance.

By monetary measure, what Stephen gave to Yale was by no means on the scale of his subsequent donations there, but, like the present of the Hopper to the Modern, it fostered the new approach in American painting that eschewed prettiness. Yale already owned its share of pictures that showed the sort of upper-class life to which most of its student body was well accustomed, the sporting art and pastoral scenes and portraits of distinguished people that reflect success and prosperity. The blatantly inelegant paintings that Stephen gave depict, by contrast, more rugged aspects of the national existence. With almost newspaper-style reportage

and a concise pictorial language, these paintings by artists of the "Ashcan School" present a cast of characters few of the university students would have had occasion to encounter. The straightforward pictures are realized with a style that was the new American idiom, without reference to impressionism or any other school of European origins. Of particular interest were two George Luks portraits of unnamed characters, one called *Bread Woman* and the other *Show Folks.* Yale would, unfortunately, sell both these paintings at Sotheby Parke Bernet in 1978, an act that was permissible because Stephen did not believe in restrictions on his gifts, but for nearly fifty years they were an important part of the collection there, even if to some people they came to seem like dated period pieces.

In 1932, Stephen was elected to the board of the Metropolitan Museum of Art, so, there too he became a contributor. He had the wherewithal to do that and even more after Rino died the following year, leaving him the Dakota, lots of art, antiques, Fenimore Farm in Cooperstown, and the bulk of the cash and investments in his estate. Rino also left Ambrose some New York real estate, but Sterling's worst fears were realized: not so much that he would get nothing, as happened, but that his brothers would inherit such a fortune rather than Rino giving it to charity as Sterling hoped.

With Rino's death, however, Stephen became truly inventive as a philanthropist. Rino had started the Mary Imogene Bassett Hospital in Cooperstown. Stephen would devote the rest of his own life to building it up, in part by buying fine homes around the town and making them available to doctors and others at low rates. This would not only become a first-rate medical institution, but would be considered the first HMO in America.

Stephen was now, especially compared to most people at the low ebb of the Depression, immensely rich. When he saw an artwork he liked, he didn't have to think twice about whether he could afford it, and the same year his elder brother left him a fortune he bought van Gogh's *Night Café,* Renoir's *Waitress at Duval's Restaurant,* a Degas pastel, and a Cézanne of Madame Cézanne, all from the Museum of Modern Western Art in Moscow. He also began buying Picassos.

At the same time, he and Susan were thinking more and more about what they could do in Cooperstown. Susan wanted to beautify the village, and began having trees planted and hanging flowerpots put on streetlights there. Then, in 1934, Stephen made an acquisition for five

dollars that would change the town's fortunes forever. It was a leather-covered baseball that had been found in an attic trunk in a smaller town nearby and that had purportedly belonged to Abner Doubleday. Doubleday is largely credited as having invented baseball, which was, at the time, erroneously believed to have initially been played in Cooperstown in 1839. (It was later discovered that the first baseball game was in Pittsfield, Massachusetts.)

The ball and other bits of baseball memorabilia went on display at the Village Club, and in 1937, Ford Frick, president of the National League, suggested that this be the basis of a National Baseball Museum. Stephen acquired further mementoes of the sport and agreed to put up money for the building, which opened in 1939, a century after that first game, and is today that National Baseball Hall of Fame and Museum.

Rino's stone dairy barn seemed the perfect place for what became the Farmers' Museum, and Stephen graciously funded it as well. He devoted himself to the state historical society, to which he would give magnanimously for the rest of his life. None of this diminished what he was doing for the two art museums he was helping support in the city. This was the

Susan and Stephen Clark and their four young children on holiday.

period when the Met was beginning to construct the Cloisters, with much of its core collection coming from George Grey Barnard; Stephen gave them three fifteenth-century marble capitals from southern France that he had bought from Barnard years earlier and that were needed to complete one of the structures. This was only the beginning of what he would do for the great presentation of medieval art on the northern tip of Manhattan overlooking the Hudson River.

Yet to family members and the people who worked either under or alongside him at the institutions he was helping fund, he remained something of a mystery. Perceptive people sensed he was often concealing something. With the Modern, he was supporting a museum where he certainly didn't like a lot that was shown; he created a Baseball Hall of Fame while he had little interest in the sport. According to his granddaughter Anne, while Stephen would support that institution liberally for the rest of his life, the only moment there that brought palpable

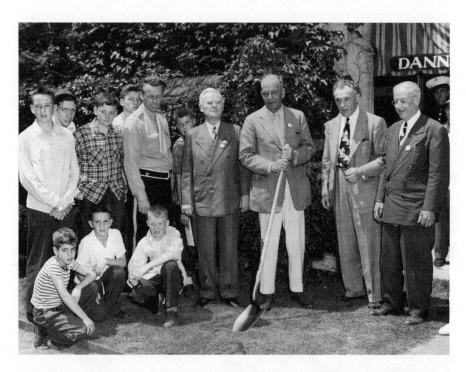

Stephen (holding the shovel) at the groundbreaking ceremony for the first addition to the National Baseball Hall of Fame and Museum in 1949. Ford C. Frick, President of the National League, is on his left, at this milestone event for the institution that began with Abner Doubleday's original baseball, and that Stephen supported.

pleasure to this man who was generally "turned inward" and "didn't care in the least about baseball" would be when Joe DiMaggio was inducted. This meant that Stephen got to sit next to Marilyn Monroe; "He was so excited; it was the one thing he talked about."[17]

IN 1935, the Museum of Modern Art put on one of the most eye-opening exhibitions in the history of America. It was a solo show devoted to work by the artist whose work never fails to stun its viewers, whether they succumb to it in a frenzy of excitement or feel it should be consigned to the dustbin. This was the painter whose madness was as famous as his fantastic painting technique: Vincent van Gogh.

The museum's advisory committee had urged that the project be abandoned, claiming that van Gogh had no effect on contemporary painting, and that the pictures were all so similar to one another that a solo exhibition would be unimaginably boring. They feared that the show would be disastrously costly and that it would only intensify the already strong criticism of the Modern for being insufficiently contemporary. The trustees, however, with Stephen one of the strongest voices, backed the project by sending Barr to Holland.

While one Clark brother was said to be funding European travel for research on the creation of an army of insurgents to install a fascist leader in America, the other was supporting a trip for investigation into the work and life of a pioneer of modern painting. Beyond that, Stephen and four other trustees had works to lend from their own collections that guaranteed the van Gogh show its quality.

The show had long been a dream of Barr's. Doing research for it, he had consulted the art historian Meyer Schapiro, an authority on the Dutch painter, who agreed with his notion that the catalogue text should consist entirely of Vincent van Gogh's letters to his brother, Theo, the artist's soul mate and greatest supporter. That idea guaranteed that the exhibition would not only present major work but also reveal the artist's intentions. By dedicating the catalogue to Theo, Barr also drew attention to the importance of offering moral sustenance to an artist even when the great majority was against him.

When the show opened on November 4, the response was more than anyone, including Barr, could possibly have anticipated. The lines stretched down the block to Fifth Avenue. The American First Lady, Eleanor Roosevelt, attended twice. The artist who forty-five years earlier

had died nearly penniless, plagued by his isolation, was now the object of obsession. And one of the main reasons was a painting lent anonymously—the catalogue simply said "private collection"—by Stephen Carlton Clark, who had bought it just two years earlier not only for his own gratification but so that it could be readily seen by the American public.

This painting, *The Night Café* (color section 2, page 2), was among the most daring of the painter's works. The canvas was unequaled in the boldness of its colors and its emotional ferocity. In this scene of an ordinary café just after closing time, a lurid mix of green and yellow and an electric brick red virtually accost the viewer. These aggressive colors are completely dominant, squeezing out any hint of softness or possibility of relief. The brush strokes gyrate. And the picture space spreads out and zooms at the same time, so that you feel physically pressed into the sordid scene. It is the visual equivalent of having music turned up so loudly that it deafens you. Every element is ratcheted up a notch.

In May 1889, Vincent van Gogh had included *The Night Café* in a shipment of paintings he sent his brother in Paris. Following Vincent's and then Theo's deaths, it ended up being inherited by Theo's widow and then his daughter, who in 1907 sold it to Bernheim-Jeune in Paris; they next sold it to a private collector, Ivan Morosov, in Moscow. Following the Russian revolution it went into the Museum of Western Art in Moscow, but once the Soviet government needed cash to finance the first of its five-year plans, it ended up selling it, through a gallery in Berlin, to Knoedler's in 1933. Stephen saw it at Knoedler's shortly thereafter, and bought it immediately.

Today a van Gogh, like a Picasso, is a rich person's status symbol, but in the early 1930s it still took incredible openness, guts, and a sharp eye to buy a painting like *The Night Café*. Stephen was among the few people to have the means as well as the enlightened approach and the self-assuredness to venture into territory that many strenuously avoided. If someone like Sterling made an exception for van Gogh among the precursors of modernism and looked favorably at the work, he and other collectors of his like were inclined to the pastoral scenes that were calmer in tone and more soothing than this painting of what looks to be the underworld.

What a vision of humanity *The Night Café* is! The collector who could have lived in a gilded cage and looked at nothing but soothing pictures of pretty subjects had opted instead to bring the low life into his living

room. Unless a summer jaunt from Yale to shabby villages in the French countryside had taken Stephen into the setting van Gogh portrayed, it was hardly a familiar world to him. For van Gogh's subject was not just a seedy country café; it was one with a billiard table at the center, hence a form of gambling establishment. And the moment the artist has captured is when life there had devolved to its low point. The clock shows that it is ten past midnight—after closing time. Side chairs are strewn about; most of the customers have left. The only ones who remain appear fairly dissolute. A man and a woman in a distant corner have melted into one, but it is not a happy scenario; the woman leans uncomfortably away from the man, who is planting his kisses on her. Next to the wine bottle on their table, two glasses are filled to the brim, as if he has tried to ply her with drink, which she has left untouched. At the table next to them, someone else appears to have fallen asleep; his head has dropped into his folded arms, and his cap is pushed down on his head so that it practically covers his eyes. He is not a pleasant companion for the couple.

Center stage, an awkward waiter stands facing us. In his bright white uniform—a sharp accent amid the blazing hues around it—he is painted in a way that is even more noticeably distorted than the other elements of the canvas. His arms and shoulders are simply part of a single undifferentiated curve, making an arch that represents the human form while in no way replicating it. His head is twice the size it should be for his body. His posture and the expression on his face are awkward, and the edgy, tremulous quality of the brush strokes that bring him to life intensifies the ill-at-ease feeling he transmits.

The only other people still left in the café at this late hour are two other dissolute types collapsed at a table on the right-hand border of our view. One of them is cut off by the end of the canvas, which adds to the feeling that this is a snapshot of real life, as opposed to the sort of meticulously organized composition that one finds in the art of most of van Gogh's predecessors and contemporaries.

Alcohol is in many ways the theme of the picture. In the back of the room, there is a bar on which bottles are packed together, and each of the many small café tables has the remains of imbibing on it. Beer steins that have been drained, half-empty wine bottles, and used glasses proliferate in the areas of conviviality that have been vacated. One pictures the occupants of those tables having stumbled home, without any care as to the cleanup waiting for the hapless waiter to do.

Van Gogh was living in Arles, a town in the Provence region of south-

ern France, when he painted this picture. He boarded at the time with M. and Mme Ginoux, and this is the café they owned across from the local train station. It functioned almost like a homeless shelter; as van Gogh wrote to Theo, "Night prowlers can take refuge there when they have no money to pay for a lodging or are too tight to be taken in."[18]

While sleeping during the days, van Gogh himself stayed up for three consecutive nights painting this scene of the place where he generally had his evening meals by gaslight. "I often think that the night is more alive and more richly colored than the day,"[19] he wrote Theo.

How remarkable it was that Stephen Carlton Clark, who could have chosen to turn his back on the elements of life others found too torrid, opted for this unsettling canvas. As van Gogh himself wrote, "The picture is one of the ugliest I have ever done."[20] Why had Stephen wanted something so jarring as part of his everyday life?

The reason most probably is that, on some level, this highly intelligent man understood van Gogh's intentions in all their depth and range, and empathized with them. However silent, however correct in his demeanor, the collector was intimately familiar with the forces the artist unleashed through color.

As Vincent wrote Theo, "I have tried to express the terrible passions of humanity by means of red and green.

"The room is blood red and dark yellow with a green billiard table in the middle; there are four citron-yellow lamps with a glow of orange and green. Everywhere there is a clash and contrast of the most disparate reds and greens in the figures of little sleeping hooligans, in the empty, dreary room, in violet and blue. The blood-red and the yellow-green of the billiard table contrast with the soft tender Louis XV green of the counter on which there is a pink nosegay. The white coat of the patron, awake in a corner of that furnace, turns citron-yellow, or pale luminous green."[21]

In a subsequent letter, van Gogh reiterated some of the same sentiments; the same intensity of feeling that inspired the highly charged atmosphere of the canvas forced him nearly to repeat himself. Vincent wrote Theo, "In my picture of the Night Café I have tried to express the idea that the café is a place where one can ruin one's self, go mad or commit a crime. So I have tried to express, as it were, the powers of darkness in a low public house, by soft Louis XV green and malachite, contrasting with yellow-green and harsh blue-greens, and all this in an atmosphere like a devil's furnace, of pale sulphur."[22]

Both of these excerpts from the letters to Theo zero in on the remarkable optics of this painting. Van Gogh did not merely use strong colors; he understood their interdependence, in a way that would have inestimable influence not just on abstract painting in the twentieth century but also on graphic and interior design. In that commentary on the patron's white jacket acquiring the hues of its surrounding colors, van Gogh was alluding to afterimage, the remarkable phenomenon whereby white appears to receive a tint that comes entirely from a powerful hue on which the eye has just been focused at a completely different location—the illusion being that the tint is actually present, whereas in fact it is not. And van Gogh makes clear that it is the "clash and contrast" and not just the colors themselves that animate the whole and heighten the emotions.

With the large gaslights at the top of the scene, the artist has intensified the mad frenzy. He has rendered these fixtures as if in a rat's nest of illumination, with feverish dashes of green-gold paint swirling around them. This use of drawing as well as color was particularly striking to Meyer Schapiro, the Columbia University professor to whom Barr had turned about the catalogue. Schapiro was another of the great sages of modern art, almost as pivotal as Barr in opening American eyes to the wonders of painting that had previously been considered the realm of crazy people. In 1950, he would write a large van Gogh compendium intended for the general audience. There Schapiro would write about Stephen's painting, pointing out, "In his account, Van Gogh says nothing of one of the most powerful effects: the absorbing perspective which draws us headlong past empty chairs and tables into hidden depths behind a distant doorway—an opening that repeats the silhouette of the standing figure. To the impulsive rush of these converging lines he opposes the broad horizontal band of red, full of scattered objects: the lights with their great haloes of concentric touches, the green clock at the midnight hour, and the bouquet of flowers, painted with an incredible fury of thick patches against the smooth wall above the crowd of bottles."[23]

The halolike shapes around the gaslight fixtures would become, in 1971, one of the main pieces of evidence used for a theory that van Gogh suffered from glaucoma. The theory posits that his knowledge that he was becoming blind was the main motivating factor behind his suicide—more than the manic-depressive disorder to which most people

attribute his desire to end his life. According to the doctor who developed this idea, *The Night Café* is the prime example of a work where one sees these "glaucomatous halos."[24]

Whatever the precise reasons, everything is highly charged. The fiery drama of the lights exists throughout the canvas. For all the abbreviations of form, all the inventiveness of the color, the seeming unreality of those furious swirls of paint to indicate light, it all feels incredibly real.

THERE WAS A PRACTICAL PURPOSE to the painting as well. Van Gogh painted it "for his landlord to pay the rent."[25] Stephen certainly knew this about the work, and it mattered to him. For the Clarks, rich as they were, were always grounded in reality.

Stephen and Susan and their children were in their opulent house on Seventieth Street thanks to those millions of people who had been able to pay for their sewing machines in modest monthly installments. Other members of his family may have been able to cut themselves off from such realities of life, living as they did at a great remove from them, but Stephen had the sort of intelligence that did not permit blindness. That eye for the truths of the existence of others is part of what prompted his powerful commitment to charity, as it had inspired his father to rescue strangers with cash. Everything about *The Night Café*—its having served as rent payment, the world it captured—added to its significance for its prosperous owner.

Schapiro, in his brief and cogent text for the American public, wrote of this work that van Gogh "has gone here beyond the agreeable side of the café world, imaged by the Impressionists, to its darker disquieting moments." Schapiro zeroes in on "the homeliness of the drawing, the interest in objects, the pervading moral concern" in this vision of "the dissipated and homeless." To the collector whose mother was a pioneer in her support of tenement housing, this was, as with the Hopper and the Burchfield, part of the meaning of his prize possessions.

WHAT IS MYSTERIOUS IS THAT, for many of us, an odd beauty emerges from the morass. The disorder of everyone's life, the garishness of the setting, the after-hours sense of wasted energies, the hysterical pitch of the paint colors and the turbulence of the brushwork: all these elements combine to create an extraordinary force. For this painting from

1888 was, from the moment van Gogh had the temerity to create it, an invitation to seeing. It captures that most elusive of subjects: light. It also summons human emotions, felt without any buffer.

In its utter lack of restraint, *The Night Café* summons the feelings that scream inside many of us. It has a candor unprecedented in the art of painting; not even as powerful a dramaturge as El Greco had ever countenanced such unabashed tortuousness before van Gogh came along. That brutal honesty has a resonant force.

Van Gogh was initially skeptical about what he had done here, but then he came to see its merits for evoking that tough underside of human existence. In a second letter to Theo about the startling canvas, he wrote, "Exaggerated studies . . . like this Night Café seem to me usually atrociously ugly and bad, but when I am moved by something, as now by this little article on Dostoyievsky, then these are the only ones which appear to have any deep meaning."[26] The comparison to writing by the author of *Crime and Punishment* and *Notes from Underground,* to Dostoyevsky's rich complexity and bold vision of human pain, makes perfect sense.

If only van Gogh could have known the effect the picture would have, nineteen years after he made it, seventeen years after he committed suicide, when the poet Rainer Maria Rilke saw it in 1907 in a storage room at the art dealer Bernheim's in Paris. Rilke had seen and written about the painting previously, but now he realized that "a lot more could be said about its artificial wakefulness in wine red, lamp yellow, deep and utterly shallow green, with three mirrors, each of which contains a different emptiness."[27]

Everyone focuses on his or her chosen elements in this moving canvas; that Rilke called attention to all three mirrors is intriguing, especially since one of them is scarcely visible. On the left-hand side of the canvas, there is the hint of the lower-right-hand corner of a frame that is probably the third mirror, but it could equally well be a picture of some sort. Rilke was probably right that such a café would only have mirrors, and that this was not a painting or poster, but his poetic license that turns this into a fact is clearly the result of his fascination with what is discomfiting in human vision, and his own obsession with mirrors. Rilke was capitalizing on the idea generated by the van Gogh that what we see is a reflection, that there is no absolute truth, that all perception is filtered through the lens of our minds. The way that the mirrors, singled out by Rilke, echo colors that are nearly bilious and quite fiery is a manifesta-

tion of the artist's psyche. Similarly, it is because of the brain that there can be the appearance of emptiness where there should be fullness, or cacophony when there might be calm. Images occur that have nothing to do with the factual truth; we are always filtering and distorting so-called reality.

Rilke, who wrote volumes of poetry devoted to windows and other frameworks of seeing, was fascinated by deceptiveness, and the artifice and limitations of all representation. For him, van Gogh had encapsulated the full gambit of human responsiveness, with all of its drawbacks and all of its wonder.

Today, in the Yale University Art Gallery, where Stephen Carlton Clark bequeathed it, *The Night Café* assumes the look of "an important object." It has achieved the status of masterpiece, and most viewers of the canvas in its ornate gilded frame are aware of its virtually inestimable financial worth. If Stephen Clark's initial inheritance from his grandfather and mother and father combined was in the range of twenty-five million dollars, now, based on the prices for lesser van Goghs, if one wanted to hazard a guess about what this single painting would fetch on the auction block, it would be safe to say that it would be more than eighty million.

The material value and landmark status of *The Night Café,* however, have nothing to do with what makes it really matter in the history of human thought and the art of painting. This canvas is about raw emotion, deeply felt; it is about the will to penetrate feeling; it is about the insistence of finding new means of revealing vision. Of course it is about decay, seediness, and the feverish forces of night—van Gogh's "powers of darkness"—but it is also about heightened feelings of every sort. The burning desire to make images, and the craving to face human life squarely, are encapsulated here. So is the will to do the unprecedented, and that rarest of forces: true creativity.

The Night Café also underscores the idea that everything is significant. It makes us consider the ambiance created by ordinary French décor at its most commercial level—what its intentions and results are. We think about the effects of gaslight, and of alcohol. Van Gogh has painted that billiard table as a child or a genius might, unabashed in his awkwardness, laying on the color with abandon; the result is that even an inanimate object comes alive.

For Stephen Carlton Clark to choose to acquire such an artwork was evidence of a willpower all its own. The decision to make *The Night Café*

part of his everyday life betrayed, however much he concealed it behind his silence and brusque demeanor, a receptivity to human feeling at its most extreme.

BEYOND LENDING PAINTINGS and chairing the building committee, Stephen was assuming all of the responsibilities of a devoted trustee at the museum where he had initially begged off from any involvement. He joined committees meant to make administrative procedures more businesslike. When the museum's first architecture show threatened to cause financial havoc, he offered ten thousand dollars to defray the damage; he might not respond to the usual sort of fundraising, but when he saw a need and could help without being bidden to do so, he was generous.

Like Sterling, he had ready cash at a time when other people who had been wealthy in the 1920s were now desperate. This enabled him not only to be a lifeline for the Modern but to collect art in what was now a buyer's market. Stephen did so passionately, and with a completely independent approach.

In 1930, when others were reeling from the stock market crash, he bought, for fifty thousand dollars at Knoedler's, Cézanne's *Still Life with Apples and Pears* (color section 2, page 3). This painting, which he eventually left to the Met, is one of the artist's quintessential studies of humble subject matter, in effect a Platonic treatise on seeing rendered with the most rigorous, reductive vision. The painting is a celebration of the earth's bounty, of the meaning of food and nourishment in their most elemental sense, and the wonderful illusion of art.

At the same time that, in the course of the 1930s, Stephen was buying such masterpieces by the giants of European modernism, he also had developed a consuming interest in the art of Thomas Eakins, now considered one of the greatest of all American painters. In January 1930, fourteen years after Eakins's death, Stephen wrote the artist's widow asking if he could see the work by her husband that she still had at home. As opposed to the missives to his brothers he dictated for a secretary to type, this time he wrote by hand. When Stephen chose to be deferential and humble, he was the model of tact. To Mrs. Eakins he was both gentlemanly and, in his understated way, willing to let his passion come through. "I suppose that you are probably pestered with dealers and other people who want to see your pictures. . . . I may say that I am not a

dealer—but have been all my life a lover and collector of pictures. . . . I am very anxious to add to my collection of pictures, which some day I expect to leave to some public institution, a very fine example of Mr. Eakins work, and naturally I am writing to you in the hope that you may be kind enough to aid me in my quest."[28]

He ended up with thirteen works. Not all came from Mrs. Eakins, and he acquired the group over a period of years, but they are a rich and varied collection of key paintings by an artist who is unique in the history of painting. And because Stephen eventually left the best of these paintings to the Yale University Art Gallery, his perspicacity as a collector has enormous benefits to the larger public.

The attraction to Eakins on the part of someone who bought Matisse

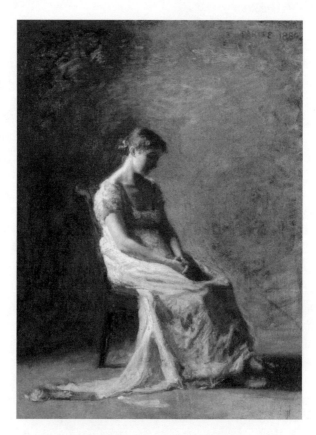

Thomas Eakins, Retrospection, *1880. Stephen was in touch with Eakins's widow when he began his substantial collection of the artist's work.*

in the same number reveals a vital aspect of Stephen's character. Like his father and grandfather, and even the brother from whom he was so fundamentally different in other ways, he combined a strong leaning toward all that was embodied in the term "French culture"—its pictorial tradition, the emphasis on pattern and color in art and life—while at the same time remaining devoted to the essence of what was American. Eakins was the Walt Whitman of painting; he captured the American intellect, the methodical side, the athleticism. He and his subjects also exemplified ferocious independence, one of the few shared traits among all the Clarks.

If other artworks connected Stephen with the complex layers of existence that were part of his family's experience abroad, one Eakins in particular brought him nearer to his summers in Cooperstown, the local

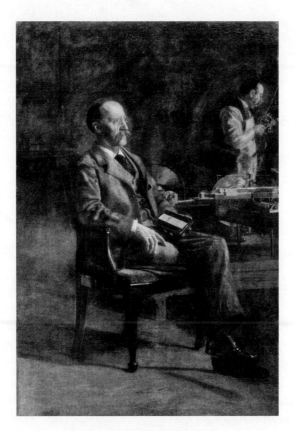

Thomas Eakins, Portrait of
Professor Henry A. Rowland, *1897.*

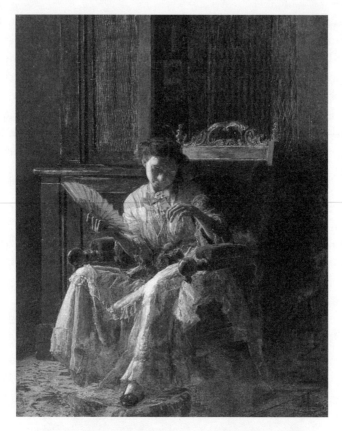

Thomas Eakins, Kathrin, *1872. This painting of Eakins's
fiancée, acquired by Stephen, was one of the artist's
most important, and startling, works.*

characters as well as the outdoor delights. In 1874, the Philadelphia-
born painter wrote, in French, to Jean-Léon Gérôme, the painter so dear
to Stephen's father, about his outdoor hunting scenes, "I have chosen to
show my old codgers in the season when the nights are fresh with
autumn, and the falling stars come and the reeds dry out."[29] This is
exactly the setting of Stephen's marvelous *Will Schuster and Blackman
Going Shooting,* now known as *Rail Shooting* (color section 2, page 6).

The painting is precise in its time of year, as it is in the placement of
its forms. In this taut and concentrated composition, the glistening bar-
rel of Schuster's shotgun, which appears to reside on the picture plane,
establishes the strong horizontal, echoed by the tops of the reeds in the

background, against which the two figures make a perfect counterpoint. With mathematical exactitude, Eakins has then angled both the flat-bottomed skiff and the pole with which Blackman pushes it along to achieve both an abstract beauty and a movement into space that makes this a very real moment of earthly existence.

The colors have been as beautifully and clearly worked out as the lines and angles. Luminous black skin contrasts with a sun-splashed white shirt. The whole is dappled by stunning accents of red. The same sense of control exists in the artistic decisions as in the sport portrayed.

In the soft marshland setting, that rigorous discipline is evident in the way that the construction of the picture and the acts of shooting and poling depend on meticulous lining up. The equilibrium of pusher and shooter is central, and the artist's clear vision works with it. For Stephen, who was forever trying to bring order and the certainty of guidelines into existence, the combined vigor and rationalism of this prize of American painting had immense appeal. He could accept the frenzy of *The Night Café,* but he also needed ballast.

With his unerring eye, Stephen also zeroed in on another aspect of Eakins's greatness in the portraits he acquired. The 1880 *Retrospection* has in common with the shooting scene the feeling of a motion picture that has momentarily stopped: a fleeting, but infinitely rich, instant has been frozen forever. This vision of a young woman deep in reverie is evidence of Eakins's ability to render interior space as plausibly as the outdoors, and, concomitantly, to suggest the activity of a ruminating mind as opposed to one engaged in decisive action. Stephen's 1897 Eakins *Portrait of Professor Henry A. Rowland,* of a physics professor who was considered one of America's most brilliant scientists and who made great strides in the field of spectroscopy, is truly a painting about knowledge, in which the intelligence of the subject is accentuated by the sureness and strength of the painting technique.

With all the artists who interested him, Stephen zeroed in on the great summation works—the canvases where a painter's ambitions and unique attributes were realized at their apogee. In that vein, he acquired the 1872 portrait of Eakins's future fiancée, Kathrin. Its rich texture and chiaroscuro effects, and the contortions of the central figure, suggest a panoply of psychological layers. Although it is an image by a young man of the woman he fancied, this remarkable portrait renders her neither beautiful nor content as one might expect. Rather, she looks prematurely

aged as well as grim—as if anticipating the tragedy that would indeed befall her when, at age twenty-eight, she died of meningitis before she and the painter were actually married.

Kathrin was the sister of Eakins's best friend, William Crowell, who was also the artist's brother-in-law, married to one of Eakins's three sisters, Frances. Stephen would have known all this, and recognized the large canvas not just as a portrait of a sitter but as an essay on human relations and their mutations. It's not a painting everyone would have wanted; the young woman with her fan and cat appears almost crippled, as if something is eating away at her. But the intense seriousness of her portrait, accentuated by the somber palette and animated brushwork, appealed to the collector who certainly was not one to turn his eyes on life's darker sides.

Stephen was simply drawn to every aspect of Eakins's wide-ranging portraiture. He also bought the 1895 *Maud Cook*—as pretty as Eakins could get. This time the image is of a beautiful woman in her bloom. She is dressed elegantly; her skin glows. Yet even here there is a coolness and a certain sternness: the traits that made Eakins Stephen Carlton Clark's natural quarry as surely as the more exuberant—and, one might say, facile—qualities of Renoir were what most captivated Sterling. Stephen had no taste for softness in his art; he went so far as to buy Eakins's 1905 *Archbishop Diomede Falconio,* among the artist's most pious works, and the 1889 study of Dr. D. Hayes Agnew, the great surgeon and professor of medicine whose clinic became the subject of one of Eakins's masterpieces. Dr. Agnew is shown scalpel in hand in a close-up and intimate vision where the qualities of competence, seriousness, and immense professionalism are palpable in artist and subject alike.

About the only aspect of Eakins's work that Stephen left alone were the homoerotic paintings. The artist's scenes of naked young men frolicking at a swimming hole, of athletic prizefighters clad only in shoes and the most minimal of briefs, might have made him too uncomfortable. But he was the greatest private collector of Eakins's work, and, because he kept his word to the artist's widow, the public today reaps the benefits.

WHILE FILLING THE HOUSE on Seventieth Street with artworks that he knew he would eventually be leaving for the benefit of the museumgoing public, Stephen was devoting increasing amounts of

energy to his work at the Museum of Modern Art, primarily the effort to get it into a new building. In the early thirties, the museum had moved from the Heckscher Tower to a town house owned by the Rockefeller family on West Fifty-third Street, but it was yet to have a headquarters that was not a refit.

In 1932, with its International Style show, the Modern had opened America to the streamlined, ornament-free architecture being practiced all over the world. Launched by Le Corbusier, Walter Gropius, and Mies van der Rohe, this approach to building utilized the latest technology and modern materials, allowing steel and concrete and glass to be seen

Alfred Hamilton Barr Jr., c. 1929–30. Stephen is still well-known at the Museum of Modern Art as the man who fired Barr, but their relationship was in many ways warmer than most people realized.

for their beauty as well as their practicality, and stripping buildings of gratuitous decoration in favor of stark and simple forms. It was time for the Modern to have a new home that reflected the aesthetics espoused inside.

The museum's building committee turned to the one of its board members who was an architect, Philip Lippincott Goodwin, to take on the task. He was a collector with what Alfred Barr called "fastidious taste"[30]—among other things, he had, in his duplex apartment on Fifth Avenue, Brancusi's *Blond Negress*—and he was devoted to the Modern. But his own work was more along the lines of the neoclassicism taught at the Paris École des Beaux-Arts than anything more contemporary, and the building committee decided he needed a partner. Nelson Rockefeller proposed that this be Edward Durrell Stone, who had been one of the designers of Radio City Music Hall and was a known devotee of Le Corbusier.

There was a lot of politics behind all this, and many questions of who knew whom. Barr, who more than anyone else had given the Modern its identity, determined its programs, and guided its collecting, was offended not to have been involved in the choice, and "declined to partake of the conversations of the Building Committee."[31] In those often charged and difficult discussions, Stephen seems mainly to have played the role he assumed with his brothers. Reserved and reticent, he quietly had strong opinions.

Conger Goodyear and Nelson Rockefeller did far more talking. They questioned everything, acting as if they knew better than the two architects. Stephen appeared less openly antagonistic, but his strong will still came through. He was simply less talkative than the others.

An observer who knew these people firsthand evokes the scene. "Neither Goodyear nor Rockefeller nor, it seems, Stephen Clark was notable for tact. 'Toughie' Goodyear made up for it by bluster, Nelson by backslapping and 'Hiya, Fella,' and Clark by relative shyness which may or may not have masked a genuine shyness."[32]

This was the essence of Stephen Carlton Clark as seen by the people whose lives he affected. Strong-willed and sure of his views, he exercised his authority with such reserve and guardedness that he was the one who inevitably left everyone else wondering what he was feeling, even when, in his lawyer-like cadences, he made his thoughts known.

John McAndrew, who was on the museum staff and functioned as Barr's emissary, said the meetings were "stormy. Clark didn't say much.

Nelson and Goodyear were awfully tough on Goodwin."[33] These men who had grown up in ornate mansions simply could not understand the concrete floor slabs and the lack of beams or partitions. They also mocked Barr's ideas that Paul Klee or Alexander Calder design one or another space. Nonetheless, by March of 1937, the building committee presented the new proposal to the rest of the trustees, and they passed it.

Stephen Carlton Clark's role in all of this as the strong but silent one, along with his great financial generosity during the construction process that had just began, earned him, two years later, the chairmanship of the museum. Shortly after the spanking new Museum of Modern Art opened its doors in 1939, he would be placed at its honorary helm. He was, in many ways, his parents' perfect son: devoted to the public good, able to comport himself with the restraint and dignity expected of an American Puritan aristocrat, tactful and resolute.

When one considers the way his brother Sterling was conducting himself in those days, the complete lack of guard and willingness to let everyone know in spades what he was thinking, it seems that rarely had two siblings been more opposite. Stephen worked within the system; Sterling would need to have his own museum if he hoped to wield authority. Stephen used his position quietly but with determination; Sterling, in his good moments, had more fun, but was out of control. On the other hand, the land managers or gallery salesmen or horse trainers who worked for Sterling all found him warm and affable; no one said as much about his younger brother.

IT TOOK A STRONG WILL to defend the new building for the Modern once a photograph of its model became known to the public. In 1937, most people did not cotton to this sort of thing. Goodwin's and Stone's facade was shockingly austere. A strict grid was all there was to see. To a world that expected its public buildings to refer back to ancient Greece or Rome, to be covered in ornament and carry the weight of history, this looked like the product of a machine shop. At ground level, a cantilevered roof over the entrance had a shape that resembled a biomorphic form cut out of metal with a scissors, swelling and then receding in the way of certain shapes in the sculpture of Brancusi and Arp. The white marble facade above it was simply divided into identical vertical rectangles, totally stark, five rows of them, sheathing the exhibition galleries within. Above that, two bands of glass indicated the industrial-style

From left to right: *Nelson Rockefeller, Conger Goodyear, and Stephen in 1937, with a model of the new building for the Museum of Modern Art. Stephen, who was on the museum's building committee, would be the first person to become simultaneously president and chairman of the board.*

windows of the fourth and fifth floors. There was a fenced-in terrace above, with, on top of it, a flat roof into which had been cut circular openings resembling a steamship's porthole windows.

What to many of us is an incredibly graceful example of streamlined modernism at its best was the sort of thing that catapulted most of Stephen's Yale classmates and associates on Wall Street into a rage. What had happened to the Gothic? Where were the Ionic columns? Where was taste? And dignity?

In the Kentucky town where Robert Sterling Clark had bought a house to pursue his horse-racing interests, the local newspaper blasted out in a way that was the norm all over America. "The new 'functional' architecture, so called, has no excuse for being. There is no concern felt to make the exterior beautiful, pleasing to the eye and conformable to architectural principles as these have been developed through the ages,"[34] insisted the *Lexington Leader*. Even as modern a visionary as Frank Lloyd Wright referred to this sort of thing as "flat-chested style."[35]

Stephen Carlton Clark, however, supported it fervently. He may have chosen to live in a house that embodied all of the traditions this austere block rejected, but once he had made up his mind, there was no stopping him.

On May 8, 1939, two days before the official opening of the new building, the trustees had a dinner in the room set aside for their meetings on the penthouse floor. There were glasses for three different wines on the long banquet table for which Alexander Calder had made meandering silver candelabras festooned with greens and lilies. Paul Sachs, many of whose students had, in the past decade, joined the ranks of America's leading museum directors, gave a speech. He warned against "the danger of timidity"—the words were underlined in his text—and insisted, "The Museum must continue to take risks. The Museum should continue to be pioneering: bold and uncompromising."[36]

Conger Goodyear then spoke. Looking out at Abby Rockefeller in her deep red long Lanvin dress and the other adventurous rich people, he went off on a tangent. "The pituitary gland, you know, has a very profound influence in the growth of the body. The skeleton cannot prosper without it, and when its activity is diminished, this leads to obesity and mental defects. Our pituitary gland is Alfred Barr." Then, to indicate all that Barr had done, he simply remarked, "I need only say, look about you."[37]

There were no other speakers, but two important events then occurred. Goodyear resigned from his presidency and handed the position over to thirty-year-old Nelson Rockefeller. Then the trustees elected Stephen Carlton Clark chairman of the board.

In so doing, they publicly voiced thanks to Stephen for his "time and money in the creation of this building."[38] But those in the know considered the election a maneuver. There was very little that would have been more important for the Museum of Modern Art in its new life than to receive Stephen's art collection in its entirety.

STEPHEN WASN'T ACTUALLY at the event. He was home ill. But, having been prepared in advance for his election as chairman, he sent a telegram. In a way this suited him; he was someone who found it easier to communicate in writing than to stand in front of an audience. He congratulated Nelson Rockefeller and praised Conger Goodyear—and then modestly accepted his new position.

Surely Alfred Corning Clark would have given his quiet smile if he had

known about his youngest son's new appointment. There would have been few better ways to honor Alfred's values than to help millions of people to enjoy artistic bravery at the forefront. The Modern endorsed the sort of imagination and creativity that took one into new domains—which is how the Clarks, at their most expansive, had made their greatest mark.

The last-born grandson of Edward Clark was where he was because he had money and position, but, as had his grandfather in his similarly understated way, he was taking an enormous risk. As one seer put it, "If Clark had known what he was letting himself in for during the next five years, he might have thought better of accepting the honorific post that was bestowed on him."[39] On the other hand, it's unlikely that he would have declined even if he had a foreboding of what lay ahead; going back to Edward's manipulations on behalf of Isaac Merritt Singer, it was not in the family tradition to be daunted or to avoid risks.

Stephen was defending what he believed in, both the faith in progress and the idea of contributing to the well-being of society. And he was doing this in the way that suited him—quietly and in the background. He did not need the limelight, and although he would have attended that banquet in the trustees' room if his health had permitted, he did not suffer from being absent.

If his elder brother Sterling needed his voice to be heard, and would conceive a building with his name perpetually associated with it, built of the marble of ancient temples, Stephen worked even more strenuously for a structure where the main material, glass, was transparent, but his role would be concealed.

There's a reason that today the public knows Sterling's name better than Stephen's, and people are sufficiently confused about the institution called "the Clark" so that even some who knew Stephen personally think his paintings went to Williamstown. Because Sterling closely controlled the destiny of his collection in its entirety, he achieved greater recognition, while Stephen believed in quietly working in the background. For the same reasons, Alfred, for all his impact on music and sculpture through the men he sponsored, has now passed into near oblivion. The extent to which renown lives on is one thing that could be controlled in advance of the grave.

WHEN THE NEW MUSEUM OF MODERN ART opened its doors, the public flocked in to a groundbreaking inaugural exhibition.

Called "Art in Our Time," it not only showed just what Goodwin's and Stone's elegant modernist structure was all about, but it had also celebrated the tenth anniversary of the museum, while coinciding with the 1939 New York World's Fair, for whose visitors it was especially planned.

Stephen Carlton Clark was a major lender to practically every part of that diverse and thrilling show. Without the presence of the work that had made the journey of some twenty blocks from Seventieth Street and left his living room and library walls half bare, the marvelous panoply of modernism would not have been the same.

The name, however, was a bit of a misnomer. "Art in Our Time" was not so much about what was being done in 1939 as about its sources, about the work of the previous century that had the guts and vigor and honesty that were the seeds of all modernism. It was an overview of the changed sensibility that had transformed a side of European and American culture.

That said, even as it dipped into the past, the recent history it presented was the most adventurous aspect. This was a foil to the world of Robert Sterling Clark's antiques dealers, to the more traditional taste embraced by Sterling and the other collectors who were like him, and who still represented majority opinion. The show at the Modern may have cast a backward glance, but it was still an affront to the millions of people all over the world for whom art stopped at impressionism. Rather, this was a new strain of human civilization. Here were intrepid souls who wanted their art to go into mysterious realms, to go past the covering to the core, to delve into the unconscious, and to be bold and audacious. Stephen Carlton Clark was a quiet man who held his cards close to his chest, but in his aesthetic taste he had been drawn magnetically to this courage and candor, and he had acquired some of the best examples of the brave new modernism to be found anywhere in the world.

The catalogue for "Art in Our Time" was snapped up by World's Fair visitors and others who had come from all over the world to breathe in the excitement on view in New York that summer. Practically a bestseller, this bright yellow tome called out its message like the town crier with the exhibition title and information in large bold sans-serif type alongside a drawing of the new building. This was Today, in all of its energy and bravura. Conger Goodyear in a quick preface explained the philosophy of the museum since its inception, a credo the show brought to life. The Modern was "primarily an educational institution. We

adhere to the policy of holding temporary exhibitions illustrating the art of today and its derivations. . . . Not all of those shows commanded a general acclaim; many were frowned upon by the ultra-conservatives; a few were scorned by advanced liberals."[40] When he had first approached Stephen about becoming a trustee at the time that the museum came into being, this is just what Stephen said the place should be; he was as loyal as he was because it had achieved his goals and honored the principles he believed in.

Alfred Barr spelled out the intentions of the exhibition to branch into new territory by putting "architecture, furniture, photography and moving pictures" on equal footing with "painting, sculpture and the graphic arts,"[41] and by including foreign as well as American work. Today we don't think twice about any of this; back then it was all startling. And it was just the sort of thing Stephen could be counted on to support. His family had, going back to his grandfather, been much more oriented than most Americans to foreign cultures, both because of where they sold sewing machines and where they traveled for pleasure. The source of the family fortune kept ideas of advanced technology, and of the enhancement of domestic living, at the forefront of his conscience, even as he lived in an old-fashioned way. Many of his confreres were allied only with a traditional aesthetic—they expected their furniture to have eagles on its finials and their paintings to recall great moments of history—but Stephen was in sync with an institution of which its director wrote, "The Museum of Modern Art is a laboratory: in its experiments the public is invited to participate."[42]

Those words—with their frank allusions to science, their notion of testing something out and working the mind rather than falling back on proven values and luxuriating in them—were especially daring in 1939. To use the language of scientific research in the sacred precinct of art was shocking. Stephen's own brothers, as well as most of the people who went to Yale with him, scoffed. But he was, quietly and determinedly, part of the revolution.

THE FIRST PAINTING of Stephen's to show up in the catalogue of that groundbreaking exhibition was Albert Pinkham Ryder's *The Forest of Arden*. It took an exceptional eye and a good deal of bravery to own this small painting. It is certainly not pretty. Rather, the Ryder conjures an Edgar Allan Poe sort of landscape with a howling wind and a haunting

sense of death. The central element is the gnarled remains of a tree trunk, and the tiny characters in the foreground look like creatures from a dream or mythology, not really of this world. Ryder handled paint the way that Poe wrote poems—almost as if in a trance. This nineteenth-century American painting was a perfect evocation of consuming melancholy. For many people, it was the role of art to divert, rather than to invoke these disquieting forces of the psyche. Stephen and the other proponents of modernism, however, were inextricably drawn to the candor.

Stephen was also the source of the earliest-known American painting in the exhibition, since the anonymous exemplars of American folk art lent by John and Abby Rockefeller could not be assigned precise dates. This was Winslow Homer's 1871 *Old Mill (The Morning Bell)* (color section 2, page 2). It is hard to imagine a more engaging image of everyday life in rural New England than this canvas by one of the few artists collected by both Sterling and Stephen. But the Homer is far from a simple testimony to bucolic pleasures. It is loaded with text and subtexts. A makeshift walkway of wooden planks cuts across the picture's main field of vision. Its rough-hewn surface, splashed in warm summer sunlight, is charming, yet, like temporary scaffolding on a construction site, it is precarious.

A well-dressed young lady in a ribboned bonnet lopes along those jagged planks, her pleated skirt flowing in the motion of her stride. She is carrying a bucket and a bag and, purposeful and pensive, looks downward. One senses in her grimly determined pace that there is something wrong. Ahead of her on the walkway there is a spaniel, its black and white spotted coat also reflecting the splendid natural light; even the dog seems constrained in his journey.

The woman and spaniel are heading toward a wooden mill building with a broad shingled roof. A bell is being rung on top of it, and this is her summons to work. The ambient sadness here is not just a result of the sense that the young woman is about to leave behind her the pleasures of being outdoors on what is clearly a warm summer morning in a lovely pastoral setting, to be confined to a long day of work in the textile mill. The feeling of discomfort is heightened because of her solitude and the way she is overdressed. In contrast to the women chatting in a group at a distance, this isolated character who is the main subject of the painting is clearly from the city; trudging off to work with her lunch, she is out of place.

Robert Sterling Clark was amassing a collection of paintings that were

invariably pretty or heroic, as seemingly triumphant and full of dash as the splendid silver he acquired in volume. Stephen, on the other hand, was drawn to the grit and difficulties of real life. This small Homer canvas, impeccably painted, is on the one hand a lovely scene of country living, set in a landscape with stone walls, wildflowers, tall grass, and a rich canopy of leafy trees; but, as a vignette of everyday life, it does not dissemble about the potential for sadness. The gaggle of women talking away at the side has nothing to do with the protagonist with her head down.

Alfred Barr, underneath the caption identifying *Old Mill* in the catalogue, used the occasion to write one of the few bits of text describing any of the artworks on view in this large exhibition. Thus singling it out for its importance, Barr writes of Homer, "Almost uninfluenced by his European contemporaries, he painted the American out-of-doors with simplicity, enthusiasm, and unsurpassed power."[43] True enough, but for all the differences between the Homer and a painting like van Gogh's *Night Café,* both made clear Stephen's penchant for artworks that showed the reality of working-class life, the moments when people are not at ease, when they are just getting by and surviving the hardships of existence.

It's little wonder that Stephen Carlton Clark had made the Homer his. It reflects tremendous skill, reveals impeccable taste, and captures what is essential to the lives of people with far less fortune than his own. Both of Stephen's parents had had a keen awareness of people whose realities were at the far end of the spectrum from their own lives. Alfred had perpetually engaged in his random acts of charity—the acting troupe in Milan, the poor child from Lyon—while Elizabeth had been an activist in the realm of tenement housing. Of their four sons, it was Stephen who, without articulating it verbally, had his eyes wide open to other populations, their experiences and their needs. In the art he bought, he never went for victory scenes or images of grand people; rather, he was magnetically drawn to art made by tough, brave painters, of different epochs and cultures, who used extraordinary technique to evoke human experience at its most generic. And he was a connoisseur of isolation.

STEPHEN HAD, in 1936, purchased Homer's 1866 *A Game of Croquet* (color section 2, page 2), for three thousand dollars from the Macbeth Gallery in New York. Barr probably did not pick it for the show at the

Modern because at first glance it appears to be mainly a pretty picture. This seems to be an essentially charming scene, brilliantly colored, of two well-dressed women playing their game in a lovely setting on a fine summer day.

But on second glance the tension becomes palpable. In this small canvas that remained installed in the dining room on Seventieth Street when *Old Mill* was at the Modern, we are drawn first to a woman who is adjusting her bonnet nervously. She is waiting while her opponent gets ready to hit what will probably be a successful shot through the wicket, perhaps taking the lead or even becoming victor. The extreme competitiveness of croquet becomes evident.

There is an edginess here; the attempt at control is fierce. The artist's mastery of his technique—the deftness of his brush strokes and sureness of the color placement—reflects a dexterity similar to what is required for an accurate croquet shot. As opposed to the artistic method, however, the subject reveals a determined one-upsmanship, the need to win primarily in order to vanquish one's opponent. A simple game is shown to be anything but. In his Cooperstown summers, and at the schools where he and his children were educated, Stephen well knew that that was often the case with activities of recreation.

IT WAS TO THE BENEFIT OF visitors to that groundbreaking show at the Modern that Stephen did not confine himself to one culture or one approach to making art. As long as a painting had candidness and forthright intensity, it captured him. Another of the masterpieces in that exhibition to which World's Fair visitors were coming in droves was one of Cézanne's quintessential paintings of card players (color section 2, page 3). That earthy, powerful oil on canvas invokes reality in a way that no painter in history prior to Cézanne had ever exactly managed. Space— the air between things—truly seems to exist before our eyes. The void between the three card players is as boldly articulated as if it were a carved sculpture. The men's elbows each have distinct weight; we know that the one in brown rests his forearms lightly, whereas the one in billowing blue leans hard and the one in white barely has the sides of his hands on the table.

The washboard finish of the wooden table reads so clearly that we believe we can touch its matte surface. The higher varnish on a side chair is equally true, and the plaster wall is so plausible that we feel our fingers

could sense its coldness. Yet Cézanne has achieved none of these effects through verisimilitude. Rather, he has employed his own brave short-hand, a completely painterly approach that boldly reveals brushwork and pigment and throws a range of blues and greens into the chalky white plaster. The artist evokes an eyebrow with a broad gash of paint rather than a more exact rendering of the hairs, declaring the act of painting as a feat of construction through the materials of the trade. That the sub-stances of earthly life become so palpable through this method is Cézanne's spectacular accomplishment—and the reason he has such ines-timable influence to this day.

The billowing smock and the roughly pleated draperies are so real that one apprehends the air encased by the folds as definitively as the surfaces. Human thought—the intense concentration of the three players and their silent observer—is also evoked in fullest force. Though Sterling thought that Cézanne was simply a bad painter, Stephen had the vision to recognize that the artist's awkward modeling, generalized facial fea-tures, and compression of space were not only completely intentional but also were unprecedented in their force of articulation. Cézanne's way of abstracting elements of visual experience evinced courage and imagina-tion, the bravery to affront tradition and the taste of others, and Stephen Carlton Clark, with his quiet intelligence, was among the first people in America to recognize the worth of this approach. He was not alone in that vision—Albert Barnes in Philadelphia and other collectors went even further in their engagement with Cézanne's work—but he was still at the forefront.

Alfred Barr, who considered Stephen among the most astute collectors on his museum board, again wrote a brief but cogent text so that the larger population attending the 1939 show might grasp what would otherwise be alien. "In his long series of *Card Players,* Cézanne concen-trated his power of building a composition until it suggests the strength of architecture." In that compact sentence, Barr exemplified modernism by distilling and zeroing in on the essential.

Some thirty years before *The Card Players* went on view at the Modern, Rainer Maria Rilke had, in response to a Cézanne show in Paris shortly after the artist's death, credited the painter with "the whole trend toward plainspoken fact." When Rilke then takes the idea further, he identifies in its full magnitude the advance beyond prettiness that underscores both Cézanne's work and Stephen Carlton Clark's taste. "First, artistic perception had to overcome itself to the point of realizing that even

something horrible, something that seems no more than disgusting, *is*, and shares the truth of its being with everything else that exists."[44] That acceptance—of color as the guide to vision, of the importance of a plain wooden table, of the value of everything and everyone—was part of the getting down to basics central to the existence of the Clark family, fancy as they had become. It was fundamental to the awareness of the need of the average homemaker to sew more efficiently, of the spirit that guided Alfred to find out the names of poor victims of circumstance and to fund their rehabilitation, of Elizabeth to improve the dwellings of the poor even as she built larger porticos for herself. And that same sort of understanding, to which Cézanne's art was a clarion call, is what led their youngest son to work for as well as contribute to the public institution that would open masses of people to a new way of seeing. This was the mentality that would lead him to fund a museum for baseball and another for folk art, and to expand a public hospital. At the same time that he lived in his cocoon, in his philanthropy Stephen embraced not the world of the rich into which he was born but life in the broader spectrum.

WHAT AN UNBELIEVABLE EYE Stephen had. Other collectors had more Cézannes, and his own brother bought paintings in greater quantity, but he zeroed in on pictures of such exceptional merit that today he strikes us as the connoisseur sine qua non of modern paintings, the one who time and again found and bought the painting that was the essence of its creator. Another of these gems was the 1891 *Madame Cézanne in the Conservatory.* Unfinished, it has a lightness and ethereality that make it completely different from other Cézannes of the period; it is more related to the watercolors Cézanne would paint at the end of his life.

This portrait conveys what it is to construct a picture from scratch. Setting and subject merge exquisitely; Cézanne's wife is unified with her surroundings in a composition of unparalleled grace. Meyer Schapiro, a man who hadn't a prayer of buying the same sort of art as Stephen Carlton Clark but who was completely attuned to the merits of the collector's choices, wrote of this work, "The inclination of the head—the bearer of a delicate submissiveness and revery—belongs as much with the tilted lines of the wall and the trees as with her own body. Foreground and background are united in the common sweep of the tree trunk and the

sitter's right arm."[45] Schapiro pointed out the "contrary, virile, intellectual quality" of the painting.

Indeed, this is a highly subtle, demanding picture. In the refinement of his taste, Stephen had gone well beyond his father. He liked art that was challenging, that forced the viewer to make an effort. He was not drawn to the facile or pretty. This painting speaks to an overarching sense of construction, an eye for formality, and a profound human tender-

Paul Cézanne, Madame Cézanne in the Conservatory, *1891. The work that Stephen bought by Cézanne included a number of the artist's most masterful paintings.*

ness. It was also the taste of someone who knew how to leave a lot out, who relished the void, who realized the sanctity of space.

WITH THE 1939 ART IN OUR TIME SHOW, Stephen now lent van Gogh's *Night Café* for a second time. What mattered more than his having bought and installed this remarkable picture in its ornate setting on Seventieth Street was the role his ownership allowed it in the lives of others. While the cognoscenti had seen it in the van Gogh show four years earlier, now it was presented to a wider and less sophisticated public. This time, Stephen was openly its lender.

As Barr pointed out in the exhibition catalogue, van Gogh had suffered inestimably because of the unpopularity of his work at the time that he was making it, but taste had changed. Writing of the Dutch painter who, desperate over his artistic solitude, ended his life in France at age thirty-seven, the museum director wrote, "Distraught by his inability to adjust his life or his art to an unsympathetic world, he killed himself. Today the world honors his martyrdom and loves his vibrant emotional pictures which 50 years ago seemed repulsive and incomprehensible." Regardless of the tragic ambiance of its scene, *The Night Café* was one of those hits.

There was, however, yet another painting Stephen Carlton Clark had had the judgment as well as the pocketbook to buy, which was, to those in the know, even more important than *The Night Café.* This was Georges Seurat's beguiling, mysterious *Circus Sideshow* (color section 2, page 3). The large painting, one of only seven great compositions the short-lived artist ever painted, is completely arresting both because of its technical virtuosity and the oddness of its portrayal of human entertainment.

Circus Sideshow had been in the Modern's very first exhibition when it was still a foundling institution in the Heckscher Building. There it hung on cumbersome rods suspended from the molding that ran along the top of the wall at ceiling height, with its gilded frame quite out of place beneath the industrial slats of the air-conditioning ventilation. At the time, it still belonged to Knoedler & Company. Two months later, in January 1930, just prior to a Museum of Modern Art board meeting, Alfred Barr, Stephen Carlton Clark, Lizzie Bliss, and Paul Sachs met at Abby Rockefeller's house. The reason was specifically to discuss this large Seurat. Everyone agreed that the work lent by Knoedler's should remain in America. The price was a hundred thousand dollars. Stephen and

Abby Rockefeller each pledged five thousand dollars that day to help the Modern acquire the work.

It was impossible to raise the rest of the money. Barr, however, did not give up. Figuring that if, at least, one of his trustees bought the work privately, it would be available for future exhibitions and might eventually be given or left to the museum, a year and a half later Barr wrote Stephen asking him to purchase the work single-handedly.

Stephen refused. On May 22, 1931, he wrote the museum director, "I . . . am sorry to say that I am not interested in the purchase of the Seurat."[46]

Between then and the following November, something changed. Stephen may well have been calculating the effects of a financial depression that would probably worsen; he may have been gambling on what would happen if no other buyer came along. Or possibly he changed his mind about *Circus Sideshow* itself. In any event, in November 1932, he ended up buying Seurat's masterpiece for forty-seven thousand dollars.

By then he had been in constant negotiations with Knoedler's. What precipitated his decision was his learning that Henry McIlhenny, a rich Philadelphia collector, was also considering buying the canvas from the gallery. By the time Stephen got around to it, the purchase was almost as calculated as the painting in question.

Circus Sideshow was a paean to the way that forethought and precision could be the tools of sheer poetry. If other modern art is often marked by its spontaneity and the frank presentation of its maker's instincts, here was a painting in which premeditation and scientific thinking had determined a result that was incredibly complex and, at the same time, highly rational.

It makes sense that Stephen would have been attracted to Seurat's hope to apply reason and logic to the art of painting. Seurat had a passionate interest in the phenomena of vision. He endeavored to achieve balance and equilibrium; the artist wrote that "Art is Harmony." He sought "calm of tone," which he believed was established by "the equality of dark and light" and a similar equality "of warm and cool."[47] He used right angles and a balance of vertical and horizontal elements to create a sense of stasis.

Seurat's application of musical systems to the craft of painting hearkened back to Stephen's childhood, because his father adored singing above all other art forms. Beyond that, the painter's restraint and deter-

mination to counter life's vagaries with regulating laws were values that Stephen instinctively prized in every area of his life.

When *Circus Sideshow* was shown in the first exhibition of the new Museum of Modern Art, Alfred Barr wrote in the catalogue, "Seurat's theory of art rested upon a very simple and purely formal aesthetic. He believed that the art of painting depended upon the relations between tones (lights and darks), colors, and lines, and on the harmony of these three elements."[48] This 1887–88 painting, which Seurat had put into the 1888 Salon des Indépendants almost as soon as he completed it, was an exemplar of these qualities. Barr wrote that in this large canvas, "the geometric perspective . . . is compressed into three planes, the lively row of heads in the foreground, the trombone player, the boy and the impresario in the middle ground, and, against the back drop, other musicians. In its formality and symmetry the composition is quite without parallel in its day."[49]

The museum director pointed out the influence of Egyptian reliefs in the way that the figures are frontal and rigid and everything is broken into tiers. "Even the frieze of gas jets suggests ornament used in the Egyptian manner. Of the seven great Seurats this is the most geometric in design as well as the most mysterious in sentiment."[50]

One can readily understand why, a decade later, Stephen would come to insist that Barr should devote himself mainly to writing. Few writers were clearer or more articulate, or better able to encapsulate the essence of an artist's style so that anyone who was interested could understand it. Barr's analysis is also a guide to why this painting so completely suited its owner. The trombone player is aloof; people are disconnected from the world around them. That elusiveness, combined with a quiet force, was emblematic of Stephen Carlton Clark as well as of the art to which he was drawn. A strong presence could have a marked distance.

At the same time, as Barr pointed out, "The whole scene is suffused with a penetrating uncanny light, yellow against violet."[51] As with van Gogh's *Night Café,* this was Stephen's preferred palette.

The artist's little oil study of bathers and portrait drawing that Stephen owned exemplified to some degree the qualities that Barr elucidated, but they were even more evident in *Circus Sideshow.* Stephen sold the smaller painting just before acquiring the larger one, for now he had a summation piece that required little else in addition.

On Seventieth Street, the masterpiece hung in the library, on raised

paneling. Pressed between ornately carved wooden molding above and the fireplace mantel below, it had electric candelabras on either side. On either side of them, narrow Gothic windows let in a small amount of daylight; the setting was as anchored to history as the picture was modern.

If it seemed a misfit in that environment, its qualities still beckoned its owner. *Circus Sideshow* has in common with van Gogh's *Night Café* the ordinary scene of everyday life in which a harsh artificial illumination, as opposed to daylight, determines the look of everything. These are bold and beautiful paintings that reflect immense artistic confidence, even as they shed doubt on aspects of how people conduct their lives. Both the van Gogh and the Cézanne were also as inextricably connected to the Industrial Revolution as were Singer sewing machines. Sterling may have chosen to escape into the world of the rich and privileged with his van Dyck and Gainsborough portraits and work by artists such as Hyacinthe Rigaud; Stephen kept coming back to subject matter that had quotidian truth to it.

Circus Sideshow also embodies the true spirit of invention, of doing what no one had done in the same way before. Seurat had developed an unprecedented painting technique. The method, which would be called pointillism, depended on small dabs of paint in which hues carefully selected for their value and their light intensity are like the construction blocks of the whole. In this refined system, dabs of indigo blue give a particular glow even to the darker reaches of the picture.

Such carefully contrived results abut order and disorder. The tumultuous atmosphere of the circus is countered by the pictorial grid, which locks in the elements. The orderly frieze that Barr had identified is a foil to the sinister atmosphere of the event.

There is a weird cast of characters here. No one is particularly likable—from the self-important martinet in his tails to the jockey-like creature, practically a dwarf, calling out the events. The hooded trombone player in his tight pants and pink boots, and the musicians with their mask-like faces and boater hats, are like modernized versions of creatures from the art of Hieronymous Bosch. As for the crowd: the good bourgeoisie of Paris surveying the low life to get their kicks are like high society gazing into the boxing ring, spectators of the bizarre.

Seurat based this quintessential Parisian scene on the Cirque Corvi, a traveling circus that performed near the Place de la Nation. Whether or not Stephen took these facts into account, a decade after the artist captured that scene, when Stephen himself was five years old, his father

would be gallivanting around the same city begging George Grey Barnard to remain in the house he was offering him in Paris rather than marry and go back to America. When Stephen finally struck his bargain with Knoedler's, was he just buying a beautiful painting of striking visual quality, a splendid exemplar of logic and aesthetic judgment in perfect tandem, or was he on some level, perhaps totally unconsciously, entering the world in which his father had been swanning about while he and his brothers stayed in far more sheltered circumstances on the other side of the ocean?

Regardless, he possessed a gem. One understands why Alfred Barr considered this the finest painting owned by any trustee of his museum, even with all the great Cézannes and Picassos and Matisses included in the category. With its complex pattern of rigidly vertical and horizontal forms, its subtly rich palette of muted greens and dusty roses, and the meticulous deployment of the amorphous gaslights, the painting defined the word *modern.* It was of its time both in the slice of life it represented when Seurat painted it and in its artistry. With its breakup of forms into those delicate dabs of paint, and the bold geometrizing, Seurat had, as Barr would well have known, paved the way for the explorations of artists as diverse as Kandinsky, Mondrian, and Picasso. It had been the harbinger of one artistic movement after another; it was also, quite simply, a great painting to look at. Richly human, evocative of the pleasures of watching a spectacle, novelistic in the panoply of characters, alternately funny and discomfiting, inviting and at the same time withholding, *Circus Sideshow* is always aesthetically miraculous.

STEPHEN'S HAVING BOUGHT and lent *Circus Sideshow, The Card Players, The Night Café,* and his other major paintings to "Art in Our Time" had a major impact on a large public. The exhibition was a landmark event. The forces behind the Museum of Modern Art had done everything to assure its significance in an America that was emerging from the Depression and was not yet burdened with the specter of the world war that would soon engulf it.

This was one of those moments in history when civilization seemed to be reviving itself, and this inaugural show at the new Museum of Modern Art was an occasion of incredibly high energy and hope. On the evening of May 10, the trustees and members of the museum's various committees organized forty dinner parties to make sure that the rich and

fashionable would be on hand to walk through the entranceway of the new building. Those whose town houses were not big enough borrowed even larger ones from their friends. Mr. and Mrs. Robert Woods Bliss, for example, deciding their own place was too small, used Mr. and Ms. Samuel Little Barlow's house on Gramercy Park that evening so that they could accommodate Sir Kenneth and Lady Clark—he was the director of the National Gallery in London—as well as the Scandinavian ambassadors and their wives, Mrs. Vincent Astor, and the president of Princeton University and his wife. Conger Goodyear gave his dinner at a hotel within walking distance—the Hampshire House, on Central Park South—where the guests included Anne Morrow Lindbergh, at the height of her fame for her recently published book about flights where she had accompanied her husband, Charles; Salvador Dalí and his wife, Gala; the actress Lillian Gish; and *Vanity Fair* publisher Frank Crowninshield. When the new museum opened its doors later that evening, seven thousand people flocked in to look at the art. The men were in white tie and opera hats, the women in everything from Mrs. Cornelius Vanderbilt's rose lace dress and matching rose lamé hair band to Gala's burgundy dress with gold embroidery to Anne Morrow Lindbergh's "simple soft blue gown."

This was the process by which the scandalous pictures of a previous era became the most accepted art of the current one. The painting with which Vincent van Gogh had paid his modest rent, and that Stephen had bravely acquired, now became the sort of thing almost everyone, except for Sterling and a few other traditionalists, embraced. Even if no one could really see the art that night, everything on view acquired a new status.

The power structure, in which Stephen Carlton Clark played no small role, had pulled out all the stops. Not only did the seven thousand attendees of the opening see van Gogh and Seurat and Cézanne and others in a new context, but the broader American public, if they tuned in to their radios, had a taste of all of this as well. Nelson Rockefeller had, at his own expense, hired a press agent, Julian Street Jr., to become secretary of the museum. Street got CBS to do a radio program at 10:45 p.m. on the night of the opening, for which Lowell Thomas served as announcer. The speakers ranged from Edsel Ford, commenting on "the industrial aspects of modern art," to Walt Disney, broadcasting from Hollywood about the significance of films as an art form, to none other than President Franklin Delano Roosevelt.

Roosevelt probably had no knowledge that the Clark who was said to have tried to have an army run him out of Washington five years earlier was the brother of the Modern's new chairman. For fifteen minutes the president spoke about the wonderful achievement of this pioneering museum. He declared that "the standards of American taste will inevitably be raised by this bringing into far-flung communities results of the latest and finest achievements in all the arts."[52]

The president also announced, "We are dedicating this building to the cause of peace and to the pursuits of peace. The arts that ennoble and refine life flourish only in the atmosphere of peace. And in this hour of dedication we are glad again to bear witness before all the world to our faith in the sanctity of free institutions. For we know that only where men are free can the arts flourish and the civilization of national culture reach full flower.

"The arts cannot thrive except where men are free to be themselves and to be in charge of the discipline of their own energies and ardors. The conditions for democracy and for art are one and the same."[53]

IF ROBERT STERLING CLARK tuned his radio in to CBS that evening, his blood would have boiled at this homily by "Rosenfart." To have the president he thought was bringing down America support the institution of which the brother he loathed had just been put at the honorary helm was beyond his worse nightmare. But for the youngest of the four sons of Alfred and Elizabeth Clark—the quietest and most reserved of the lot, the one who in public kept to himself much as his father had—this pairing of art and personal liberty was the ideal that now more than ever would be his raison d'être.

More than one and a half million people went to see that exhibition, which included the work Stephen had collected with such independent taste, in the building he had helped fund. The press was by no means enthusiastic—modernism was not yet okay—and a lot of people balked at what they saw, but at least people took the new architecture and its contents seriously. And a prescient few gleaned the wonder of it all.

Then, a few days after the opening, every single staff member—all completely exhausted by the final preparations and the opening festivities—received a two-paragraph letter. Its message was concise: "An unbelievable job has been done, and the Museum has taken another important step forward. This has all been made possible by the work

which you and the other members of the staff have done. We hope that you will accept the enclosed token of our personal gratitude."[54]

The three people who signed it were Abby Rockefeller, her son Nelson, and Stephen Carlton Clark. It was out of their pockets that the enclosure of a month's salary came. He was his father's son.

FOLLOWING ART IN OUR TIME, the new museum continued at a strong clip. At the end of 1939, Barr staged an exhibition called "Picasso: Forty Years of His Art." Yet again, dynamic paintings and sculpture revealed fantastic aspects of the human imagination to a receptive public. Barr worked closely with Picasso. The combination of the intelligent art lover and a spectacularly original creative genius was felicitous. The audience in New York benefited from that collaboration in having the opportunity to see a range of work by the Spanish-born painter, from his early and highly emotional images of circus figures and society's downtrodden to his breakthrough into cubism to his robust classicism to his surreal images penetrating the darker aspects of his own soul. Stephen, who had already anonymously given the museum the important 1927 canvas *Seated Woman,* now had his interest piqued in the artist's later work.

Once America was at war, however, the running of the Museum of Modern Art was a different thing than it had been in peacetime. In the early forties, there was a new tension between a staff that was "intellectual and not socially knowing"—as the museum trustee Eliza Parkinson put it[55]—and the trustees. In particular, Stephen was having problems with Barr. As the originator and catalyst behind so many aspects of the museum, now Barr was struggling to maintain control of every aspect of a larger institution with more departments, more publications, and a larger plant to run. He was not always practical about issues like raising money or getting catalogues to press on time. To Stephen, who "was beginning to take his responsibilities seriously in the early '40s," Barr was "a hurdle and a hindrance, not an executive with whom he could possibly, much less happily, work. Relations between them declined rapidly and, it almost seemed, catastrophically."[56]

There were also problems revolving around John McAndrew, Director of the Department of Architecture and Design. In many ways, this department was one of most exciting and original parts of the Modern. It presented the latest work of pioneering geniuses like Le Corbusier, Frank

Lloyd Wright, and Alvar Aalto, and delved into the realm of household design with objects like Buckminster Fuller's compact one-piece bathroom made of sheet metal, intended for efficient mass production. But McAndrew had exceeded budget on his shows, and was "high-handed" with trustees, often responding to their inquiries by saying, "I'm too busy to tell you."[57] Nelson Rockefeller and Stephen were in agreement that he should get the ax; it was the first in a series of clashes between trustees and staff. Barr was deeply upset over McAndrew's departure, and although he had not defended him directly to the trustees, he was stewing after this person he considered "the most brilliant person on our staff, at once sensitive and energetic" had been forced out, and felt "profoundly angry . . . and alarmed"[58] about the way this would affect the morale of others who worked at the Modern.

Stephen, meanwhile, was doing more and more for the museum. In the spring of 1941, he gave, anonymously, nine important artworks. Barr wrote about the donation in the museum bulletin; while assiduously avoiding any suggestion of who the donor was and making clear only that the windfall was from a trustee who wished to remain unidentified, Barr said it was the greatest single boost to the museum collection since the bequest of Lizzie Bliss's collection seven years earlier. The donation included Rouault's powerful *Christ Mocked by Soldiers;* Matisse's 1917 *Coffee,* an exotic scene of two women; Bonnard's *Breakfast Room;* and Hopper's *New York Movie,* painted only two years earlier. Barr also let it be known that the same mysterious trustee had given Brancusi's 1928 *Bird in Space,* Picasso's 1927 *Seated Woman,* and works by, among others, André Derain and José Orozco.

The caliber of this work made the donation in aggregate an extraordinary gift to the American public. For what Henry Clay Frick was with the Old Masters, Stephen Carlton Clark was with the moderns: a collector who not merely had a lot of money and the wish to own quintessential works by great artists, but one who often managed to get the best of the best. Unlike Frick, however, Stephen did not depend on dealers or advisers to steer him; rather, he had a remarkable eye of his own.

This was particularly evident in Bonnard's *Breakfast Room* (color section 2, page 4). This miraculous evocation of the joys of everyday life was a contemporary painting when Stephen gave it to the museum; it had been painted only ten years earlier, and its artist was still working hard in France. The large canvas is a sumptuous feast of brushwork and color, with its blurred, deliberately indistinct forms conveying a feeling as

much of memory as of the present. Nothing is distinct; everything is an impression. Bonnard has represented the objects in a way that gives them an impact that belongs uniquely to the realm of art.

Yet there is complete plausibility. The brioche and teapot and cream pitcher sit on the striped tablecloth that covers the breakfast table in such a way that we are convinced of the proper weight of each object. Porcelain is clearly denser than bread, and liquids and fabrics seem to have just the right substance. For all this truthfulness, however, the result is an enchanting folly.

Similarly, the issues of perspective and scale have been addressed with such accuracy that one knows precisely how far away the tiny figures are beyond the garden gate, just as one knows the angle of the sunlight falling on the balustrade of the terrace. Yet this is all, brazenly, oil pigment applied to canvas, a painting as much about painting as about its subject.

The Breakfast Room is the real world, but it is the real world as filtered through the human mind. The transformations of optical and psychological experience all enter in. Bonnard has carefully considered retinal effects as well as the emotions that can be stimulated by color play and surface animation. Because of the way he has shown the female figure in his own brushy shorthand and blurred all the edges, and has put things in a beautiful mist rather than given us crisp edges, he emphasizes that we never perceive anything completely, that certainty is not within our grasp. This deliberate lack of precision and exactitude brings with it a stunning beauty and sensory reactions that are easier to pinpoint than is factual knowledge with its inevitable ambiguities.

The window in *The Breakfast Room* is a perfect device to capture a small segment of the vastness that lies outside. It both isolates what can be seen and suggests the infinity beyond it. The window frame clearly lops off our view of the balustrade; we know that it extends beyond our sight line, both to left and right, just as we know that there are more trees than we can see, as well as more leaves and branches on the visible ones, and another part to the figure who is cut off on the left. Thus we are reminded that, in all human experience, we grasp only a tiny fraction of what is before us, and the little that we do take in is limited, blurred, mysterious, and transient.

How sumptuous this fragmentary, fleeting vision is! Had Bonnard painted a highly structured canvas, with the woman at the center, with

nothing cut off at the edges, with an order and hierarchical structure, we would have felt faced with a totality; instead, we are left with a sense of the unknown, which, combined with the corner of beauty that is presented, is infinitely rich.

There is no moral point here, no story told, no heroic action, no recording of a historical event, no knowable characters. Rather, it could be a Monday or Tuesday equally; it could be one nice house or another. Even if we know the model was Bonnard's wife, she could be any number of people. What matters, rather, is visual pleasure, in the most general sense, and the ambient sense of plenitude.

People and objects merge in this environment. The woman appears so two-dimensional that she might be part of the wall, which has a color quite similar to her housedress. Everything is bathed in sunshine; flesh and wood have equal value in the way they respond to light; people and inanimate objects are all on a par. A human being—this limp, soft-shouldered, golden-haired woman—is different from a teapot only because of her shape, and that shape is a deliberately weak one, apparently crushed from all sides, as is clear in the way she meekly holds her arm in against her chest. A coffee cup and the woman do the same things—reflect light, occupy space, and assume their forms.

Just as Bonnard diminishes the importance of his human subjects, imbuing them with no psychological aspect, he treats himself as unimportant. He brings nothing of himself into the work; he does not interject his opinions or personality. Rather, he lets things happen to him, receives impressions, and renders them through his art. He structures the flood in which he is submerged and controls it exquisitely, but he does not take a point of view beyond one of heartfelt pleasure and celebration. Colors fade out rather than stop; there are no solid surfaces; there are no edges. There are simply endless variations, as if under a veil. The only reality is the frame.

To all of this, Stephen Carlton Clark was totally susceptible. Bonnard made art as ethereal as music, so central to Stephen's childhood. He gave materials and objects the splendor they had in the Clarks' various houses. The artist also evoked the immense pleasure of vision while making clear that all cannot be entirely grasped. By dint of how Stephen's parents lived and what they valued, they had prepared him totally to appreciate both beauty of this sort and the limitations inherent in seeing. The art Stephen chose mirrored his own life just as it enhanced it.

· · ·

IN 1942, Nelson Rockefeller was appointed by President Roosevelt to head the Office of Inter-American Affairs in Washington. This unpaid job, which focused its attention on fighting fascism in Latin America, forced him to resign the presidency of the Modern he had only recently begun. John Hay Whitney, another rich young man who had been a trustee almost since the museum began, was elected to replace him, but in May, Whitney was commissioned as a colonel in the air force. The trustees turned to the next logical candidate. There remained on the board one individual with the determination as well as the personal wealth to devote himself to the museum's survival at a time when the main issue on everyone's mind was the world war that had engulfed civilization. He was less affable and outgoing than either Rockefeller or Whitney, but he was also older, which meant he had done his military service in the previous world war. Stephen Carlton Clark immediately took on the presidency of the Museum of Modern Art in addition to remaining its chairman of the board.

Alfred Barr was not thrilled. He and Stephen had had their occasional differences since 1933, when Stephen had questioned the major fund-raising campaign being undertaken at Barr's behest to acquire the collection of museum founder Lizzie Bliss. In 1934, when Barr had hoped that Stephen would come up with half of the eight thousand dollars necessary to buy Picasso's 1921 *Three Musicians,* Abby Rockefeller having consented to pay the other four thousand dollars, Stephen had repeatedly declined despite Barr's "many blandishments."[59] Barr saw Stephen primarily as "the severe, humorless, black-clad heir to the Singer sewing machine and Clark thread fortunes"—that error about one of the sources of the family's wealth was often repeated—who was a leader of the segment of his Board dominated by "conservative, elderly trustees."[60] Barr was not the only person to view Stephen in that way, especially since Stephen had "resisted the museum's involvement with films, photography, and industrial design."[61]

Barr was also distressed that Stephen was a trustee of the Metropolitan Museum of Art. The two institutions were competitive with one another. People at the Modern felt that their counterparts at the Met viewed them with condescension, and Barr feared a divided loyalty on the part of his new president.

There was also the issue of red-checkered tablecloths and polka-dot

upholstery fabrics amidst which Stephen and Susan had hung their Matisses on Seventieth Street. Matisse was second only to Picasso in Alfred Barr's pantheon of great artists. When Stephen had "proudly displayed this room to the artist in 1930, Matisse had been appalled."[62]

At least this was the legend and how Barr described the events, although it is hard to imagine Stephen flaunting anything in the way suggested. Barr had a vision of Stephen as a bit too bourgeois, not part of the inner sanctum of modernism. The museum director had the utmost admiration for some of Stephen's possessions, but was skeptical of Stephen's general taste.

Their differences in aesthetic judgment became all the more apparent in the mid-1930s. This was when Barr had been forced off the building committee because of his insistence that a European architect, someone like Le Corbusier or Walter Gropius or Mies van der Rohe, should have the architectural commission that went instead to Edward Durrell Stone and Philip Lippincott Goodwin. It was Stephen who replaced him, shifting the balance within the committee in favor of the ultimate choices. Then, at the end of 1939, when Barr had become unhappy about all that the museum had begun to do in the realm of Latin American art, where he felt that the quality standards were not the same as those applied to other national schools, Stephen, recently appointed chairman, insisted that the acquisition and exhibition program continue as it had, since to diminish it would be an insult both to Lincoln Kirstein and Nelson Rockefeller, rich supporters of the museum with a particular interest in this area.

Matters became worse because, once Stephen assumed power as president, he became intensely dependent on a young man on the museum staff whom he regarded, it was "repeatedly said, 'as a sort of son.' "[63] This was John E. Abbott, whom everyone called "Dick." Abbott was the second husband of Iris Barry, who had been the museum's librarian since 1932.

Because Barry had such élan, her husband had, quickly, gone further within the museum than he otherwise would have. Barry had been introduced to Barr by the actor Charles Laughton and his wife, the actress Elsa Lanchester. Philip Johnson, the fledgling architect who was an early non-paid employee and financial supporter of a lot that the Modern did, had liked her so much when he met her that at first he paid her salary out of his own pocket. Johnson, by his own account, "also gave her money to buy a dress at Saks Fifth Avenue. . . . It was a terrible dress."[64] These

were the days when style counted greatly in the corridors of the museum; Barry was known for working with her hat on, in the manner of the editors of *Vogue* and *Harper's Bazaar*.

In 1935, Barry organized the Museum of Modern Art Film Library, a breakthrough idea, given that previously no one would have taken motion pictures seriously as an art form. That same year, having recently divorced her first husband, an English poet and critic named Alan Porter, she had married Dick Abbott, "a lean, blond, be-spectacled, smooth-talking Wall Street customer's man"[65] five years her junior. Abbott became director of the film library, which got going with a hundred-thousand-dollar grant from the Rockefeller Foundation, while she was its curator. John Hay Whitney, who had done extremely well with an investment in *Gone with the Wind,* also supported the project generally and then became president of the library, a separate corporation, while Abbott was vice president and Edward M. M. Warburg, another rich young man who was an unpaid museum employee, was treasurer. The film library was of no particular interest to Stephen, but Abbott was; his clean-cut Wall Street demeanor and efficiency at his work had immense appeal. The former businessman, who had had his office not far from the Singer Building, was the sort of person with whom Stephen Carlton Clark was comfortable. He thought this was just what the Modern needed.

In 1939, Abbott had helped put together a history of film that was a vital part of the great "Art in Our Time" show. More recently, as Barr's role had begun to wane in regard to the mechanics of running the museum, Abbott's had ascended. In the new building, the film library had become part of the parent institution—there was an auditorium with a projection room, as well as storage space and offices just for this department—so there were no longer any "physical complications in the way of Abbott's wearing two administrative hats at the same time." But what suited Stephen and some of the other trustees rankled the people who worked inside the museum all day long. "From the point of view of the staff, he wore neither of them gracefully. From the point of view of the trustees, he was, at least for a time, their man."[66]

Conger Goodyear had not liked Abbott either. But once Goodyear had given up his presidency, the coast was clear. "Because of his experience as a broker in Wall Street he was regarded as a 'money man' and a practical operator, and so he was named Executive Director, whose function was to keep the museum's daily operations running smoothly and its purse

plump."[67] Nelson Rockefeller had been the one to appoint Abbott, and Stephen was grateful. The former broker was just the sort of person he liked to have running things, whether it was Singer & Company or the family's real estate interests. If others deemed him a straight arrow, it was not a problem for Stephen. Here was his ideal "right-hand man,"[68] someone he "liked . . . and trusted."[69]

Stephen naturally gravitated to these people where you felt that you knew what was up, and who could run things in an organized way. In this same period, he commandeered a friend of his, Henry Allen Moe, who was director of the Guggenheim Foundation, to become a trustee of the Modern. Moe was of a similar bent. He characterized Abbott as "a most useful fellow. He was a good enough administrator, and he was so sensitive to the winds of change that he was a good listening device for all the board members."[70] However much Sterling might accuse Stephen of sheer avarice, it had long been the younger brother's habit to apply correct business procedures in order to achieve financial security, whether for his family or for a nonprofit institution under his aegis, and Abbott gave him confidence.

Stephen's choice of minister was a major problem for others. Abbott was "heartily disliked and distrusted" by many of the people who now had to answer to him. "He treated the staff terribly," according to Dorothy Miller, one of the legendary curators at the Modern. Elodie Courter, who ran the program of traveling exhibitions, said of Abbott, "I used to lie awake nights worrying about him. He was the menace of the Museum. Am I the only one who thought of him as a Hitler?" In his capacity as Stephen's aide-de-camp, with his boss now wearing the two mantles of president and chairman, Abbott was known to insist that all requests come in the form of written memoranda. In return, he would answer only by telephone; then, when quoted, he would deny what he said. Courter called him "slippery"; another employee said "slick, and . . . aggressive."[71]

Stephen had a very different bearing than the man he assigned to run roughshod over his terrified staff. But he was trying to commandeer a tight ship, and there was no question that Abbott reported back to him.

The Modern in this period was often criticized from the outside at the same time that it was coping with tensions within. At the start of 1940, it agreed to provide a venue to a traveling show of Italian masterpieces that included a Masaccio, a Giovanni Bellini, a Fra Angelico, a Titian, a Mantegna, and a Michelangelo, all on loan from major Italian museums.

The Modern was bitterly attacked for having agreed to a project that seemed counter to its purpose and would better have been hosted at the Metropolitan. It was up to Stephen to issue a public statement, which he did with his predictable businesslike clarity. "Our acceptance of this exhibition of Italian masterpieces does not indicate a change in the established policy of the Museum or any shifting of its emphasis on the contemporary arts. Great masterpieces are not, however, bound by any period, and the influence of the Italian renaissance and Baroque upon the modern artist is fundamental and continuous. The Museum will show simultaneously . . . an exhibition of work of some of the greatest modern artists of both the European and American schools."[72]

This was very much his usual style: to apply logic and intellect, albeit in a slightly pompous voice, with the hope of calming unsettled seas, and to offer a form of compromise solution. The technique proved more effective than with his brother Sterling. Although the Modern was periodically criticized by outsiders like the members of American Abstract Artists, an organization supporting nonobjective art, who accused it of not being sufficiently contemporary and issued a broadside against the institution's policies, Stephen had mostly put out the fire.

EVERY CONTROVERSY only added to the tension that was building between Stephen Carlton Clark and Alfred Hamilton Barr Jr. Stephen had his limits, and Barr overstepped them. The then unknown sculptor Louise Nevelson had introduced Barr to the work of the "primitive" artist Joe Milone, a Sicilian immigrant living in New York. Nevelson had seen Milone walking down the street carrying a brightly decorated shoe-shine box. She was so taken by it that she began asking the bootblack questions, and discovered that this was only part of a larger stand he had at home. At the end of 1942, Barr exhibited Milone's shoe-shine stand covered with its vibrant ornamentation; the museum director thought the sparkling piece especially fitting to present at Christmastime. Stephen concluded "that Barr had taken leave of his senses," and many of the other trustees shared his outrage.

Barr was ahead of his time with this groundbreaking embrace of what would be considered today "outsider art"—work by an unknown and untutored individual who, while innately talented, would not have considered himself "an artist." Barr defended his choice by telling a *New York Times* reporter that "Joe Milone's shoeshine furniture is as festive as

a Christmas tree, jubilant as a circus wagon. It is like a lavish wedding cake, a baroque shrine or a super-juke box. . . . Yet it is purer, more personal and simple hearted than any of these."[73] To Stephen, this was a "felonious assault on taste and on the dignity of the Museum." And it was further evidence that "Barr's taste [was] unaccountable, erratic, and, he was free to say in some instances, frivolous."[74]

Barr believed that Stephen had more true masterpieces that any other museum trustee, but he also "found Clark's taste in pictures limited and inelastic and stuck in a single generation."[75] Today a museum director and his chairman or president might not be expected to concur about the art they considered worth buying, especially because what one might want at home would not necessarily be what one would expect to hang on a museum's walls, but in the Modern's second decade these differences of conviction were like disputes between founders of a new religion.

The tensions came to a head when Barr put on an exhibition by Morris Hirshfield. Hirschfield had been a manufacturer of slippers and dresses who, at age sixty-seven, following his retirement from his job, had started to paint tigers and flowers and nude women, all of whom had two left feet because the salesmen's samples going back to the artist's days as a slipper manufacturer were only for left feet. The show was curated at Barr's request by Sidney Janis, a clothing manufacturer and collector who would soon become an art dealer. It outraged the critics and public. Not only did Stephen personally despise the childlike style of painting, but he had to deal with a hostile press almost unequaled in the history of an institution that, in spite of its youth, had already had a fair bit of controversy. "One of the most hated shows the Museum of Modern Art ever put on," the Hirshfield exhibition was attacked not only for its contents but also because Janis, clearly not a museum professional, had curated it. One esteemed art critic named the painter the Master of Two Left Feet; another said the show was "a frivolous and ill-considered gesture."[76] Janis had installed Hirshfield's work with wall text and photographs intended to explain the work, prompting the New York Times critic to say that it was "as if Hegel were pausing to demonstrate a lollipop."[77] This was more than the usual mockery.

In Stephen's eyes, the museum director was failing on every front. Barr was no longer completing his own writing; at the same time, he was obsessively editing other curators' essays. He had declined lecture invitations at important institutions outside New York where the attention to the Modern would have been a good thing. Barr was also losing his grip

on administrative details at his home base. Stephen "believed that Barr's only use to the Museum had come down to what he wrote, and that otherwise he was a burden to the institution."[78]

As usual, Stephen was acting according to the rules he had made for himself. He had an unwavering commitment to his own clearly defined ideas of right and wrong, and nothing would get him to shift course. Stephen had responded to all of the variables of his own life—his childhood with his father's escapades and then Alfred's death just when Stephen was the vulnerable age of fourteen, the controversies with Sterling, Rino's limitations and Ambrose's dissoluteness, the immense wealth and sense of responsibility that came with it—by attaching himself to a code of steadfastness and attempted orderliness, with an eye to steering everything toward a safe port. This is what he wanted to do with the Museum of Modern Art in its second act, after a strong opening, in a time when the country was at war.

Nelson Rockefeller and Jock Whitney were in Washington; Eddie Warburg and Lincoln Kirstein had enlisted in the army and were serving in Europe. A lot of the other principal players at the Modern were off with the military as well, and, as Franklin Roosevelt had pointed out, peace was a requisite for the pleasures of art. This was a rocky period, and

> May I say, in conclusion, how greatly we regret the necessity for taking this step. All of us are mindful of the great services you have rendered to the Museum and all of us have the friendliest and kindliest feelings toward you. When the first shock of this decision wears away you may, perhaps, realize that in taking this step we are acting in your own real interest. If you go on worrying over petty details of museum management and continue to spend most of your time editing and revising the work of other people you will soon lose the capacity to do any original work of your own. You have great talents and a great reputation in the world of art, but for several years past you have done little to justify that reputation. You will now have the opportunity and the incentive to devote your undivided attention to the kind of work that will be of real value to yourself and to the Museum. Our best wishes for your happiness and success will always be with you.
>
> Very sincerely yours,
>
> Mr. Alfred H. Barr, Jr.
> 49 East 96th Street
> New York 28, N. Y.

From Stephen's letter to Alfred Barr, October 15, 1943. When Stephen dismissed Barr as director of the Museum of Modern Art, he did so out of a heartfelt belief that he was helping the museum, but most of the staff would regard him as the devil.

what Stephen perceived as Alfred Barr's lack of professionalism only made it worse.

Stephen handed Barr his walking papers. For the second time in a decade, one of the sons of the heir to the Singer sewing machine fortune felt that he knew best and had taken it upon himself to oust a powerful leader. Stephen, however, went through the proper channels, and even while demoting the director told him he should remain at the museum with an office in the library so he could continue his scholarship and writing. For another, he may have been making a mistake, but it was the result of the most serious and conscientious intentions to save an institution for which he was responsible and that he felt was floundering. Not only were people laughing at the Modern as never before, but the institution to which Stephen had been giving fifty thousand dollars annually was now, for the second year in a row, running a deficit.

When Stephen Carlton Clark demanded Barr's resignation on October 15, 1943, he had the majority of the executive committee behind him. Abby Rockefeller, even if she did not have a title equal to her position, was still the guiding force of the institution, and she was at Stephen's side in his decision. From Stephen's perspective, he and she were two diligent people trying to navigate out of stormy waters. He would later tell Abby Aldrich Rockefeller's biographer, "In undertaking the management of the Museum during the war years, we were faced with an unusually difficult situation. Our chief concern was to try to keep the organization intact and to make the members of the staff work together in harmony."[79] For a man whose father had never worked a nine-to-five job, Stephen had, in keeping with the way he had tried to deal with his parents' estates over twenty years earlier, tried to adopt a completely businesslike approach. He treated his volunteer role in a nonprofit organization with the utmost seriousness, in a way that had nothing whatsoever to do with personal gain and everything to do with service in the truest sense. When, right or wrong, he made the decision to fire Barr— or, at the very least, consented to be the henchman—he had one essential motive, which was to help an institution in trouble. Soon however, he would be accused of having committed a heinous act for a variety of other reasons.

FOR ALL OF HIS DRY CORRECTNESS, Stephen was not the undertaker-like curmudgeon that the historians of this period have made

him out to be. Like his father before him, though rich, he was not a snob, and he considered most of the staff at the Modern "likable, extremely intelligent, and filled with a boundless enthusiasm for the Museum and all it stood for."[80] In demoting Barr—for, while dismissing him from the helm, he carefully crafted a different position that enabled the former director to remain at the museum—Stephen tried to do what he was unable to do with his brother Sterling to calm troubled seas. Aware of the "bickering, jealousy, and dissension" within the ranks of the Modern, he recognized the need for "someone . . . to quiet their emotions, soothe their wounded feelings, and disengage them from violent controversies."[81] He felt that Abby Rockefeller was without equal in that capacity; "Everybody liked and admired her, and so great was her tact and understanding that, even when she had a disagreeable duty to perform, she left no scars behind."[82]

Stephen was determined to back her up and help her fulfill her mission of keeping the museum on course, and when he fired Alfred Barr, he did so in order to achieve that objective. He acted, however, in a high-handed manner, and failed to communicate well with the museum's staff; if he had behaved less imperiously and shown more respect for the other startled employees, the sincerity of his intentions might have been recognized, and he might have caused less suffering among the people he terrorized.

By the time Stephen came to the conclusion that Barr needed to be ousted from the directorship, he had done his utmost to understand all that was going on at the Modern. Every morning he would rise early and walk downtown from Seventieth Street so that at 8:00 he would arrive at the offices of the Guggenheim Foundation at Fifth Avenue and Forty-fifth Street and have the chance to talk with his friend Henry Moe. Walking those twenty-five blocks down Madison or Fifth Avenue, hours before there was any risk of running into his brother Sterling out with Francine on their ritual shopping expeditions, the "tall and rangy" Stephen, "generally considered to be handsome,"[83] cut quite a figure in his dark suit. The walk gave him time to reflect, and the hour or so he spent with Moe provided the chance to discuss the museum with an objective and intelligent professional in the field of nonprofit management.

Then Stephen would head back up Fifth Avenue and into the museum offices on Fifty-third Street. Allen Porter, who had worked for the Buick Company before joining Julien Levy's art gallery, a showplace for surreal-

ism, and then becoming assistant secretary of the Modern, was one of the people with whom he most enjoyed chatting. Porter recalled, "He loved a piece of gossip. I was scared to death of him: he seemed so simple on the surface, and then he'd come out with something terrific. He also could be furious."[84] Not that Stephen's temper was in the same league as Sterling's, but when, for example, a new chair being considered for the offices became unbalanced so that Stephen fell on his face, he flew into a rage and demanded that it be removed immediately.

Stephen had a routine. Every Wednesday he would take Monroe Wheeler, the affable membership director, for lunch a block and a half away at the University Club. Then he would return to review in detail all of the museum's programs before meeting with Barr. This was when the problems became apparent. In the new museum headquarters, with all of its concomitant problems, Barr, now responsible for a far larger and more complex institution than the one he had launched only a dozen or so years earlier, was overwhelmed. The meetings with his chairman/president were not easy for him. Stephen asked tough questions, and his responses were hard to read.

In fact, Stephen was a mystery to most of the museum staff. Most "found him very laconic."[85] He spoke little, which terrified people; Andrew Carnduff Ritchie, who eventually would become director of the department of paintings, said, "You almost had to read what he was thinking." Jere Abbott, director of the film library, was intimidated by Stephen's "powerful silence" and the fear "that he was the one member of the board who could pounce."[86] Most of the staff considered him "greatly removed from them, a distant figure and a lonely man."[87] He had a manner that people found off-putting. He was, just as he had been with his own brother, conspicuously formal; when he was chairman of the board, he was "Mr. Clark," almost always, even if Rockefeller was called "Nelson" and Whitney "Jock." There were various theories about his personal reticence. "His shyness was considered a carefully cultivated pose by those who did not like him."[88] Others found his social withdrawal and icy silence virtually pathological, even if completely genuine. One staff member at the museum who dealt with Stephen extensively reflected, "I think he really was shy and it sometimes made him do irrational things. But wouldn't you be shy if all through Yale you'd been known as 'Bathroom' Clark?"[89]

On the other hand, Victor d'Amico, who was in charge of education at the museum, and who had to submit his program budget twice a year to

Stephen and Abby Rockefeller, while knowing that Stephen would scrutinize it closely and always ask if there was any way he was wasting money, appreciated Stephen's candor and insight. D'Amico quoted Stephen saying, "I just want to tell you something about wealthy people. Money is not just money; it's a symbol. You waste a penny or a thousand dollars and it's the same thing."[90]

In that wry humor and insight, Stephen sounded remarkably like his own father, and his motives were the same as Alfred Corning Clark's—to use his insider's position to help people who lacked such wealth.

People also liked Susan, who, according to Moe, was "one of the completest ladies I have ever known."[91] In her candid lack of interest in the collection, as in her general kindness and gracefulness in all of her encounters, she was considered the real thing. She was respected for her straightforwardness and lack of pretension. Susan was known for her perfect ladylike behavior and for her inevitable navy blue dresses, of simple cut with white collar and cuffs. If Sterling saw her as a harpy who kept her husband from doing what he wanted, everyone else felt that she willingly stayed in the background when it came to Stephen's artistic tastes, not joining him but, with the infrequent exception, rarely opposing him. Stephen always lent pictures in his name alone, and on the one occasion when that rule was excepted, at a charity benefit showing of the collection at Knoedler's, and she was asked if she didn't agree that an El Greco they had recently acquired was marvelous, Susan replied, "Oh, I don't know anything about the pictures. Stephen buys the pictures, I buy the wine and cigars."[92]

Stephen was recognized for having the power of his convictions as an art collector and about everything else. He didn't express himself with Sterling's bluster or cockiness, but he was every bit as confident in his judgments. Except for the 1913 trip to Europe with George Grey Barnard, he didn't take advice. After all, he had grown up in a home where art was truly respected, where it was the center of life, not an accoutrement of the rich. He told Henry Moe, "When I was a boy in my teens, I'd sell one and buy another when a picture hadn't lived up to my first expectations. It was all my own judgment, nobody else's."[93]

People also recognized that his involvement with the Modern, even as one of its more conservative trustees, was a daring act. Stephen's pictures were so shocking to his brother Sterling, for example, that Sterling often announced to people they both knew that, even if van Gogh was in the realm of acceptability, Stephen's other chosen artists were not worth

owning. And Sterling wasn't the only person from Stephen's same world to cast aspersions on his support of the brave origins of modernism.

At the Museum of Modern Art, Stephen had, at least, found the few other people of backgrounds similar to his own who also hazarded into the realms of revolutionary styles of art. Whitney, Rockefeller, Warburg, and Sam A. Lewisohn also came from rich families who were startled by their tastes, and if two of them were Jewish while the others fell into the category of American bluebloods, what mattered above all was their common support of the new vision.

But even if they had one another, these rich people who bought work by Picasso and other modern painters were, in the 1930s and '40s, if not outsiders, then to some extent rebels. Most of the people without their money or position who worked at the Modern respected them for that, however pronounced some of the personality differences.

WHY STEPHEN CARLTON CLARK FIRED Alfred Hamilton Barr Jr. is one of the important questions of twentieth-century American cultural history. Barr *was* the Museum of Modern Art; he had defined its programs and determined the artistic tastes it would promulgate. Picasso and Matisse and the Italian futurists and the surrealists and the dadaists and Klee and Mondrian would have been artistic geniuses with or without Barr, and would have been introduced to the American public, as they had been in Europe, no matter what. But Barr was the evangelist, and he guided the institution that legitimized and popularized what might otherwise have been relegated to the sanctum of an elite few. He also wrote so cogently and clearly about the art he defended that he made it accessible to a vast population that would otherwise have been in the dark. To take away his crown was a very significant act.

One of the main issues is the relationship of the voluntary support structure of a nonprofit organization and the people who are paid to run it. And then there is the balance of power between a board's executive committee and the rest of the board. To a highly upset museum staff, Stephen was regarded as the culprit; he still is. But Stephen's canning of Barr, if substantially his own decision, was certainly done in concord with Abby Aldrich Rockefeller and A. Conger Goodyear—who were, after all, the people who had gotten the museum going and had hired Barr to begin with.

One of the problems is that, at the time that Stephen notified Barr of

his need to relinquish the directorship, there was, to most observers, no certainty as to what precipitated what and who held the reins. Stephen did not sufficiently gauge the effect his actions would have on many other people at the museum; nor did he bother to explain to them what felt like their leader's beheading. When Barr was dismissed, "No one seemed to know what had happened; who, if anyone, was in charge; and, even worse, what would happen next."[94] But there was no doubt about the identity of the executioner, even if the museum staff and general public were unaware of Goodyear's and Abby Rockefeller's dissatisfaction with Barr because of his shortcomings as an administrator, brilliant though they deemed him as an intellect, or that Barr himself had nearly thrown in the towel five years before he was dismissed.

When the event occurred, everything was pinned on one man alone. "The myth begins with a dour and difficult villain clothed in funereal black, Stephen C. Clark, who senselessly and ruthlessly ambushes our frail and innocent hero, Alfred Barr, in the fullness of life. Clark hated Barr, it was said, because 'he was infernally jealous of Alfred's knowledge of modern art.' "[95]

If jealousy was, indeed, the main motive, then Robert Sterling Clark's take on his younger brother was completely justified. The lust for power and the need to be the one in charge would have been what drove Stephen exclusively. If so, he would have been compensating for the circumstances of his childhood that required his asserting himself now. But that interpretation of the events of 1943 is less plausible than the idea that Stephen, however awkwardly, was doing his best, selflessly rather than selfishly.

MOST PEOPLE WHO HAVE WRITTEN about the event have not only pinned the decision on Stephen but have portrayed him as having gone about Barr's firing cruelly. Russell Lynes, whose history of the Museum of Modern Art has become the bible on the institution's first three decades, said of the letter Stephen wrote Barr, "It scolded. It berated. It accused. It was gauche and harsh and carping."[96] The bullet was three single-spaced typewritten pages. Its complaint centered on Barr's failure to complete a long-overdue book on modern art that Stephen and Abby Rockefeller had told him to write. Barr was not doing what he needed to do, yet he was frittering away his time. Lynes's account, and subsequent texts for which Lynes provided the basis,

emphasize Barr's suffering, attributing it largely to the brutality with which Stephen chastised the director in this sharp missive.

The language that is repeatedly quoted from the fatal letter emphasizes Stephen's Sunday-school-teacher voice. It makes it seem that, when he was terminating a man's employment, he was especially harsh from his pulpit. "The amount of time you are able to devote to unimportant matters and to philosophical discussions in the course of a presumably busy day has been a constant source of wonderment to me. . . . In these difficult times the relatively unimportant work you are doing does not justify a salary of $12,000 a year."[97] Stephen went on to say that it would be "in the interest of the Museum" for Barr to begin working at half that annual salary in a position as advisory director, and concluded, "This letter has been written with the approval of a group of one or more active and influential Trustees, but without the knowledge of any member of the staff."[98]

Stephen copied the document to other key players at the museum. The list included Abby Rockefeller, Philip Goodwin, Conger Goodyear, and James Thrall Soby. The knife must have taken a further twist each time Barr imagined one or another of them reading it.

Stephen proffered a solution, but not one that was easy for Barr to swallow. This was that he should become advisory director, with a salary of six thousand dollars annually that might be supplemented with royalties from his long-overdue book. At least he could continue in this lame duck role.

SO IT HAS ALL BEEN TOLD again and again—and so Stephen Carlton Clark has come to be seen as a despot. But the letter itself has some very different elements that have until now never been part of the public record. What has been quoted to date leaves out any element of kindness. The letter was in fact more diplomatic and understanding than it has been represented as being.

Stephen did not pull his punches, but he opened by voicing the concern of a number of trustees that Barr was devoting too much time to administrative matters and too little to what he was most "particularly qualified to do."[99] The issue, unquestionably, was that Barr had not written his general history of modern art that had been under discussion for years. To both Abby Rockefeller, whose concurrence about all this Stephen mentioned from the start, and to Stephen, that book was part of

the educational mission of the museum. One of the Modern's main roles was to enlighten the public, an activity for which they considered Barr immensely qualified, and esteemed him greatly.

Stephen pointed out that the recent appointment of Monroe Wheeler as director of exhibitions had been intended to lighten Barr's load of administrative responsibilities so that he could pursue this goal. Yet Barr had made no progress on the book and had turned down important lecture invitations that, Stephen maintained, "would have redounded greatly to the credit both of yourself and of the Museum."

All of the accounts published to date make it sound as if Stephen's letter came out of the blue, but, as the letter itself points out, the previous December 15 he and Barr had had a long talk at the University Club. "At that time I told you frankly that unless you resumed your literary activities your usefulness to the Museum would be ended." Stephen had on that occasion proposed making James Thrall Soby assistant director—yet another step to relieve Barr of the administrative tasks that burdened him. Stephen now reminded Barr, "You were enthusiastic about this suggestion and declared that it would give you a new lease on life. Indeed, you said when I left you that you felt as if you were walking on air."

When one reads these words and sees the harsher ones in their context, Stephen Carlton Clark seems more humane and compassionate than the moody tyrant he has repeatedly and exponentially been made out to be.

On the other hand, Stephen did not mince words. While Soby had not come on board as quickly as Stephen had hoped, for a number of months now the assistant director was being paid seventy-five hundred dollars annually—significant in the overall budget of the Modern—and had worked hard to relieve Barr of all sorts of responsibilities. Stephen was candid about his dissatisfaction with Barr's response. "But, again, nothing constructive happened so far as you were concerned. Instead of devoting your energies to writing you spent a large part of your time checking and rechecking with meticulous care the work of other people or engaged in endless discussions of matters of minor importance. The amount of time you are able to devote to unimportant matters and to philosophical discussions in the course of a presumably busy day has been a constant source of wonderment to me." Stephen was haughty in his choice of words, but when the "wonderment" sentence—which, standing alone in Russell Lynes's book, has always indicated his arrogance—gets quoted in context, it makes clear Stephen's frustrations based on his belief in Barr's real abilities.

Stephen Carlton Clark had his grandfather's mettle. These men who functioned behind the scenes in the affairs of erratic creative geniuses— for Edward Clark, the brilliant wild card had been Isaac Singer—could, in their quiet ways, be mighty tough. When they had a goal, they would find the way to get there, and they were masters of logic and legalistic thinking as they pursued their quarry. Stephen now laid out the facts to Barr.

Barr had written little other than *What Is Modern Painting?*. "After several years of urging on the part of Mrs. Rockefeller and myself, it had been impossible to get you to realize where your usefulness to the Museum lies." This is when he let go with his zinger, the line that has been repeatedly quoted: "In these difficult times the relatively unimportant work you are doing does not justify a salary of $12,000 a year." Of course this was harsh, and not easy for Barr to read, but the surrounding comments make it different from a nasty and unjustified salvo.

Moreover, from then on, Stephen was conciliatory. He emphasized that he and the other trustees had determined Barr's new position and salary "regretfully." Barr was invited to remain a trustee; they would relish his knowledge and advice. Although the change would be effective in two weeks' time, Stephen said, "In order to give you time to readjust yourself to this new situation, we shall be glad to continue your present salary until May 1, 1944"—more than six months away. Above all, they hoped Barr would now publish and lecture more, and would supplement his salary with earnings from both. Stephen said, "We would be glad to let you have any profits derived from the sale of the History of Modern Art, or of any other of your works that may appear as Museum publications." This was an important precedent in the field of museum administration—the idea that a salaried employee could supplement his income from work done on the job and for books financed by the institution.

Also, as consolation to Barr, Stephen assured him they would not appoint another director of the museum; rather, there would now be a director of painting and sculpture, and others to take over administrative work.

It is Stephen's last paragraph—which, like all of these efforts to smooth Barr's transition, has never been quoted previously—that is the most telling of all. It sheds light both on the nature of Stephen Carlton Clark and on the way that biased pundits can misrepresent someone. It begins, "May I say, in conclusion, how greatly we regret the necessity for taking this step. All of us are mindful of the great services you have ren-

dered to the Museum and all of us have the friendliest and kindliest feel-
ings toward you. When the first shock of this decision wears away you
may, perhaps, realize that in taking this step we are acting in your own
real interest. If you go on worrying over petty details of museum man-
agement and continue to spend most of your time editing and revising
the work of other people you will soon lose the capacity to do any origi-
nal work of your own. You have great talents and a great reputation in
the world of art. . . . You will now have the opportunity and the incen-
tive to devote your undivided attention to the kind of work that will be
of real value to yourself and the Museum. Our best wishes for your hap-
piness and success will always be with you."

Stephen wasn't easy, but he was never false. He was following the tra-
dition of his family in trying to support real contributions to society; he
had a notion of how Alfred Barr could make one. He could be coolly arro-
gant, but he was not that way out of malice. He needed the museum to
function properly, and he wanted to see a brilliant man realize his poten-
tial rather than fritter away his energies to everyone's detriment.

Alfred H. Barr Jr., Philip Johnson, and Margaret Scolari Barr in Cortona, Italy,
in 1932. Margaret was adamant that her husband rule the Modern unimpeded.

. . .

IN THE FILES OF MARGARET SCOLARI BARR, Alfred's wife, there are pages of notes of the answers she wanted her husband to give Stephen. Marga, as everyone called her, was enraged. Naturally, she was miserable at the prospect of her husband's salary cut. Beyond that, she could not bear to see him dethroned. A spouse's fury is no easy thing, and here it played a significant role—both as to how Barr actually responded, and how all of this has passed into history, given that for the next thirty years Marga would fulminate against Stephen Carlton Clark.

According to Marga, after Stephen's letter arrived on October 16, a gray Saturday, she suggested that she and Alfred go to an afternoon movie. She knew nothing about the letter, and Alfred had not said a word about what had come in the mail that morning. Only on the way home from the cinema did he tell her about his having been fired.

Marga's diary entry for that day reports, "The effect on A. is one of nausea and contempt for the obtuseness of Clark, who obviously has no understanding of the scope or purpose of the museum."[100]

Then Barr fell into complete depression. While his wife was "torn between shock and outrage at the heartless dismissal" and was busily trying to figure out how to economize—a friend suggested that for starters she begin taking the bus on Madison Avenue, where the fare was five cents, rather than on Fifth, where it was ten—by her account Alfred was in far worse shape. "In the house there is a sense of nightmare. A. won't go out. He won't dress. He won't eat. He sits at his desk formulating answers to Stephen Clark."[101] She maintained that for thirty days, he would not leave his bedroom; practically emaciated to begin with, he hardly touched the food his wife brought him.

Three decades later, Marga recalled that "for months, Barr languished in pajamas and robe on the living room couch" and would not even touch his favorite cocktail when she offered it. In these versions of history, which have become part of the mythology surrounding Stephen, Stephen was more than a henchman; he was the devil itself.

It wasn't quite that bad. On October 27, 1943, only eleven days after he had received Stephen's letter, Barr met with a coordinating committee back at the Modern. He explained that "his work in recent years had been hampered by 'heavy pressure in an atmosphere of emergency.' "[102] He was trying to do more than any one person could accomplish, and so he

had decided to take the position of advisory director. He was down but not out. Barr sounded happy to be relieved of his administrative possibilities and to have more time to write and extol the wonders of modernism.

Then Barr suffered a worse blow. It was no longer possible to blame Stephen Carlton Clark alone as the source of his woes. As Marga's journals report, on November 3, Abby Rockefeller wrote "to assure A. that his demotion is for his own good. He is more hurt by this than he was by Clark's letter."[103] Barr had always considered Mrs. Rockefeller his closest ally as well as a personal friend, his soul mate in their mutual ambitions for the museum.

Yet Marga did not let up about Stephen. She reported that in November he ruled out the idea of Barr's having an office anywhere in the museum. Then he decided that Barr might become curator of museum collections—for which a separate building could be built after the war. Then that idea was scrapped as well, and by spring of 1944 a plan was made whereby Barr would spend his time writing and doing nothing else. Stephen made it clear that if anyone dissented he would not only resign from the board but would "take his fifty thousand a year with him."[104]

Barr did, indeed, remain on the premises, albeit in horribly reduced circumstances. As Philip Johnson recalled in a memorial tribute to Barr in 1981, "We underestimated our bulldog. It never crossed his mind, against the advice of many of his friends, to desert the museum."[105] Barr "refused to leave the building" even if it meant working "in a tiny cubbyhole,"[106] which he did when a table in the library was sawed in two to create a desk small enough to fit into the cubicle that was erected in a corner of the library so that Barr, living with Stephen's title for him of "Advisory Director," had a place where he could sit with his books and continue his research. The monarch had been deposed, but not exiled.

Stephen's actions had not been as rash as they seemed, even if his delivery had been blunt. As he reminded Barr in his letter, ten months earlier the director had met with the trustees when the possibility was raised of his relinquishing the directorship in order to have more time for research and writing. Even Marga Barr admitted that that lunch meeting between Stephen and Alfred at the University Club had occurred on December 15, 1942, when the museum president and chairman had laid his cards on the table. Marga wrote at the time, "Stephen Clark informs A. that unless he resumes his literary activities his usefulness to the museum will end."[107] This was when he proposed appointing James

Thrall Soby, a wealthy, young, and affable art collector and scholar, as "assistant director."

Soby had come on board in April 1943, with Stephen explaining to Barr that this was "so that you would have plenty of time to devote to your literary labors."[108]

One of the problems, however, was that Barr agonized over those labors. He could not decide how he wanted to write his history of modernism. Yet he longed to write this book that Stephen wanted, which would be a general guide for the average citizen; good enough to be respected by scholars but succinct enough to appeal to everyman.

Barr had written to Stephen and Abby Rockefeller that he was planning a "*visual* demonstration, a revelation of modern life . . . the life of the mind and the heart—of poetry, wit, science and religion, the passion for change or for stability, for freedom or perfection."[109] They had responded enthusiastically. Stephen especially was keen about educating the general population on the thrilling strides that had been taken in the development of a new art. In the months preceding the events of that October, he had done his utmost to guide Barr toward decisions about his method. The man whose family had sold sewing machines to the masses and who believed in public service had plenty of ideas for the one who came from the world of academics and artists and museum people.

Barr, however, consistently failed to get his hands around the project. Additionally, he was floundering as an administrator in just the sort of way that drove Stephen over the edge of despair. At the Museum of Modern Art, as in all of his dealings, Stephen prized clarity and directness. One had to announce a precise plan and carry it out. He hated unnecessary layers and complications. Barr prevaricated in just the way that was Stephen's nemesis. The museum director had a way of appearing to agree with a proposal being presented to him; then, just as others felt the proposal had been approved, "Barr would inexplicably dig in exactly where he had been before, unconvinced, unyielding, inscrutable. After such a session, taciturn Stephen Carlton Clark would rush fuming out of Barr's office and down the corridor, screaming, 'What does he want? What does he want?' "[110]

Stephen could look at the psychological darkness of *The Night Café* day in and day out, but he could not stand irrational behavior. Things had to be brought to logical conclusions. When people like his brother Sterling or Alfred Barr made unnecessary complications, he despaired.

There was also the thorny issue of artistic judgment. Stephen wanted

to arbitrate taste. He was like Sterling in his idea that his notion of what was good or bad in art was the correct and only way. Henry Moe recalled of Stephen, "If there was an exhibition going up and there was a picture on the wall that he didn't approve of for that particular exhibition, he'd walk up and take it off the wall."[111]

Barr would have had every reason to find this intolerable. It was one thing that Stephen didn't like the Milone and Hirshfield shows—especially if his reason for disapproving of the second one stemmed from its having been mounted by someone with a conflict of interest. But for the museum president to be so high-handed as to censor artworks and interfere with Barr's selection in that way was more than any professional could have been expected to bear. Stephen has been falsely maligned in some of the ways the events of 1943 have been represented; that he was quietly arrogant, however, is beyond a shadow of doubt.

What remains hard to sort out is what Alfred Hamilton Barr Jr. thought of the eye of Stephen Carlton Clark. Monroe Wheeler, who believed that Stephen's collection was totally marvelous, advised that Stephen should be courted to give it in its entirety, but it has been said that Barr, much as he admired the Seurat and van Gogh and what he considered the other gems, turned up his nose at the Matisses and a lot of the lesser work. Russell Lynes has written that when Stephen tried to give Matisse's 1919 *White Plumes* to the museum, "Alfred said it was cheesecake and didn't want it in the collection."[112]

This seems, in fact, another instance of a falsification in order to explain the rift between Stephen and Alfred. To get to the truth of why a rich art patron working in a voluntary capacity at a public institution fired the man who had laid the groundwork for that institution and established most of its policies, it is essential, in this issue of artistic taste, as in the aspects already discussed, to look beyond these comments that have become part of legend and determine what the facts really were. If, as has been printed and reprinted, Alfred Barr called such a magnificent painting "cheesecake"—an evaluation that casts aspersions not only on Stephen Carlton Clark but on one of the greatest painters of the twentieth century—the opinion, coming from as astute an observer as Barr, would have enormous weight and influence on how a less cocksure public regards Matisse. If he belittled the work, why would Barr, in the great Matisse book he wrote in 1951, have singled out *The White Plumes* as having been such an important component of the January 1927

exhibition organized by Matisse's son Pierre and held at the Valentine Dudensing Gallery?

In the same text, Barr also opined, of this painting and a couple of companion pieces, "The plumed hat series expresses a range of mood and characterization quite extraordinary for Matisse."[113] He goes so far as to name *The White Plumes* as an example of the particular "intensity, boldness, scale and sheer pictorial excitement which inform [Matisse's] pictures of 1919."[114] Even if these opinions were a reversal, a man as serious about his views as Alfred Barr would not, less than a decade earlier, have denigrated such a work as "cheesecake"—which, when used as a pejorative, makes it sounds sickly sweet and cloyingly rich, as well as emotionally sloppy. To say that Barr did as much is a dangerous distortion, for not only does it cast the difficulties between Stephen and Barr in a false light, but it inevitably makes people begin to question the quality of the Matisse.

One thing is clear: the rift between Barr and Stephen had a big audience, and there were almost as many points of view as to who was right and who wrong, and what had precipitated the demotion, as there were staff and trustees at the Museum of Modern Art. One of Barr's most devoted champions believed that "it was Alfred's directness and honesty and passionate, passionate feeling about things that put Stephen Clark off and made him feel that he couldn't work with this man. Without knowing it, Alfred made Stephen Clark feel like a fool because Alfred was always right."[115] Because Russell Lynes quoted that remark, it has become part of the accepted truth. How wrong it is! This claim that Barr succeeded in diminishing Stephen's sense of his own intelligence is without basis. Barr respected Stephen, and Stephen must have known as much; to say that the museum director was so unkind as to make a serious art collector question his own judgment, and that, because the museum president felt second-rate, he acted out of spite, is to malign both of them without basis.

The evidence that Barr actually thought highly of Stephen is in what Barr wrote in his book on Matisse. The full title of the book is *Matisse: His Art and His Public*. A big part of Barr's subject is the audience response to the art. In an account of the reception given Matisse's work in America, Barr wrote, "Stephen C. Clark by 1930 had assembled the finest collection in the world of Matisse's paintings done during the previous dozen years."[116] Later in his text he turned the praise up a notch by saying, in a comparison to better-known Matisse collectors, that in the

1930s "many Matisses were added to New York collections but Stephen Clark's group of canvases of the first decade of Nice remained the finest in the world, though not so numerous as Barnes' or Etta Cone's."[117] All of this was written eight years after Stephen had sent him the dreadful letter. Barr was not the sort of person to do lip service to someone in power; rather, he was the rare human being who put issues of art and taste above pride and ego. He made these statements in print because he believed them, and had always done so, and because he had a deep respect for Stephen.

Over sixty years have passed since Stephen fired the man who defined the Museum of Modern Art, and even at the time it would have been hard to be objective, but there is a lot of evidence that Stephen's real issue was that he didn't think the museum could survive with a leader who was in ways inefficient, brilliant as he was, and who didn't meet his own targets. This isn't to say that there wouldn't have been other solutions or better ways of handling things.

THE STAFF AT THE MUSEUM was shocked when Barr told them about his change of plans. Most people considered Dick Abbott a turncoat; they were sure he had regularly gone running to Stephen with complaints about Barr. Soby endeared himself by being the one member of the establishment who stood by Barr; he threatened to resign when Barr was deposed. No one was quite sure which side Monroe Wheeler stood on. But as one person who knew most of the cast of characters has said, "Whatever the truth may have been . . . it was Clark who made the decision,"[118] and for that reason almost everyone who worked at the museum, with a couple of exceptions like Abbott, instinctively felt threatened by him.

Barr himself was ultimately philosophical about Stephen's reasons. He wrote to Paul Sachs, the Harvard professor who kept a watchful eye on the Modern and who, as both heir to a banking fortune and a professional art historian might grasp the difference of personality types, that "Clark was at heart a collector who distrusted the intellectual and educational approach to gathering a museum collection, and he thought that Barr's only use to the museum was as a scholar and writer."[119] Barr himself believed there might be some truth in that idea.

What most people did not know was that, even if he came from the world of money and industry, Stephen Carlton Clark had been brought

up by a man who had more in common with Alfred Barr than they could have imagined. Alfred Corning Clark had also been first and foremost a man who loved art and scholarship, who was happier in a sculptor's studio than in a boardroom, and for whom books were sacrosanct. Stephen had a keen sense of how sad it was when someone was living a life that did not really suit him.

The person most determinedly against Stephen, and eager to perpetuate the image of him as the devil, remained Margaret Barr. Beyond all that she wrote in those diaries at the time, in 1974, she gave a long oral history for the Archives of American Art, part of the Smithsonian Institution, in which she laced into Stephen venomously. Marga's views have had their effect. The transcript of that interview has entered into the canon of information about the history of the Museum of Modern Art, and her opinions have colored the views of many other people.

Marga maintained that Stephen told her husband "he really was no good," that he was being fired immediately, "that the only thing he was good at was writing," and that his salary, which she erroneously said was then nine thousand dollars (it was twelve thousand) was being cut in half. There are, of course, elements of truth to this, regardless of the mistake about the salary, but her statement that "I do not dramatize but you have no conception of what this did because it was completely unexpected"[120] does not hold up—largely in light of the information in Marga's own diaries reporting these conversations Stephen and her husband had had ten months before that fateful October day. Margaret Barr also described conversations between her husband and Abby Rockefeller in which "they found themselves wondering whether Stephen Clark was really as stupid as they thought him to be." This seems unlikely, given that Abby and Stephen often spent long evenings discussing the Modern and that, although Stephen was fiscally conservative, known for his opposition to big fund-raising campaigns, he played a particularly useful role because of his double trusteeship, which enabled him to negotiate between the Met and the Modern.

Marga attributed Alfred's dismissal entirely to the Hirshfield exhibition. She also said that Stephen had prevented Alfred, in the spring of 1943, from joining other art experts, among them Lincoln Kirstein, who were being sent to Europe by the OSS to work for the preservation of artistic monuments. Stephen maintained that Barr was too valuable to the museum to take a leave of absence. Of course, this would have been horrible if it were true, since he then demoted Barr.

In that same interview she again insists that "Alfred stayed in the house without getting dressed for at least a whole month"[121] after receiving Stephen's letter. Given that there is no question that he was at a meeting at the museum eleven days later and subsequently made a public statement to his staff, this is patently false. But it has helped feed the myth not just that Alfred Hamilton Barr Jr. was a martyr, but that Stephen Carlton Clark was a despot and an oppressor of the worst sort.

Following the director's demotion, Stephen and Barr managed to get along. By February of 1944, there was a marked improvement in relations. Stephen wrote Barr, "Personally I am always in favor of having you write as often as possible as you write very well and I am sure that your vocation lies in that direction. You certainly did an excellent job in *What is Modern Painting.*"[122]

When Barr asked Stephen for some leniency on his salary cut, however, Stephen was merciless. For Barr, the reduction was crushing. In 1939, the year the museum moved and his salary had been raised to twelve thousand dollars annually, he and Marga had taken a new apartment on East Ninety-sixth Street, between Madison and Park. Because of increased expenses for their young daughter, Marga had started teaching art history at Spence, a girls' private school; having taught at Vassar, she felt that this was a comedown but one she had to accept. Barr implored Stephen not only to keep him at his old salary but to increase it to fifteen thousand dollars. He pointed out as a reason the greatly increased value of the work he had bought for the museum collection. Stephen simply replied that he was "astonished"[123] and would not consider it.

Gradually, Stephen let Barr regain some of his old standing, just not his former income. Shortly after turning him down so abruptly on the question of pay, he sent Barr one of his particularly formal letters asking the former director to become a member of the committee for museum collections. Barr accepted.

The issue of what should or should not go into the Modern's collection was a point of rapport between the two men whom others regarded as such foes. Contrary to what Russell Lynes would suggest, the respect went both ways. It was not so long after Stephen had handed Barr his walking papers that Barr wrote Stephen, "Your interest in the collection is greater than that of any trustee. . . . I value your judgment in painting more than anyone else on the board."[124] It was an extraordinary compliment, given the collectors—Sam Lewisohn, Eddie Warburg, Jock Whitney, and Nelson Rockefeller—who were on that board, and considering

the reasons for which Barr might have been less generous with praise. And it spoke to two issues: Stephen's seriousness about the institution and his eye.

What Barr recognized, and what distinguished Stephen from the other trustees, is what we may now think of as the Clark family trait. There was a linking thread between Stephen, Sterling, and their father. As different as the one who bought Cézanne was from the one who acquired Renoirs by the yard but loathed Cézanne, and as they both were from their father, with his preference for being in the company of sculptors, painters, and musicians in Paris rather than in the New York money world, they had in common their consuming engagement with artworks. Alfred, Sterling, and Stephen all respected the creative act as a high point of human existence. And they scrutinized the results with utmost care.

As Barr gradually began to reassume some of his former power at the Modern, he would on occasion consult Stephen by requesting a second opinion on a work he was considering for the collection. When he was trying to make a decision about a Vuillard, he asked the museum president to come by and give his take on it. For all their differences about people like Milone and Hirshfield, particularly in the field of late-nineteenth- and early-twentieth-century art, there was no one else as able to provide an objective and solidly based judgment.

From his point of view, Stephen relented about Barr. There was no getting around his importance to the museum; Barr's eye and guidance were indispensable. Having put the former director back on the committee responsible for acquisitions, he now got him involved again with exhibitions. Stephen also continued to encourage Barr with his writing and speechmaking.

Awkward in manner, steely in his silences, Stephen was determined to do the right thing. In 1945, he wrote Barr, "I want to tell you how greatly I appreciate the splendid work you are doing at the present time and hope you realize how much more important and effective you are in your present position than you were as director of the museum, much of whose time was taken up with a lot of trivialities."[125] It was vintage Stephen. These were the sort of sentences he carefully constructed while assiduously avoiding speaking. And this was his commitment to fairness.

Stephen well knew what the trivialities were. At home he would sit in his high-backed chair at the dining room table, its red velvet framing his head, while, at the other end, his wife sweetly babbled away; he took in the world, and observed and reflected, while the others went about their

silliness. Like the man he had fired, he was an outsider. He too wanted to get to the core of things. He sought lasting values. He lived in a family where emotion often got the better of people—Sterling mouthing off and going on wild tangents, Ambrose drinking himself silly. Even if the territory he chose was so different from that of his father, he followed Alfred Corning Clark in opting for silence and thoughtfulness, and the wisdom of what he read, to lead him to a higher plane; even more so, he emulated his mother in his self-control and in his deliberate balance of restraint with imperiousness.

Stephen went on to tell Barr, "You will leave behind you a reputation as the foremost art critic of our time. That amounts to a great deal more than anything you could do in your capacity as director."[126] This was not just an effort to rationalize his own high-handedness less than two years earlier. It was a conscious effort to engineer what would be best for civilization as a whole, which, in Stephen Carlton Clark's eyes, was to steer the brilliant Alfred Barr to write in a way that could inform the masses about van Gogh, Matisse, Picasso, and the other artistic daredevils whose achievement, without cogent explication, would be lost on less knowing viewers who might otherwise profit from it.

Stephen, meanwhile, remained tight with the one staff member at the Modern whom most everyone else detested and who was viewed as Barr's nemesis, Dick Abbott. It was a relationship that people talked about. "Abbott and Clark worked more and more closely, and they were so much together and seemingly so close that in the gossip mill that was the Museum there were raised eyebrows."[127]

The director of the Art Institute of Chicago, Daniel Cotton Rich, was heard to ask the director of the Whitney Museum, Juliana Force, "What is this between Clark and Abbott?" Force's reply was simple but ambiguous. "Innocence,"[128] she said. More than anything, Stephen was probably looking for a sort of surrogate son. His own sons were not cut of the same material as he was; none of the three showed a great work ethic. The man his daughter, Elizabeth, had married, Henry Labouisse, was in many ways more his cup of tea—a hardworking diplomat, living in Washington and then in France, making his mark on the world. Dick Abbott lacked the qualities of Stephen's son-in-law, but both helped, in different ways, fill a void.

Dick Abbott and Iris Barry were divorced in the early 1940s. Stephen was his witness at the wedding when Abbott remarried. The marriage was short-lived; everyone knew that one of the problems was Abbott's

drinking. It became clear that he would not be able to keep his job, but this time Stephen made it his responsibility to find a solution before wielding the ax. He got Abbott a job as a restaurant manager, and only then had him informed he needed to leave the Modern. Abbott was allowed to remain on the museum's board for several more years, but he could not keep the restaurant position for long, either. Alcoholism took its toll; Abbott died tragically at home when "he fell and killed himself."[129]

Tough, acerbic, an emperor who ruled through silence, Stephen Carlton Clark achieved remarkable success in his wartime tenure at the Museum of Modern Art. In the course of it, the number of museum members doubled. The war in Europe meant that people were traveling less and needed their entertainment closer to the home front, and the new building was itself an attraction. By the time Nelson Rockefeller and John Hay Whitney were back in their civilian clothes in 1946, and Rockefeller could again take up the presidency with Whitney as chairman, half a million people were walking through the Modern's doors annually.

Under the new regime, there were endless negotiations about the role of Alfred Barr, who now threatened to leave the museum and go to the Fogg at Harvard instead. The person who ended up going to bat to keep the former director on the scene was Stephen, still on the executive committee. By 1947, Barr was back in the old office he had had as director. He had a different title, and his authority was not what it had been in the museum's first decade, but he was again in a leading role.

THERE WAS NO PAINTER MORE IMPORTANT to Alfred Barr than Pablo Picasso. He often visited the artist in France; he included the work in exhibitions frequently, and wrote eloquently about it. He also did his utmost to secure key examples from the many phases of Picasso's oeuvre for the Modern. Barr bought or had his trustees buy so many of the artist's masterpieces that, even compared to Paris, where Picasso worked for most of his life, or Spain, where he was born, New York still has the greatest trove of all.

Stephen understood and supported Barr's enthusiasm for the cubist master. His own fondness for Picasso, and the bold originality of the work he bought by the Spaniard, are part of what made the youngest Clark brother unusual. No one else in his family would have considered buying paintings of such raw and brazen force, constructed with a picto-

rial language that was completely avant-garde. Even today, when we look at any of the ten important Picasso oils that Stephen owned at one point or another, it is astonishing to think that this collector of such conservative demeanor, with his stiff banker ways, put these works on the paneled walls of his ornate, traditional house on Seventieth Street. That choice reveals a courage, a receptiveness to artistic risk-taking, that were exceptional.

Picasso's work may also have been something of a pawn in the rivalry that continued between Stephen Carlton Clark and Alfred Hamilton Barr Jr., regardless of the rapprochement. When Stephen bought one of his two most important Picassos, *First Steps,* he was not the only one who had his eye on it (color section 2, page 5). Years after the fact, Samuel Kootz, the important New York art dealer who sold Stephen this remarkable painting, one of the artist's most beloved, recounted the events surrounding its purchase.

The canvas, which was painted in May 1943, when Picasso was holding out in occupied Paris in his studio on the rue des Grands-Augustins, shows a toddler awkwardly attempting to walk while being supported by his mother. Constructed with bold simplicity in Picasso's unique pictorial language, it uses deliberate distortions to great effect. The highly charged image of this exquisite moment in a child's and parent's life is profoundly touching. Charming and humorous, at the same time it is tender and profound. Picasso considered it one of his best works, for which reason he had sent it to the Salon d'Automne in 1944.

Barr borrowed it from the artist for "Picasso: Fifty Years of His Art," a spectacular exhibition he put on at the Modern two years later, as he began to take the reins again. In the catalogue of that show, Barr used language as robust and direct and eloquent as Picasso's artistry. "In this large canvas the child is well over life size so that his raised foot, his face puckered with effort, and the over-arching figure of the mother take on something of the monumental character as well as the intensity of a Romanesque mural. The human and formal relationship between the two heads is remarkable. . . . In design and feeling this is one of Picasso's most notable recent paintings."[130]

The following year, Barr went to Kootz with a photograph of *First Steps* and asked the dealer, who worked with Picasso all the time and was his main American representative, if he would buy it for the Modern. Kootz agreed to go to Paris for just that purpose if the museum would pay for his trip and give him a ten percent commission on top of the cost

of the painting. Barr proposed this to the board of trustees, but they said they would need to see the actual artwork first.

"Later that same afternoon Mr. Clark came in to see me and asked if I would offer him the same terms as I offered the museum," Kootz recalled. The dealer had no qualms. "I agreed to do so and immediately left to visit Picasso and purchase the picture for Mr. Clark." Stephen had agreed that, if Kootz succeeded, it could be in Kootz's next show of Picasso's work, as long as no one was told who owned it.[131]

The deal went exactly as planned. When Kootz included *First Steps* as an anonymous loan in an exhibition shortly after Stephen had acquired it, he was bombarded with questions from Barr and a number of the other trustees. It was inevitable that they should wonder how the seminal painting had made its way into private hands. Naturally they were annoyed that Kootz would not answer, but Stephen had insisted on this.

The library at 46 East Seventieth Street, Christmastime, c. 1960. The ornate paneling and dark interior made an unusual setting for Seurat's Circus Sideshow, *a masterpiece of modernism.*

Now that the trustees could see the actual painting and realized how great it was, they were upset that they had missed out on it.

For Stephen to have bought *First Steps* was as brave on the one hand as it was sly on the other. Its scale and boldness and raw energy made it daringly modern in the truest sense. To have come from his world and picked it made him out of the ordinary. Everything is deliberately heavy, the opposite of the prettiness and gracefulness that was expected of someone born into nineteenth-century New York elegance. It is a painting that makes one wake up and come to; it is both deeply humane and truly disconcerting. Whether Stephen bought it mainly out of passion or out of a wish to trump both Alfred Barr and the institution he served, or for both reasons, remains, however, a question.

The following year, Stephen made two more Picasso purchases that were even bolder, each from a different period of Picasso's life. One was the 1921 *Dog and Cock* (color section 2, page 5). The highly charged large vertical canvas is hard to understand in its entirety—a lot of the details are elusive and have multiple readings—but what is clear in the flurry of action is that a large black dog is lunging, with his purple tongue hanging out of his mouth, at a red rooster. It's all a visual cacophony; there's violence in the air. The sharp rhythms and the jarring colors have the same savage feeling as the subject matter.

In Stephen Carlton Clark's world, most of the people who had paintings or prints of dogs were likely to have nice English sporting scenes with sleek hunting animals in them. The subject matter belonged to a well-ordered, upper-class way of life, which the style was meant to suit. The colors would match the chintz of the Chippendale sofas. Stephen's acquisition of this painting so startling in its imagery, color, and cascading forms showed that even if he spoke rarely and wrote in the most controlled style, he had another, less visible, side.

Picasso's 1937 *Vase of Flowers and Pitcher,* another of Stephen's 1948 purchases from Galérie Paul Rosenberg in Paris—who had acquired it directly from Picasso—was, though smaller and less complex than these other two paintings, no less daring. The same sort of electric sulfurous yellow of the fixtures in van Gogh's *Night Café* outlines the simple earthenware pitcher. The flowers are painted in bold, primitive strokes, their colors iridescent. If it belongs to the French still life tradition in subject matter, *Flowers and Pitcher* also, significantly, was from the period when Picasso was painting *Guernica,* and even this simple domestic theme has a high emotional pitch. There was something in the owner of this canvas

and *The Night Café* and *Circus Sideshow* that was drawn to intense, powerful colors and uncompromised emotions.

In 1954, Stephen gave the *Still Life* to the art gallery at his alma mater, Yale University. In 1958, he gave Yale the other two works. By then, he had sold all the other seven important Picassos he had bought over the years except for the two he had given to the Museum of Modern Art in 1937.

People are still trying to understand why Stephen Clark, for all of his engagement with the Museum of Modern Art, and the connection of that institution with Picasso, had, by the time he had given the Picassos to Yale, stopped making gifts to the Modern, and in his will left the museum not so much as a single drawing. It was at the end of 1953 that Barr wrote William Burden, then the museum president, his confidential letter ranking Stephen's paintings. The document also went to Jock Whitney and Jim Soby. Clearly the intention was for them all to gather their forces to persuade Stephen that the Modern was the place where this work should end up. Everyone knew that the artwork would go to the public and not to Stephen's children; the only question was *which* institution.

Beyond the encomiums quoted at the beginning of this book about Seurat's *Circus Sideshow*—"the most important single picture in the collection of any of our Trustees"[132] and the creation of a special class 1+ for that work—in class 1, Barr put Cézanne's *Card Players* and van Gogh's *Night Café.* Two other Cézannes, the *Still Life* and *Mme Cézanne in the Conservatory,* made class 2. Class 3 included Picasso's *First Steps* and *Dog and Cock,* three Renoirs, and other works. The list of what Barr coveted went on to include a lot of other works, although he deliberately left out the Americans like Eakins, Homer, and Hopper. The first two are understandable—they really did not fit into the Museum of Modern Art's focus—but the exclusion of Hopper is surprising, because by then Stephen had acquired a number of that artist's pivotal paintings, and it was with his Hopper donation twenty-three years earlier that the Modern had started its permanent collection.

When the museum celebrated its twenty-fifth birthday in 1954—at another celebration with a speech from a U.S. President (Eisenhower), followed by one by UN Secretary General Dag Hammarskjold—René d'Harnoncourt, the current director, publicly called Stephen "wise and sensitive."[133] Paul Sachs praised Stephen to the audience as the person who "more than any other single trustee, gave his time and thought to

keeping this Museum going during the war years when the younger men were away."[134] Surely, Stephen should have felt so much a part of the institution that gave him these kudos that he would have wanted it to enjoy his legacy.

One can understand why Stephen might not have considered the Modern the right place for his work by Corot or Eakins or even Winslow Homer. But he must have recognized that the Cézannes, Seurat, van Gogh, and Picassos would have become among its most prized possessions and taken the museum he had helped nurture since its infancy into another realm. There were smaller Seurats in the collection already, but nothing that was remotely the equal of *Circus Sideshow* in its complexity or in its obvious connections to so many developments of modernism that followed it and on which Seurat had had such an impact. There were other van Goghs as well, but none quite as powerful as *The Night Café.*

Stephen would never declare his motives for assigning these works in his will to other institutions. There was no reason he would have; he was someone who never said more than was necessary. It was a Clark family trait to make up one's own mind and to stick to a decision. He was not one to waver. He was, even less, the sort of person who bowed to pressure, and the more he was courted to donate work, the more he may have bristled.

There was also, still, the issue of taste. In 1951, Stephen had argued vehemently with the collections committee when the Museum of Modern Art was considering acquiring Giacometti's *The Chariot.* According to Philip Johnson, Stephen was so furious that he said if they accepted the work he would take his paintings and leave. It seems odd that Giacometti's elongated figure, so powerful and noble, would have brought such rage to the man who collected Picasso, Bonnard, and Brancusi, for even if those artists belonged to the previous generation, they shared with Giacometti a drive for truthfulness and a willingness to go to the limits of the imagination. Nonetheless, Giacometti and a lot else that Barr was championing in the fifties—including the American abstract expressionists like Jackson Pollock—were completely foreign to Stephen's sensibility.

But the general view is that his differences with the Modern were not, finally, over artistic judgment. Stephen continued to lend works there and serve as a trustee even after his purported threats following the Giacometti acquisition. And the institution to which he finally gave the

Picassos and the van Gogh—the Yale University Art Gallery—also had a Giacometti, one that many viewers would have found even more challenging than *The Chariot,* given that it was a rough plaster of a virtually skeletal figure pressed by an abstract plane, a work that tears at the soul and is as far from being pretty or pictorial as one could imagine.

Besides, in 1958, Stephen's loyalty to the institution he had backed and for which he had once worked as if it were his full-time job was still palpable. On April 15, the Museum of Modern Art had a devastating fire. At the time, there was a major Seurat show taking place.

The fire began in the middle of the day. When Allen Porter, acting secretary of the museum, tried to return from lunch at a nearby Italian restaurant, the street was blocked and smoke was billowing. But standing there in front was Stephen, arguing with a policeman who was denying him entry. He insisted that he be allowed in immediately to rescue the paintings on view. In vain, Stephen was imploring the cop to understand that there were irreplaceable artistic masterpieces in the burning building, and that someone who knew what was what needed to identify them and help get them out before they were gone forever from the face of the earth.

Stephen was not used to being turned down when he wanted his way. But the policeman would not budge.

It took Nelson Rockefeller, who saw fire trucks on Fifth Avenue and ran to the scene, to come to the rescue. Fortunately for everyone, the police recognized the Standard Oil heir even if the Singer sewing machine heir was unknown to them. Nelson quickly told the cops who Stephen, as well as Allen Porter, was, and gave them the task of identifying others on the museum staff as they returned from lunch, so that they would be permitted in. Then Nelson threw on a rubber coat, boots, and a fireman's helmet and rushed in. At precisely that moment, the real firemen were about to break through a false wall with their axes.

Nelson Rockefeller managed to prevent them from swinging. He knew that Seurat's *La Grand Jatte* was on the other side. By getting the firefighters to change their plan and enter the exhibition space without destroying the wall, he saved that masterpiece just in time. None of the Seurats was damaged except for having the residue of a film of smoke on them; *Circus Sideshow* escaped unscathed.

But an electrician was killed that day, and the damage to the building was extensive. Stephen's wanting to enter it as the flames leapt showed

just how much the seventy-six-year-old man cared about the preservation of great art for humanity.

THE BREAKING POINT between Stephen and the Modern occurred only in the following year. Although there would have been no reason to predict it, this was shortly before Stephen's death, so there would never be a chance for reconciliation if one might have been achieved.

In 1959, an incident took place that would have bothered him enough to change his will if, in fact, he had designated anything for the Modern previously. That year, there was a major fund-raising campaign with a goal of raising twenty-five million dollars for the museum's thirtieth anniversary. A trustee involved with the drive informed Stephen, "We've put you down for a million dollars."[135] If there was one thing Stephen could not stand, it was being treated presumptuously, and having someone else try to make his decisions for him.

"This was not the kind of arrogant bite that he would tolerate, nor the kind of pressure that it would ever have occurred to him to put on someone else. This was not within his definition of how a gentleman behaved to another gentleman."[136] Stephen acted according to a code. That code, which he applied to himself as to others, was precise about how one solicited contributions from other rich people. The rules had been violated, and the Museum of Modern Art suffered the consequences.

In all likelihood, the person who had peremptorily put Stephen down for a million dollars and made the tactical error of telling Stephen he assumed the donation was a given was David Rockefeller. David Rockefeller, true to his family legacy, was a major figure in the anniversary fund drive. Stephen had had great respect for David's mother, Abby, going back to the founding of the museum, but the positive feelings did not extend to the next generation. In March 1959, Stephen's Yale classmate and old friend James Fosburgh wrote Alfred Barr that Stephen "was irritated when David Rockefeller tried to approach him about the fund drive, is rather generally anti-R (like Goodyear)."[137]

One of Stephen's friends from Cooperstown had a different take on Stephen's problems with the Modern, attributing the difficulty to Stephen's disdain for some of the more flamboyant staff members like Philip Johnson. The friend explained to Russell Lynes, "All those homosexuals bothered him, and he really didn't like the pictures."[138] Presumably, the friend in the community where the Clarks had for a century

been the ruling family had no idea why the notion of homosexual men was so loaded to a son of Alfred Corning Clark.

OF ALL OF THE CLARK BROTHERS, Stephen was the only one who led a way of life that resembled any sort of norm for most people, with a semblance of a day job and life at home with children.

Rino, while beloved in Cooperstown, had been seriously hampered by his disabilities and lived pretty much as a recluse. Sterling had an office on Wall Street, but he didn't go there regularly. He devoted himself to the breeding and racing of horses and to the acquisition, and then the disposition, of his art as if they were jobs, but he lived basically as a rich man who could indulge his whims. His main companion was his wife; while pretty and always agreeable in public, she was on other occasions so withdrawn and uninterested in things that he felt entirely alone, consoling himself with his vintage Burgundies and his lovely Renoirs. Brose was the most frivolous of all of them, the furthest from their God-fearing mother and complicated father. He was probably the one who had the most fun, with his balls for the Prince of Wales and his splendid houses and sporting art and horses and endless bottles of Champagne, all savored with a fun-loving wife. Their greatest woe in life, beyond their handicapped daughter, was the use of macadam for paving roads.

Stephen, on the other hand, had a routine that was much more like that of many denizens of New York's Upper East Side. He walked to an office where he spent long days—for many years at the Singer Building, and for a few at the Museum of Modern Art. His wife seemed the perfect lady, bringing up their four children to fit into the upper-class world into which they had been born. Their houses in the city and country were luxurious to a fault.

But beyond the guise of propriety and the incredible material well-being, it was not an enviable existence. One of Stephen and Susan's five children, Peter, had died in infancy. Their oldest surviving child, Elizabeth Scriven Clark, named for Stephen's patient and noble mother, was her father's favorite, but she died at age thirty-five, in 1945, just as Stephen was in the throes of his work at the Modern.

Elizabeth had grown up wanting to break free of the confines of the Gothic mansion on Seventieth Street and the way of life that went with it, and had happily married a diplomat, Henry Labouisse, and moved to

Washington. But then illness overcame her when their only child, a daughter named Anne, was only six years old. The illness had come quickly, and everyone had been loath to acknowledge its severity. Labouisse, who had moved to a new position in Paris where his wife and daughter were to join him, had no idea of the urgency of the situation, and when he found out, travel was so slow in wartime that he did not make it back before she died.

Susan and Stephen's second child, Stephen C. Clark Jr., had by then married Jane Forbes Wilbur, and Jane and Susan in tandem acted according to the rule book for the six-year-old whose mother had died. The aunt and grandmother did their best, but for several weeks following Elizabeth's death, neither they nor Labouisse let the child, who was staying with family friends, know what had happened. Facing hard facts was not the family forte.

Jane and Susan did, however, find the perfect nanny for the motherless child. Frieda Shipley became the ideal surrogate parent. Anne was brought up mostly in Paris. Her father, whose being a Democrat would surely have confirmed Uncle Sterling's worst suspicions about anything or anyone connected to his brother Stephen, remarried, to Eva Curie, daughter of the famous scientists. Then Anne was sent back to America to boarding school at Miss Porter's in Farmington, Connecticut, and from there she went to Smith College, where she studied art history.

Anne would periodically visit her grandparents in the house where her mother had grown up. Her descriptions of life on Seventieth Street are vivid. Sometimes her uncles were present. If so, the difference between the generations was impressive: a hardworking, taciturn father and socially correct but playful mother had brought up three young men who ranged from cynical to good-natured but had none of their father's intention to make a major mark on civilization.

The youngest, Robert Vanderpoel Clark, Bobby—a playboy with none of the family's work ethic but with a lot of charm—was his father's favorite son. It was when Bobby died in 1952 at age thirty-four that Stephen wrote Sterling his touching letter in the slight rapprochement brought about by that sad event that prompted Sterling to break the ice and initiate communication. It had been the eldest son, Stephen Jr., who had been given the task of trying to buy Sterling's property in Cooperstown when Sterling declared his intention of giving it away, but other than that the father delegated few tasks to his namesake. According to Stephen Jr.'s daughter Jane, the son never once went into his father's

office, or trained for any of the family roles, either in business or philan-
thropy. Family was left to Susan, and while Stephen Jr. took up his
uncle's pleasures of racehorses and fox hunting, he never worked at a reg-
ular job. The eldest son was notably cynical, born to privilege and furious
at anyone he thought might take his entitlement away from him.
Although he ultimately became the executor of his father's estate, he was
not prepared for the responsibility, and he was in no way his father's
match.

Neither was Alfred Corning Clark II, Stephen and Susan's middle son.
At the Museum of Modern Art, Alfred was known only for reproaching
his father's friend James Fosburgh because the Modern did not have—at
least at that time—anything by Andrew Wyeth.

But Alfred II has achieved immortality for a very unusual reason. Mar-
ried and divorced six times, he was so much the essence of a rich young
man, and had such charm, that his decadent, Fitzgeraldian style of life,
and relatively early death, inspired a magnificent short poem by Robert
Lowell.

Lowell, who used to play chess with Alfred at boarding school, was
fascinated by his rich young friend from New York. The poem is an
amazing testament to an amiable wastrel, ostensibly a failure, very differ-
ent from the generations of Clarks that had preceded him and from the
grandfather for whom he had been named, but also someone of indu-
bitable allure:

> *You read the* New York Times
> *Every day at recess,*
> *But in its dry*
> *Obituary, a list*
> *Of your wives, nothing is news,*
> *Except the ninety-five*
> *Thousand dollar engagement ring*
> *You gave the sixth.*
> *Poor rich boy,*
> *You were unreasonably adult*
> *At taking your time,*
> *And died at forty-five.*
> *Poor Al Clark,*
> *Behind your enlarged,*
> *Hardly recognizable photograph,*

I feel the pain.
You were alive. You are dead.
You wore boy-ties and dark
Blue coats, and sucked
Wintergreen or cinnamon lifesavers
To sweeten your breath.
There must be something—
Some one to praise
Your triumphant diffidence,
Your refusal of exertion,
The intelligence
That pulsed in the sensitive,
Pale concavities of your forehead.
You never worked,
And were third in the form.
I owe you something—
I was befogged,
And you were too bored,
Quick and cool to laugh.
You are dear to me, Alfred, our reluctant souls united
In our unconventional
Illegal games of chess
On the St. Mark's quadrangle.
You usually won—
Motionless
As a lizard in the sun.[139]

What a portrait of the brilliance and sadness of the Clarks! Alfred II was, like the children of Franklin and Eleanor Roosevelt or Winston Churchill or so many other heroic figures of the twentieth century, in many ways the opposite of his parents, but he still had traits that linked him to the rest of the family, for all the differences among them. With that reference to the expensive ring, Lowell had homed in on the attempt at pleasure through material objects, the longing to wrestle well-being from what one could buy and own, that was central to the Clarks' existence. The poet also was perceptive enough to recognize the kindness and sensitivity that, for all their diffidence and haughtiness, marked the Clarks. Lowell knew firsthand what it was to come from a powerful family, and to plummet into the darkness intermittent with life's joys. Intu-

itively, he grasped his friend's charmed and charming, yet lonely and tragic, journey.

Could Lowell have been aware that Al's father had at home, in with his van Gogh and Seurat and Cézannes, the best drawing of William Butler Yeats ever made? Stephen had many works by John Singer Sargent, but perhaps none were as powerful as the bold pencil sketch that perfectly captures the Irish poet's fierce intensity as well as his handsomeness. Sargent's quick lines manage to evoke the sharpness of the mind of the person he was portraying, which is why this work has been reproduced on the cover of more than one work devoted to Yeats. Wouldn't Robert Lowell have been intrigued that this was part of his bored friend's privileged childhood? And stunned to read the moving texts and know about the other life of the man for whom Al had been named?

ANNE LABOUISSE WAS, from the time she was a teenager, fascinated by her intelligent and thoughtful grandfather. Today she leads a life far from the world in which her mother grew up, but with philanthropy and art still at the core. Founder of the Family Center in Somerville, Massachusetts, she is also a gifted and successful painter, mainly of landscapes of the ponds and marshes on Cape Cod, and an engaged mother of four children, two from each of her marriages. She has clear recollections of Stephen that center on him at family meals. Because of where Susan and Stephen had situated the dining room table, there wasn't a single artwork immediately visible, although Seurat's *Circus Sideshow* was in the sight line. What came into sharpest focus was Stephen himself.

By the time Anne was in high school and college, Stephen was in his seventies. As described by his granddaughter, he looked remarkably like one of the Eakins portraits he owned. On a high-backed chair covered in deep red velvet, he was mostly slumped down, often deep in thought. What Sterling called a "floating chin" Anne thought of as being like a double chin, although Stephen was never fat. This was the hallmark feature of his stern face; his chin was almost bulbous, with a dimple in it. Stephen Carlton Clark did not talk a lot, but, at the other end of the table, Susan, ever amiable, would be chattering away. To her observant and independent granddaughter, she was the perfect exemplar of her type: "social and sociable, regal, with her high cheekbones and clean jaw." Inevitably, she had come in from a day devoted either to shopping or her charitable concerns. The Norwegian chauffeur named Breeve

would have taken Susan around in their large Buick, which was rarely needed for Stephen, who generally walked everywhere. Whether the reason for having Norwegian staff had anything to do with Skougaard is unknown, because no one of Anne's generation had any inkling of the tenor who had been their great-grandfather's companion.

Susan had a lot of friends, most of whom had less money than she did. She would take them shopping and treat them to things, so that they ended up looking like carbon copies of her, also in blue dresses, blue shoes with buckles, and blue pocketbooks. Besides all the blue, Susan herself was sometimes wrapped in fox pelts. As a small child, Anne had been fascinated with the fox's head that opened and shut so that it could seem to swallow the tail and complete the enclosure.

As "Grandmother was chirping away, Grandfather was always thinking about something. He was quite spaced out and in his own world, puffing his cigar and blowing smoke circles. He was in a dream world. I had the feeling that he was thinking negative thoughts; he was disappointed by his sons, and just seemed to be observing everything around him."[140]

Stephen clearly depended on other young men to assume roles that his own wastrel sons, who were often in trouble in the classic ways of their era, did not. Just as he delegated responsibilities to Dick Abbott at the Modern, he put his son-in-law, Henry Labouisse, Anne's father, on several boards. He accorded a similar respect to his beloved Elizabeth's sole child. While Stephen "didn't talk much," he advised Anne about his philosophy of how to be effective in giving money away. "My grandfather did speak with me about philanthropy. He said one must look at the budget of the organization. And that you should give ten per cent of the budget if you could. You don't want to be too powerful—which would happen if you gave more—but you want to make a difference."

When Anne was at Smith College studying art history, she decided to write a term paper about a Rembrandt her grandfather owned, the 1661 *St. James the Greater* (color section 2, page 6). This extraordinary painting, with its rich impasto, its atmosphere that seems somewhere between the earth and the cosmos, and the spiritual aura of its subject, fascinated her, and she went to New York to study it. The painting, which Stephen had only recently acquired, in 1952, hung quite high in the library on Seventieth Street. For two days, Anne sat perched on a heavy table beneath it so that she could observe it more closely and write. Stephen periodically glanced her way as he walked up or down the stairs, but said nothing.

*Stephen and Susan in front of portraits by Frans Hals at a show of their collection at the
Yale University Art Gallery in 1956. These works would be part of Stephen's bequest
there five years later, along with masterpieces by van Gogh, Eakins, Hopper, and
Picasso that gave the museum at his alma mater a new importance.*

Following her graduation from Smith, Anne married and moved to
New York, where she and her husband, a doctor who was a resident at
New York Hospital, lived in a tenement-like apartment way east in the
seventies, near York Avenue. She was impressed that her grandfather vis-
ited. The apartment was a walk-up, less fashionable than any place he
would have been likely to see except possibly for some of the housing his
mother had helped fund for the very poor at the end of the previous cen-
tury. Clearly he was in alien territory, but he was, as he always was to his
granddaughter, gentlemanly and gracious—and nearly silent.

Then, shortly after Anne turned twenty-one in 1960, Stephen Carlton
Clark died. Having said nothing whatsoever to her about it, he had left
her the Rembrandt.

HIS FAMILY KNEW HIM to be quiet, reserved, and devoted to phi-
lanthropy. He did not present himself as an art collector; he never
boasted about the collection or featured the idea that he owned this or

that. The pictures were simply *his* thing, like a hobby. His value system was clear: he believed in work and service, and was not the sort of person who thought he was entitled to feel pride because of what he was fortunate enough to own.

To the family members who spent a lot of time in Cooperstown, it was there that they saw Stephen's commitment most clearly. Both Stephen and Susan took delight in providing the town with public facilities. Another granddaughter, Stephen Jr.'s daughter Jane Forbes Clark—who, both globally and in village life in Cooperstown carries on the family legacy with impressive professionalism as well as understatement— recalls that Stephen "saw himself as part of a team" in his determination to give the residents of the farming community a better way of life. People "worked with him, not for him," as far as he was concerned. "He could connect with a farmer as readily as with the cultural elite of New York."[141]

Stephen nurtured the people he thought could serve the community best. He worked closely with the head of the historical society, and, above all, he devoted his energy to the Mary Imogene Bassett Hospital, which Rino had started many years earlier. When Stephen decided that Dr. James Bordley, a surgeon based at Johns Hopkins, was the perfect man to run Bassett as its chief doctor, and Bordley declined the offer, Stephen hopped into his car and drove down to Baltimore himself— this time without Breeve at the wheel—to persuade his candidate. The gesture worked; Bordley came; Bassett became a first-rate medical center.

Beautiful Susan with her translucent skin organized band concerts for the village residents, and used her greenhouses at Fernleigh to grow the poinsettias she sent to the five local churches every Christmas and the lilies for Easter, as well as the carnations she wore unfailingly each day, in a color that matched her outfit. She also organized baskets of flowers to be hung along Main Street, and devoted herself to continuing-care facilities for the elderly. But, unlike her husband, Susan let her sense of mischief show. When she gave a Robin Hood party in the late 1940s, she had each invitation wrapped around its own arrow and shot into the house of everyone she was asking. If the hole was too big, she sent around a member of her household staff to repair it.

The antics didn't stop there. A couple of years later, she and Stephen gave a party in a quarry. This time each invitation was wrapped around a rock. The Clarks' butler went from house to house of those invited and

heaved the rock, which generally broke a window. The cost of replacement windowpanes was of no note; Susan simply had new ones installed after the invitations had been delivered. Stephen, whom no one knew for humor or anything resembling a light touch, "loved her and loved everything she did";[142] the pinstripe conservative who owned *The Night Café* and those bold Picassos clearly had his other side.

IN 1959, John Richardson, an English art critic and friend of Picasso's, arrived in New York to work at Christie's. Soon after starting his new American life, he was taken to the Clarks' house, and, as one who knew the best private collections in the world, was struck by the extraordinary quality of this one. But he noted that Stephen seemed almost disconnected from the artwork, as if it belonged to a different world. "There were modern paintings, but these were not modern people."[143] For

The fifth floor at 46 East Seventieth Street at the time of Stephen's death. First the children's playroom, then the Matisse gallery, the top of the house eventually became a gallery for many of Stephen's masterpieces.

Richardson, the only hint of a sense of fun in the house was because of the Peter Arnos on the stairs—these left a memory as big as that of the masterpieces.

Stephen was reserved, Susan charming. Stephen was completely "comme il faut"—dignified and correct—the opposite of the other renowned collector Richardson met in his new American life, Sterling's friend Chester Dale, at whose house Richardson had been shocked to see the collector feeding caviar sandwiches to his dogs.

When I told Richardson, who does not mask his homosexuality, about Alfred Corning Clark's other life, he remarked simply that Alfred's youngest son "was somewhat censorious of other people—and of nonstandard behavior. One felt that."

ON SEPTEMBER 17, 1960, Stephen Carlton Clark died in New York. He was buried in Cooperstown in the family cemetery plot, alongside Rino and their parents and his son Bobby. Death had not joined him with his brother Sterling, whose ashes had, three years earlier and nine months following Sterling's death, been placed in a repository at the Sterling and Francine Clark Art Institute.

TWO YEARS after Stephen's death, a novel said to be a roman à clef about the Clarks appeared. It was called *The Sex Cure*. A bookseller near Cooperstown said that "the Clarks are all over the book" and that Stephen's descendants had, over the years, bought up every copy. The only copy available anywhere, a paperback published for fifty cents, cost me more than a hundred dollars.

The book may be more of a problem for people connected with Bassett Hospital than for relatives of Stephen Carlton Clark. Anne Peretz knew nothing about it until I told her. The main character is a doctor at what is clearly a fictional version of Bassett Hospital. The paperback cover—which shows the handsome cad molesting a half-naked woman of the perfect blond debutante type of the era—lets us know that "suave, young Dr. Justin Riley who's ready to take sex wherever he can find it . . . had a favorite prescription. . . . 'If you'll just open the front of your dress,' Dr. Riley said coolly. Socialite Misty Powers smiled and began to take things off, everything. Her husband was away and it seemed a good time for one of Dr. Riley's 'special treatments.' "[144]

But clearly the setting of the excruciatingly badly written novel is Cooperstown, the hospital the one that the Clarks had financed, and one of the central characters a feeble attempt to portray a combination of Ambrose and Stephen Clark, complete with a pseudonym that is a variation of their names. "The township covered a series of rolling hills. Whenever you topped a ridge, a whole new view crashed into your line of vision. Ridgefield Corners was bordered by the humpbacked shadow of the Adirondacks. Stretching toward the shadow as far as the eye could reach were the houses, farmlands, stud farms and dairy farms that belonged to old Cyrus Stevens. Ridgefield Corners was Cy's town and he ruled it with a tyrant's hand. Stevens also owned the hospital, and would have it within his power after tonight, to see Justin Riley driven out of the medical profession."[145]

Cyrus Stevens is more Stephen in his power at the hospital, but more Brose in his deliberate old-fashionedness and racehorses. "Too bad, Justin thought remotely, that Cyrus Stevens could not spare a few million from his prize cattle and race horses to modernize his hospital. Maybe Cy had no desire to modernize the hospital, or the town. The town was his, a small almost eighteenth-century world divorced from the larger world without."[146]

Two thirds of the way through this trashy book, there is a typographical error. *Cyrus* Stevens is in his grand house surrounded by three hundred acres of farmland—this could be either Ambrose and Florence's, or Stephen and Susan's estate, but no one else's—while drinking a bourbon and looking through a telescope at Marge Miles, a sexy woman who lives at a neighboring farm and is walking around naked. Shortly thereafter, the old man's nurse checks his pulse and scolds him because it is so high. " 'The doctors at that hospital,' *Clark* Stevens had informed her, 'are all a bunch of horses' asses. When I want a doctor, I'll get my doctor from New York. I just keep that hospital for the peasants.' "[147]

That in this one instance Cyrus's first name has been transformed and the name "Clark" has slipped in, and an inversion of "Stephen Clark" been so clearly made, is more of a giveaway than one expects even in this poorly written roman à clef.

In the following days, "Clark Stevens" keeps looking at Marge Miles through his telescope. "Although he was an old man of seventy, for whom sex had ceased to have meaning, he wanted a toy of his own. He wanted a woman, and he wanted one bad, to fondle and possess and look at. Often he had longed to put his arms around that slender body of

Marge's, and kiss it in all the places he had watched her husband kiss it."[148]

This is when Cyrus Stevens—as his name again becomes—has his right-hand man replace his nurse. "This nurse they've sent me is an old fart. Get down to the hospital. Find something good to look at who'd like to come up and take care of me."[149]

A voluptuous woman arrives. Stevens gives her a bourbon and a hundred dollars to take her clothes off. Out of the window, he sees a young man ride by on his horse. "Cy Stevens recalled how he had liked to ride, himself, when he as a young man, how all that rocking motion would stir him up. He wanted the girl to sit in his lap and just let him rock her."[150] After making himself another bourbon on ice and lowering himself into a rocking chair, he pulls the young woman, who by then is naked, on top of him. She proposes that he should have his clothes off as well, and undresses him.

At the next moment, Cyrus Stevens, now lying on the bed naked, is unconscious from a coronary occlusion. Justin Riley operates, but the old man dies in surgery.

Stephen had died in New York two years before the publication of *The Sex Cure;* his son Alfred, Robert Lowell's subject, who had been married and divorced six times, died in 1961. Brose, the most heavy-drinking, pleasure-seeking one of his generation, was still alive. Even a roman à clef that mistakenly uses a real name is rarely based on facts, and its characters are a compendium, but there is a reason this trashy book has been kept, to the extent possible, out of the public eye.

IN HIS WILL, Stephen left six million dollars to Bassett Hospital, two to the New York State Historical Association, a million to Yale, five hundred thousand to the Metropolitan, and another five hundred thousand to his son-in-law, Henry Labouisse. Anne received the Rembrandt, although when her grandfather had passed her on the staircase while she wrote about it passionately a few years earlier, she had had no inkling that this would be the case. But Stephen had had strong feelings about his daughter, Elizabeth, now dead for fifteen years. Although he had two living sons when he died, in his will he had written that if Susan, his primary heir, did not survive him, everything in his residuary estate should go to Henry Labouisse or Anne.

As had Sterling with Francine, Stephen left his widow life interest in a

lot that he owned—the house and some of the art. Like their father and their grandfather, these two brothers, little as they had in common, had most of their immense fortunes in trusts, to minimize estate taxes and to assure that the money would serve both their descendants and society at large as they intended. The Dakota went to the Clark Foundation. Regardless, the "Clark Estates," created in 1896 by Elizabeth Scriven Clark to manage the family's investments, now became even wealthier than the foundation. Some of the most important paintings—the Cézannes, a Degas, the El Greco, the Renoirs, and the Ryder—went to the Met. So did Seurat's *Circus Sideshow*. For all of Alfred Barr's efforts, that masterpiece of modernism was now ending up at the institution with which the Modern was, in certain areas of collecting, the most competitive. But the Museum of Modern Art, the institution to which Stephen Carlton Clark had devoted himself so zealously for nearly thirty years, and to which he had anonymously given the Brancusi and the Bonnard and other masterpieces in its early years, was not even mentioned in his will, which Stephen had rewritten after David Rockefeller had presumed, without asking, that he was giving a million dollars.

In the last decade of his life, Stephen had become increasingly devoted to the Yale University Art Gallery. In 1954, no longer anonymously, he had given it, among other things, Picasso's 1937 *Vase of Flowers and Pitcher* as well as Matisse's *Robe Lamée.* Then, in 1958, he had donated two more important Picassos—*Dog and Cock* and *First Steps.*

Andrew Carnduff Ritchie, who had worked at the Modern and whom Stephen greatly liked, was by then the director of Yale's museum. Like many collectors, Stephen may have been swayed as much by his rapport with the person at the helm as by a feeling for the larger institution. But at Yale he knew that his paintings would make even more of a difference than at the Modern, while they would still be only an hour and half from New York. He also had school loyalty, and must have recognized that the university was increasingly at the forefront in the visual arts. In the 1950s, just as Stephen was giving great paintings there and writing a will that would elevate their collection into another category of excellence, a new gallery building was being designed by Louis Kahn, and the Bauhaus-trained Josef Albers was transforming the art school next door into a place where America's best young artists were eager to be.

Typically, when Stephen gave the Picassos, he made no attempt to have his name on the gallery wall or to receive public kudos. He did not presume to donate the paintings until he checked that they would be

welcome. Just after giving *Dog and Cock,* he wrote Ritchie on the letterhead of the Singer Building at 149 Broadway to say they could have *First Steps* if they wanted. When the director replied with a burst of enthusiasm, Stephen was careful to pay for the packing and shipping and to impose nothing on the recipient.

The gift of Picasso's *First Steps* was, however, national news. And so was the bequest that came to Yale the year after Stephen died, bringing the total to sixty-one important paintings they received from the collector. Besides van Gogh's *Night Café* and the trove of work by Eakins and Homer already discussed, this included the very fine Corot *Harbor of La Rochelle,* a marvelous work from 1851 that Stephen had bought at Wildenstein and that Corot himself considered among his finest (color section 2, page 4). One of the few rather gentle and pleasing paintings Stephen owned—one could actually use the word *pretty,* often applicable to work that Sterling bought but rarely to Stephen's choices—this was a painting Susan Clark chose to borrow and keep in the house on Seventieth Street after her husband died. The other was Winslow Homer's *Game of Croquet.* Susan could do without the art that was harsh and troubling, but she loved the picturesque and enjoyed these masterpieces up to the time she died in the same house seven years later. The paintings then joined the rest of the collection in New Haven.

Another of the works Stephen left Yale was Manet's *Young Woman Reclining in Spanish Costume.* It's not surprising that Susan felt no need to keep this canvas, which had belonged to the photographer Felix Nadar, at home. One of the least pleasing of all Manets, it portrays a woman some deem a seductress but others consider remarkably unpretty, her costume far too tight for her body. The appeal of the work does not derive from surface charms; rather, it is a painting about artistry and, at the same time, human isolation.

Manet's startling whites and blacks interact vibrantly, and an orange in the right foreground is one of the most convincingly round objects ever evoked on a flat canvas. As for the woman, she is dressed almost like a male toreador: seemingly uncomfortable, she is pensive in a way that suggests total alienation from the purpose for which she is wearing this get-up. What an effort it sometimes is to present oneself in finery.

STEPHEN CLARK'S public gifts are known, but few people other than the direct beneficiaries would be aware of his quieter acts of helpfulness.

When "Shippy"—Freda Shipley—the woman who had been such a splendid surrogate mother for his dead daughter's child, reached retirement age, Stephen created a trust fund for her that allowed her to buy a farmhouse in Vermont with a hundred acres, and to live there comfortably. (Today it belongs to Anne's four children.) Stephen remained devoted not just to his widower son-in-law but also to Henry's second wife.

The Rembrandt he gave his granddaughter reached such an astronomical financial value that Anne gave it to a foundation she created for "the Aid of Education, Social Justice, and Human Service," and named for Shippy. On January 25, 2007, it was sold at auction for $25 million. It is the family tradition of philanthropy, rather than of acquiring, that prevails.

In addition to all the Clark brothers did for museums and gave and built during their lifetimes, they left, for the benefit of others, a great deal of cash. Beyond the Piero, the van Goghs, the Cézannes, the Renoirs, the Picassos, and the Seurat with which the American public benefits from Sterling's and Stephen's wealth and generosity—and beyond what Stephen left his descendants—their estates funded significant charitable foundations.

In its 2004 annual report, the Robert Sterling Clark Foundation published its assets as being $98,717,719. This money is used to preserve the environment and to support liberal causes. What is simply called The Clark Foundation, created in 1931 under Stephen's guidance and based on a previous charitable organization to which all four brothers had initially contributed, maintains an even quieter profile. One can hardly find information about it, beyond what is required by law, but its assets in June of 2003 were listed as $440,150,252. As Sterling had feared, Stephen's net worth had been bolstered by Rino's and Brose's.

Sterling was, however, wrong in thinking that the money would go to a greedy family. In the Chippendale- and chintz-furnished offices at Rockefeller Center where Jane Clark manages an active program of giving, there is no hint of the aesthetic modernism in which her grandfather played such an active role, but scholarships and other causes are funded generously. People of the same economic stratum as those who bought Singer sewing machines on Edward Clark's layaway plan a century and a half ago are still close to the family's heart.

TOWARD THE END of his life, the artist whose work Stephen was acquiring almost more than any other was Edward Hopper. For all of his

forays into French culture, the collector was as fascinated as ever by this quintessentially American painter.

Hopper and Stephen were one month apart in age. They were both born in New York State and ended up spending their lives based in New York City, but had had a lot of their artistic formation in Paris. Each was known for his reticence, and to other people seemed aloof, but each had, in his cool way, a palpable fire and engagement.

A quarter of a century had passed since Stephen had started the permanent collection at the Museum of Modern Art, the year after that institution had opened its doors, by giving them Hopper's painting of a Victorian house by a railroad track. That scene of emptiness and isolation, frozen cinematically in a strong sunlight at odds with the bleakness of the image, had opened people's eyes to a new approach to American life. Stephen remained as attracted as he had always been to Hopper's dry realism with its inexplicable poetry. The way the artist illustrated a tragic world had no exact equal.

Stephen had anonymously given the Modern a second Hopper in 1941. Painted in 1939 and called *New York Movie,* it shows a despondent looking woman—we presume she is an usher—standing near the stairs of an empty theater (color section 2, page 8). It has in common with van Gogh's *Night Café* and Seurat's *Circus Sideshow* the force with which it illustrates the ominous impact of artificial light on a dark and desolate environment. In the many pencil sketches Hopper made of the miserable-looking usher and the rows of seats under the balcony, he gave close consideration to the way the safety lighting in a darkened movie theater falls on the woman's hair, on the palm of the right hand with which she is supporting her chin, on the backs of the seats, and on some of the ornate architectural details of the theater. He also evoked the artificial glow of movie projection in the fraction of the large screen we glimpse on the left-hand side of the painting. If Robert Sterling Clark was catapulted to joy by impressionist paintings that showed the impact of sunshine in the open air, the sun's rays streaming through the golden tresses of Renoir's young maidens, his dour, humorless brother acquired pictures that revealed the impact of gas lighting and electricity on modern life in its everyday haunts.

The next major Hopper Stephen bought was the 1945 *Rooms for Tourists,* a night scene. The seemingly fluorescent, cold white light on a sign advertising the rooms being rented in this private house, and the equally strong but far more yellow light that emanates from the many

windows, are the main subject. Light counts more than matter; the clap-board siding and awnings are secondary in this scene on a quiet street in a New England town. The harsh luminosity, so clearly artificial rather than natural, again recalls Stephen's great van Gogh and Seurat—even though everything else in those breakthroughs of European modernism is differ-ent from the vision of the more stylized, particularly American, Hopper.

Today these paintings have all become, because of the workings of the art market, treasures if measured in their financial worth. But the Hop-per, the van Gogh, and the Seurat have in common their focus on the very ordinary lives of people of limited means. They all show the everyday manifestations of nineteenth-century industrialization, the leap forward civilization made during that era in which the sewing machine played a major role. Stephen Carlton Clark probably did not take any of those issues into account when he bought these artworks that were so different in style from one another, but something inside him was attracted to the

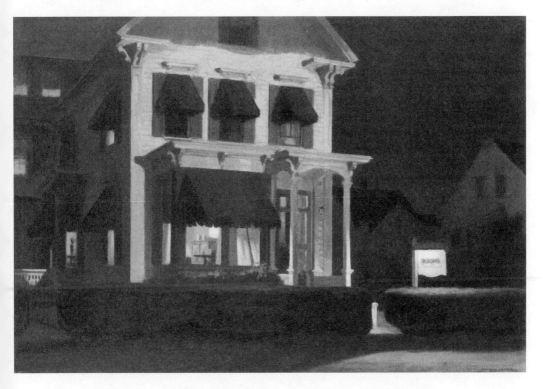

Edward Hopper, Rooms for Tourists, *1945. Stephen chose to have paintings of American life of the sort he was unlikely to know from personal experience.*

quotidian and, to some extent, the ugly. In the case of Hopper's *Rooms for Tourists,* he had opted for a portrait of accommodations where he and Susan would not possibly ever have had occasion to stay; into his own elegant life, Stephen deliberately brought, time and again, evidence of other, less appealing, forms of existence.

Hopper's 1951 *Rooms by the Sea,* Stephen's next acquisition by the artist, has, unlike the previous two works, but like the first one he gave to the Modern, the bright, clarifying sunshine that is, more than the harsh luminescence of electricity, a hallmark of Hopper's work (color section 2, page 7). In spite of the ambient daylight, however, the emotional climate is again far from the world of the impressionists. There is a complete absence of people and a pervading silence in this empty room. We imagine it to be the most isolated of settings.

The painting depicts the geometric composition made by the raking sunlight that comes in through an open door, which gives onto the ocean and a clear blue sky. The light falls in a bright prism that has smaller echoes. Deep shadows serve as their foil. Everything is spare in this scene painted near the tip of Cape Cod, where Hopper had a house, but there is nothing Zen-like about that simplicity. What might be calm is charged with a sense of anguish, a feeling of a tragic void.

Stephen next bought Hopper's *Western Motel,* painted in 1957, almost as soon as it came off the easel. Now more than ever, the collector was attracted to ordinary life at its most charmless, to a world he could most certainly have afforded to avoid.

This was completely in character. The heir who could have lived any way he wanted had always eschewed what was easy or facile. He had chosen to battle Alfred Barr and to build a hospital; he had not had to do either. His remaining brother, Ambrose, had taken the opposite path, to seek amusement above all else; Stephen took on challenge, and liked challenging art.

Lloyd Goodrich, who had been observing Hopper's work for as long as Stephen had, nailed the effect of this painting: "*Western Motel* with its awful interior in decorator's green, beige, and crimson, its hard-faced blonde, its bright green automobile, and its bare desert landscape under a burning sun, is one of the toughest pictures of any period. It makes no concessions to accepted ideas of what is artistically admissible. Its garish colors are unsoftened by grays. It captures the quintessence of that most American of institutions, the motel. In a purely naturalistic style it is as firsthand an expose of our mass culture as pop art."[151]

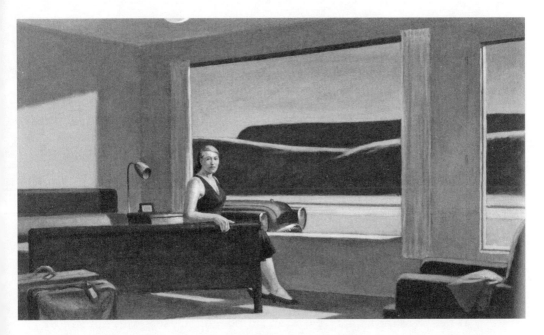

Edward Hopper, Western Motel, *1957. This late work by Hopper is one of the artist's most important, another example of Stephen Clark's fascination with a world very different from his own.*

For the beneficiary of mass culture to own it had a certain justice. But most of America's heirs to similar fortunes—the people who have made multiple billions of dollars through discount stores and supermarkets and automobile parts—have, in their collecting and taste and the way they live, deliberately chosen luxuries at the opposite end of the spectrum from what has paid for their way of life, and opted instead for gilding and travertine. Stephen Carlton Clark was different. Something inside him was completely open to this cheap motel room, to the tough middle-aged woman with her suitcase packed and the car waiting outside, to the loneliness of her journey.

Hopper's gaudily colored canvas had nothing to do with the coffered ceilings and raised paneling at Seventieth Street, or the splendors of Cooperstown, yet Stephen willingly brought it into that way of life. Stephen did not turn his back; rather, he looked at things squarely and had his eyes open to tough truths. *Western Motel* encapsulates in all its grit the America familiar to millions, not just to a lucky few.

How true this was of the last Hopper Stephen purchased, the very large *Sunlight in a Cafeteria* (color section 2, page 7). Stephen bought it in

1958, when he and Hopper were both seventy-six years old. In New York, the collector would periodically go to the artist's studio, where he relished the rare privilege of watching Hopper work. When he acquired *Sunlight in a Cafeteria,* Hopper immediately wrote him to say how pleased he was that it was Stephen who had bought it, for he considered it one of his best works ever.

Like all of the Hopper pictures except for the two he gave to the Modern, Stephen would leave this one to Yale. When he died two years later, it was part of his bequest to the university art gallery. So its effects can readily be felt firsthand by the public.

As usual with Stephen's most important acquisitions, a sad scene is rendered with consummate artistry. What was true for everyone, even the amorous couple, in *The Night Café,* and for all the performers in *Circus Sideshow,* is true here; each character exists in a void, locked in his or her own universe. The lack of communication seems tragic; the man in the Hopper stares at the woman, but she fails to respond.

Different as the ambiance was, and although the issues were not alike, this is the same silence of Stephen Carlton Clark's own life. It is a world in which all that is left undiscussed and unsaid hangs heavily in the air. People are technically together yet fundamentally isolated from one another. The atmosphere is morose, possessed of that sadness Robert Lowell captured in Stephen and Susan Clark's middle son—one of their two surviving children, out of the five born to them, at the time Hopper painted this picture and Stephen bought it.

The painting shows the standard ingredients of empty coffeeshops and cafeterias of the type generally seen in the neighborhoods surrounding railroad stations in many American cities: the restaurant-service sugar pourers, the silly rubber doily, an unappealing flowerless potted plant, a plate-glass window opening onto a grim commercial street, a revolving door with the brass plates and bars on it. The chairs are plastic and metal, right out of a catalogue, the heavy tables topped in Formica that is easy to wash.

Hopper had been looking for most of the summer of 1958 at a large empty stretcher on his easel, without even a canvas stapled to it. This powerful picture that resulted from the period of contemplation has a well-defined geometry. A picture, like one's life, is constructed according to rules. Hopper had positioned the characters and tables and shaft of sunlight with incredible care. A sense of structure has been established by the patterns deliberately formed by the tabletops and the row of win-

dows across the way. The visual harmony counterbalances the emotional disharmony. The order and balance and extreme clarity that exist optically are missing in the human interaction at the hour of the day when most everyone else, we imagine, is more comfortably at home.

In Edward Hopper's world, as in that of almost all of Stephen Carlton Clark's chosen artists, people look into space, or downward. There is little communion. The social class and economic situation were completely different from Stephen's milieu, but the emotional climate was the same. His was a life in which two brothers could sit at adjoining tables without breaking the silence that had engulfed them for twenty years, where a father might keep his son out of his office. Art was everywhere; the décor was perfect; but feelings were locked up.

No wonder Stephen was drawn to Hopper all the more as he knew he was approaching the end of his own life. Hopper understood, and evoked, loneliness. At the same time, he captured, and augmented, the poetry of the tragic world he illustrated. Color and form—the wonders of art—coexist with doubt and distance.

ALFRED CORNING CLARK had certainly experienced those divides in life in all their magnitude. Each of his sons, blessed with the obligations of almost unimaginable financial wealth and burdened by its obligations, had to figure out for himself how to parcel out private feelings, a sense of responsibility (which weighed only lightly on Ambrose), and the eye and ear for life's beauty they had inherited from their father and could accommodate with the well-being engendered from *his* father. All of it—emotions, secrets, conscience, the love for material quality—were extreme.

Sterling had, lifelong, craved the light of the impressionists, the vivid dashes of his Renoirs—and the celestial glow of Piero della Francesca. Stephen had also been drawn to light as much as matter. But in his case it was the more sulfurous luminescence of van Gogh and Seurat, or the unbroken, flat, cool northern light of his three great American artists— Eakins, Homer, and Hopper.

Light was what both brothers cherished. They were looking for brightness; they needed the sun that unites us all.

ACKNOWLEDGMENTS

This book came about thanks to Victoria Wilson, an unequaled matchmaker of subject and writer. Vicky has rare perceptiveness, originality, courage, and humor; that she is my editor adds immeasurable richness to my life. I thank her especially for the unwavering independence and fortitude she has shown throughout the work on this project.

The initial matchmaker, a couple of decades ago, was Gloria Loomis, who, with her usual wisdom, led me to Vicky Wilson. As my literary agent, Gloria has transformed my existence; I cannot say this often enough. To enable someone to write about what fascinates him, under felicitous circumstances, is a magic act. I appreciate her professionalism, generosity, and warmth more than she can imagine.

I could not have written about the Clarks without the marvelous support of those who so ably manage Sterling's legacy at the Sterling and Francine Clark Art Institute in Williamstown, most especially Michael Conforti, director, and Curtis Scott, director of publications. I am also deeply indebted to Daniel Cohen-McFall, former curatorial assistant at the Clark, now curator at the Louisville Slugger Museum and Factory, and Mari Yoko Hara, curatorial and publications assistant. Their rare supportiveness and truly extraordinary efficiency have been tremendous assets to my work.

I am also extremely grateful to Kathleen Tunney, library and museum archives coordinator at the Museum of Modern Art Archives, and to Milan Hughston, chief of library and museum archives, and Michelle Elligott, museum archivist, for the expertise and graciousness that are usual for them but unusual in the world.

Stephen Clark's two granddaughters are very different in many ways but very similar in the openness with which they answered questions and the willingness with which they probed their memories and offered insights about their families. With her rare ability to recall childhood scenes with psychological and visual exactitude, Anne Peretz has enabled me to see her grandparents as if I were seated at their dining room table in the 1950s. She also demonstrates the true quality of philanthropy that belongs to the Clarks at their best, and has added enormous pleasure to the work on this book—in part because she has herself gone so far from the givens of her family, becoming one of those rare people who kept the best of her heritage while gracefully shedding its burdens and inventing herself. Jane Clark, too, has shown a great under-

standing of family dynamics, perceptively observing the effect of her grandfather's character on his sons; she also is the source of the anecdotes that elevate Susan from being merely ladylike to being immensely colorful, and for revelations about the marvelously named Ambrosina.

With his quick mind, strength of character, and unfailing good humor, Tyler Sage has done a phenomenal job of helping with a myriad of details on this project, attending to the issues of the illustrations and photographic rights and bibliography and footnotes in a way for which I am inestimably grateful. He has both helped the book fantastically and given its author a peace of mind that would otherwise not have existed. He has my profuse thanks.

As always, I am immensely appreciative of the backing, friendship, wise counsel, and personal generosity of both Charles Kingsley and John L. Eastman, my two fellow trustees of the Josef and Anni Albers Foundation. These two men, clear in judgment, strong in heart, affect the lives of many fortunate people, myself included, in countless ways for the better.

Oliver Barker, with his painter's eye and his feeling for personality, and his alertness and tenacity, has, as always, been the greatest help. And Philippe Corfa, in assisting with preparation of the manuscript at a crucial stage, has been a truly remarkable ally, helper, adviser, and supporter.

At a moment when I was in need of quiet and solitude to write about the fascinating, mysterious Alfred Corning Clark, Veronique Wallace provided the perfect setting in the city where Alfred carried on his "other" life. I am incredibly grateful.

Kenneth Marcus, with his rare understanding of human nature, his insights, and his personal generosity, also has been of fantastic help, for which he has my profuse thanks. Mickey Cartin, with his astuteness about the true issues of art collecting and his particular grasp of the human comedy, has been a great support.

On the issue of the relationship between the trustees of a nonprofit cultural institution and its professional director, Doug Hughes and his marvelous wife, Lynn Fusco, as well as Declan MacGonagle, provided me with great perspective. Fine institutions suffered great loss, as the Museum of Modern Art did with the demotion of Alfred Barr, when my friends Doug and Declan were ousted. I regret the personal suffering of these two fine men, as I regret the loss for the institutions they served, but I appreciate the way events in both of their lives helped me understand some of the wretched tensions that can occur between dedicated professionals and lay trustees as they did at the Museum of Modern Art in 1943.

I also want to acknowledge the helpfulness and support of Molly Wheeler, Brenda Danilowitz, Jessica Csoma, Fritz Horstman, Andres Garces, Anne Lundberg, Anne Chambreaux, Lynn Mehta, Katherine Fausset, Justin Allen, Jacqueline Hackett, Amanda Pennelly, Christopher Gray, and Peter Deasy. To my patient and understanding friends—in particular Daphne Astor, Sophie Dumas, Joan Warburg, Martin Filler, Joan J. Kohn, Eve Tribouillet-Rozenczweig, Jeanette Zwingenberger, Pierre Otolo, Ellen Weber Libby, Pierre-Alexis Dumas, Helen Ward, Nicholas Ohly, Sanford Schwartz, Samuel Garbe, Niolas Marang, Patrice Mariotti, Raffi Kaiser, Adam Brophy, Nancy Lewis, Brigitte Degois, Carole Obedin, Michel Navarra, Gilles

Degois, Eskandar Nabavi, Alan Riding, Marc-Antoine Goulard, Henry Singer, Francine DuPlessix Gray, and George Gibson—I am, as always, indebted.

With his exceptional grasp of French history and wonderful professionalism as a researcher, Stéphane Potelle provided vital information about Le Croix de Feu. I am grateful as always to this generous colleague and friend.

Sean O'Riordain gives my life a balance and perspective it would otherwise lack; about the Clarks as about everything else, he listens acutely and provides insights of phenomenal value, always adding immense pleasure to the moment, whether we are kayaking off the Irish coast or trooping through Senegal.

Laura Mattioli Rossi has, significantly, stood as an exemplar of the knowing collector and public-spirited patron whose humanity and sanity and clarity of judgment have offered balast and counterpoint as I have navigated my way through the lives of the Clarks.

Petrina Crockford and Zachary Wagman, both at Knopf, have been enormous aides, always gracious as well as immensely effective. Petrina, having been the more intensely involved with this project, has engaged herself with wonderful professionalism and welcome humor.

My wife, Katharine, has, as ever, brought her own unique perspective to my work, which I cherish, as I do her. Our marvelous daughter Lucy Swift Weber has given wonderful responses and shown her usual stunning insights into human behavior, which have nourished this book. Our other extraordinary daughter, Charlotte Fox Weber, has, as always, evinced her incredible understanding of human interaction, as well as her lively vision of paintings, and has added unparalleled delight to the work on this project. My superb sister, Nancy Fox Weber, has, as ever, been a stalwart friend, ever available to consider my latest thoughts about the Clarks, their art, and any other subject, offering fresh and original observations and a blessed lack of judgment.

There are certain people no longer alive whose perspectives and understanding have remained wonderful guides and supports throughout the work on this book. In particular, I perpetually relish the mental presence of Leland Bell, Jack Kenney, Lee V. Eastman, Anni Albers, Josef Albers, Clara Nell McIntee, R. W. B. Lewis, Cleve Gray, Lester Weber, Pearl A. Weber, and most especially my parents, Saul and Caroline Fox Weber. On matters of great pertinence to this text, ranging from the meaning of Franklin Delano Roosevelt to their generation of Americans (my parents having been from the opposite pole of Sterling Clark) to issues of privilege and human charity, and in their early receptiveness to Picasso and his art, my patient father and vibrant mother helped immeasurably to prepare me to pursue a variety of subjects raised by the Clarks.

This book is dedicated to two of the most wonderful people I know: Leslie and Clodagh Waddington. Their knowledge of the art world, of the motives for collecting, of the complex interaction of wealth and family and objects, has helped me immensely in my understanding of the Clarks. More significantly, their intellect and warmth and immense qualities of friendship have become mainstays of my personal happiness as well as that of my wife and daughters. The offering of this book is but a slight way of expressing the most heartfelt appreciation and the love I feel for both of them.

NOTES

INTRODUCTION

1 Alfred Barr, memo to Trustees of
 MoMA, Dec. 11, 1953, ABP.
2 Rydberg, *Roman Days,* p. 205.

I · EDWARD

1 From an 1882 obituary in an
 unidentified Cooperstown-area
 newspaper.
2 Ibid.
3 Bissell, *The First Conglomerate,*
 pp. 4–5.
4 "The Late Nathan Clark," *Freeman's
 Journal* (Cooperstown, N.Y.),
 Apr. 7, 1896.
5 Beers, *History of Greene County.*
6 Bissell, *The First Conglomerate,*
 p. 66.
7 Hoeltzel, "Interesting Arcadians."
8 Ibid.
9 Ibid.
10 Bissell, *The First Conglomerate,*
 p. 66.
11 Here, too, most of the recent
 literature, which is substantial,
 about the connection of Isaac
 Singer and Edward Clark gives the
 chronology differently. Most
 histories of Singer and his business

ventures place the date a few years
later and attribute their initial
meeting to matters revolving
around the sewing machine rather
than Singer's earliest business
interests. The accounts written
closer to Clark's life by people who
knew him, and several well-
researched obituaries seem more
reliable, however, which is why we
depend on them instead.
12 "Cast of Characters."
13 Ibid.
14 Beers, *History of Greene County.*
15 Hoeltzel, "Interesting Arcadians."
16 Ibid.
17 Bissell, *The First Conglomerate,*
 p. 68.
18 "Cast of Characters."
19 Ibid.
20 Beers, *History of Greene County.*
21 Bissell, *The First Conglomerate,*
 p. 83.
22 Ibid., p. 27.
23 Ibid.
24 Ibid., p. 28.
25 Ibid., p. 13.
26 Ibid., p. 29.
27 Ibid, p. 30.
28 Ibid., p. 97.
29 Hawes, *New York, New York,* p. 94.

30 Ibid, p. 96.
31 *Cooperstown Journal,* Oct. 21 1882, p. 16.
32 Ibid.
33 Ibid., p. 19.
34 Ibid., p. 17.
35 This is based on contemporary accounts. Some texts give his estate as having been as high as $50 million.
36 "News Summary" from an unidentified Cooperstown-area newspaper, July 1872.

II · ALFRED

1 Moffatt, "Touching Encounters," p. 17.
2 Moffatt, unpublished notes.
3 DMW, p. 368.
4 Ibid., pp. 398, 369.
5 Ibid., p. 369. Conforti, et al., *The Clark Brothers Collect,* says that ACC and LSS met in 1869, but Alfred's comment in the 1885 biography that they had known each other for nineteen years makes clear that they had met earlier.
6 Moffatt, unpublished research notes on George Grey Barnard, given to author, n.p.
7 Dickson, "Barnard and Norway," p. 44.
8 Ibid., p. 3.
9 DMW, p. 369.
10 Ibid.
11 Ibid., p. 369. This information, which comes from the biography of GGB, differs from the chronology in Conforti, et al., *The Clark Brothers Collect,* which has Ambrose dying in New York.
12 Ibid., p. 370.
13 Birdsall, *The Story of Cooperstown,* p. 360.
14 Moran, *A Man,* p. 1.
15 Ibid.
16 Ibid, p. 3.
17 Ibid., p. 7.
18 Alfred Corning Clark, *Lorentz Severin Skougaard,* n.p.
19 Ibid., pp. 5–6.
20 Ibid., p. 6.
21 Ibid., p. 137.
22 Ibid., p. 218.
23 Ibid., p. 219.
24 Ibid., p. 240.
25 Ibid., p. 241.
26 Ibid., p. 245.
27 Moffatt, "Touching Encounters," p. 19.
28 Charles Black, letter to Edna Monroe, Feb. 25, 1893, in Moffatt, "Touching Encounters," p. 16.
29 Moffatt, "Touching Encounters," p. 15.
30 Dickson, "Barnard and Norway," p. 55.
31 Moffatt, unpublished notes, n.p.
32 Ibid.
33 GGB, letter to parents, CCHS. Letter is numbered 6/1886: May 2, 1886.
34 *Reader's Digest,* 1937, p. 50, in Moffatt, unpublished notes.
35 GGB, letter to parents, CCHS. Letter is numbered 6/1886: May 2, 1886.
36 Moffatt, unpublished notes, n.p.
37 Dickson, "Barnard and Norway," p. 56.
38 Rydberg, *Roman Days,* p. 188.
39 Ibid.
40 Ibid.
41 Ibid., p. 189.
42 Ibid.
43 Ibid., p. 192.
44 Ibid., pp. 192–93.
45 Ibid., p. 197.
46 Ibid., p. 198.

47 Ibid., p. 206.
48 DMW, p. 368.
49 Ibid., p. 370.
50 Ibid., p. 370.
51 Schonberg, *The Complete Josef Hofmann.*
52 Ibid.
53 Ibid.
54 DMW, p. 370.
55 Moffatt, unpublished notes, n.p.
56 Moffatt gives various sources.
57 DMW, p. 415.
58 DMW, version B, pp. 365–98.
59 Moffatt, "Touching Encounters," p. 22.
60 DMW, pp. 391, 392.
61 Ibid., p. 392.
62 Ibid., p. 371.
63 Ibid.
64 Ibid.
65 Ibid.
66 Ibid., p. 376.
67 Ibid.
68 Ibid., pp. 377–8.
69 Ibid.
70 Ibid., p. 379.
71 Ibid., p. 380.
72 Ibid., p. 381.
73 Moffatt, unpublished transcriptions of George Grey Barnard's letters.
74 Undated letter, GGBP.
75 GGBP.
76 Dickson, "Log of a Masterpiece," p. 139.
77 DMW, p. 440.
78 Ibid.
79 Ibid.
80 Ibid., p. 441.
81 Ibid., p. 443.
82 Ibid., p. 444.
83 Ibid.
84 Dickson, "Log of a Masterpiece," p. 139.
85 DMW, Box 2, Folder 1, quoted in Moffatt, unpublished notes.

86 Dickson, "Log of a Masterpiece," p. 140.
87 Ibid., p. 141.
88 Ibid.
89 Letter to brother, March 25, 1888; quoted in Moffatt, unpublished notes, n.p.
90 Ibid.
91 Dickson, "Log of a Masterpiece," p. 142.
92 July 1891 letter; quoted in Moffatt, unpublished notes, n.p.
93 Dickson, "Log of a Masterpiece," p. 142.
94 Moffatt, unpublished notes, n.p.
95 DMW, p. 446.
96 Ibid., pp. 446–7.
97 Ibid., p. 447.
98 Ibid.
99 Ibid., p. 447.
100 Ibid., p. 448.
101 Ibid., p. 449.
102 Ibid., p. 451.
103 Ibid., p. 459.
104 Ibid., p. 185.
105 Moffatt, unpublished notes, n.p.
106 Ibid.
107 Ibid.
108 Ibid.
109 Moran, *A Man Who Lived,* pp. 9, 11.
110 Ibid., pp. 11, 13.
111 Ibid., p. 7.
112 Birdsall, *The Story of Cooperstown,* p. 361.
113 Moran, *A Man Who Lived,* p. 15.
114 Ibid., pp. 17, 19.

III · ELIZABETH

1 Conforti, et al., *The Clark Brothers Collect,* p. 202.
2 DMW, p. 12.
3 Ibid.
4 Birdsall, *The Story of Cooperstown,* p. 361.

5 Ibid., p. 363.
6 Ibid., pp. 362–3.
7 Jacob Riis, *The Battle with the Slum* (www.bartelsby.com).
8 Ibid.
9 "Bishop Potter to Wed," *The New York Times,* July 11, 1902.
10 Gray, "Once the Tallest Building."
11 Ibid.
12 Ibid.

IV • STERLING

1 "Society in Washington," *The New York Times,* Dec. 23, 1902.
2 Ibid.
3 Onians, "Sterling Clark in China," p. 42.
4 Ibid., p. 43.
5 Ibid., p. 43; Clark and Sowerby, *Through Shen-Kan,* p. 40.
6 Onians, "Sterling Clark in China," p. 42.
7 RSC, letter to SCC, Mar. 7, 1911.
8 RSC, letter to SCC, Apr. 4, 1911.
9 RSC, letter to SCC, Apr. 4, 1911, p. 4.
10 SCC, letter to RSC, Apr. 17, 1911.
11 SCC, letter to RSC, Apr. 20, 1911.
12 Ibid.
13 RSC, letter to SCC, Apr. 26, 1911.
14 RSC, letter to SCC, Aug. 2, 1911.
15 RSC, letter to SCC, Oct. 4, 1911.
16 Ibid.
17 Ibid.
18 RSC, letter to SCC, Nov. 19, 1911.
19 Ibid.
20 Ibid.
21 SCC, letter to RSC, Dec. 1, 1911.
22 Ibid.
23 RSC, letter to SCC, Feb. 4, 1913.
24 Ibid.
25 Ibid.
26 GGB, letter to Edna Barnard, Apr. 12, 1913.
27 GGB, letter to Edna Barnard, April 1913.
28 Susan V. Clark, letter to Edna Barnard, Apr. 17, 1913.
29 Ibid.
30 RSC, letter to GGB, Apr. 27, 1913.
31 GGB, letter to Edna Barnard, June 1913.
32 GGB, letter to Edna Barnard, May 10, 1913.
33 GGB, letter to Edna Barnard, Dec. 1913.
34 Moffatt, unpublished notes.
35 Prucknicki, *Barnard,* n.p.
36 Fry, "The Lincoln Statue," p. 240.
37 "Barnard Forced to Vacate Studio," *The Art News,* Nov. 22, 1930, p. 13.
38 RSC, letter to SSC, Mar. 2, 1914.
39 RSC, letter to SCC, May 5, 1914.
40 Whistler, *The Gentle Art of Making Enemies* (www.artcyclopedia.com).
41 RSC, letter to SCC, May 21, 1914.
42 RSC, letter to SCC, Mar. 12, 1916.
43 From Steling Clark's cookbook, photocopy of 1952 version, Clark Art Institute Archives.
44 Conforti, et al., *The Clark Brothers Collect,* p. 38.
45 Ibid.
46 Ibid.
47 Clark History file from the Clark Art Institute Archives.
48 RSC, diary, Apr. 19, 1923.
49 Ibid.
50 Ibid., Oct. 29, 1923.
51 Conforti, et al., *The Clark Brothers Collect,* p. 135–8.
52 RSC, diary, Oct. 27, 1923.
53 Ibid., Dec. 5, 1924.
54 Ibid., Jan. 19, 1924.
55 "Upholds State Tax on Stock Dividends," *The New York Times,* Sept. 16, 1925.
56 RSC, diary, Mar. 29, 1926.

57 Ibid.
58 Ibid., Mar. 30, 1926.
59 Ibid., Apr. 3, 1926.
60 Ibid., Apr. 4, 1926.
61 Ibid., Apr. 6, 1926.
62 Ibid.
63 Ibid.
64 Ibid., Apr. 30, 1926.
65 Ibid., Dec. 31, 1926.
66 Ibid.
67 Ibid., Jan. 5, 1927.
68 CDR, n.d., n.p.
69 "Clark Trust Funds Put at
 $80,000,000," The New York Times,
 Oct. 22, 1927.
70 Ibid.
71 RSC, diary, Jan. 5, 1929.
72 Ibid.
73 Ibid.
74 Ibid.
75 Ibid., Jan. 16, 1929.
76 Ibid.
77 Ibid., Jan. 5, 1929.
78 Ibid., Jan. 16, 1929.
79 Ibid.
80 Ibid., Jan. 29, 1929.
81 Ibid., Mar. 2, 1929.
82 Ibid., Mar. 10, 1929.
83 Ibid., Mar. 11, 1929.
84 Ibid.
85 Rickman, "Memorative
 Biographies," n.p.
86 RSC, diary, May 11, 1929.
87 Ibid.
88 Ibid., June 17, 1929.
89 Ibid., June 30, 1930.
90 Ibid.
91 Ibid.
92 Ibid.
93 Ibid., June 17, 1929.
94 Ibid., Sept. 27, 1929.
95 Ibid., Oct. 1, 1933.
96 Ibid.
97 Ibid., Nov. 21, 1933.
98 Ibid.
99 Ibid., Jan. 1, 1927.
100 Ibid., Mar. 13, 1934.
101 Ibid., June 21, 1934.
102 "Gen. Butler Bares 'Fascist Plot' to
 Seize Government by Force," The
 New York Times, Nov. 21, 1934.
103 Ibid.
104 The purported coup, and the
 conspiracy behind the efforts to
 achieve it, has been written
 about extensively. Opinions
 differ as to the validity of some
 of the secondary texts about it,
 and as to whether or not the
 illegal ousting of President
 Roosevelt was ever a real
 possibility. Arthur M. Schlesinger,
 Jr., for example, has written that,
 while the House Committee
 verified the claims of the
 contemplated putsch as
 reported by General Butler
 and corroborated his account,
 "the gap between contemplation
 and execution was considerable
 and it can hardly be assumed
 that the republic was in much
 danger." (Arthur M. Schlesinger,
 Jr., The Age of Roosevelt, vol. 3
 [Mariner Books, 2003], p. 83.)
 In order to focus on the
 certainties of events rather than
 on hypotheses, I have depended
 primarily on the sources I
 consider the most reliable: the
 published testimony of the House
 of Representative Hearings, the
 report issued by the House
 Committee investigating the
 matter, and statements by John
 McCormack and Samuel
 Dickstein, the Committee chairs.
105 Archer, The Plot, p. 4.
106 U.S. Congress, Public Hearings,
 p. 19.

107 Ibid.
108 Archer, *The Plot*, p. 9.
109 U.S. Congress, *Public Statement*, p. 1.
110 Archer, *The Plot*, p. 7.
111 Spivak, *A Man in His Time*, p. 299.
112 Ibid.
113 Ibid.
114 U.S. Congress, *Public Statement*, p. 2.
115 Archer, *The Plot*, p. 10.
116 Ibid.
117 U.S. Congress, *Public Statement*, p. 2.
118 U.S. Congress, *Public Hearings*, p. 13.
119 Archer, *The Plot*, p. 15.
120 Sanders, "Robert S. Clark."
121 Archer, *The Plot*, p. 15.
122 Ibid.
123 *Public Hearings*, p. 130.
124 Ibid.
125 U.S. Congress, *Public Statement*, p. 2.
126 Ibid., p. 3.
127 Archer, *The Plot*, p. 148.
128 U.S. Congress, *Public Statement*, p. 3.
129 Archer, *The Plot*, p. 160.
130 Ibid., p. 148.
131 Ibid., p. 16.
132 Ibid.
133 Ibid.
134 Ibid.
135 Ibid., p. 23.
136 Spivak, *A Man in His Time*, p. 304.
137 Ibid.
138 U.S. Congress, *Public Statement*, p. 3.
139 Archer, *The Plot*, pp. 22–3.
140 Spivak, *A Man in His Time*, p. 305.
141 U.S. Congress, *Public Hearings*, p. 18.
142 Ibid.
143 Spivak, *A Man in His Time*, p. 305.
144 U.S. Congress, *Public Statement*, p. 4.
145 U.S. Congress, *Public Hearings*, p. 19.
146 Archer, *The Plot*, p. 26.
147 Ibid., pp. 26–7.
148 Ibid., p. 26.
149 Ibid., p. 29.
150 Ibid., p. 30.
151 Ibid., p. 31.
152 U.S. Congress, *Public Statement*, p. 4.
153 Ibid.
154 U.S. Congress, *Public Hearings*, p. 21.
155 Ibid., pp. 21–2.
156 U.S. Congress, *Public Statement*, p. 7.
157 Ibid., p. 8.
158 Ibid., p. 11.
159 Ibid., p. 10.
160 Ibid., pp. 11–12.
161 *Public Hearings*, p. 64.
162 Wolfe, "Franklin Delano Roosevelt."
163 U.S. Congress, *Public Hearings*, p. 124.
164 Ibid., p. 125.
165 Ibid., p. 134.
166 Wolfe, "Franklin Delano Roosevelt."
167 "Plot Without Plotters," *Time*, Dec. 3, 1934.
168 Archer, *The Plot*, p. 91.
169 Spivak, *A Man in His Time*, p. 307.
170 Wolfe, "Franklin Delano Roosevelt."
171 Ibid.
172 *Public Hearings*, p. 151.
173 Ibid., p. 156.
174 Ibid., p. 157.
175 Ibid., p. 158.
176 Ibid., p. 159.
177 Ibid., p. 160.
178 Ibid., 161.
179 Conrad Black, quoted in Alex Beam, "A Blemish Behind Beauty at the Clark," *The Boston Globe*, May 25, 2004.
180 Archer, *The Plot*, p. 192.
181 Ibid., p. 193.
182 Ibid.

183 Ibid., p. 197.

184 Ibid., p. 218.

185 Ibid., p. 212.

186 Ibid., pp. 213–16.

187 RSC, diary, Apr. 25, 1934.

188 "Clark Land Fight Splits Heirs Anew," *The New York Times,* Nov. 27, 1936. The rivalry of the rich never failed to fascinate.

189 RSC, diary, Feb. 3, 1937.

190 Ibid., Mar. 10, 1937.

191 Ibid.

192 Ibid.

193 Ibid.

194 Ibid., May 31, 1937.

195 Ibid., Jan. 21, 1937.

196 Ibid., diary, May 21, 1937.

197 Ibid., Nov. 15, 1938.

198 Ibid., Nov. 30, 1938.

199 Ibid., Dec. 7, 1938.

200 Ibid., Jan. 21, 1939.

201 Ibid.

202 Ibid.

203 Ibid., Jan. 23, 1939.

204 Ibid., Aug. 10, 1939.

205 Ibid., Aug. 13, 1939.

206 Timothy Cahill, "The Naughty Painting," p. 53.

207 RSC, diary, Jan. 22, 1942.

208 Ibid.

209 Ibid.

210 Ibid., Jan. 23, 1942.

211 Ibid., Mar. 5–26, 1947.

212 Ibid.

213 CDR.

214 Ibid.

215 RSC, diary, Oct. 19, 1944.

216 Ibid., Mar. 29, 1944.

217 Ibid., June 9, 1944.

218 Ibid.

219 Ibid., June 10, 1944.

220 Ibid.

221 Ibid.

222 Ibid.

223 Ibid., Nov. 5, 1945.

224 Ibid.

225 Ruby's Report, *The Courier-Journal* (Louisville, Kentucky), June 3, 1954.

226 Ibid.

227 Finney, *Fair Exchange,* p. 68.

228 Ibid.

229 Ibid., p. 69.

230 "Clark, 78, Weeps for Joy as Colt from U.S. Wins Classic St. Leger," *The New York Times,* Sept. 12, 1954.

231 Ibid.

232 Finney, *Fair Exchange,* p. 70.

233 David S. Brooke, in *Three Cheers,* p. 7.

234 SCC, letter to RSC, Aug. 31, 1952.

235 SCC, letter to RSC, Aug. 21, 1952.

236 "Art Repository Heir to Millions," *The New York Times,* Jan. 18, 1957.

237 Martin Langeveld, "The Secret Life of 'Joe' Clark," in "Celebrating Fifty Years at the Clark," a supplement of *The North Adams Transcript, The Berkshire Eagle,* and *The Advocate,* summer 2006, p. 6.

238 Ibid.

V · EDWARD AND AMBROSE

1 Winants, "F. Ambrose Clark," n.p.

2 Unidentified obituary.

3 Wernick, "The Clark Brothers," p. 123.

4 Winants, "F. Ambrose Clark," n.p.

5 Jane Clark, interview with the author, Apr. 18, 2006.

VI · STEPHEN

1 Ed Stack, interview with the author, Mar. 24, 2006.

2 Conforti, et al., *The Clark Brothers Collect,* p. 138.

3 Weber, *Patron Saints,* p. 45.

4 Aragon, *Henry Matisse,* p. 103.

5 Ibid., p. 109.

6 Alfred H. Barr Jr., *Matisse,* p. 206.

7 Ibid.

8 Lynes, *Good Old Modern,* p. 17.

9 Ibid., p. 13.

10 Conger Goodyear, letter to SCC, Oct. 14, 1929. MoMA Archives.

11 *Vanity Fair,* November 1929, p. 136.

12 Lynes, *Good Old Modern,* pp. 61, 62.

13 Ibid., p. 63.

14 Goodrich, *Edward Hopper,* p. 9.

15 Lynes, *Good Old Modern,* p. 83.

16 Ibid., p. 80.

17 Anne Peretz, interview with the author, Apr. 12, 2006.

18 Van Gogh, from letter no. 518, vol. 3, p. 2, *The Complete Letters of Vincent v. Gogh,* 3 vols. (New York: Graphic Society, 1958). Quoted in the Yale University Art Gallery Registration files.

19 Ibid. Letter no. 533, vol 3, p. 28.

20 Ibid.

21 Ibid.

22 Van Gogh, from letter no. 533, in Robert Harrison, ed., *Complete Letters of Vincent van Gogh* (Bulfinch, 1991).

23 Schapiro, *Vincent Van Gogh,* p. 70.

24 Maire, "Van Gogh's Suicide," p. 938.

25 Schapiro, *Vincent Van Gogh,* p. 70.

26 Van Gogh, letter no. 535. Quoted in *Art in Our Time,* illus. 68, n.p.

27 Rilke, *Letters on Cézanne,* pp. 60–1.

28 Conforti, et al., *The Clark Brothers Collect,* pp. 140–1.

29 Goodrich, *Thomas Eakins,* p. 93.

30 Lynes, *Good Old Modern,* p. 191.

31 Ibid., p. 193.

32 Ibid.

33 Ibid.

34 Ibid., p. 194.

35 Ibid., p. 195.

36 Ibid., pp. 200–1.

37 Ibid., p. 201.

38 Ibid., p. 202.

39 Ibid.

40 *Art in Our Time,* p. 11.

41 Ibid. p. 13.

42 Ibid.

43 Ibid., n.p.

44 Rilke, *Letters on Cézanne,* p. 67.

45 Schapiro, *Cézanne,* p. 82.

46 Lynes, May 22, 1931, p. 208.

47 Rewald, *Seurat,* p. 166.

48 Alfred H. Barr Jr., *Museum of Modern Art,* p. 23.

49 Ibid., p. 25.

50 Ibid., p. 26.

51 Ibid.

52 Lynes, *Good Old Modern,* p. 206.

53 Ibid.

54 Ibid., p. 211.

55 Ibid., p. 220.

56 Ibid.

57 Ibid., p. 221.

58 Ibid., p. 222.

59 Marquis, *Alfred H. Barr Jr.,* p. 119.

60 Ibid., p 201.

61 Ibid.

62 Ibid.

63 Ibid., p. 225.

64 Lynes, *Good Old Modern,* p. 109.

65 Ibid., p. 111.

66 Ibid., p. 215.

67 Ibid., pp. 224–5.

68 Ibid., p. 224.

69 Ibid., p. 225.

70 Ibid.

71 Ibid.

72 Ibid., p. 229.

73 Ibid., p. 241.

74 Ibid.

75 Ibid.

76 Ibid., pp. 241–2.

77 Ibid. p. 202

78 Ibid., p. 242.

79 Ibid.

80 Ibid.

81 Ibid., pp. 242–3.

82 Ibid.

83 Ibid.

84 Ibid.

85 Ibid., p. 244.

86 Ibid.

87 Ibid.

88 Ibid., p. 17.

89 Ibid.

90 Ibid., p. 244.

91 Ibid.

92 Ibid.

93 Ibid.

94 Marquis, *Alfred H. Barr Jr.,* p. 203.

95 Ibid.

96 Lynes, *Good Old Modern,* p. 246.

97 Margaret Scolari Barr, "Our Campaigns," p. 68.

98 Ibid.

99 All quotations here are from SCC, letter to Alfred H. Barr Jr., Oct. 14, 1943.

100 Margaret Scolari Barr, "Our Campaigns."

101 Ibid., p. 68.

102 Marquis, *Alfred H. Barr Jr.,* p. 205.

103 Margaret Scolari Barr, "Our Campaigns," p. 69.

104 Lynes, *Good Old Modern,* p. 246.

105 Marquis, *Alfred H. Barr Jr.,* p. 204.

106 Ibid.

107 Margaret Scolari Barr, "Our Campaigns," p. 65.

108 Marquis, *Alfred H. Barr Jr.,* p. 205.

109 Ibid., p. 206.

110 Ibid., p. 207.

111 Lynes, *Good Old Modern,* p. 245.

112 Ibid.

113 Alfred H. Barr Jr., *Matisse,* p. 206.

114 Ibid., p. 208.

115 Ibid., p. 245.

116 Ibid., p. 201.

117 Ibid., p. 224.

118 Lynes, *Good Old Modern,* p. 247.

119 Ibid.

120 MB, p. 14.

121 Ibid.

122 Margaret Scolari Barr, "Our Campaigns," p. 71.

123 Marquis, *Alfred H. Barr Jr.,* p. 213.

124 Ibid., p. 209.

125 Ibid., pp. 211–12.

126 Ibid., p. 212.

127 Lynes, *Good Old Modern,* p. 258.

128 Ibid.

129 Ibid., p. 259.

130 Alfred H. Barr Jr., *Picasso,* p. 232.

131 Samuel M. Kootz, letter to Alan Shestack, Oct. 7, 1974.

132 Alfred H. Barr Jr., letter to William Burden, Dec. 11, 1953.

133 Lynes, *Good Old Modern,* p. 351.

134 Ibid., p. 352.

135 Ibid., p. 314.

136 Ibid.

137 Ibid., p. 314.

138 Ibid.

139 Lowell, *For the Union Dead,* pp. 20–1.

140 All quotes by Anne Peretz from interview with the author, Apr. 12, 2006.

141 Jane Clark, interview with the author, Apr. 18, 2006.

142 Ibid.

143 John Richardson, telephone interview with the author, Mar. 24, 2006.

144 Elaine Dorian, *The Sex Cure* (Canada: Beacon, 1962).

145 Ibid., p. 12.

146 Ibid., p. 17.

147 Ibid., p. 100.

148 Ibid., p. 101.

149 Ibid., pp. 100–1.

150 Ibid., p. 102.

151 Goodrich, *Edward Hopper,* p. 151.

BIBLIOGRAPHY

ABBREVIATIONS FOR
ARCHIVAL MATERIAL AND
UNPUBLISHED SOURCES

ABP Alfred H. Barr Jr. Papers. The
 Museum of Modern Art
 Archives, New York.
CCHS Harold E. Dickson / George
 Grey Barnard Collection. Center
 County Historical Society, State
 College, PA.
CDR Durand-Ruel, Charles.
 "Souvenirs de Charles Durand-
 Ruel sur Monsieur Robert
 Sterling Clark." Unpublished
 typescript, dated Sept. 19,
 1961. Trans. Sarah Lees.
 Sterling and Francine Clark Art
 Institute, Williamstown, MA.
DMW Daniel M. Williams
 Biographical Collection of
 George Grey Barnard,
 1863–1969. Philadelphia
 Museum of Art Archives.
GGBP George Grey Barnard Papers,
 1895–1941, Philadelphia
 Museum of Art Archives.
MB "Interview with Margaret Barr
 Conducted by Paul Cummings
 at the American Federation of
 Art in New York: 1974."

Smithsonian Archives of
American Art, Wahington, DC.
Moffatt Moffatt, Frederick C. "Touching
 Encounters: The Calamus
 Roots of George Barnard's
 Pennsylvania Capitol Statuary."
 Unpublished article, 2005.
 ———. Unpublished notes,
 2005.
 ———. Unpublished
 transcriptions of George Grey
 Barnard letters, 2005.
RSC Robert Sterling Clark diary,
 1923, 1924. Sterling and
 Francine Clark Papers. Sterling
 and Francine Clark Art
 Institute, Williamstown, MA.
SCC Stephen C. Clark. Department
 of European Paintings.
 Correspondence File.
 Metropolitan Museum of Art,
 New York.

PUBLISHED SOURCES

Addison Gallery of American Art.
 *American Paintings from the Collection
 of Stephen C. Clark.* Andover, MA:
 Addison Gallery of American Art,
 1940.
Aragon, Louis. *Henry Matisse: A Novel.*

New York: Harcourt, Brace, Jovanovich, 1972.

Archer, Jules. *The Plot to Seize the White House.* New York: Hawthorn Books, 1973.

Art in Our Time: An Exhibition to Celebrate the Tenth Anniversary of the Museum of Modern Art and the Opening of Its New Building. New York: Museum of Modern Art, 1939.

Barr, Alfred H. Jr. "A Gift of Paintings from a Trustee." *Bulletin of the Museum of Modern Art* 8 (April–May 1941).

———. *Matisse: His Art and His Public.* New York: The Museum of Modern Art, 1951.

———. *The Museum of Modern Art First Loan Exhibition.* New York: The Museum of Modern Art, 1929.

———. *Picasso: Fifty Years of His Art.* New York: The Museum of Modern Art, 1946.

Barr, Margaret Scolari. "Our Campaigns." *The New Criterion: Special Issue,* Summer 1987.

Beers, J. B. *Index to History of Greene County, New York: With Biographical Sketches of Its Prominent Men.* J. B. Beers and Co., 1884. Quoted in "Edward Clark," RootsWeb.com, http://www.rootsweb.com/~nyotsego/edclark.htm (August 31, 2006).

Birdsall, Ralph. *The Story of Cooperstown.* 1917. Repr. ed., Cooperstown, NY: Willis Monie Books, 2004.

Bissell, Don. *The First Conglomerate: 145 Years of the Singer Sewing Machine Company.* Brunswick, ME: Audenreed Press, 1999.

Cahill, Timothy. "The Naughty Painting." *CAI: Journal of the Clark Art Institute,* 3 (2002).

"Cast of Characters: Singer Presidents." Singer Memories, http://www.singermemories.com/cast-of-characters.html (August 25, 2006).

Chanin, A. L. "The Unerring Taste of Stephen Clark." *The Art Digest* 28, no. 7 (January 1, 1954).

Clark, Alfred Corning. *Lorentz Severin Skougaard.* New York: G. P. Putnam's Sons, 1885.

Clark, Robert Sterling, and Arthur de C. Sowerby. *Through Shên-Kan: The Account of the Clark Expedition in Northern China.* London: T. F. Unwin, 1912.

Conforti, Michael, et al. *The Clark Brothers Collect: Impressionist and Early Modern Paintings.* Williamstown, MA: Clark Art Institute, 2006.

Dickson, Harold E. "Barnard and Norway." *Art Bulletin* 44 (1962).

———. *George Grey Barnard: Centenary Exhibition, 1863–1963.* University Park, PA: The Pennsylvania State University Library in conjunction with the Pennsylvania Historical and Museum Commission, Harrisburg, PA, 1963.

———. "Log of a Masterpiece: Barnard's *Struggle of the Two Natures of Man.*" *The Art Journal* 20 (1961).

———. "The Other Orphan." *The American Art Journal* 1, no. 2 (Fall 1969).

Dorian, Elaine. *The Sex Cure.* Canada: Universal Publishing, Beacon paperback, 1962.

"FDR, Man on the White Horse, Chapter 10." Reformation Online, http://www.reformation.org/wall-st-fdr-ch10.html (September 5, 2006).

Finney, Humphrey S. *Fair Exchange: Recollections of Life with Horses.* London: J. A. Allen, 1974.

Fry, Roger. "The Lincoln Statue." *The Burlington Magazine for Connoisseurs* 32, no. 183 (June 1918).

Goodrich, Lloyd. *Edward Hopper.* New York: Harry N. Abrams, 1971.
———. *Thomas Eakins.* Cambridge, MA: Harvard University Press, 1982.

Gray, Christopher. "The Clark Family: Patrons of New York Architecture." *CAI: Journal of the Sterling and Francine Clark Art Institute* 6 (2005).

Hawes, Elizabeth. *New York, New York: How the Apartment House Transformed the Life of the City (1869–1930).* New York: Alfred A Knopf, 1993.

Hoeltzel, Bob. "Interesting Arcadians— Isaac Singer." Newark Courier-Gazette, http:// www.cgazette.com/towns/Newark/history/933787798218.html (August 25, 2006).

Jones, Louis C. "The Farmer's Museum at Cooperstown." *Art in America* 43 (May 1955).

Kern, Steven. *The Clark: Selections from the Sterling and Francine Clark Art Institute.* New York: Hudson Hills, 1996.

Kern, Steven, et al. *A Passion for Renoir: Sterling and Francine Clark Collect, 1916–1951.* New York: Harry N. Abrams in association with the Sterling and Francine Clark Art Institute, 1996.

LaMonica, Barbara. "The Attempted Coup Again FDR." *Probe* 6, no. 3 (March–April 1999).

Lane, James W. "Thirty-three Masterpieces in a Modern Collection: Mr. Stephen C. Clark's Painting by American and European Masters." *Art News Annual* (1939).

Lansford, Alonso. "Clark Collection Shown for Charity." *The Art Digest* 22, no. 12 (March 15, 1948).

"The Late Nathan Clark." *Evening Journal* (undated).

Lipman, Jean H. "Matisse Paintings in the Stephen C. Clark Collection." *Art in America* 22 (October 1934).

Lowell, Robert. *For the Union Dead.* New York: Farrar, Straus and Giroux, 1964.

Lynes, Russell. *Good Old Modern: An Intimate Portrait of the Museum of Modern Art.* New York: Atheneum, 1973.

Maire, Frederick W. "Van Gogh's Suicide." *Journal of the American Medical Association* 217, no. 7 (August 16, 1971).

Marquis, Alice Goldfarb. *Alfred H. Barr Jr.: Missionary for the Modern.* Chicago, IL: Contemporary Books, 1989.

Maylon, John. "James McNeill Whistler." Artcyclopedia, http:// www.artcyclopedia.com/artists/whistler_james_mcneill.html (January 4, 2007).

Moran, E. T. *Alfred Corning Clark: A Man Who Lived for Men.* Privately Printed, 1896.

Onians, John. "Sterling Clark in China." *CAI: Journal of the Sterling and Francine Clark Art Institute* 1 (2000).

"Plot Without Plotters." *Time,* December 3, 1934.

Pruchnicki, Paul John. *Barnard.* Manteno, IL: The Bronte Press, 1982.

Rewald, John. *Seurat.* New York: Harry N. Abrams, 1990.

Rickman, Eric. "Memorative Biographies." *The Bloodstock Breeders' Review.* Photocopy without further identification.

Riis, Jacob A. *The Battle with the Slum.* Bartleby, http://www.bartleby.com (October 10, 2006).

Rilke, Rainer Maria. *Letters on Cézanne.* New York: Fromm International Publishing, 1985.

Rydberg, Viktor. *Roman Days.* Trans. Alfred Corning Clark. New York: G. P. Putnam's Sons, 1880.

Sanders, Richard. "Robert C. Clark (1877–1956)." Press for Conversion, http://coat.ncf.ca/our_magazine/links/53/clark.html (September 5, 2006).

Schapiro, Meyer. *Vincent Van Gogh.* New York: Harry N. Abrams, 1950.

———. *Cézanne.* New York: Harry N. Abrams, 1952.

Schonberg, Harold C. Liner notes. *The Complete Josef Hofmann, Volume 5: Solo Recordings 1935–1948.* Marston Records, 1997. CD.

Spivak, John L. *A Man in His Time.* New York: Horizon Press, 1967.

Three Cheers for the Twenty-fifth: Essays for Three Exhibitions to Celebrate the Twenty-fifth Anniversary of the Sterling and Francine Clark Art Institute. Williamstown, MA: Sterling and Francine Clark Art Institute, 1980.

U.S. Congress. House of Representatives. Special Committee on Un-American Activities. *Investigation of Nazi Propaganda Activities and Investigation of Certain Other Propaganda Activities: Public Hearings.* Hearings No. 73-D.C.-6. 73rd Congress. 2nd Session. 29 December, 1934.

———. *Investigation of Nazi Propaganda Activities and Investigation of Certain Other Propaganda Activities: Public Statement.* 73rd Congress. 2nd Session. 24 November, 1934.

Weber, Nicholas Fox. *Patron Saints: Five Rebels Who Opened America to a New Art, 1928–1943.* New York: Alfred A. Knopf, 1992.

Wernick, Robert. "The Clark Brothers Sewed Up a Most Eclectic Collection." *Smithsonian,* April 1984.

Winants, Peter. "F. Ambrose Clark." *In and Around Horse Country.* April–May 2000.

Wolfe L. "Franklin Delano Roosevelt vs. the Banks: Morgan's Fascist Plot, and How It Was Defeated, Part IV." *The American Almanac,* July 25, 1994.

INDEX

A NOTE ON THE TYPE

The text of this book was set in Garamond No. 3. It is not a true copy of any of the designs of Claude Garamond (ca. 1480–1561), but an adaptation of his types, which set the European standard for two centuries. It probably owes as much to the designs of Jean Jannon, a Protestant printer working in Sedan in the early seventeenth century, who had worked with Garamond's romans earlier, in Paris, but who was denied their use because of Catholic censorship. Jannon's matrices came into the possession of the Imprimerie nationale, where they were thought to be by Garamond himself, and were so described when the Imprimerie revived the type in 1900. This particular version is based on an adaptation by Morris Fuller Benton.

COMPOSED BY
North Market Street Graphics, Lancaster, Pennsylvania

PRINTED AND BOUND BY
Berryville Graphics, Berryville, Virginia

DESIGNED BY
Iris Weinstein